GAUGUIN by himself

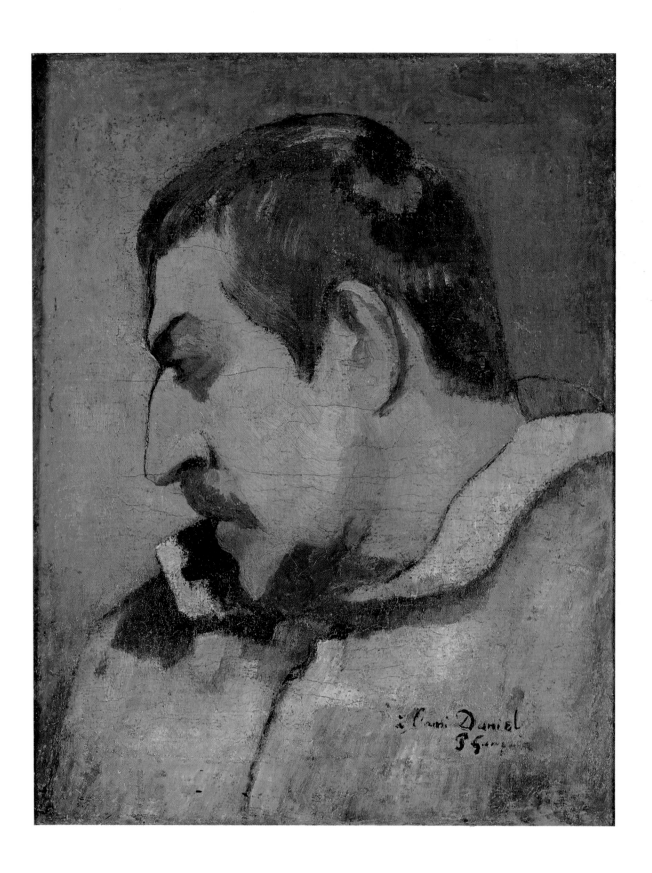

Edited by Belinda Thomson

GAUGUIN by himself

LONDON NEW YORK SYDNEY TORONTO

First Edition

Produced in association with
Book Production Consultants, Cambridge, UK

Editorial management: Rosamonde Williams
Production co-ordination: Debbie Wayment
Series design: Derek Birdsall, RDI
Design: Tim McPhee
Picture research: Sarah Wombwell
Typeset by August Filmsetting
Colour separation by Anglia Graphics

Published simultaneously in the United States of America by Bulfinch Press,
an imprint and trademark of Little, Brown and Company (Inc.),
in Great Britain by Little, Brown and Company (UK) Limited
and in Canada by Little, Brown & Company (Canada) Limited

This edition published 1993 by BCA by
arrangement with Little, Brown and Company (UK) Ltd

CN 8339

PRINTED AND BOUND IN ITALY

FRONTISPIECE (1): SELF-PORTRAIT, inscribed 'à l'ami
Daniel', 1897

Contents

6 Preface and Editor's
Acknowledgements

7 Paul Gauguin: Interpreting the Words
 *

10 1873–1887 The Impressionist Years
 *

82 1888–1891 Emergence as an Avant-
Garde Leader
 *

164 1891–1895 The First Tahitian Voyage
and its Aftermath
 *

244 1895–1903 The Last Years: Tahiti and
the Marquesas
 *

303 List of Plates

311 Guide to the Principal Personalities and
Organizations Mentioned

315 Index

317 Sources and Bibliography

Introduction

Following established precedent, *Gauguin by himself* is concerned to present as comprehensive a picture of the life and work of its subject as possible, by means of the artist's paintings, drawings, ceramics, sculpture and prints on the one hand, and his written words on the other. Paul Gauguin, like Vincent van Gogh, was unusual among his contemporaries in the importance he attached to the activity of writing. As well as being a lively correspondent, at certain moments in his career he found the written word a more biddable medium for self-expression than paint and canvas. Gauguin's art and writing combined provide an extraordinary charting of his progress as he learned to master his craft and ventured forth around the colonial globe in pursuit of an elusive dream. Although compilations have been devoted to Gauguin as a writer, this is the first publication to attempt a complementary presentation of the two activities.

A complete edition of Gauguin's correspondence is in the process of being published and a number of facsimiles of his various self-contained 'books' such as his *Cahier pour Aline* or *Noa Noa* exist, but a comprehensive collection of his other writings and journalism has yet to appear. The current selection has been made with a view to providing insights into Gauguin's character and thought, as well as a concise and self-explanatory counterpoint to his artistic development; it does not pretend to be exhaustive. It draws most heavily on Gauguin's correspondence with family and friends. His writings on more general topics, most of which came at the end of his life when he was too ill to paint, are introduced in so far as seemed appropriate to elucidate the decisions he had made in life and art and his attitudes to the rôle of the artist in contemporary society.

Preface and Editor's Acknowledgements

Gauguin by himself is a paradoxical title for a book which could not possibly have been realized without help from numerous individuals and institutions whose generosity has enabled me to bring it to fruition.

For their help in tracing pictures I am grateful to Claire Frèches, Musée d'Orsay; Gloria Groom and Peter Zeghers, Art Institute of Chicago; Thomas Gibson, Thomas Gibson Fine Art Ltd; Christopher Lloyd, The Royal Collection; Samuel Josefowitz; Paul Josefowitz; Andrew Dempsey at the South Bank Centre; Barbara Schapiro at the Museum of Fine Arts, Boston; Colta Ives, Metropolitan Museum of Art, New York; and Mikael Wivel, Ordrupgaardsammlingen, Charlottenlund. I would also like to express my appreciation to those anonymous private collectors who have allowed their works to be reproduced, sometimes for the first time, in this volume.

For authorization to cite letters from his father's edition of Gauguin's letters I am grateful to Daniel Malingue, and to Éditions Bernard Grasset; to Éditions Gallimard for use of documents in Daniel Guérin's anthology; to Maître Tajan for Ader-Tajan for permission to cite letters to Camille Pissarro; to the Vincent van Gogh Foundation for permission to cite the letters to Vincent, Theo and Jo van Gogh from Douglas Cooper's edition; to Roseline Bacou for the letters to Odilon Redon.

Although it has not been possible to trace each letter or document, where possible I have consulted original documents. I am particularly indebted to those owners of original documents who have granted me permission to publish them and enabled me to consult facsimiles. Certain minor corrections have been made where the printed version was found not to conform with the original. I would like to thank the following who have facilitated this editorial task: the staff of the Fondation Jacques Doucet, Bibliothèque d'Art et d'Archéologie, Paris: J. L. Gautier Gentes, Denise Gazier, M. Sevin; Fieke Pabst, Rijksmuseum Vincent van Gogh, Amsterdam; Leila Krogh and Karen Stovring, Willumsens Museum, Frederikssund; Caroline Durand-Ruel Godfroy at the Durand-Ruel Archive, Paris; Donald Anderle at the Getty Resource Center for the History of Art and the Humanities, Santa Monica; Isabelle Cahn, Anne Roquebert, Nicole Savy at the Musée d'Orsay, Paris; Arlette Serullaz at the Département des Arts Graphiques, Musée du Louvre, Paris; Anne Thorold and Jon Whiteley at the Ashmolean Museum, Oxford; Bengt Danielsson, Tahiti; Samuel Josefowitz; Eberhard Kornfeld of Galerie Kornfeld, Bern; Mary Anne Stevens, Royal Academy, London; Bernard Lolié autographes, Paris; Thierry Bodin autographes, Paris: Janine Bailly-Herzberg; Michael Howard; Joachim Pissarro; Richard Thomson.

Every effort has been made to contact copyright holders but any persons apparently overlooked who would wish to be acknowledged in future editions are invited to contact the publisher.

For help of a practical kind, my thanks go to Nancy Carline, Ronald Thexton and Julia Willcock of the Department of Art History, University of Manchester, and to Felicity Bevan and Monica Tipple of North Area College, Stockport. Finally I am indebted to Richard Kendall for proposing the project in the first place and for setting, with Juliet Wilson Bareau, such notable precedents, and to my husband Richard and my family as a whole, whose support, as always, helped me accomplish it.

At Book Production Consultants editorial work was ably overseen by Rosamonde Williams, picture research tirelessly undertaken by Sarah Wombwell, and Tim McPhee worked patiently and imaginatively on the design. At Little, Brown (UK) Ltd, Vivien Bowler, who took over the project from Macdonald, coolly helped me to see it through to completion.

EDITORIAL NOTE

Gauguin's writing has a robust character that complements his art. In editing the present selection and translations, I have endeavoured to be faithful to the idiosyncrasies of his style. To facilitate the flow of his prose for the English reader and to avoid confusion, some punctuation has been introduced and his somewhat erratic spellings of other artists' names (e.g. Césanne for Cézanne, Raffaeli for Raffaëlli, Schuffeneker for Schuffenecker) have been standardized.

Gauguin rarely dated his letters. Where he did so, or where dates of letters can be given with security, they are printed without brackets; conjectural dates and places of writing are within square brackets. Corrections to earlier published datings have been made where more recent scholarship has highlighted inconsistencies. I am happy to acknowledge my indebtedness to the many scholars whose publications on Gauguin have helped to resolve these chronological problems, notably John Rewald, the late Merete Bodelsen, the late Douglas Cooper, Janine Bailly-Herzberg and Richard Field. Where appropriate they are cited in connection with individual letters in the Sources and Bibliography section. Such errors as may remain are my responsibility.

TRANSLATIONS

For the translations, most of which are original to this edition, I have worked in close collaboration with Andrew Wilson. In addition to noting them as they occur, the editor would also like to thank Viking Penguin for permission to re-use translations by Eleanor Levieux, Thames and Hudson for permission to re-use translations of letters to Vollard and Fontainas by Gerstle Mack, and Mrs Gunter Hill for permission to re-use Jonathan Griffin's translation of *Noa Noa*.

Paul Gauguin: Interpreting the Words

'...*je suis un grand artiste et je le sais. C'est parce que je le sais que j'ai tellement enduré de souffrances. Pour poursuivre ma voie sinon je me considérerai comme un brigand. Ce que je suis du reste pour beaucoup de personnes.*'

'... I am a great artist and I know it. It's because I know it that I have endured such sufferings. To have done what I have done otherwise I would consider myself a brigand – which is what many people think I am.' (Letter to Mette Gauguin, Tahiti, *c.*March 1892)

'...*je crois qu'il a été dit sur mon compte tout ce qu'on devait dire et tout ce qu'on devait ne pas dire. Je désire uniquement le* silence, *le* silence *et encore le silence. Qu'on me laisse mourir tranquille,* oublié, *et si je dois vivre, qu'on me laisse encore plus tranquille et oublié...*'

'... I think that everything that should have been said as well as everything that shouldn't have been said has been said about me. All I want now is *silence, silence* and yet more silence. Let me die in peace, *forgotten,* and if I must go on living, all the more reason for leaving me in peace, forgotten...' (Letter to Daniel de Monfreid, Tahiti, November 1897)

'*Je tiens à cette publication car c'est en même temps qu'une vengeance un moyen de me faire connaître et comprendre.*'

'Getting this published matters to me for it will be both a form of vengeance and a way of getting myself known and understood.' (Letter to Daniel de Monfreid, Atuona, Marquesas, February 1903)

A publication which gives as much weight to an artist's written words as to his artistic production is particularly apt in the case of Paul Gauguin. The son of a journalist with a literary grandmother, his remarkable body of writing includes hundreds of letters and numerous pieces of journalism and other prose, some published in his lifetime. Much of this literary activity would seem to have been intended as a form of self-publicity or self-justification: the quest for recognition and acclaim was undoubtedly a strong guiding force in Gauguin's exceptional career, only denied in moments of deep despair. His excursions into art criticism were often motivated by a combative desire to beat the *littérateurs* at their own game.

If the action of time and familiarity have blunted some of the intended shock value of Gauguin's art, particularly of his paintings, his words retain an abrasively subversive quality to this day. In his letters, which are generally speaking the least circumspect of his writings, Gauguin was apt to make vehement pronouncements intended to upset the recipient; some of these he only half believed and later contradicted. Whether he was more prone than the rest of us to contradict himself is debatable.

Just as the 'primitivism' of Gauguin's art is now seen to have been the product of a remarkably sophisticated and synthetizing mind, similarly we should guard against accepting the writings of the self-styled 'savage', however frank they may

seem, at face value. In his art, building on Impressionism, Gauguin developed an innovative style in tune with the Symbolist aesthetic criteria of his day, incorporating elements from a variety of disparate sources: Breton, Japanese, Javanese, Egyptian and Polynesian. In rather the same way Gauguin's writing combined aspects of his own varied experience with ideas culled, scarcely disguised, from his eclectic reading.

Largely due to the circumstances in which Gauguin chose to live and work – outside the bounds of bourgeois marriage, family and society and eventually many miles from his native homeland – communication through his pen became vitally important. In Tahiti, the arrival of letters from France in the mail boat every month was a high spot in an existence otherwise unvariegated by weather, season or social encounters, and it was often the case that he hastily set about answering such letters before the same boat departed on its return voyage.

The habit of corresponding with friends as a means of keeping in touch set in well before his self-imposed exile from Europe, beginning with his seven-month stay in Copenhagen in 1884–1885. Subsequently, despite having ostensibly dispensed with family life and other such trammels of bourgeois existence in order to devote himself to art, the former stockbroker kept in regular contact with his Danish wife Mette. Her replies sometimes took several months to reach him due to the vagaries of his movements and of the postal services to Brittany, Panama, Martinique, Arles and Tahiti. Indeed their intermittent arrival and his frustrated hunger for news was usually the pretext for the irritability so often evident in his letters. Yet in them, alongside the anger and bombast with which Paul Gauguin launched himself into the artistic fray, we are also sometimes able to discover a more sympathetic side to the man, as he flounders without the traditional rôles of husband, father and breadwinner, struggling to find a new status for himself.

Alongside strictly practical letters are others where Gauguin gives free rein to his more personal emotions and to his developing ideas about art. These ideas are pursued at greater length in a variety of prose pieces such as the *Notes synthétiques* of *c.*1885 or the *Racontars de rapin* of 1902. A consistency of thought underlies his interventions on art. A latecomer to his vocation, having struggled without formal teaching to master his craft, he is passionate in his allegiance to a liberal avant-garde and violently opposed to all state-promoted teaching and reward systems which, he argues, militate against talent and stifle individual creativity. Another of his themes is the damaging infiltration of art criticism by literary professionals, who only seek confirmation of their own ideas and lack the necessary aptitudes for an understanding of the visual arts. It was his firm belief, first hinted at in a letter to Pissarro of 1883 and reiterated in a letter to Maurice Denis in 1895, that artists had better look to penning their own defences if they were to avoid

being sold down the river by ignorant critics. There is irony here, for in the 1890s when Gauguin was proclaimed in certain quarters the leader of Symbolism in the visual arts, it was largely due to the sympathetic reviews of literary men such as Albert Aurier, Achille Delaroche and August Strindberg, whose articles he carefully preserved. Moreover he was the first to suffer when one of his former painter colleagues, Émile Bernard, took to publishing his own defence, since he did so precisely to deny his supposed indebtedness to Gauguin.

As might be expected from the combative nature of the man, Gauguin's writing style is vigorous and direct, liberally scattered with colloquialisms and colourful metaphors which often have a seafaring origin. (Gauguin spent several years of his youth in the merchant navy before settling down in Paris.) One senses that the irony and timbre of Gauguin's voice, familiar to his correspondents, would have given a particular inflection to some of his more pithy or oblique remarks. After 1891, when isolated in the South Seas, writing increasingly became a substitute for conversation and without warning one often finds Gauguin introducing his imagined interlocutor's argument, (referring either to a letter or article he has just read), before answering it point for point. Such devices can make his meaning difficult to recapture in translation. But the content is eminently readable, his handwriting always neat and legible and sometimes embellished with sketches. Indeed it is one of his many contradictions that Gauguin sought to bring order and beauty to all aspects of his work and environment, belying the squalor and emotional disorder of his circumstances. The letters also reveal how he prided himself on his powers of reasoning and calculation and kept a watchful eye over his business affairs, a legacy perhaps of the years spent earning a living in the money markets.

It is never, of course, fully satisfactory to overhear one-way conversations and a volume of this kind raises many questions which cannot always be answered. The highest proportion of the surviving letters were addressed to Mette (née Gad), Gauguin's Danish wife, whom he married in Paris in 1873. Mette Gauguin has been frequently dismissed in the Gauguin literature as irredeemably narrow-minded and bourgeois, failing to understand her husband's artistic calling or appreciate his work, charges Gauguin himself frequently laid at her door. More recently she has been championed by her countrywoman Merete Bodelsen, the distinguished late Gauguin scholar. She describes Mette Gauguin as cutting an extraordinarily lively figure in turn-of-the-century Copenhagen society, in itself so much more liberal than France. Clearly Mette did her best to promote Gauguin's work in Scandinavia, even if her motives for doing so were self-interested.

Gauguin's feelings for his wife seem to have been confused, much as were his attitudes to family life. The couple's parting came about in 1885 and followed a period of considerable marital strife as they faced up to the full financial implications of the ruinous career decision he had taken. Gauguin blamed Mette's character and her family's interference for the rupture. Once the dust had settled, his letters to Mette occasionally express tenderness and sympathy for the position he had placed her in and regret for the companionship they must once have enjoyed; more often he upbraids her for her coldness of heart, her mercenary attitudes, her vanity, bemoaning his folly in marrying a woman who expected to maintain a costly standard of living when he would have been better off married to a cook, to a woman who knew her place and respected her husband's authority. One suspects Gauguin compared his own situation with that of Camille Pissarro, whose wife Julie, of peasant stock, laboured courageously to hold a similarly numerous family together (though not cheerfully or uncomplainingly as we now know from Pissarro's correspondence!).

Some of Gauguin's attitudes were typical of his time: home was understood to be the woman's domain where the father was only expected to put in irregular appearances. (Gauguin, of course, had not known his own father who died when he was two.) And although he sent out plenty of warning signals that it was Mette's rejection that forced him to it, he also lived by the double standards of the day, expecting fidelity from his wife whilst claiming unlimited sexual freedom for himself. In the end the enforced separation from his wife and children troubled Gauguin less than the frustrated awareness of failing, in society's eyes, as the economic supporter of his family. On repeated occasions he argued that concentrating on art offered him the best chance of providing an income and establishing a name his wife and children would be proud to bear – it was the honourable course of action. Whilst clinging to this traditional view of the masculine rôle, Gauguin was impatient with his wife's difficulties as she juggled with enforced new rôles of dependent relative and independent working woman.

Mette brought their correspondence to an end in 1894, soon after Gauguin returned from his first trip to Tahiti, seeing no point in continuing a relationship with such a 'ferocious egotist'. The pretext was ostensibly money, though one might imagine a certain degree of jealousy came into it. For all Gauguin's claims that he had hardened himself to sensitive feelings, this severance of ties undoubtedly contributed to the souring of his temperament. Sales of his work continued to prove elusive despite considerable critical acclaim. He railed against the institution of marriage which he felt had become no more than a form of licensed prostitution from which women alone stood to gain. And whereas he had once upheld the view that human society had not yet invented any better solution than the family, henceforth he felt entitled to transgress that ideal, propounding instead a kind of free association – which he effectively practised in Polynesia – where no stigma would attach to illegitimacy and where society would take care of the children.

Despite her pessimistic outlook, it would appear that Mette Gauguin was a remarkably courageous and resourceful woman, and if she complained bitterly, she also took pride in having shouldered the burden of her children's upbringing, as some of her surviving letters show. Had she been unequal to the task, the freedoms Gauguin was able to claim as an artist would have been considerably curbed. Happily for his reputation, history was to bear out his belief in his great destiny and his Danish family were eventually reconciled to his success: two of his sons would sign prefaces to posthumous publications devoted to their famous father.

The frequently acerbic tone of Gauguin's letters to his estranged wife is perhaps to be expected. He was also capable of adopting a deferential tone, as we see from the few surviving letters addressed to the painter Odilon Redon and the poet Stéphane Mallarmé, for instance; equally respectful, one suspects, must his letters to Edgar Degas have been, none of which survive. Degas appears not always to have replied but it is certain that his opinions and encouragement of Gauguin's artistic efforts from the mid-1880s onwards carried enormous weight. In seeking to understand Gauguin's developing ideas as a painter perhaps the most revealing of his letters are those to his first mentor Camille Pissarro, to whom he confides his hesitations and convictions as he struggles to master Impressionism, as well as those to Vincent van Gogh with whom he enjoyed a fruitfully collaborative relationship at a key moment of artistic maturation between 1888 and 1890. On the other hand his increasingly desperate letters to de Monfreid in the later 1890s make more painful reading, for one senses not only a loss of vigour in Gauguin's artistic ideas but the want of a mind he considered his equal.

Gauguin's domineering tone and striking lack of *politesse* when writing to most of his male friends demands explanation. One reason for it was that, due to his not being on the spot in Paris, many of his letters consisted of requests to the recipient to perform errands on his behalf. Another was that his correspondents tended to be less experienced and self-assured than himself. The artists associated with Pont-Aven for instance – Émile Bernard, Jens-Frederik Willumsen, Paul Sérusier, Armand Seguin and Maxime Maufra – all came into this category. So too did Émile Schuffenecker and Daniel de Monfreid, who acted at different periods as Gauguin's general factotum and most loyal correspondent: they had the advantage for Gauguin of being men of independent means who could be directly appealed to for funds with the minimum of flattery and circumlocution. One might argue that they also served to bolster Gauguin's ego, while posing little threat to his sense of superiority.

Being Gauguin's confidant was in the main a thankless task. His letters late in life were sometimes so full of bile that Seguin, for one, admitted his reluctance to continue their correspondence. When Schuffenecker finally turned the tables on Gauguin, criticized his high-handedness, pleaded difficulties of his own and, worse, took up the cause of Mette in Copenhagen, he received short shrift and was discarded. De Monfreid fared better and remained loyal to the bitter end: perhaps mindful of his increasing dependence, Gauguin occasionally remembered to thank him for his devotion.

A number of his last letters were no longer addressed to family or friends but to influential individuals such as André Fontainas, art critic of the *Mercure de France*, whom he saw as a suitable vehicle for the broadcasting of his views; in a sense these last missives, like his book which was not a 'book', *Avant et après*, were addressed to posterity.

From our historical perspective it is difficult not to find fault with Paul Gauguin the man. His prescriptions for behaviour and attitudes to his fellow human beings, most particularly to women, which deliberately flouted the conventions of his day, are liable to arouse still greater moral censure in a postcolonialist era whose consciousness has been raised by feminism. In order to wrest certain freedoms in the name of art without compromising his artistic integrity, Gauguin felt justified in being outlawed and branded a criminal by a world he considered corrupt and hidebound – indeed he pre-empted society's judgments by repeatedly presenting himself in a variety of savage and diabolical guises in both visual and written form. Yet though he exploited the beliefs and traditions of Brittany and Polynesia essentially for his own ends, there was also a certain humility in his championing of the peoples of Polynesia, a sad awareness that he was witnessing and participating in the corruption of their ancient beliefs. In his seeking to reach out and enrich his own practice with elements drawn from a broader world culture, Gauguin was very much an artist of the twentieth century. And Gauguin's preparedness to invest his whole being into that ambition commands respect. We can still find food for thought in the intense love of the activity of making art and almost incredible self-belief that saw Gauguin through chronic illness and persistent disappointment, even if we can no longer comfortably countenance the 'heroism', the exploitative adventurism that the whole enterprise of his career represents.

1873–1887 *The Impressionist Years*

This section begins with Gauguin's own account of his exotic family origins from Avant et après, *a manuscript drafted in 1902–1903 shortly before his death.*

Following Paul Gauguin's six years' naval service, the period from 1873 to 1887 saw his transformation from the sociable newly-wed with a promising career on the Paris stock market who drew and painted in his spare time, to the committed artist, cut loose from society, searching for ways to revitalize Impressionism. How that change came about is recorded year by year from 1879, particularly in the letters to Camille Pissarro, the Impressionist with whom Gauguin associated most closely and whose works he was buying at minimal prices, along with those of Armand Guillaumin and Paul Cézanne. Gauguin's early efforts as a landscape painter had already earned him acceptance at the Salon of 1876, but from 1879, when Pissarro first invited him to exhibit with the Impressionists, he identified with their cause with all the fervour of the new convert. Pissarro was responsible for encouraging Gauguin's development away from the dark tonalities associated with the Barbizon school towards a lighter palette and freer handling. The letters show the bold intervention Gauguin made in the behind-the-scenes politics of the Impressionist exhibitions at a moment when the group seemed to be losing cohesion and direction. The various references to sculpture and later to ceramics (Gauguin was initiated in these media by his Paris neighbour Jules Bouillot and Félix Bracquemond respectively) reveal Gauguin's early aptitude for three-dimensional work.

During these years Gauguin held down a series of jobs in investment and insurance, struggling to balance his business career with his activities as an artist. In late 1883 his position with the insurance firm Thomerean came to an end and he resolved to commit himself wholeheartedly to art which by then preoccupied more and more of his time and thought. The move coincided with a severe recession, when jobs were scarce. As Gauguin soon discovered, with a family of five to feed it was not a propitious time to launch oneself as a painter; Durand-Ruel, the Impressionists' dealer, was unable to shift his stock and finding it hard to survive. With the exception of Joris-Karl Huysmans who had written favourably about his Study of a nude *exhibited in 1881, Gauguin experienced nothing but discouragement from the critics and from his wife, on whose family's mercies he and Mette had to force themselves at the end of 1884. But throughout his career Gauguin seems to*

have thrived on hard knocks, and his determination to resist comes through in the letters from Copenhagen to artist friends in Paris.

In the letter Gauguin wrote in December 1884 to the tarpaulin firm Dillies & Co., a representative example from a series of such letters written that winter, we see evidence of his competent, if by then half-hearted, approach to his business ventures. Yet at the same time he was writing a series of letters, and drafting the Notes synthétiques, *in which he first explored aesthetic ideas at length.*

In 1885 Gauguin left his wife and family and, after a summer in Dieppe, settled back in Paris. He had with him his second son Clovis, then aged six, for company. A bitterly cold winter ensued and Gauguin resorted to taking a menial job billsticking to make ends meet while Clovis lay ill in bed. It was the last time Mette would allow him to have custody of any of the children.

Following his disappointing showing at the eighth and final Impressionist exhibition, where the novel pointillist paintings of Georges Seurat stole all the attention, Gauguin spent the summer of 1886 in Pont-Aven. It was the first of numerous visits to Brittany where, alongside painters of many nationalities, Gauguin found cheap lodgings, available models and an atmosphere more conducive to art. Indeed, the antagonism of the other artists for whom the tag of 'Impressionist' was tantamount to 'revolutionary', seems to have suited him.

In 1887 Gauguin set out to explore the tropics, convinced that they offered novel opportunities for the Impressionist. With a young painter friend, Charles Laval, he worked his way via the isthmus of Panama, where the canal was being cut, to Martinique in the West Indies. Stimulated by the spectacle of its people, colours and exotic vegetation, he wrote home enthusiastic letters, conjuring images of a future colonial life of comfort reunited with his family. Although illness forced Gauguin to return to Paris sooner than he wished, he brought with him a group of paintings in which he had struck a decidedly new note. Their dense saturated colours, previously thought by critics to have a deadening effect, had at last found a raison d'être. *He was invited to exhibit them that winter at the branch of the Boussod and Valadon gallery managed by the Dutch art dealer Theo van Gogh.*

Atuona, 1903

...Scattered notes, unconnected, like dreams; like life, made of bits and pieces ... This is not a book ...

My grandmother was quite a woman. Her name was Flora Tristan. Proudhon said she had genius. Not knowing anything about it, I rely on Proudhon.

... She probably did not know how to cook – a socialist blue-stocking, an anarchist.

I also know that she used her whole fortune in support of the workers' cause and travelled constantly. At one point she went to Peru to see her uncle, the citizen Don Pio de Tristan Moscoso (Aragon family).

Her daughter, who was my mother, was brought up in a boarding school ...

It was there that my father, Clovis Gauguin, met her. At the time my father was a political reporter for *Le National*, the newspaper of Thiers and Armand Marrast.

After the events of 1848 (I was born on 7 June 1848) ... he conceived the idea of going to Lima, where he intended to found a newspaper. The young couple had a little money.

Unfortunately the captain of their ship was a dreadful man; this did my father terrible harm as he suffered from severe heart disease. As a result, when he was about to go ashore at Port Famine, in the Straits of Magellan, he collapsed in the whale-boat. He was dead of a ruptured aneurysm.

... The old man, the very old uncle, Don Pio, positively fell in love with his niece ... my mother was as petted and spoiled as a child.

I have a remarkable visual memory, and I remember that period, our house, and a lot of things that happened; I remember the President's monument, the church whose dome, entirely carved out of wood, had been added on afterwards.

I can still see our little Negro girl, she who, according to custom, must carry to church the little rug one kneels on. I can also recall our Chinese servant who ironed so well.

... As a very noble Spanish lady, my mother had a violent nature, and her little hand, flexible as India rubber, gave me several slaps. It is true that a few minutes later, my mother was crying, hugging and petting me.

... How graceful and pretty my mother was when she wore the local costume, the silk mantilla covering her face and leaving only one eye visible, such a soft and imperious eye, so pure and caressing.

... Don Pio de Tristan Moscoso ... had left my mother an income of 5000 piastres, which meant a little over 25,000 francs. At his deathbed, the family managed to get around the old man's wishes and seized this immense fortune, which was swallowed up in a spending spree in Paris. Today one very wealthy female cousin is still living in Lima, a near-mummy. The Peruvian mummies are famous.

... As you can see, my life has always been very restless and uneven. In me, a great many mixtures. Coarse sailor. So be it. But there is also blue blood, or, to put it better, two kinds of blood, two races.

... when we arrived from Peru we lived in my grandfather's house. I was seven years old.

... A little later on I whittled and carved dagger handles – without the dagger; a lot of little dreams that grownups couldn't understand. An old lady who was a family friend exclaimed admiringly: 'He will be a great sculptor.' Unfortunately this lady was not a prophet.

I became a day pupil in a boarding school in Orléans. ... At eleven I went to a secondary

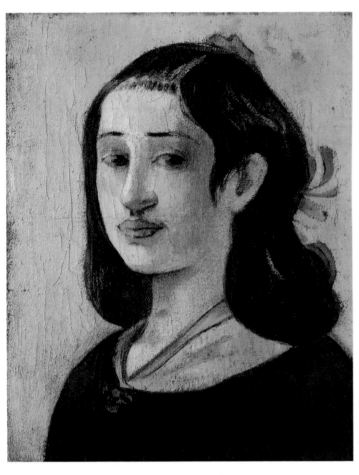

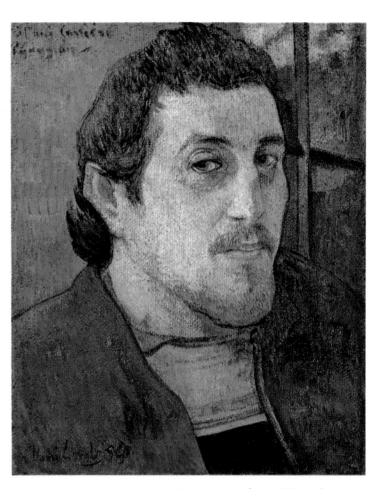

2 THE MOTHER OF THE ARTIST, *c.*1890 3 SELF-PORTRAIT, dedicated to E. Carrière, 1888 and 1895

school run by priests, and there I made very rapid progress . . . this education . . . I believe . . . did me a great deal of good.

As for the rest, I think it was there that I learned very early on to hate hypocrisy, false virtues, informing on others . . . to mistrust everything that was contrary to my instincts, my heart, and my reason.

*

Paris, 9 February 1873

TO MADAME HEEGAARD Your kind letter congratulating me on the choice I had made in asking for Mette's hand in marriage proves that you love her too . . .

Mlle Mette was sure to find many admirers in France; her singular character and loyal sentiments make her esteemed by everybody, and so I must consider myself very fortunate in having chosen her. I assure you that, in depriving Denmark of such a rare pearl, I will do everything possible, and even impossible, to ensure that she will not miss all her friends, whom she will continue to love, despite everything, as dearly as in the past . . .

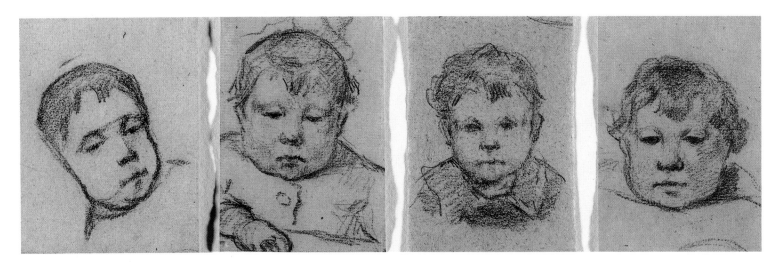

4 THE ARTIST'S INFANT SON, EMIL, *c.*1875–1876

[Paris] 25 April 1874

TO MADAME HEEGAARD . . . We have spent a delightful winter, a little severe for
some perhaps, but it was very comfortable in our little apartment . . .

Mette would be unable to give you any idea of current fashions – despite all my efforts it
remains beyond her – and I do not know how ladies are dressing, except that they are dressing
well. I believe hats will be extravagant this year, and the dresses will make designers rich and
husbands poor . . .

*

[Paris] 8 July 1874

TO MADAME HEEGAARD . . . I will stay a few more years in France before I shall have
an opportunity to come to Copenhagen for a short stay. I am one of those whom Fate has
condemned to stay at home; because I have travelled too much I am now obliged to keep my
nose permanently to the grindstone. We shall have to make the best of a bad job . . .

We will certainly be very happy to welcome your young Anker, but as to acting as his
mentor, I have to confess I would not know where to begin. As you know, I am utterly unable
to distinguish virtue from vice. Mette could give him some sound advice, but I doubt whether
he will heed it.

*

[Paris] 12 September 1874

TO MADAME HEEGAARD To think you could go on a trip without passing through
Paris, your favourite city and where after all you have good friends. Mette would have been so
happy to see you and to show you her baby.

You know he is bonny: it's not just our paternal and maternal hearts that judge him so,
everybody says it. As white as a swan, and strong as Hercules, but I certainly couldn't say if he
is lovable, he is quite likely not to be with such a surly father . . .

I forgot to tell you his name. It's Emil . . .

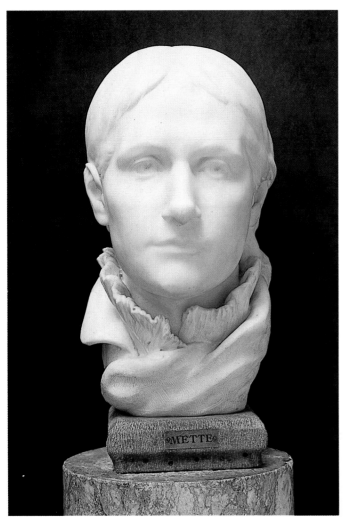

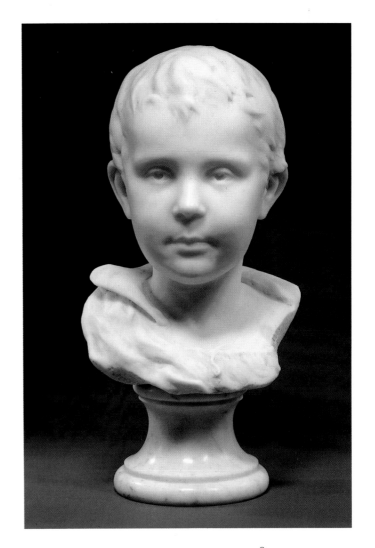

5 PORTRAIT BUST OF METTE GAUGUIN, 1879 6 PORTRAIT BUST OF EMIL GAUGUIN, 1879

[Paris] 3 April 1879

To Camille Pissarro I have great pleasure in accepting the invitation that you and Monsieur Degas have extended to me, and in this case, naturally, I accede to all the rules governing your society . . . I will probably see you at Madame Latouche's and we will talk about this further . . .

*

Paris, 26 July 1879

To Camille Pissarro . . . I found Degas in his studio; unfortunately his pastel has been bought by May, so I was unable to take it. It's regrettable because it was stunning. I am sending with your son the money for the 2 small pictures and your paints . . . I am glad I had the idea of stretching my canvases myself. This means I can save more than half the cost. I have found 10 metres of canvas, 1 m 20 in width, for 18 francs, you see it's not expensive, although admittedly it was in a shop that had gone bankrupt, and my carpenter is making me some stretchers cheaply . . . Several of your pictures and some by Sisley and Claude Monet are being shown at the moment at the newspaper *l'Evénement* . . . Madame Latouche has sold a FAN of yours.

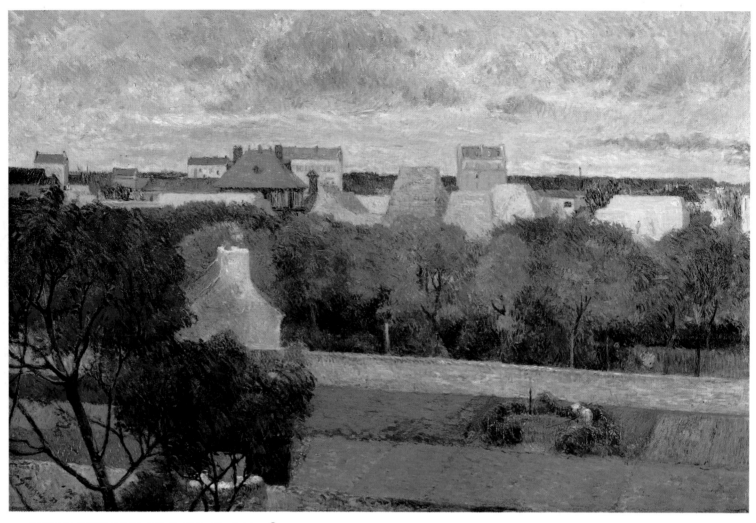

7 THE MARKET GARDENS OF VAUGIRARD, 1879

[Paris, summer 1881]

TO CAMILLE PISSARRO . . . I have heard you put forward the theory that a painter
must live in Paris in order to keep alive his ideas. How can you say such a thing when we poor
devils are sweltering at La Nouvelle-Athènes and all you choose to do is to live like a hermit in
his hermitage . . . Has Monsieur Cézanne found the precise formula for a work accepted by
everybody? If he should find the recipe for giving full expression to all his feelings in one single
procedure, I beg you to try to make him talk during his sleep by giving him one of those
mysterious homeopathic drugs and come to Paris immediately and tell us all about it.

*

[Paris, summer 1881]

TO CAMILLE PISSARRO I am very much afraid that at your last meeting with Degas
you did not make yourself completely clear to him. I had a very long talk with that
cantankerous person yesterday evening, from which it emerged that Degas had understood that
Durand-Ruel was putting on the exhibition, that Renoir is not asking to be included but, on
the contrary, is being pushed into it by Durand-Ruel, in other words it is Renoir who makes
the rules etc . . .

After many arguments, each as violent as the last, I managed to calm Degas somewhat by saying to him that if it did come to a fight with those fellows (as he calls them) we would stand staunchly by and resist them, etc . . .

We have to give all this some thought, our future depends on it. Once we let the public fall into the habit of despising us the fight will be over and we will never be able to start again. I hope we will have a *general meeting* this winter in order to talk frankly about all this; when everybody has said exactly what he thinks, something must come of it, dash it! It is not possible to establish a movement outside the École [des Beaux-Arts] and the Salon without mutual esteem among the exhibitors . . .

We have to be prepared to live without Durand-Ruel in case he should fail.

Did you know that the way things are going with Sisley and Monet, who are churning out pictures at top speed, he will soon have 400 paintings on his hands that he will not be able to get rid of? Dash it all, you can't flood the place with pictures of rowing boats and endless views of Chatou, it'll become a dreadful trademark. Think about it, my dear Pissarro, let's not overdo it, you'd only make a fool of yourself: you are serious about your work, but you will be lumped together with everybody else, as you well know. A *hint* of fresh air may be a nice thing from time to time, but it hardly constitutes a real *picture*, and the proof is that you are going to a lot of trouble to paint some! . . .

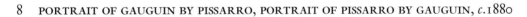

8 PORTRAIT OF GAUGUIN BY PISSARRO, PORTRAIT OF PISSARRO BY GAUGUIN, *c.*1880

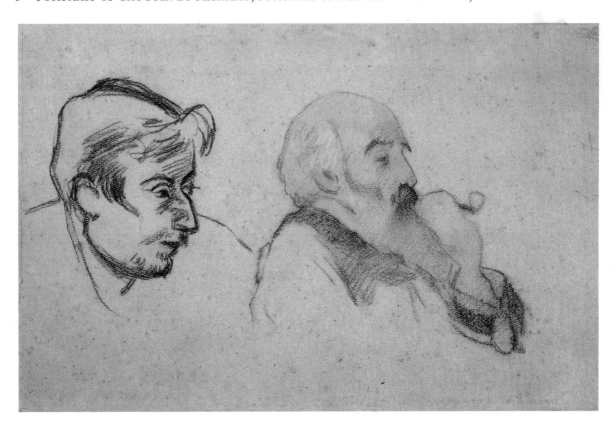

Paris, 11 November 1881

TO CAMILLE PISSARRO A Panorama has been installed at the salle Valentino. A beautiful large room on that plot of land has been fitted out for exhibitions of paintings – in fact they have just hired out to Jacquet.

Someone came to see me offering to take responsibility for our exhibition in exchange for a minimum fee and a share of the admission fees. I think this is an excellent opportunity to put on our exhibition (with light both day and night), provided Degas doesn't put too many spanners in the works.

What do you say? I will wait for you before negotiating any deal so if there's nothing to prevent you, come up, I'll expect you at any time and we can talk it over and see to it without delay. From my point of view it seems an excellent proposition.

He is offering us the hire of the room for between 6 and 8000 francs, *all costs paid by him*, plus a share of the admission fees.

Since by this means, and as a consequence of the people coming into the Panorama, there is a good chance of us having 20,000 people coming to the exhibition, you see we stand to make a handsome profit of 5000 francs for ourselves and 5000 for him. Furthermore, an exhibition in a room equipped for the purpose is much preferable to one held in small apartments.

I am relying on you. P. GAUGUIN

*

[Paris] 14 December 1881

TO CAMILLE PISSARRO Yesterday evening Degas told me angrily that he would rather resign than dismiss Raffaëlli.

If I cast a dispassionate eye over your situation in the ten years since you undertook the task of putting on these exhibitions, I see immediately that the number of Impressionists has risen and that their talent as well as their influence has strengthened. On the other hand, however, as far as Degas is concerned – and it is his will and his will alone – the tendency has been getting worse and worse; each year one Impressionist has left, making way for nonentities and pupils of the École [des Beaux-Arts].

In 2 years' time you'll be the only one left amongst schemers of the worst kind, all your efforts will have been ruined and Durand-Ruel into the bargain.

Despite all my good will, I can no longer continue to serve as jester to Messrs Raffaëlli & Co., so please accept my resignation; as from today I shall stay at home . . .

*

[Paris] 18 January 1882

TO CAMILLE PISSARRO . . . Another thing that worries me is the exhibition. You come to Paris for two days every month; thus between now and March you have two days to spend here, and what's new – nothing – Everything's gone quiet – we are committed to paying out 6000 francs, there's the most awful muddle in the group and nothing resolved. Guillaumin

doesn't know whether he should order *his frames* and it's time to take a decision ... in any case I warn you that Raffaëlli is making every effort to go to the watercolourists, but he will not abandon our exhibition until he is sure of being accepted somewhere else, just when we will have to start showing our work. I will never be able to forget that, for Degas, Raffaëlli is merely an excuse for a split: that man has a perverse character that devastates everything ... There are already four painters' organizations that put on exhibitions, with God knows what talent. We are the only ones who do nothing but squabble.

*

[Paris, March 1882]

To Camille Pissarro ... I do not have the time I need to produce a steady stream of work, which saddens me. Still I suppose I shall have to wait until I am able to work consistently. I am not losing heart and I hope that my lengthy reflections and the observations I have gradually stored away in my memory will help me later to make up for lost time. I confess that since the last exhibition I have been quite disgusted by everything, particularly my fellow men; I am increasingly aware of how much our age is a savage one of money and jealousies of all sorts. Never mind, it has thrown me ever deeper into my painting, my sole purpose is to win through on the strength of my talent, despite all the difficulties not experienced by those who have all year in which to study ... I'm in a real mess this year from the financial point of view ... Messrs Renoir and Co. have made a nice job of running us down with Durand-Ruel! ... you ask me what I think of Renoir's Italian paintings ... I find them *absolutely intolerable* ... if that's what I have to do to court popularity I would prefer never to show my paintings again ...

*

[Paris, 1882?]

To Camille Pissarro ... the masters or the greats as you call them ... most of them began their education when young. By this I mean they learnt all the ways of using a formula, (a formula that at certain periods tends to change) – so when they reach a certain age and create pictures they do so with a sure hand and an accurate memory ... Our age is becoming very difficult for us, history painting no longer has a justification for its existence or else people just paint anecdotal scenes like in military pictures. We're left with genre painting or landscape – which is, moreover, where all the work of the latest masters comes from. Look at Courbet, Corot, Millet. As for you, I think it's time (if you are so disposed) to do *more work in the studio*, but things that have already been worked out in advance from the point of view of composition and *scene*. In this connection, you need only devote everything you've learnt before to what you will be doing and not look for a new *vision* of nature and you will improve immediately ...

*

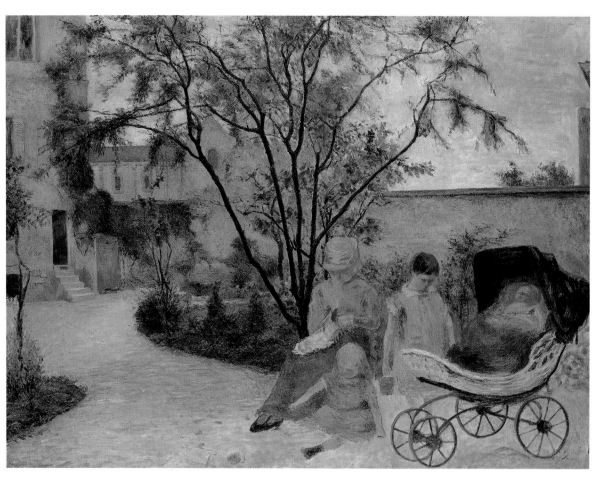

9 THE FAMILY IN THE GARDEN, RUE CARCEL, 1882

[Paris, late 1882]

TO CAMILLE PISSARRO … The passion for sculpture is certainly growing. Degas (it would seem) is making sculptures of horses, and you are making cows; you ask me for information on making metal models but, my poor friend, I don't know any more about it than you do. I do the best I can, and my best is almost always rather bad.

However, I think the best thing for you to do would be to buy some of those little tin pipes that are sold for pneumatic bells. You can twist them as you want and they keep their shape pretty well because they are much less elastic than wire. Obviously you only make the main *shape* – modelling in wire is indeed an art in itself.

My wife is supposed to be calling on you today and perhaps at this very moment she is with you. She is to scold you on my behalf, for it's ages since you set foot in our house. I've been working quite well all the same but I confess that just now I have periods of disgust – not with painting but with the fact that I'm not equipped to do what I want – with the fact that I have this deep inner urge but am unable to work for lack of money!!

My business affairs are in a really bad way and the future doesn't look too brilliant; what's more you will understand that as one gets older one cannot pursue 2 goals at once as one did in youth. My mind is quite given over to dreams, observations of nature, and longings to work and I am gradually forgetting business deals or rather how to go about them. As for abandoning painting, never, not for a minute do I think of it! …

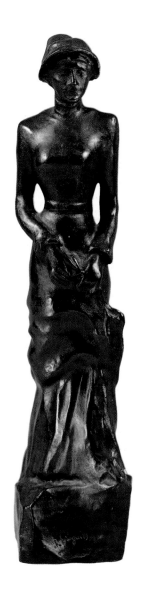

10 WOMAN WALKING (THE LITTLE PARISIENNE),
 1880

11 THE SINGER/PORTRAIT OF VALÉRIE ROUMI,
 1880

[Paris] 8 December 1882

TO CAMILLE PISSARRO I received your letter this morning and thank you for
remembering the question of the 800 frs. I requested from you for the horizontal picture of the
man sawing. However I am rather embarrassed on two counts: firstly, I thought you were to
keep the picture and I don't know whether to take it to Durand-Ruel or just collect the money
using a receipt from you. Secondly I owe Durand more or less that amount and it's somewhat
awkward to be paid money by someone you owe. So I'd be obliged if you could get your son to
receive the payment and you can give it to me later . . . you are happy with the area where you
have gone to live and you are going to produce some masterpieces if your enthusiasm is
anything to go by; in any case, a change of scenery does the spirits good. Nevertheless, the
countryside must be rather similar to that around Pontoise.

 I will come this winter to see how you have settled in; Madame Pissarro told me you had
room for me in which case I would leave on a Saturday evening in order to have a whole
Sunday to myself for doing a winter sketch . . .

[Paris, early 1883]

To Camille Pissarro
It is not without profound regret that I see your exhibitions becoming individual showings at an art dealer's premises. At a time when everybody has just had an exhibition and the public has lost its enthusiasm, the Impressionists who had a certain number of customers who were interested in them and followed their progress each year are going to disperse and ask the public to come out several times ... when you are together, people can see the difference between each one, but if you separate everyone is going to think you are all the same ... I agree that the main thing is to do good pictures but you still have to show them. Guillaumin and I will be left high and dry; who will be able to tell if we are making progress?

... An artist holds an exhibition of his works once in his life and he is judged, but that must be all and even then I think it is better to hold the exhibition *on his death*.

... Mark my words – We were interesting because we formed a talented phalanx of painters *committed to a movement* who stood out against commercialism ...

12 VILLAGE STREET, OSNY, 1883

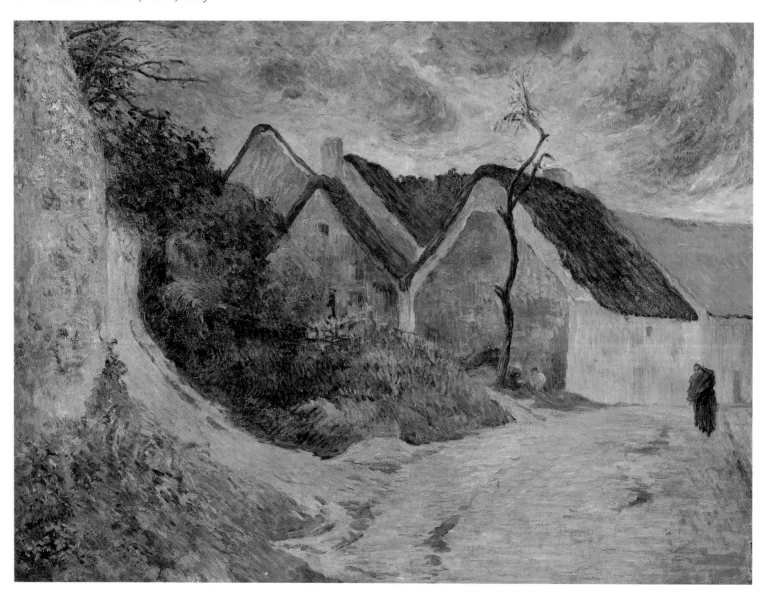

... what poor tactics. I am surprised that you, a socialist, a student of socialism (you know all that that word encompasses), are not a bit sectarian as far as painting is concerned; I am sorry you are on the side of the dissolvers.

Please forgive all these arguments which are of no concern to you; I assure you that whatever happens I will be proud to remain what I am and not to adopt *a purely selfish position*.

Kind regards to Madame Pissarro.

All the best to you.

P. GAUGUIN

*

[Paris, mid-May 1883]

TO CAMILLE PISSARRO I will send Huysmans's book to your son tomorrow. I've just skimmed through it and I confess it's a disappointment ... he is utterly mistaken throughout the book, championing the Impressionists without understanding at all in what respect they are modern. He argues from the literary point of view and so sees things through the work of Degas, Raffaëlli, Bartholomé and co. because their work is figurative; basically it is naturalism that gratifies him.

He has not understood Manet for a single minute, and he mentions you but does not understand you either. He is right about Bastien-Lepage, it is true he is easier to understand. I am still overwhelmed by the fulsome praise *he throws in my face*, and despite his flattery I can see that he is only seduced by the literary aspect of my nude woman [*Study of a nude*] and not by its qualities as a painting. We are a long way from having a book that gives an account of Impressionist art ...

*

[Paris, summer 1883]

TO CAMILLE PISSARRO I am having two of Cézanne's pictures relined at the moment, I eventually persuaded Tanguy to let me have them for the reasonable price of 120 francs the pair. You must know them – one of them is of an avenue roughly sketched in, the trees standing like soldiers and their shadows arranged like the steps of a staircase. The other is a landscape painted in the Midi, it is incomplete but nevertheless very advanced. Blue-green and orange. I think it is quite simply a miracle. Madame Latouche accused me of madness ...

*

[Paris, 1883]

TO CAMILLE PISSARRO ... You wish to follow Degas's example and study movement and look for style, in short create art with the human *figure*, although I think it's risky from the point of view of sales. You can take it as read that things will be accepted from Degas (at the moment at least) that will be rejected with a Pissarro signature. Do those things for yourself, later on people will buy them from you without comment. For Durand just keep on producing landscape after landscape ... See what opinion is and how it varies ...

Paris, 11 October 1883

To Camille Pissarro I am going to launch an all-out campaign on the dealers . . .
you really must help me do this by imposing the authority of your judgment . . . I am sure that
any dealer who took me on would not lose out because, having my free time, I am eager to
work day and night, to take the bull vigorously by the horns and you know I have a great deal
of stamina . . . Love of my art is preoccupying me too much for me to be a good employee in the
business world where dreamers are of no use, and on the other hand I have too large a family
and a wife incapable of living in poverty. So I cannot embark on a career as an artist unless I
can be certain that our needs can be met. In a word, I absolutely have to make a living as a
painter . . .

*

[Rouen, January 1884]

To Camille Pissarro I very much regret not having been to the Manet exhibition
but I am relying on you to bring me up to date with what has been said. I have already seen a
stupid article in the *Gil Blas* in which it was said that Manet had some talent but that it was
not *personal*. Imbeciles! because masters are loved *their work is copied*. Manet is supposed to have
made a mistake in following the Impressionists (a school founded by *Renouard* and *Ciseley* sic!).
So no more values, relief or drawing; how did you find the exhibition? In any case you just have
to accept that you're only seen as having any talent once you're dead . . .

*

[Rouen, spring 1884]

To Camille Pissarro . . . Your observations on painting are correct, unfortunately
it is not sufficient to point things out in order to remedy them. As I wrote to you, those things
were driving me to despair because I was aware of them and I had to wait and overcome them
with exercises. What I have at home at the moment is better in that sense and I'm hoping to
succeed in working in a very broad and not monotonous way, although I have the idea that
things in nature are on the whole simple. In order to express thoughts one has to be certain of
one's execution, and in that respect I have not yet found what I want to do. I must fret and
fume a bit longer . . . In 3 months' time I won't have a penny left to live on and it's not as
though my pictures are likely to sell – I'd rather not think about it. Be sure to urge Portier to
see about selling my Manet; I need money.

How is Madame Pissarro and what has she to say about all this? I know she's plucky, not
like my wife who's forever shouting 'fire' without bringing a drop of water . . .

*

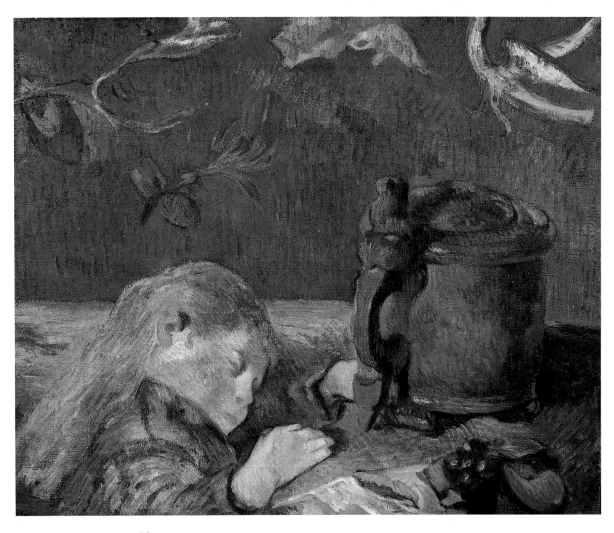

13 CHILD ASLEEP, 1884

[Paris, July 1884]

TO CAMILLE PISSARRO I am in Paris and am leaving again almost immediately.
What people are telling me here about business is so distressing that I am afraid of hearing too
much and getting discouraged. The people at the Stock Exchange claim *this is the beginning* (sic).
People in the picture trade are expecting a general collapse and some are even [advising] clients
to refrain from buying so [later] they can have pictures for 10 francs . . . What Durand's up to is
more and more impossible to understand . . . Catastrophe is now *certain* and that Jesuit should
have warned you of this long ago so you could take precautions, that was his duty but these
people are just *speculators* and have cheated you shamefully. For my part, and I've had my eye
on him for long enough now, I think he's an incompetent so-and-so, and for some time I've had
evidence of this . . .

I have seen the Claude Monets of Italy; they are astonishing in their execution, and that is
partly where their failure lies; I confess that I utterly dislike them, particularly as a way
forward. It cannot be denied that they have superior qualities specific to that artist, but that is
very dangerous. On leaving I saw in Tanguy's four very polished *Cézannes* from *Pontoise*; they
are miracles of an essentially pure art that one never tires of looking at.

If you have time, drop me a line so that we can find consolation in our art in the midst of all
our troubles. We must try to form a *unified group*, that'll be our best means of picking ourselves
up from the storm . . .

[Rouen, October 1884]

To Camille Pissarro

Today my trip to Denmark is settled ... what am I supposed to do – I haven't got a penny to my name and cannot live like Guillaumin who has no children ... I am the representative in Denmark for a large company in Roubaix ... I hope this will provide us with our daily bread, but I will retain my freedom and can continue to paint. I am even counting on doing as much of that as possible, and not abandoning the French movement ... I thus beg you not to *think* of me as *forgotten* ...

I am passionate about studying character through handwriting ... Yours gives the following indications: simplicity, frankness, lack of diplomacy, a well-balanced thinker, more of a poet than a logician, no great powers of assimilation. Lively mind, very enthusiastic, great ambition, stubbornness and gentleness mixed. Lazy. Sometimes [embarrassed?] and greedy. Parsimonious, sometimes selfish and unloving. Does not deviate from the path he has outlined for himself. Very mistrustful. Slightly odd nature. Harmonic letters. Artistic but not aesthetic sentiment. Your often invented spelling is a sign of a man disposed to reject one detail in order to fabricate another. To sum up, a very complex nature.

*

[Rouen, November 1884]

To Camille Pissarro

... When you go to Paris write to the Marsouin at 17 rue Perdonnet in Paris and go and choose for yourself the picture you want and that you'll do me the honour of hanging in your own home ...

You were wrong not to exhibit in Norway with me; I've had a letter from Auty who tells me my 5 pictures naturally astonished people but enthused a lot of painters who saw great qualities in them ... the main thing is not to pass unnoticed and to be talked about.

As I write I am in the process of packing all my canvases into cases and it's absolute chaos ...

*

[Copenhagen, late 1884]

To Camille Pissarro

... in my most recent work I've been finding the skies difficult. I'm trying to achieve great simplicity yet strong colour division ... I realise that great colouristic accuracy should produce all this, I need practice and as yet I've had very little compared to all of you: we'll see later on. Copenhagen is extraordinarily picturesque and where I live it is possible to paint very typical, very pretty things ... It's both very easy and very difficult to be a strong painter in Denmark. Very easy because what there is here is so bad, in such bad taste that the slightest work of art shines like a beacon in the middle of all that rubbish. On the other hand, it's difficult because this bad taste is so much part of the national character that it is almost impolite to produce anything else ...

*

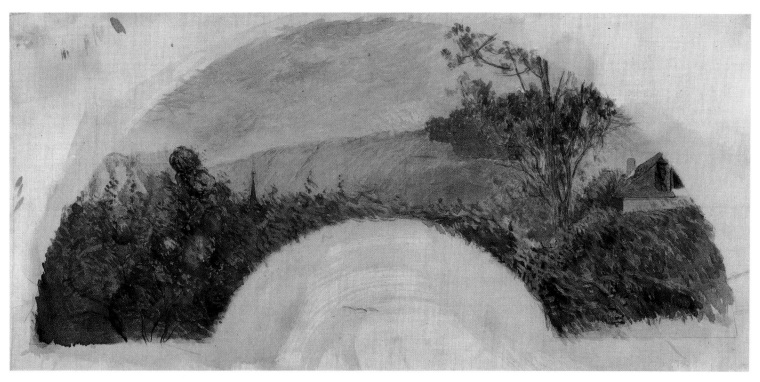

14 FAN, VIEW NEAR ROUEN, 1880–1885

Copenhagen [late December 1884]

TO DILLIES & CO., ROUBAIX Sirs, Do not think I have been inactive here, it is just that the celebrations lasting from Christmas to New Year's Day take over everything. I was told at the Customs that the duty was 33 øre per pound which increases the price per metre by 0.92 centimes and that is very expensive in a country where they prefer things cheap and nasty. That is outrageously stupid, because the duty on hemp cloth is 0.12 øre and on cotton cloth 0.16 øre, but yours is considered an *unknown* material. I am taking steps to have it classified in the first category...

Despite my desire not to keep harping on about this, I am obliged once again to broach the question of advances... I have to pay a tax of 220 krone which is a great drain on my slender resources and I am forced to ask you quite frankly to go back on your decision.

... if I am pressing the point it is because I find myself financially embarrassed here, since I need to lead an active social life in order to obtain the necessary introductions. Copenhagen is not like Paris and businessmen are not received until inquiries have been made and references produced.

*

[Copenhagen, early 1885]

TO CAMILLE PISSARRO ... Your etchings are very interesting, particularly the design which is very personal to you and extraordinarily close to the old masters. And you are said to be going in the opposite direction. The workmanship is less curious, I would have liked to have one of your old ones, the ones where you used to use *aquatint* to give the blacks that coldness that you put into the shadows in your paintings. On the other hand, simplicity of execution is not a bad thing. I've just been to see some young Danish painters who have worked in Paris of course; they all copy de Nittis or the great Bastien-Lepage. They are having a subscription in order to contribute to the great man's monument...

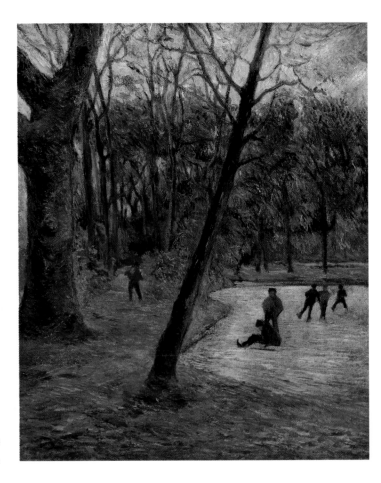

15 SKATING IN FREDERIKSBERG
PARK, 1884

Copenhagen, 14 January 1885

TO ÉMILE SCHUFFENECKER . . . As for myself it seems to me sometimes that I am crazy,
and yet the more I think in bed at night the more I believe I am right . . . for me the great artist
is the form taken by the greatest intelligence, he is the vehicle for the most delicate and thus
the most invisible of the brain's emotions.

Look around at the vast creation of nature and you will find laws, each with their own very
different aspects and yet alike in their effect, which generate all human emotions . . . All our five
senses reach *the brain directly*, affected by a multiplicity of things that no education can destroy.
I conclude from this that there are lines that are noble and those that are false, etc. Straight
lines reach to infinity, curves limit creation, to say nothing of the fatality in numbers. Has
enough been said about the numbers 3 and 7? Colours are even more susceptible of explanation,
though less numerous than lines, as a result of their powerful effect on the eye. Some sounds are
noble, others vulgar; there are peaceful and consoling harmonies, while others excite with their
boldness. In graphology you will find some characteristics belong to sincere men and others to
liars; why should not lines and colours reveal to an art lover the more or less imposing
character of the artist? Look at the misunderstood Cézanne, with his essentially mystic Eastern
nature (he looks like an old man of the Levant). In his forms, he affects the mystery and heavy
tranquillity of a man lying down to dream, his colours are grave like the character of Orientals.
A man of the Midi, he spends whole days at the top of mountains, reading Virgil and watching
the sky; as a result, his horizons are placed high, his blues very intense and his red is
astonishingly vibrant . . .

The further I go into this question, the translation of thought into a medium other than
literature – the more I am convinced of my theory – we shall see who is right. If I am wrong,
why does not your entire Academy, which knows all the methods used by the old masters,

paint masterpieces? Because it is impossible to create a nature, an intelligence, a heart. The young Raphael knew all this intuitively, and in his pictures there are harmonies of line that pass almost unnoticed for they are the veiled reflection of the innermost recesses of the man's mind...

Here I am tormented more than ever by art, and neither my money worries nor my search for business can divert me from it. You tell me I would do well to join your society of independents. Do you want me to tell me you what will happen? There are now a hundred of you: tomorrow there will be 200... You have had a *favourable press* this year; next year those with a malicious frame of mind (there are Raffaëllis everywhere) will have stirred up all the mud to fling at you, while appearing respectable themselves.

Work *freely and furiously*, you will make progress and sooner or later your worth will be recognized, if you have any. Above all, don't sweat over a picture. A strong emotion can be translated immediately: dream on it and seek its simplest form.

The equilateral triangle is the most solid and perfect form of triangle. A long triangle is more elegant... A long neck is graceful but heads sunk into shoulders are more pensive... Why are the willows with hanging branches called weeping willows? Is it because drooping lines are sad? And is the sycamore sad because it is found in cemeteries? No, it is the colour that is sad...

*

Copenhagen, 30 January 1885

To Camille Pissarro You are entirely forgiven for having taken so long to write to me since it wasn't due to forgetfulness; your letter finds me at a stage when everything around me is beginning to look black and I'm cursing everything, my fellow men above all –
... Set your mind at rest, change is indicated for several centuries and is the natural consequence of the unification of men through universal rights and the education that will ensue. Everyone will have money, property, an equal share of sunshine, etc... Yes, things will improve, and in all my republican philosophy I cannot disavow what I have desired since I have been a man. There is a crisis at the moment and naturally, smoothly, not only through the generous efforts of a few but by an instinctive process a time will come when great poverty will disappear. In this gradual revolution I foresee a good future on the horizon, but in intellectual terms we shall have lost a great deal. You believe that art will do the same thing; I believe that you are mistaken, because it will go in the opposite direction. Everyone will have talent since everyone will have education. Where there is an aristocracy, where there is government by the few, there are patrons and protégés, but where everybody governs, nobody is obliged to support his neighbour. In short... I think that the more the masses are equal the less need they have of art. For such needs, it is necessary to have contemplation, a love of luxury born of nobility, a feeling for irregularity in the social scale and little self-interest. However, the new society is moving away from all that, and will continue to move still further... You are right to meet every month (the Impressionist group); I hope you will manage to understand that unity is strength, but that personalities and privilege must be replaced by cohesion on the intellectual level... I hope you will not be long in adding Guillaumin to the group... some consider me an Impressionist, while others reject me altogether; apart from you and Guillaumin, nobody supports me...

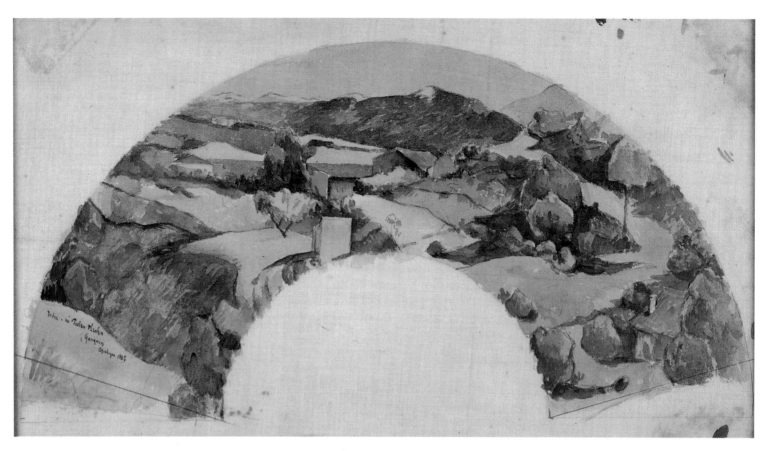

16 FAN, PROVENÇAL LANDSCAPE AFTER CÉZANNE, 1885

Copenhagen, 17 March 1885

To Émile Schuffenecker . . . I hope you are going to become ever more intransigent: it's the only way you will ever make any progress in the art world, particularly if you go to extremes. After us, young people will be more radical and in 10 years you will see that it was only in comparison with our time that we seemed to be rather extreme . . . You ask whether we are earning any money. My wife earns 60 francs per month from her teaching, while I am still waiting for my first payment; I have a few tarpaulins being tested by several companies and I hope to conquer the market within a year. Until then it's a question of managing as best one can. I've incurred a few debts and survived miserably on the 1300 francs I raised from selling a Manet. I am not very good at living frugally, so you will understand why my hair is turning grey. Despite all this, I am committed more passionately than ever to the artistic struggle. I am going to be known everywhere in Copenhagen; for friends I have many young painters, and for enemies I have the old fossils and other incompetents who fear me like the plague . . .

105 Gamle Kongevej,
from 25 April – Nørregade 51.

*

Copenhagen, 24 May 1885

TO ÉMILE SCHUFFENECKER . . . Your idea of going to Durand-Ruel made me smile, for the fellow can hardly keep his head above water and the little he does for the Pissarros and others is not done out of friendship but rather because he has almost a million francs worth invested in them and he's afraid the Impressionist painters might degrade their products by selling at any price. You know full well that that blessed jesuit couldn't give a tuppenny cuss about me in my poverty. Bertaux! Why, it is entirely due to him that I'm in the soup, for I should never have launched out if he hadn't promised to support me for a year, a promise he hasn't kept . . . Here I've been undermined by a few sanctimonious protestant women; I'm known to be an infidel and so they would like to see me cut down . . . to begin with the Countess of Moltke, who was paying my son Emil's school fees, withdrew her support suddenly for religious reasons. Many pupils have not come for their French lessons for the same reason, etc . . . I'm beginning to get fed up with it all and I'm thinking of abandoning everything to come to Paris to work as an operative in Bouillot's studio, for just enough money to live on – I would be free there. Duty! Let anyone put himself in my place. I have taken things as far as I can, and I am only being forced to give way by the utter impossibility of meeting my material needs. Thank you once again for all the interest you have shown in us: there aren't many who respect a man when he's on his beam ends! If you see Guillaumin tell him that a letter from him would give me pleasure just now; whenever I receive a letter from France I breathe again. I've gone for six months with no-one to talk to. Complete isolation, but of course in the eyes of the family I am a monster not to be earning money. These days only the successful man earns any respect.

Our little Paul is in bed with pneumonia, which nearly killed him – fortunately now he's over the worst, but it hasn't been much fun. It would have been a pity, he has become so handsome with black eyes and matt complexion.

My wife asks me to send her best wishes to yours. She's not very pleasant at the moment; poverty has completely soured her, and has particularly wounded her vanity (in her own country where everybody knows her) and I am getting all the blame. Naturally the fact that I'm not an eminent stockbroker is due to my painting etc . . .

A handshake for you both.

PAUL GAUGUIN

Please write to me with details of the Exhibition. That's what distracts me most of all. And has yours at the Tuileries been held?

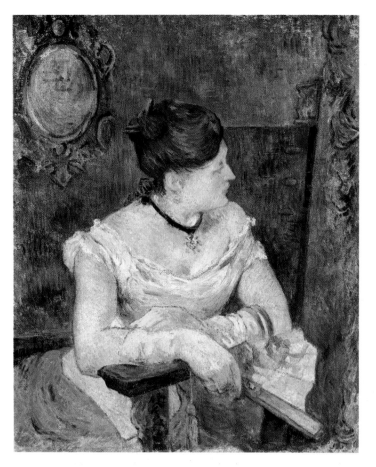

17 METTE GAUGUIN IN EVENING DRESS, 1884

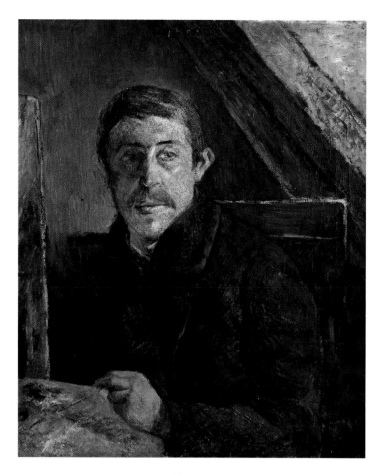

18 SELF-PORTRAIT IN FRONT OF AN EASEL, 1885

[Copenhagen, spring 1885]

TO CAMILLE PISSARRO . . . I have been working out of doors, and without any
special effort or conscious desire to paint in a bright, luminous style the results are very
different from those I produced in Rouen. I think I can say this constitutes an enormous step
forwards; it's more flexible, lighter, more luminous, although I've not really changed my
method: the colours are still laid on side by side with very little differentiation between them.
In Rouen the cold tints in the sky, in the vegetation and in the soil were missing . . . every day
I wonder whether I shouldn't go to the attic and put a rope around my neck. It's only painting
that prevents me from doing so and that's the real stumbling block . . . Anyway, in two months
I shall either have departed this world or returned to Paris to live as a vagrant *worker*, anything
rather than suffer in this wretched country. The Danes! You have to have come here as I've
done to know them. The most abject slavery . . .

*

1884–1885

FROM *NOTES SYNTHÉTIQUES* Painting is the most beautiful of all the arts; it is the summation of all our sensations, and contemplating it we can each, according to our imagination, create the story, in a single glance our souls can be flooded with the most profound reflections; no effort of memory, everything summed up in a single instant. – A complex art which contains and completes all the others. – Like music, it works on the soul through the intermediary of the senses; harmonies of tones correspond to harmonies of sounds . . .

Like literature, the art of painting narrates whatever it wishes with the advantage that the reader immediately grasps the prelude, the setting and the outcome. Literature and music demand an effort of memory if one is to appreciate the whole. The last named is the most incomplete and least powerful of arts.

You can dream freely while listening to music as well as when looking at a picture. When reading a book you are enslaved to the thoughts of the author. The writer has to address himself to the mind before he can impress the heart, and God knows how little power a reasoned sensation has. Sight alone produces an instantaneous impulse. But then again, only literary men are art critics; they alone defend themselves in the eyes of the public. Their preface always contains a defence of their work, as if a truly good work of art was not its own justification.

. . . To judge a book, you must be intelligent and well educated. To judge painting and music, you need – in addition to possessing intelligence and artistic knowledge – special feelings which are not in everyone's nature. In a word you must be a born artist; and though many are called, few are chosen. . . .

Like numbers, instrumental music is based on a unit. . . . Using an instrument, you start with one tone; in painting you start with several. Thus, you start with black and divide it up until you reach white: there's your first unit; it is the easiest, and accordingly the most widely used and, therefore, the best understood. But take as many units as there are colours in the rainbow, add to those the units made by the composite colours, and you arrive at a respectable number of units. What an accumulation of numbers, a regular Chinese puzzle, and it is not surprising that the colourist's science is so little developed by painters and so little understood by the public. But still, what a wealth of means by which to enter into intimate contact with nature!

We are criticized for using colours without mixing them, placing them next to each other. On those grounds, we have to be the winners, being mightily helped by nature, which proceeds in just the same way. A green next to a red does not yield a reddish brown as would the mixture of the two, but gives two vibrant notes instead. Next to that red put a chrome yellow; you have three notes each enriched by the others and increasing the intensity of the first tone, the green. Instead of the yellow put a blue, and you'll find three different tones but all vibrating because of each other. Instead of a blue put a purple, and you'll be back in a single composite tone, merging into the reds.

The combinations are unlimited. Mixing colours gives you a muddy tone. A colour by itself has a raw quality that does not exist in nature. Colours exist only in a visible rainbow; but how right rich nature was in carefully showing them to you next to each other in a deliberate and immutable order, as if each colour was born of the other!

Now, you have fewer means at your disposal than nature and you decide to deprive yourself of all the means that nature offers you. Will you ever have as much light as nature has, as much heat as the sun? And you talk about exaggeration! But how can one exaggerate, since one can't go all the way, as nature does?

Oh! If by 'exaggerated' you mean any work that is badly balanced, then, in that sense, you would be right; but I would like to point out that however timid and pale one's work may be, it will be accused of exaggeration whenever there is a mistake in harmony. Is there really a science of harmony? Yes.

And it happens that the sense the colourist possesses is, in fact, natural harmony. Like singers, painters sometimes sing off-key; their eye does not have harmony. Later on, through study, a whole method of harmony appears of itself unless – as in the academies and most of the studios – they pay no attention to it. As a matter of fact, they have broken up the study of painting into two categories. First, you learn to draw; then you learn to paint – which amounts to saying that you come back and colour within prepared contour lines, more or less like painting a statue after it's been carved. I must say that so far the only thing I've understood in that exercise is that colour is nothing more than an accessory. 'Sir, you must be able to draw properly before you can paint,' and this is said in a pedantic tone of voice – for that matter, that is the way the stupidest things are always said.

Does anyone wear shoes on his hands, confusing them with gloves? Can you really make me believe that drawing does not derive from colour, and vice versa? And to prove it, I propose to make any drawing look larger or smaller, depending on the colour with which I fill it in. Just try to draw a Rembrandt head in exactly the same proportions as he did and then use Rubens's colour: you'll see what a shapeless thing you end up with and the colour will have become disharmonious.

For a century enormous sums have been spent to propagate drawing and the mass of painters has grown larger; but not the least progress has been made. Who are the painters whom we admire at this time? All those who found fault with the schools, all those who have derived their knowledge from a personal observation of nature. . . .

*

[Paris] 22 June 1885

To Paul Durand-Ruel Forced by the complete lack of business abroad to return to Paris, completely destitute, to set myself up again I need funds that I can only raise by selling, with the greatest reluctance, pictures by artists I admire. You once gave me a Claude Monet and a Renoir in lieu of commission, which I preferred to receiving cash. I would be very grateful if you would take them back. [illegible word] that for these painters in all my dealings I have helped to spread their fame without thinking of my own.

Please let me know if I may bring the paintings to you.

Yours faithfully, P. Gauguin

Gauguin c/o M. Schuffenecker, 29 rue Boulard.

*

19 STILL LIFE WITH MANDOLIN, 1885

[Paris] 19 August 1885

TO METTE I see from your letter that you are still away; I conclude
from this that your friends are paying you some attention and in the midst of all my
disappointments it is a comfort to me to know you have some support and amusement... You
ask me what I'll do this winter. I hardly know myself – it all depends on what resources I may
have at my disposal. Nothing can be started with nothing. I have neither money nor house nor
furniture – only a promise of work from Bouillot if he has any. If he has, I shall rent a little
studio from him and sleep there... If I sell a few paintings, in the summer I'll go and find an
inn in a little place in Brittany and paint and live economically. Brittany is still the place where
you can live most cheaply. When I get over the worst, if business picks up and my talent
develops and finds suitable recompense, I shall think of settling down somewhere.

For your part, try to make me known in Denmark. If you succeed, this would benefit you as
well as me, and this is the surest means of bringing us together again.

...I don't want to buy new clothes. Are you thinking of making me some shirts with
detachable collars with the cloth you have left; they would be most useful for working in? If
you are, put some cuffs on the sleeves in a rather better cloth so they'll last...

Give my love to all the children. P. GAUGUIN

*

Dieppe, 19 September 1885

To METTE

Since my last letter I have been travelling. I have arrived here in Dieppe, where I shall stay 2 or 3 days before spending almost 3 weeks in London, you know where...

Schuffenecker wrote to tell me that M. Bouillot was sorry he could not find any work for me this winter... I find something underhand in all this which I dare not try to fathom. Did you write to Madame Bouillot? I know you want to see me working at the Stock Exchange.

I confess your present silence seems to me extraordinary – a month has gone by without a word from you...

...I am suffering at the moment from severe rheumatism in the shoulder; yet another of the delightful mementoes I have brought with me from Denmark. But why bewail the past? If only that were all, I would congratulate myself on having got off so lightly. Unfortunately I expect anything from your country and your family. As you know, I have an instinct that alerts me to what is happening, and I'm sure your dear sister has got her claws into me at the moment. It is true I've been dealt a cruel blow, but I am man enough to get over it...

*

Dieppe, 2 October 1885

To CAMILLE PISSARRO

... I am just back from Dieppe where I've spent the past 3 months living with a friend who offered me hospitality. Of course I've done a lot of work, although with a great deal of difficulty since we're a long way from the real countryside and there's a lack of good subjects... I went to London for a week and I'm glad to have seen English painting...

*

Paris, 13 October 1885

To METTE

...I have rented a small apartment at 10, rue Cail next door to le Marsouin... As for Clovis, his school is right next door to the house and at times when I'm not there the *concierge*, who is a very nice woman, will look after him, sometimes in her own flat and sometimes at le Marsouin's...

[Paris] 2 November 1885

To Mette

...have you sent off the things I asked you for? I have urgent need of them now. Clovis does not have a woollen jersey to wear, but apart from that he's well. I am still on *tenterhooks* about the sale of the pictures, and it's been very difficult these past few days to feed ourselves adequately. I still haven't found anything at the Stock Exchange; there is so little business and so few openings for all the out-of-work employees...

I have received the stockings for Clovis; he's now got something to put on his feet and they'll last him for some time. He is very good and plays all alone in his little corner without troubling me. He sometimes asks where his mother is and when she will come. You will find he has nothing but good memories of you; let us hope the others will not be brought up in ignorance of their mother tongue and of their wretched father. It would take me until old age to come to terms with that...

20 EDGE OF THE POND, 1885

[Paris, late November 1885]

To METTE I am answering by return of post so that you can reply
immediately as to the sale of the pictures, about which I am very uneasy. I left the pictures in
Denmark, and at this rate I shall have *nothing* left at all one day. I am very attached to my 2
Cézannes; they are very rare of their kind, since he did few finished pictures and one day they
will be very valuable.

I would rather you sold the drawing by Degas, but it has to be admitted that he sells very
readily, so it should fetch much more than 200 krone. I will leave you to decide since *you are in
need* and in the absence of any money from me you have something to fall back on. Except for
the Manet – and the Miss Cassatt – the sales will have to stop now, otherwise I will have
nothing left.

The important thing is to get mine sold.

Don't worry about Clovis, he has everything he needs apart from the little woolly vests. It
is extremely cold at the moment and I could really do with mattresses and blankets. Who
knows, perhaps I'll receive them one of these days. You only gave me three pairs of sheets
which means I can't send them off alternately to the laundry, one pair for Clovis and one pair
for me. And what about my canvas shirts?

*

Paris, 29 December 1885

To METTE . . . In March we are going to hold a very comprehensive
exhibition with some talented new Impressionists. For some years now all the schools and
studios have been preoccupied by it, and it is reckoned this exhibition will create quite a stir;
perhaps it will prove the turning of the tide – we shall see. In any case, the art dealing business
here is completely dead, and it is impossible to sell any paintings, especially the orthodox
stuff . . .

. . . Clovis is in bed today with a bit of a temperature and a cold, but it won't come to
anything. The only problem is that I am obliged to be out and leave him alone in the house . . .
in any case, don't worry about him, he's always in good spirits and has become very talkative,
astonishing everyone . . .

*

[Paris, April 1886]

To METTE . . . Necessity knows no law, and sometimes it also forces
men out of the confines that society imposes on them. When the little boy fell ill with smallpox
I had 20 centimes in my pocket and we were buying food on credit – for 3 days we had been
eating *dry bread*. In desperation, I hit upon the idea of offering my services to a billposting
company as a billsticker in the stations . . .

Your Danish pride will be wounded by having a husband working as a billsticker, but what
do you expect, not everybody has talent. Don't worry about the boy, he's getting better and

better and I'm not thinking of sending him back to you. On the contrary, as my situation improves, I am *most certainly* hoping to take back some more of the children.

I have the right to do so, as you know.

You ask me to to reply as gently as you write, so I have gone very calmly through all your letters which tell me quite coolly and reasonably enough that I did love you, but that you are only a mother and not a wife, etc . . . These are very pleasant memories for me, but they have the great disadvantage of leaving me no illusions for the future. So you should not be surprised if one day, when my situation has improved, I find a wife who will be something more to me than a mother, etc . . .

I realize that you consider me devoid of all attraction, which is an incentive to me to prove the reverse . . . In the meantime, continue as you are doing now, looking the world in the face, fully conscious of your duties, your conscience clear. There is only one crime: adultery. Apart from that, everything is legitimate. It is not fair for you to be turned out of your home, but it is reasonable that I should be turned out of mine. So you won't take it to heart if I set up another household, in which it won't be held against me if I stick bills for a living. Everyone blushes in their own way.

*

[Paris] 24 May 1886

To METTE . . . I have seen my sister, to whom you write long letters. To comfort me, she is shouting from the rooftops that I am a wretch, that I left Bertin's to be a painter, that that poor woman, without a home, without furniture and without support, has been abandoned for that abominable painting.

I believe in fact that the crowd is always right, that you are angels and that I am an odious knave. And so, I shall make proper amends by grovelling at your feet . . .

*

[Paris, May 1886]

To METTE It is a long time since I had any news of you and the children; it is true you are very busy with the translation of Zola's novel – his worst book from every point of view.

. . . I think you are right to do a bit of translating, despite the poor returns at the outset . . . What I don't advise you to do is to try to explain slang words; it would be better to translate them with a Danish *equivalent*, or even leave some of them in the original French.

In your last letter there was no mention of little Aline. I thought she was supposed to be coming to Copenhagen with your sister Pylle. How is she? Has her hair grown? I strongly advise you to cut it short, *just a little*, where it meets the forehead and at the nape of the neck, that'll strengthen it there for later on . . .

Clovis is still at his little school in the country; he'll still be there next month, since Marie has decided to pay his fees for another month . . .

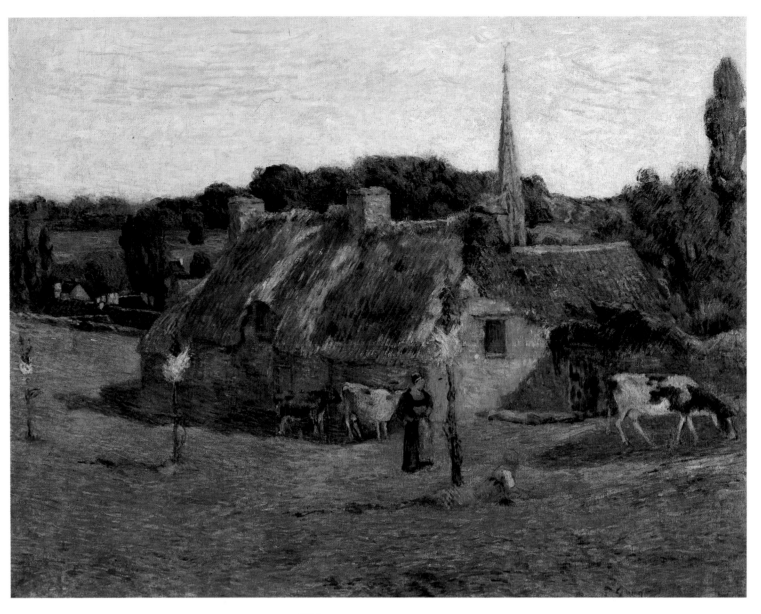

21 COTTAGES, LE CHAMP DEROUT-LOLLICHON, 1886

[Paris, late May 1886]

To METTE . . . Don't move heaven and earth to come for a short time to
Paris; money disappears quickly when you're travelling, particularly since I have nowhere to
put you up. I shall not have my flat next month since I have given my notice.

My best course would be to slip away to Brittany and live in a boarding house for 60 francs
per month, where I could work. Our exhibition opened the whole question of Impressionism up
for discussion and in a favourable way. I had a lot of success among artists. M. Bracquemond, the
engraver, was delighted to buy a picture from me for 250 francs, and he also put me in touch
with a ceramicist who is planning to make vases. He was very taken with my sculpture and he
asked me to create some other pieces this winter to be sold on *a fifty-fifty basis*. Perhaps this will
turn out to be a profitable sideline for the future. Aubé used to make pots for him, and they
kept him alive, which is something.

In any case, this is only for this winter, and I am most anxious to do some paintings in
Brittany. If you could sell my Manet locally, I could pay Clovis's fees for some months,
otherwise I have nothing left at all . . .

[Paris, early July 1886]

TO METTE . . . I've just returned from Schuffenecker's; he's always a good fellow, and he's grateful to me for having helped him make progress. Unfortunately, he is getting increasingly fed up with his wife, who far from being a companion for him, is developing into a real harpy. It's funny how marriage succeeds: it leads either to ruin or to suicide. Why *Pot-Bouille* only tones down the truth!

By the way, I didn't tell you that on more than one occasion I have met (Mlle de Munstiana) tripping along the fashionable Boulevard des Italiens at about five o'clock in the afternoon. Upon my word, she was very elegant, and her pale complexion and sparkling eyes said a world of things. Let us think no evil of our neighbour, but there are limits to the liberties a foreign lady may take in Paris. If a Frenchwoman in Copenhagen allowed herself just a tenth of those liberties, your good Danish women would be less discreet than I am being.

Still, these things are of little importance to me, and if I mention them it's because she used to be one of your best friends (against my better judgment).

*

[Paris, June–July 1886]

TO PAUL SIGNAC . . . I am a badly brought up, tactless man; it is very good of you to tolerate such a lack of consideration on my part. This is what Monsieur Seurat said to Pissarro and Guillaumin . . . I may be an artist full of uncertainty and lacking in erudition, but as a man of the world *I will not accept that anyone* has the right to manhandle me . . .

*

Pont-Aven, July 1886

TO METTE . . . What is this you're telling me? That you have a tumour on your breast – truly there is no end to our bad luck. In any case, since you have a cousin who is a good doctor, ask him seriously if it is cancer, but above all, do not be afraid of an operation before it gets worse . . .

I'm working hard here, and with some success; I am respected as the best painter in Pont-Aven, although that does not put any more money in my pocket. However, it may be a good sign for the future. In any case, it gives me a respectable reputation, and everybody here (American, English, Swedish, French) is anxious to seek my advice, which I am stupid to give because when all is said and done people make use of us without proper recognition.

I shan't get fat in this trade. I now weigh less than you – 138 pounds.

I'm getting as thin as a rake, but on the other hand I'm feeling younger. The more my troubles accumulate, the more my energies are stimulated, but without giving me any encouragement. I don't know where I'm going, and I'm living on credit here . . .

*

Pont-Aven, 15 August 1886

To METTE ...Let us stop all these recriminations. I have buried the
past, and I have no thought of being awkward, any more than I wish to be kind. My heart is as
cold as ice, and now that I am hardened against adversity I can think only of working at my
art. It is the only thing that does not betray you: thank God I am progressing each day and
there will come a day when I shall be able to enjoy it...

*

Paris, 26 December 1886

To METTE ...The life I have been leading since my arrival in Paris is
far from happy!... I have just spent 27 agreeable days in hospital; unfortunately I have now
been discharged. These wretched colds and tonsilitis always plague me in the winter; I thought
I'd had it this time, but this confounded iron constitution of mine is getting the upper hand...

Ask Schuffenecker what artists think of my work, and yet I have *nothing*. People shun a man
who has nothing.

I am doing some art pottery. Schuff says they are masterpieces, so does the maker, but they
are probably too artistic to be sold. However, he says that, given time, and perhaps if they are
shown at the exhibition of industrial arts this summer, they will be an amazing success. I hope
the Devil is listening! In the meantime, my entire wardrobe is in the pawnshop, and I can't
even pay visits to people...

*

[Paris, January 1887]

To FÉLIX BRACQUEMOND Thank you for all you have done, which must at times have
been a nuisance to you. As you said one day with good cause: it is not difficult to produce art,
the great thing is to sell it! Let us hope we'll manage it with pottery, but when?...

*

[Paris, early April 1887]

To METTE I was waiting impatiently for your letter, as I am leaving
from St-Nazaire on 10 April, so you see I have no time to lose.

You seem to have misunderstood my letter about Clovis; you have to find *someone to pay his
fare*. I have *just* enough to pay my fare and shall arrive in America penniless. What I shall do
there I do not yet know myself... what I want above all is to leave Paris, which is a wasteland
for a poor man... I am going to Panama to live the life of a *native*. I know a little island called
(Tabogas), a league off Panama; it is virtually uninhabited, free and very fertile. I shall take my
paints and brushes and reinvigorate myself far from the company of men. I shall still have to
endure the absence of my family but I shall no longer be reduced to this state of beggary, which

22 VASE DECORATED WITH FIGURE OF A BRETON
 WOMAN, 1886–1887

disgusts me. Do not be concerned for my health – the air is very clean there, and there is plenty of fish and fruit to be had for the taking.

I am also toying with another idea, which may turn out to be just the ticket. A splendid proposition was put to me a little while ago. In view of my energy, intelligence and, (above all, my honesty), it has been suggested that I go to Madagascar as an active partner in a business that has been established for a year . . .

It would be excellent for us because it is only 3 days by boat from Île Bourbon, which is very civilized these days with schools etc . . . It's a more significant place than Copenhagen. I don't think you would object to joining me there . . .

. . . you say that you loved me: do you remember your attitude towards me, the vilest person in the house? Now you say you have changed for the better, and I would like to hope this is true. If I succeed one day, after so many trials and tribulations, (we shall have to be reunited); will you bring with you the hell, the discord we used to experience every day? Is it love you are promising, or hate and all the bitterness of those years we spent in torment? I know that you are good at heart, and not ignoble, moreover I put some faith in reason.

You are going to have Clovis; the child will not tolerate the meagre affection you and your family have for him. He is sensitive and intelligent; he will say nothing, but he will suffer. With kindness you will be able to do everything you wish with him; otherwise you will antagonize him and make him behave badly. If people speak ill of his father, he will feel it cruelly. It is a delicate plant I am entrusting to you . . .

[Panama, late April 1887]

To Émile Schuffenecker

You think me already settled on our island, but you are mistaken! The digging of the canal across the isthmus has made life impossible, even in the most deserted places... Martinique is a beautiful country where the living is easy and cheap, and that's where we should have stayed; we would already be at work, with half as much again in our pockets. I cannot get anything out of my brother-in-law. In short, we have mismanaged the whole business, and have had little luck to boot. We must make good our mistakes, and I am going to (work on the canal) for two months in order to try to earn enough money to get to Martinique. If Portier has been clever enough to sell something for me, *send me the money immediately*, so that I can clear out of here.

...We are both in good health. (Laval is still a little frail but I have never felt stronger.) Nevertheless, we must still take care; some people die here in just three days...

*

[Saint-Pierre] Martinique, 20 June 1887

To Mette

I am writing to you this time from Martinique...

We are at present both lodging in a negro hut, and it's paradise compared to the isthmus. Below us is the sea fringed with coconut trees, and above fruit trees of all kinds; we are twenty-five minutes from the town. Negroes and negresses mill around all day, with their creole songs and incessant chattering; don't think it's monotonous, on the contrary, it's very varied. I cannot begin to describe my enthusiasm for life in the *French* colonies, and I am sure you would be equally enchanted. Nature at its most luxuriant, and a warm climate but with cool intervals. With a little money one could be very happy here. But a certain amount of money is necessary. *For thirty thousand francs* you can buy an estate which would bring in eight to ten thousand francs a year, and you would be living off the fat of the land to boot. The only work required is to supervise a few negroes harvesting the fruit and vegetables that grow without cultivation.

...I can tell you that a white man here has his work cut out to hang on to his coat, for there is no shortage of Potiphar's wives. Nearly all of them are coloured, from ebony to *the dull white found in the darker races*, and they go so far as to work their charms on the fruit they give you in order to ensnare you...

Now I am warned I will not succumb, and you can sleep soundly, assured of my virtue. I hope to see you and the children here one day. Don't be alarmed: there are schools in Martinique and Europeans are treasured like rare birds.

Write to me twice a month.

Fort-de-France, 14 July 1887

To Émile Schuffenecker . . . We have been in Martinique, the country of the creole
gods, for three weeks. It is true to say that we have found, two kilometres from the town, a
negro hut in the middle of a large estate. Below us is the sea, with a sandy beach for bathing,
and on each side there are coconut trees and other fruit trees that are wonderful for the
landscape artist.

But what I find most attractive is the people's faces; each day there is a continual toing-and-
froing of negro women dressed in colourful rags, with an infinite variety of graceful movements.
At the moment I am confining myself to making sketch after sketch in order to get their
characters firmly fixed in my mind, and then I shall have them pose for me. They chat
incessantly while carrying heavy loads on their heads. Their gestures are quite extraordinary;
their hands play an important role, in harmony with the swaying of their hips . . .

23 MANGO PICKERS, MARTINIQUE, 1887

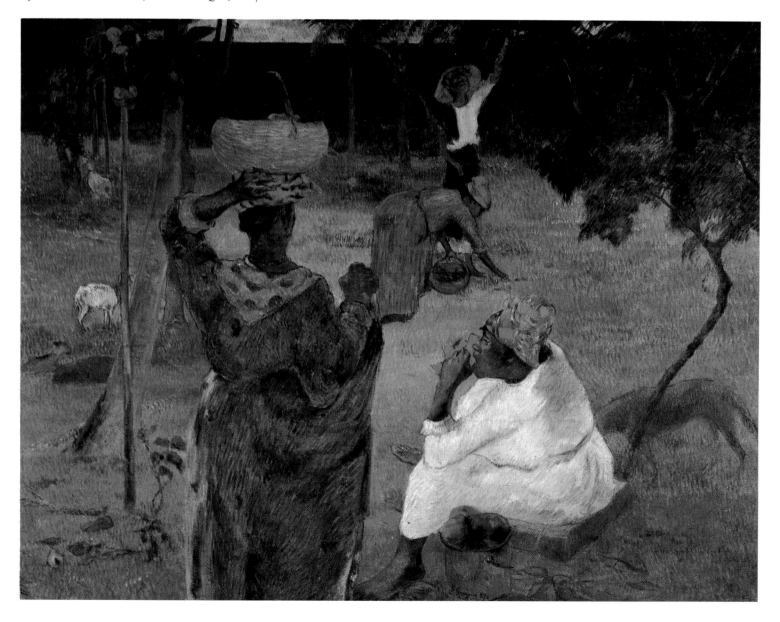

[Martinique, August 1887]

To METTE Do not be too sad when you receive this letter; day by day
we have to accustom ourselves more and more to misfortune. Since I left Copenhagen it seems
that everything has crashed in on us. It's hardly surprising – nothing good can come of the
family being broken up.

I am virtually dragging myself from the grave and have propped myself up on my mattress
to write to you. I received your news for the first time today, all your letters having strayed all
over the place.

During my stay in Colon I contracted an illness, an infection from the marshy miasmas of
the canal. I had enough strength to resist, but once I reached Martinique I began to get weaker
day by day. In short for the last month I have been down with dysentery and marsh fever. At
present my body is like a skeleton and I can hardly whisper. After being very low and each
night expecting to die, at last I've taken a turn for the better, but I have suffered agonies in the
stomach . . . Ah! My poor Mette, how I regret not being dead. All this would be over. Your
letters have given me pleasure as well as an anguish that now overwhelms me.

If at least we hated one another, (hatred is sustaining), but you are beginning to feel the
need of a husband just when it is impossible to be together. And poor Mette, worn out by
work, you ask me for help.

What can I do; at the moment I am in a negro hut, exhausted, lying on a seaweed mattress
and I have no money to return to France. I am writing to Schuffenecker to come to the rescue
for the last time, as he has always done up to now. This post brought me good news of my
ceramics. It seems they have met with some success . . .

*

Martinique [September 1887]

To ÉMILE SCHUFFENECKER . . . I am still ill and will not recover without a change of
climate. The arrival of each post brings on a relapse due to emotional shock. In spite of that I
am limping along in an effort to make up for lost time and produce a few good canvases. I shall
bring back a dozen canvases, 4 of which have figures far superior to those of my Pont-Aven
period.

. . . despite my physical weakness, my painting has never been so light, so lucid (with plenty
of imagination thrown in) . . .

*

Paris, 24 November 1887

To METTE . . . I reached France somehow on a sailing boat. . .
. . . You seem to think that my lack of earnings is deliberate and that I am not making any
effort to improve matters . . . It is an artist's duty to work in order to improve his art; I have
fulfilled that duty and everything I have brought back has met with nothing but admiration.
Nevertheless, I am not succeeding . . .

24 MARTINIQUE (WOMAN WITH MANGOES), 1888–1889

Paris, 6 December 1887

TO METTE Since my return there has been no great change, except that
in a month's time I hope to have some work in ceramics. In that case I shall earn enough money
to help you a little; if I have not done so up to now, it's because I haven't been able to . . . I am
sending you 100 francs which I happen to have at the moment; they're not surplus to
requirements, but I do not actually need them for the present, because Schuff is not pressing
me for what I owe him and is providing me with food. I've sold a pot to a sculptor for 150
francs.

My health is not too good. I have put on weight but from morning to night I have
unbearable stomach pains, and I have neither the time, the place nor the money for medical
treatment . . .

Whatever else may be invented, nobody will hit on anything better than a united family.
And for that, each family must have a *head*: I am happy for it to be the wife, but she should
shoulder all responsibility and the task of feeding the family.

. . . I was delighted to see you in April, but could not fail to see in you the same
characteristics which would make our life together so difficult – the same rebellious instincts,
stronger than ever, the same leaning to flattery rather than to truth. Cultivate your pride but
do away with *vanity*, which is only fit for the small-minded and mentally deficient.

*

25 LANDSCAPE, 1873

26 THE SEINE AT THE PONT D'IÉNA, SNOW, 1875

27 LANDSCAPE WITH POPLARS, 1875

28 WINTER LANDSCAPE, 1879

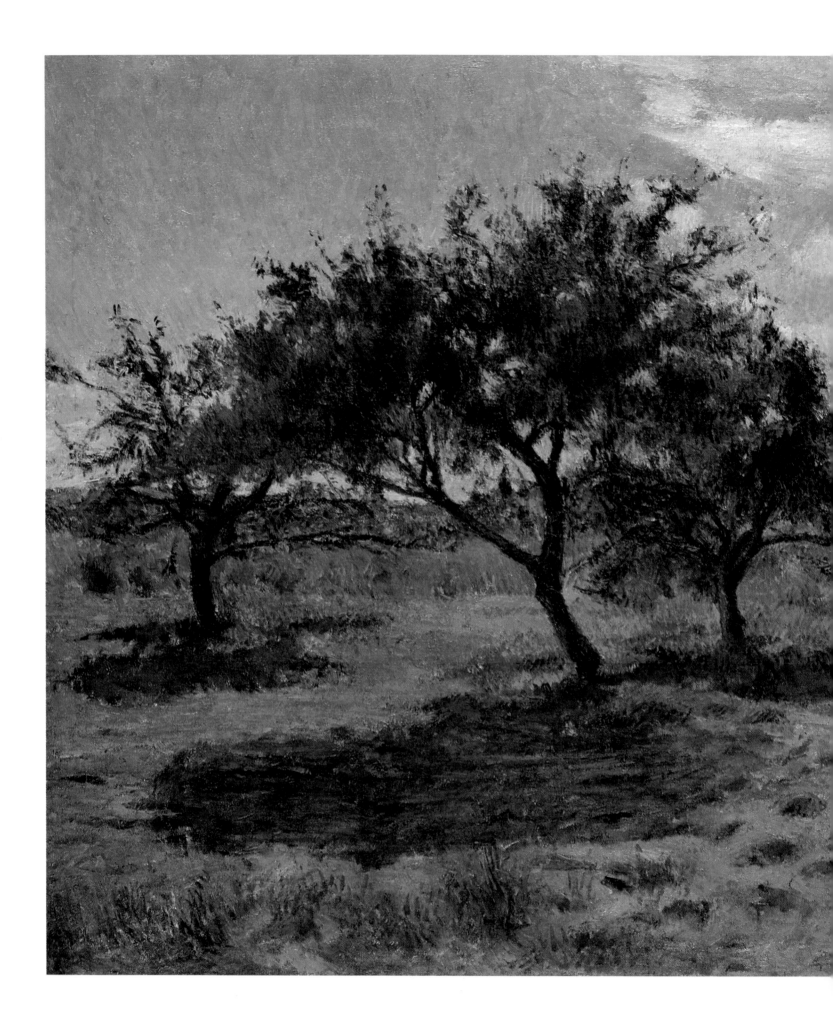

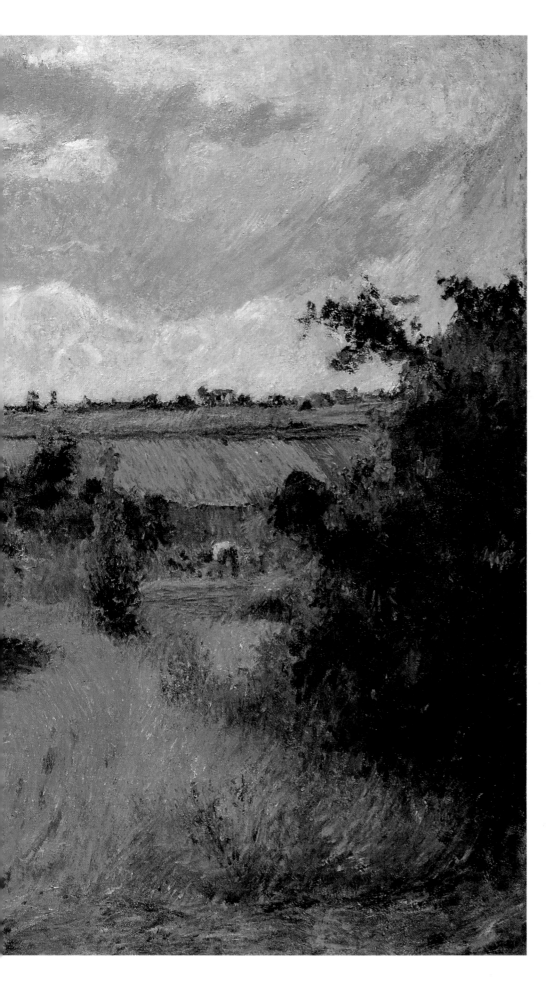

29 APPLE TREES AT L'HERMITAGE,
 NEAR PONTOISE, 1879

30 INTERIOR OF THE PAINTER'S HOUSE, RUE CARCEL, 1881

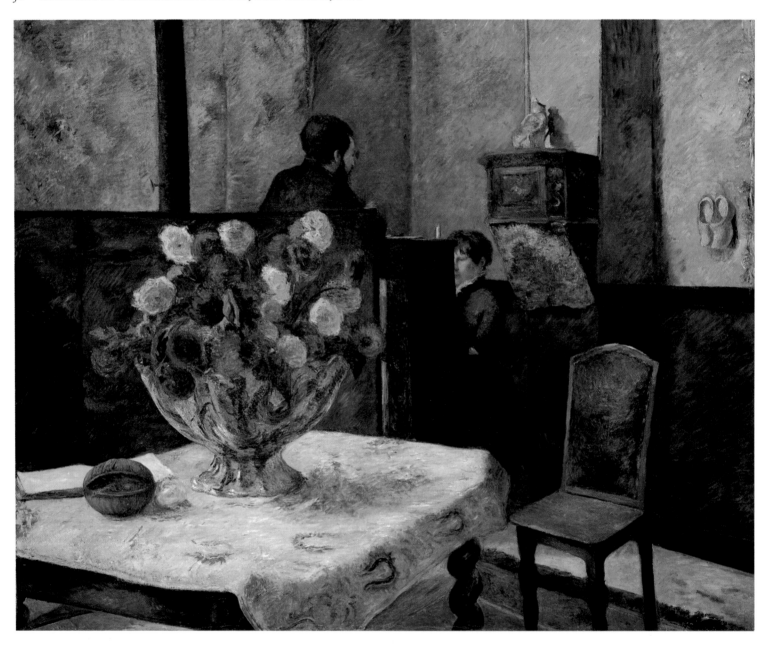

31 PORTRAIT OF METTE GAUGUIN, 1878

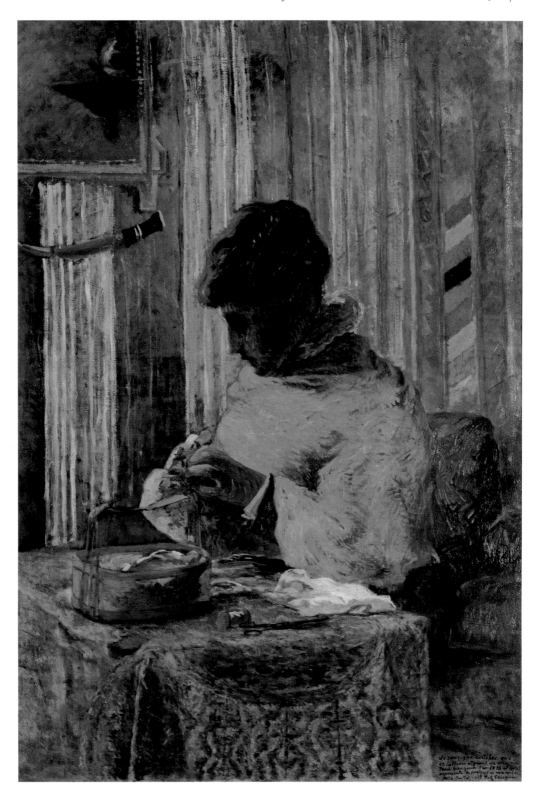

32 STILL LIFE, CLAY JUG AND IRON JUG, 1880

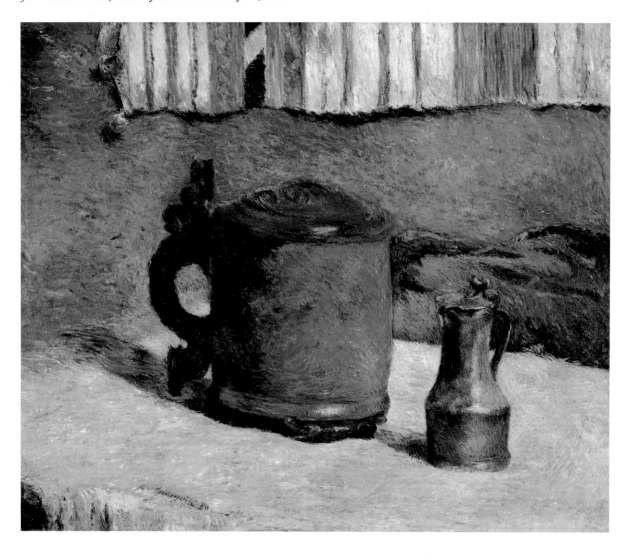

33 STUDY OF A NUDE, SUZANNE SEWING, 1880

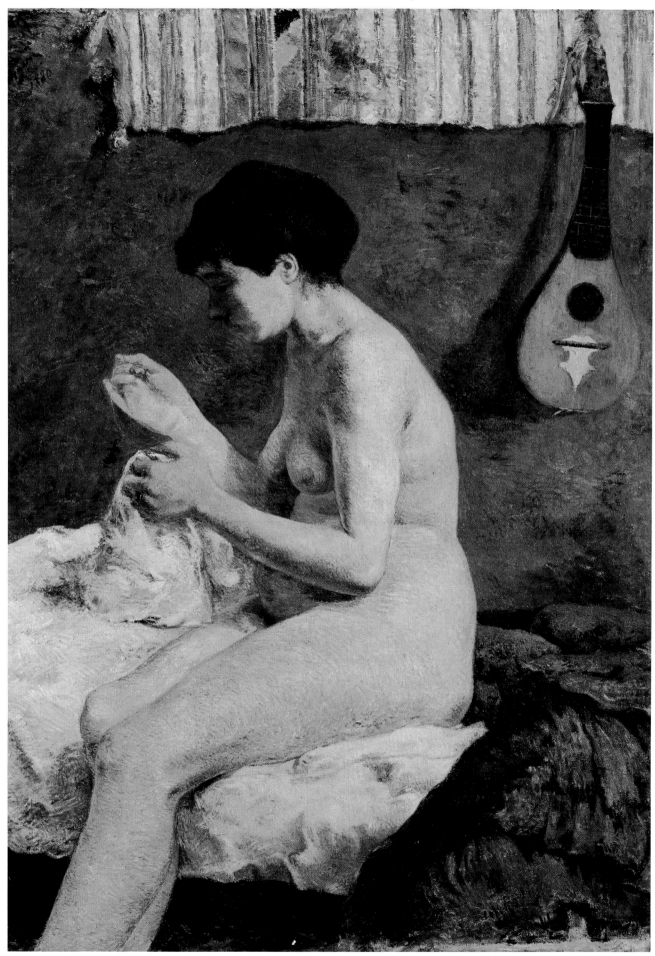

34 YOUNG GIRL DREAMING, STUDY/CHILD ASLEEP. THE PAINTER'S DAUGHTER ALINE, RUE CARCEL, 1881

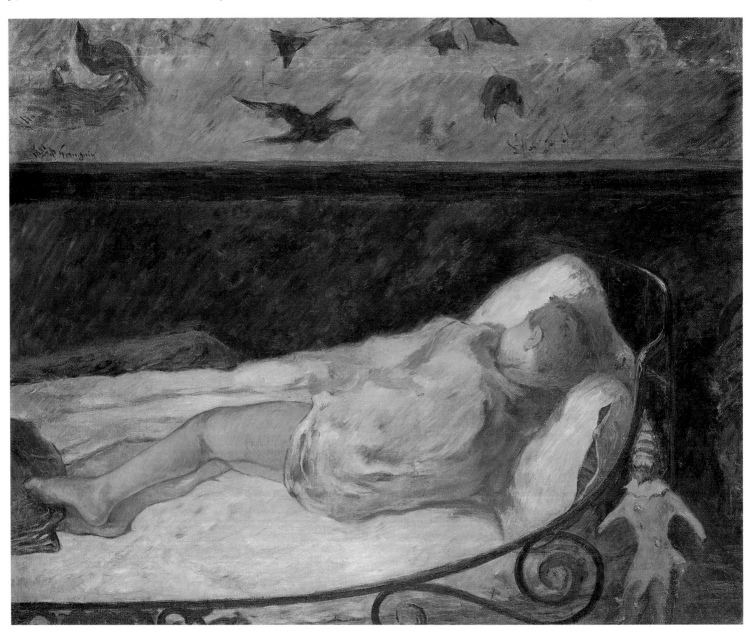

35 THE SCULPTOR AUBÉ AND A CHILD, 1882

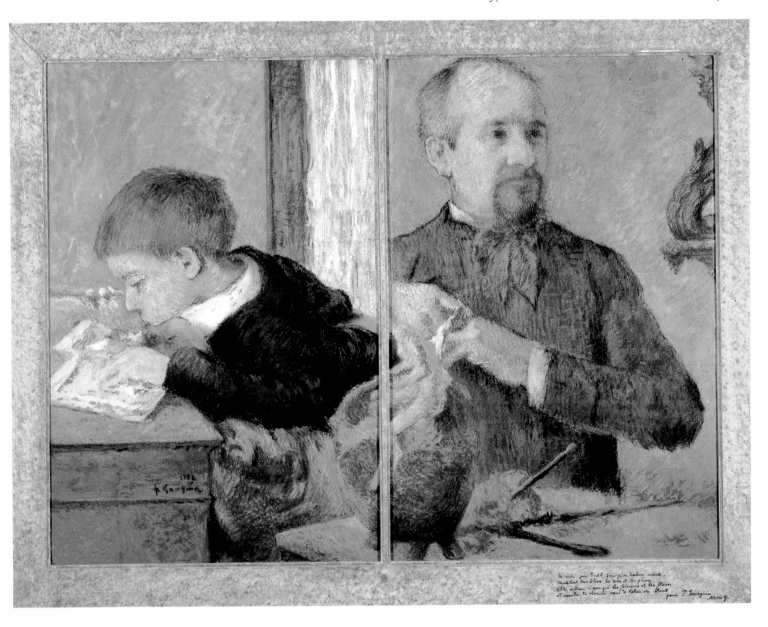

36 THE POPLARS, 1883

37 DRONNINGENS MILL, OSTERVALD, 1885

38 THE BLUE ROOFS, ROUEN, 1884

38 THE BLUE ROOFS, ROUEN, 1884

39 LANDSCAPE WITH COWS IN AN ORCHARD, 1885

40 BATHING, DIEPPE, 1885

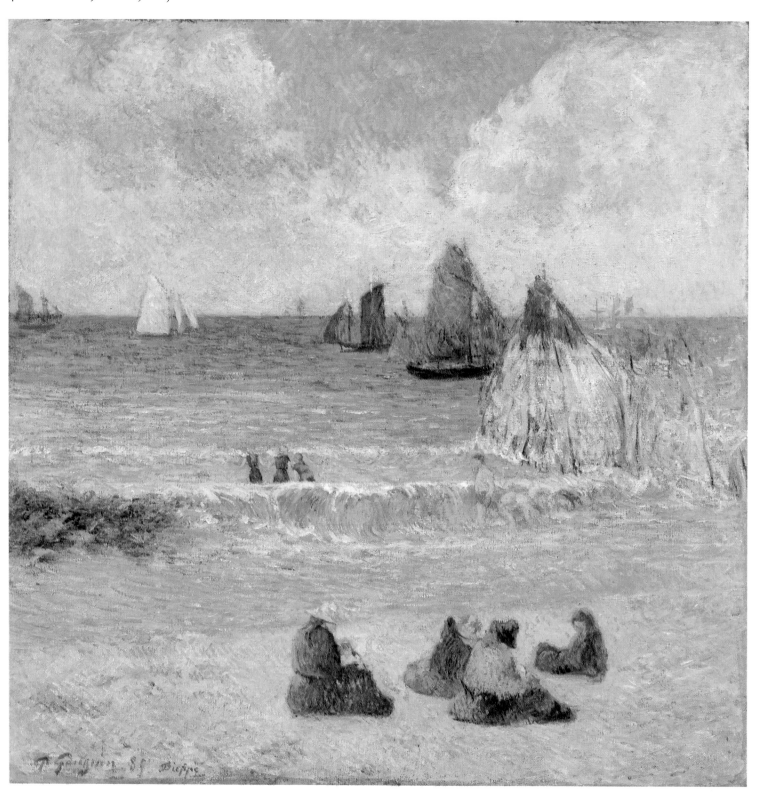

41 WOMEN BATHING, DIEPPE, 1885

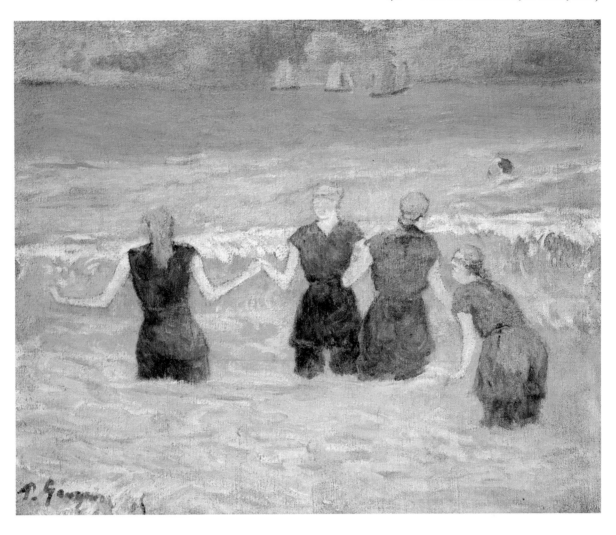

42 STILL LIFE, THE WHITE BOWL, 1886

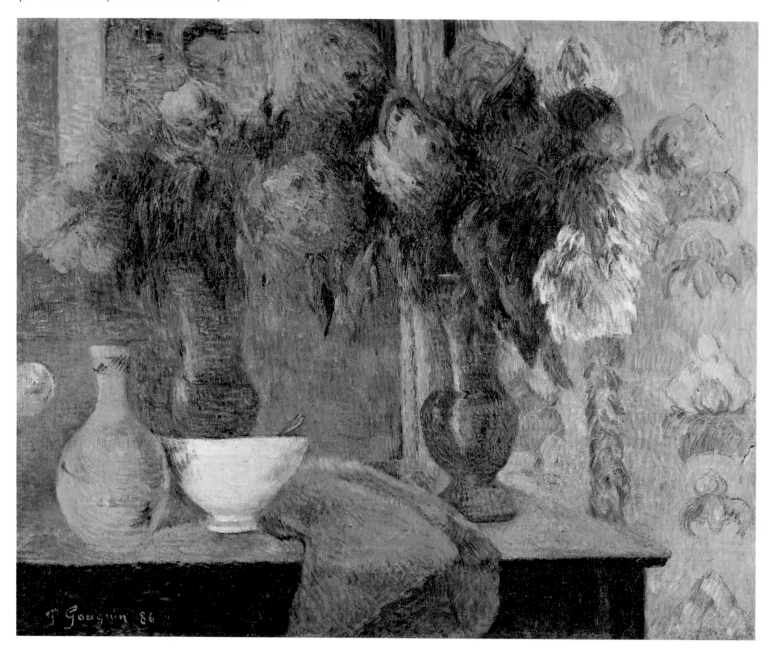

43 STILL LIFE WITH PROFILE OF LAVAL, 1886

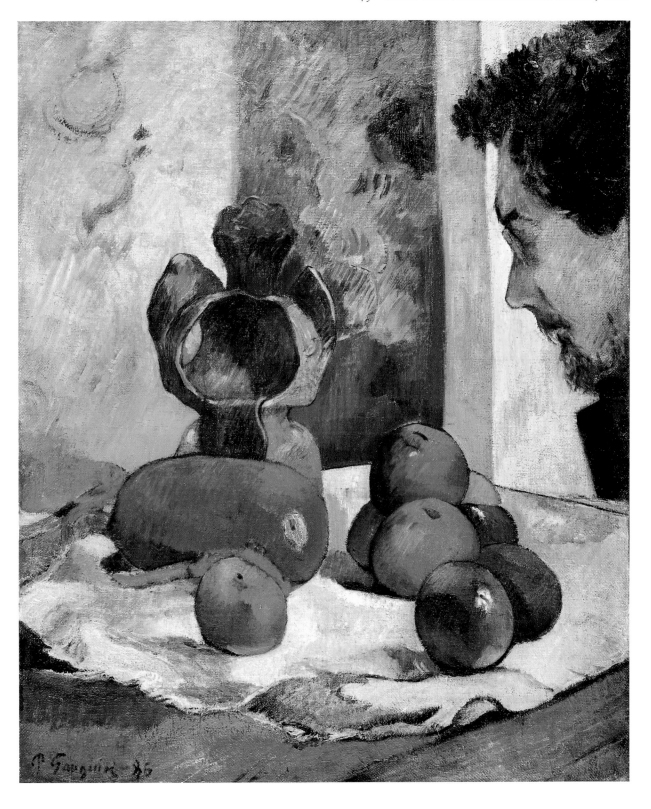

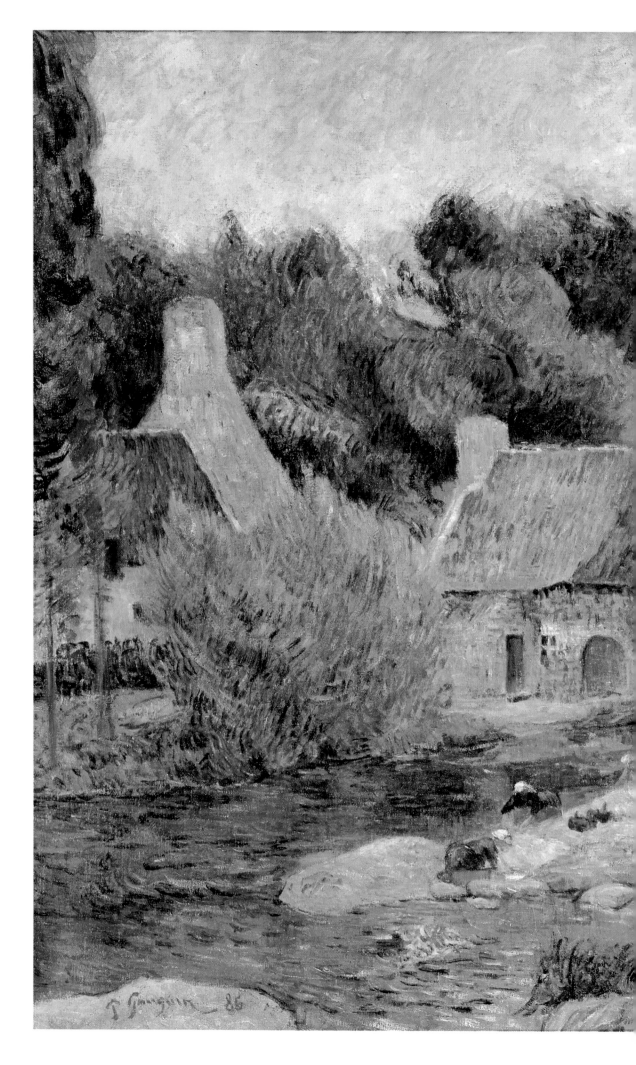

44 WASHERWOMEN AT
PONT-AVEN, 1886

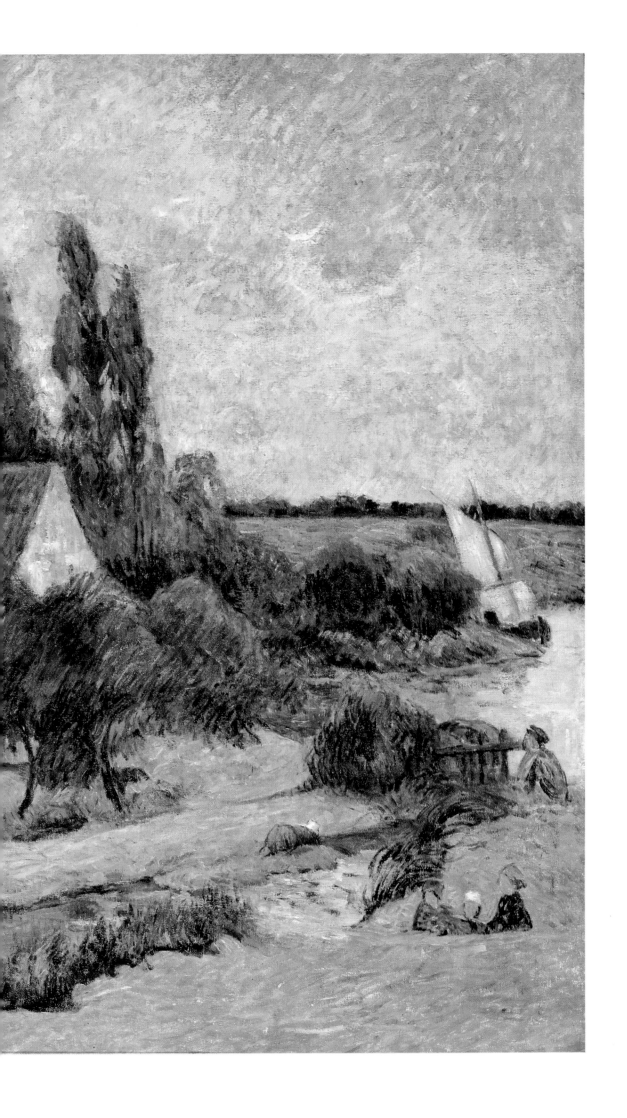

45 BRETON SHEPHERDESS, 1886

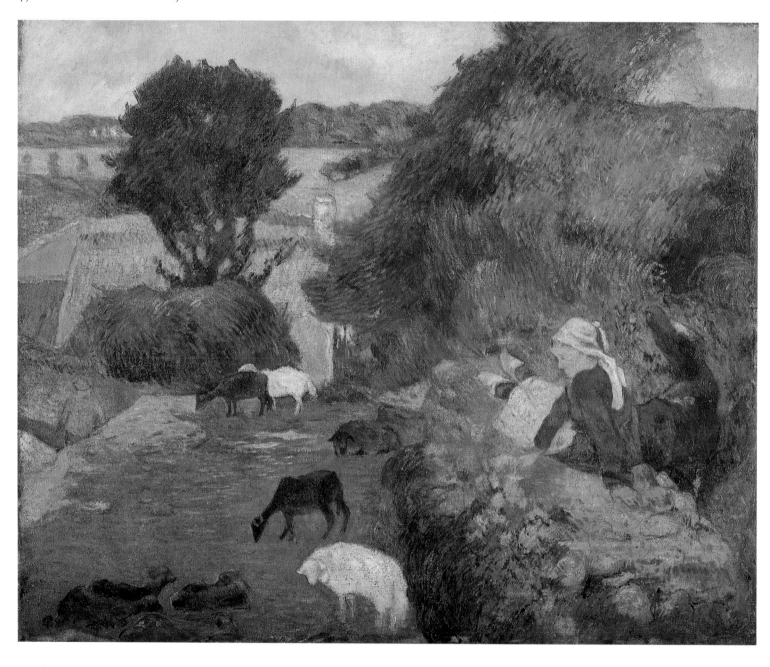

46 SEATED BRETON GIRL, 1886

47 BRETON GIRL, 1886

48 VASE DECORATED WITH BRETON SCENES, 1886–1887

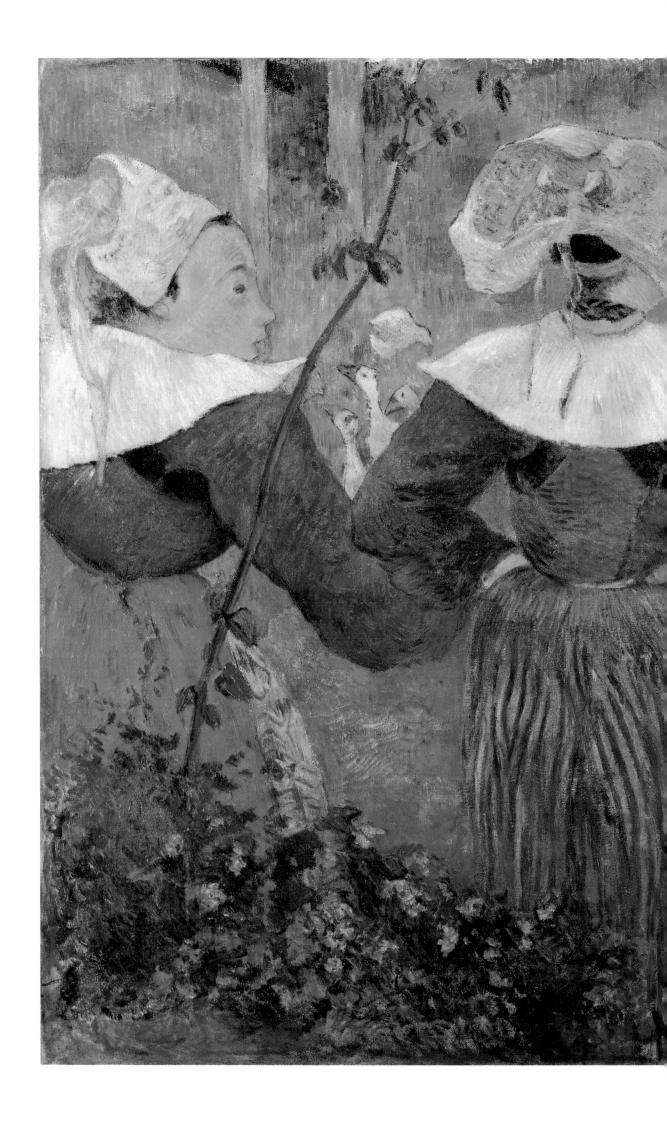

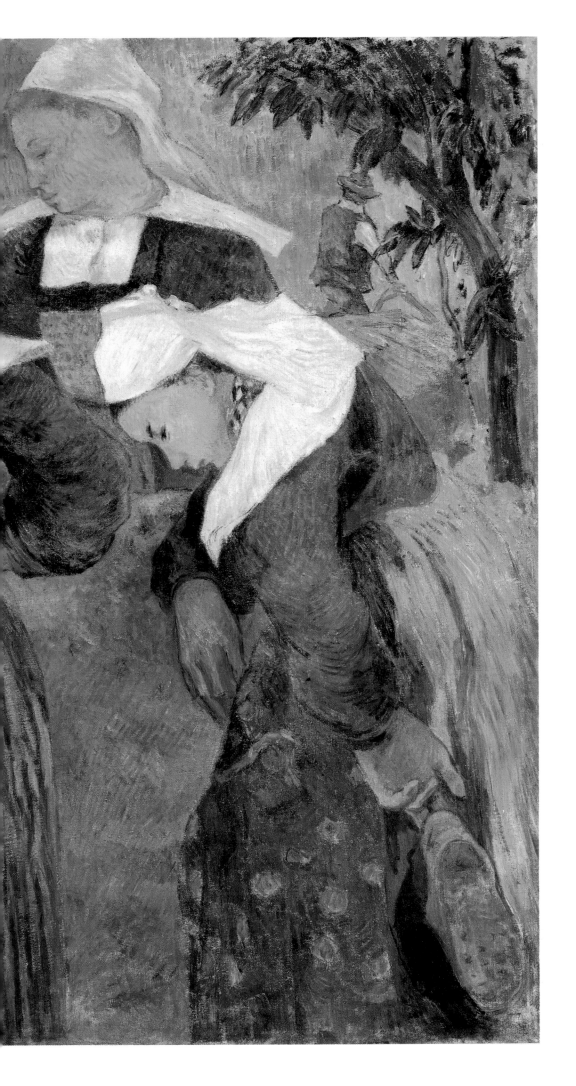

49 FOUR BRETON WOMEN, 1886

50 TROPICAL VEGETATION, MARTINIQUE, 1887

51 MARTINIQUE LANDSCAPE (COMINGS AND GOINGS), 1887

52 SEASHORE, MARTINIQUE, 1887

53 BY THE SEASHORE, MARTINIQUE, 1887

54 BATHER (STUDY FOR LA BAIGNADE), 1887

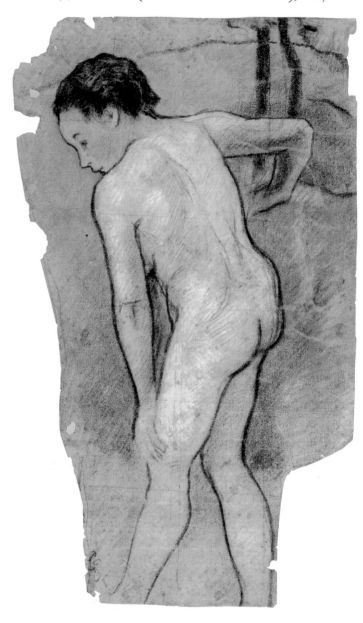

55 LA BAIGNADE, 1887

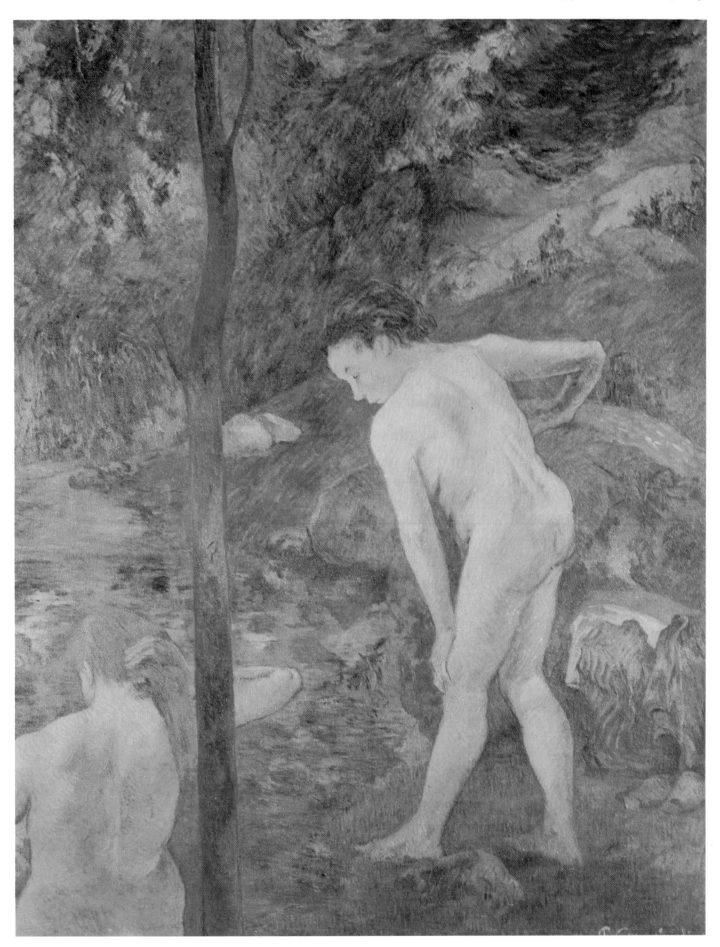

It is regretted that this reproduction does not reflect the colours of the original.

These years encompassed the short-lived but intense correspondence between Gauguin and the van Gogh brothers. The positive relations Gauguin established with Theo van Gogh in late 1887 augured a more secure commercial future and gave him the fillip he needed to embark with optimism on a new campaign of work in Brittany. He returned to Pont-Aven in February 1888, staying once again at the Pension Gloanec. Throughout the summer, the question of Gauguin's going south to join Vincent in Provence was discussed, but the prolonged stay in Brittany gave him vital time to experiment further and consolidate his style; progressively he abandoned the broken, fussy brushwork of Impressionism in favour of flatter, more unified blocks of colour held between strengthened, simplified contours, changes which accompanied a turning away from the natural motif towards imagination and memory. These developments are clearly visible in such paintings as Breton boys wrestling *and* Still life with three puppies. *His letters express satisfaction with his technical advances towards synthesis and with his more symbolic new pictures, among them* Vision after the sermon (Jacob wrestling with the angel), *painted in September 1888. The example of the younger painter Émile Bernard who arrived in Pont-Aven in August, bringing strikingly simplified, cloisonist works of his own, reinforced Gauguin's confidence and faith in the lines of research he was developing. At this time he began projecting the image of his 'savage' nature, both in self-portraits and in written descriptions, while his letter to Bernard's sister Madeleine, exposing his 'advanced' ideas on the status of womankind, seemed to solicit the reputation of malign seducer which he later cultivated.*

Working and living with Vincent van Gogh in Arles from October to December 1888 proved a fruitful but emotionally charged experience, as Gauguin hinted in letters to Bernard and Theo. The two painters tackled parallel subjects, emboldened by the similarities in their experiments with heightened colour and simplification. That he gained little from the collaboration compared with the benefits reaped by Vincent was ultimately Gauguin's verdict in Avant et après, *although this was a less than candid account. Following the relationship's notorious débâcle, Gauguin was more than ever anxious to keep on the right side of Theo in 1889, a year which saw the production of many new pictures and an important wood carving,* Soyez amoureuses. *His letters take care to forewarn the dealer of changes in his Breton work, particularly his cultivation of religious themes which he expects will arouse controversy and be misunderstood; he is anxious to clear up misunderstandings that arise over his unofficial participation in the 1889 Universal Exhibition – an exhibition with friends at the Café Volpini. Although not much is made of this event in the correspondence, Gauguin and Bernard's published articles in* Le Moderniste *were intended to help draw attention to it and their aesthetic position. The exhibition proved a key turning-point, establishing Gauguin's reputation on a par with Seurat as a leader of the young avant-garde. The tone of some of Gauguin's letters to Schuffenecker and Bernard gives an insight into the didactic rôle he played at this time.*

The letters of 1890–1891 harp on the theme of Gauguin's plans to flee Europe for remoter shores – whether Madagascar, Tonkin, or Tahiti – an objective that the colonial section of the Universal Exhibition, his increasing debts and, finally, the demise of Theo van Gogh did much to foster. Gauguin's partly prosaic, partly romantic descriptions of his imagined tropical paradise were culled from different sources: official guidebooks, for instance, and Le Mariage de Loti – Rarahu, *Pierre Loti's popular, factually based but romanticized novel about a European's experience of Tahiti. Returning to Paris in 1890 to prepare for his departure, Gauguin was much courted, not only by artists but also by poets and playwrights. With support in Symbolist circles from such prominent writers as Mallarmé, Octave Mirbeau, Albert Aurier and Charles Morice, Gauguin launched a successful press campaign to publicize an auction of his recent work in February 1891.*

Paris, February 1888

To Mette

I am leaving on Thursday for Pont-Aven and I would rather reply to your letter now, while I am undisturbed. Obviously the countryside in winter is not entirely beneficial to my health, but I have to work as fast as I can and I am unable to do so here, without a studio, models, etc... Whereas in the part of Brittany where I've already been I shall be able to work for 7 or 8 months continuously and really become imbued with the character of the people and the locality, which is essential if I'm to paint well. On the subject of painting, I see from your letter that there is still a barrier in your mind which makes you behave just like any other bourgeois woman. There are two classes in society. Those in the first class are born into capital, which enables them to live on unearned income, to be a partner or owner of a business. The other class has no capital – what are they to live off? The fruits of their labour, of course. In the first class, persistence and tenacity over many years, (in administration or commerce), is rewarded with more or less mediocre results. In the other class, the spirit of initiative, (whether in art or literature), creates, over a long period it is true, an independent and productive situation. In what respect do an artist's children have to suffer more than those of an employee? What employee does not have to suffer poverty at least for a time?

And what is the most splendid part of a living nation, the most productive element, the one that brings about progress and enriches the country? Why, the artist! You do not like art, so what do you like? Money – and when the artist earns money, you share it. There are winners and losers in any game, and you should not take part in the joy of winning if you do not also share the pain of losing. Why do you educate your children since it's a present difficulty with a view to something that is uncertain? This question brings me to that of Emil's future. Why should he be an officer in the engineers? It's exactly the same thing as being an officer in the navy...

Will he be French or Danish? He will be French like his brothers... Once he qualifies as an engineer I shall be able to use the contacts I will have established by then to set him up in business by himself. The more progress is made, the more machines dominate our lives and there will always be a place for engineers.

Of the drawings by the children you sent me, Aline's are the best, provided of course that they are her own work. I don't see why you don't encourage her in that direction, but please, no art lessons. If she takes a liking to drawing, let her copy what's in the house and then have her make sketches from life.

Your idea of us meeting at the seaside in Denmark is a bad one from every point of view. 1) I can live for three months in Brittany on the cost of the journey alone. 2) The work I would do there, disturbed by the children, would not be as good as the work I do here. What is more, I have no summer clothes, which is a disgrace in a bourgeois country. 3) Apart, we get on after a fashion, but if we're together for a while we'll just have the same problems, arguments, etc... And what would your family say – just think, you might have another child! 4) And this is my final reason: since my departure, I have gradually closed off my heart to sensitive feelings in order to conserve my moral courage. That side of me is dormant and it would be dangerous for me to see my children beside me, only to have to go away again afterwards. You have to remember that I have two natures – the savage and the oversensitive. The oversensitive one has disappeared, which enables the savage to advance resolutely and unimpeded.

There was a long article recently in *Le Figaro* on the minor revolution taking place in Norway and Sweden. Bjornson and company have just published a book in which they demand that women should have the right to sleep with whomever they wish. Marriage is to be abolished or becomes nothing more than a partnership, etc . . .

Have you read about this? What are they saying in Denmark about it? See if the book has been translated into French. If not, it would be a good idea for you to translate it and then send it to me so I can correct and publish it. It might make a little bit of money.

*

[Pont-Aven, February 1888]

To Émile Schuffenecker

. . . I am living in silent contemplation of nature, devoting myself entirely to my art. Without that there is no salvation, and it is the best means of keeping physical pain at bay. In that way, I acquire the strength to live without too much bitterness for my fellows.

. . . I like Brittany, I find a certain wildness and primitiveness here. When my clogs resound on this granite soil, I hear the dull, matt, powerful tone I am looking for in my painting . . .

*

[Pont-Aven, late February 1888]

To Vincent van Gogh

I wanted to write to your brother, but I know that you see each other every day and I fear that I shall merely annoy him, occupied with business as he is from morning till night. I have gone to work in Brittany (I still have a desperate urge to paint) and I had hoped to have the funds to do that. The few works I have sold went to pay off some of my most pressing debts, and within a month I am going to find myself completely penniless. Nothing is a negative force.

I do not want to pester your brother but if you could have a quiet word with him on this subject, it would calm me down or at least help me wait patiently. My God, money questions are terrible for an artist! . . .

*

[Pont-Aven, *c.*19 March 1888]

To Vincent van Gogh

Thank you for replying to my letter; I see you are in a good place for studying the sun, which you find so fascinating, and that you are working all the better since the subject grips you . . .

Pont-Aven is very dismal at the moment because of the bad weather – continual wind and rain. I am waiting for the good weather to get back to work; illness has prevented me from doing very much.

*

[Pont-Aven] 26 March 1888

To Émile Schuffenecker Thank you for the 50 francs you sent me; although it's not enough to solve the problem, things are a little easier now.

For several days I have not had a trace of illness and I think I shall soon be completely recovered . . .

I have received an article by Fénéon, *La Revue indépendante*, January. Passable as regards the artist, curious about his character. These gentlemen have apparently suffered from my behaviour and are little angels. And that is how history is written.

*

[Pont-Aven, June 1888]

To Émile Schuffenecker . . . it won't bother me if the price of the Monets goes up; it will be another example for the speculators as they compare yesterday's prices with those of today. And in that sense 400 francs for a Gauguin does not seem excessive compared with 3000 for a Monet . . . I have written to van Gogh – I'm still hoping he will sell something for me. The Cézanne you enquired about is an absolute gem, and I've already refused an offer of 300 francs for it. I treasure it, and unless it became absolutely necessary I would not sell it until after I had sold my last shirt. Besides, who is the lunatic who would buy that for himself? You don't explain.

*

[Pont-Aven, *c.*15 June 1888]

To Theo van Gogh . . . If affairs are in a hopeless state for us painters, your excellent reply is encouraging and your courteous behaviour touching. . .

For several years I have had a plan to which I am currently devoting a great deal of intense thought. This plan is the result of detailed study of the question and may appear rather extraordinary. Although it appears audacious, it nevertheless includes some essentially sound opportunities . . . Your brother is going to write to you at greater length on this subject. I need your approval before I set about doing anything, our interests being bound up with yours. I am too tired at the moment to explain any further . . .

Some time ago I received a letter from a creditor at the Stock Exchange, (Myrtil), to whom at a pinch I admittedly owe 300 francs. I told him I had no money at the moment but that if he wanted a picture in lieu of payment he should get in touch with you. However, there is one picture I would like you to reserve – the one of the black women chatting that you took recently. That one is *hanging fire* with a lady who wanted it passionately and for whom I brought it down from *500* to *400* francs. She has not made her mind up yet, but she might decide to buy it at any time.

A thousand pardons for all this trouble I am causing.

*

[Pont-Aven, *c.*15] June 1888

To METTE ...your letters are like things used to be in our life
together, anything but an exchange of thoughts and feelings, and I am getting tired of writing
without receiving any kind of response... You ask me to give you courage. Why do you need
it, unless it's for the struggle for the material things in life? Are you confined within the 4
walls of an inn, are you bereft of a mother, or deprived of the sight of your own children and
their conversation? What you really mean is that if you had a private income you would be the
happiest of women. Nobody to thwart your wishes, surrounded by people, cherished, courted
even.

Now and then I receive letters from people said to be intelligent, full of *sympathy*, *of
admiration*, etc for me. I was 40 on 7 June and I have not yet received one tenth of such good
wishes from my family. When your son comes of age, will you dare advise him to marry anyone
except a cook? Should he marry a lady she will have nothing to talk to him about except
domestic matters. There will be no conversation, merely twaddle about bread and butter
matters, clothes and tittle-tattle about the neighbours. If your son is more intelligent than his
wife, she will begin to hate him. Only a cook will be proud of her husband, will respect him
and find it natural that the husband manages their affairs...

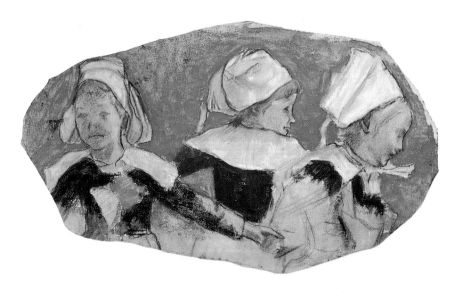

56 THE DANCE OF THE BRETON GIRLS, 1888

[Pont-Aven, *c.*8 July 1888]

To ÉMILE SCHUFFENECKER ...I have just finished several *nudes* that will please you.
And not at all in Degas's style. The last is a fight between 2 boys near the river, quite Japanese,
by a Peruvian savage.

It has very little execution, green grass and the upper part white...

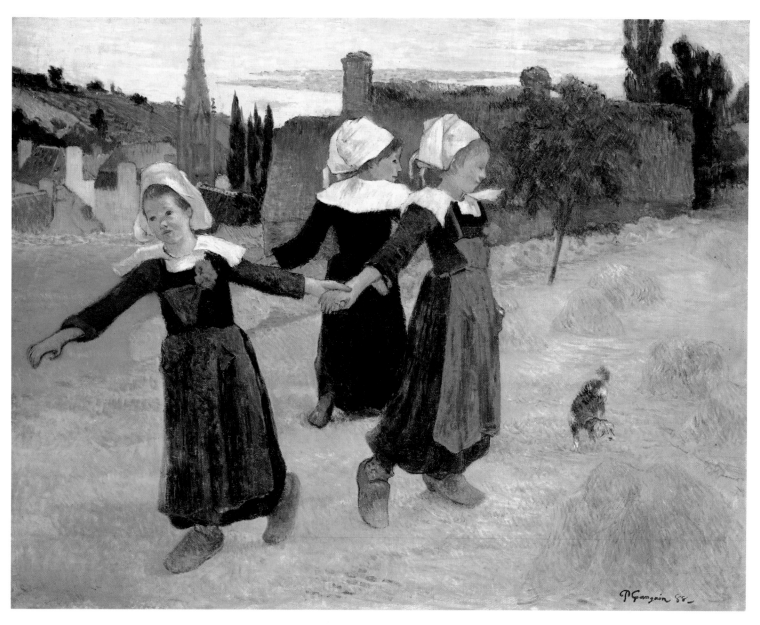

57 BRETON GIRLS DANCING, PONT-AVEN, 1888

[Pont-Aven, mid-July 1888]

TO THEO VAN GOGH I was delighted to receive your letter containing a money
order for 39.60 francs. I am glad to have solved the problem of paying a creditor who was
annoying me . . . I am in the middle of painting a picture of 3 girls dancing a Breton *gavotte* at
haymaking time. I think you will be pleased with it. This painting seems to me quite original
and I am fairly happy with my draughtsmanship.

*

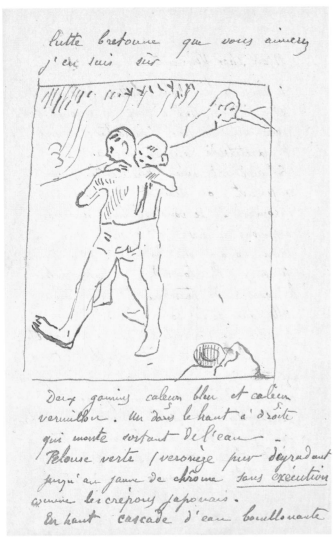

58 LETTER TO VINCENT VAN GOGH WITH SKETCH OF
BOYS WRESTLING, c.25 July 1888

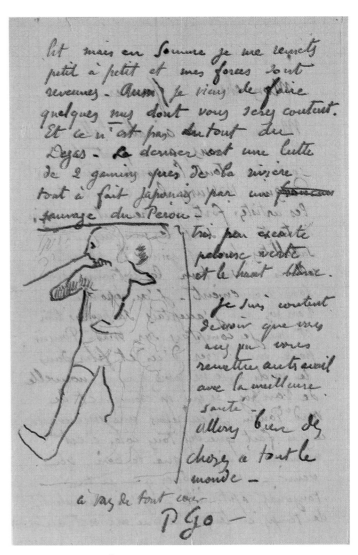

59 LETTER TO ÉMILE SCHUFFENECKER WITH SKETCH
OF BOYS WRESTLING, c.8 July 1888

[Pont-Aven, c.25 July 1888]

To Vincent van Gogh
I have just read your interesting letter and I absolutely
agree with you about the unimportance of exactness in art.

Art is an abstraction, unfortunately one becomes less and less understood. I would like us to
realize our plans, namely my trip to Provence. I've always had a fancy to interpret the bull
races in my own way, as I understand them. I am beginning to regain the freedom of my
faculties: my illness had weakened me and in my most recent studies I have, I think, gone
beyond what I have done up to now.

Naturally the band of louts who are here find me quite mad. I don't mind that – it just
proves to me that I'm not. I've just finished a Breton wrestling match that I'm sure you'll
like . . .

If it wasn't for this wretched money, my trunks would already be packed. I don't know
why, but for ten days my head's been full of the crazy paintings I'm planning to do in the
Midi . . . It's as if I had a need to *fight*, to hew things out with a bludgeon. After all the research
I've just done here I think I will have no difficulty in making progress.

[Pont-Aven] 14 August 1888

To Émile Schuffenecker ...One piece of advice: do not copy too much from nature. Art is an abstraction; extract it from nature while dreaming in front of it and pay more attention to the act of creation than to the result. That's the only way of advancing towards God, by imitating our divine master and creating.

...All the Americans here have been raging against Impressionism. I was forced to threaten them with violence, and now we have peace.

I am still waiting to leave. I have taken on a pupil who will go far: the group is expanding. Young Bernard is here and has brought some interesting things with him from St Briac. He is one person who is not afraid to try anything.

I'm making good progress with my latest works, and I think you will find a new note, or rather the affirmation of my earlier attempts at synthesizing one form and one colour, without either being the dominant...

The self-esteem that one acquires and the justified awareness of one's own strength are the only consolations to be had in this world...

60 STILL LIFE WITH THREE PUPPIES, 1888

[Pont-Aven, September 1888]

To Émile Schuffenecker

...The gathering here is now more or less complete. Laval and Bernard are working Impressionism to death. He's very strange, young Bernard. We speak of you occasionally. We need you here to inflame this band of hewers of paint.

...In the absence of religious painting, what beautiful thoughts can be evoked with form and colour. How prosaic they are, those naturalist painters, with their trompe-l'œil rendering of nature. We alone sail on our phantom vessels, with all our fanciful imperfection...This evening, when I have dinner, the beast in me will be sated, but my thirst for art will never be quenched...

*

[Pont-Aven, *c.*10 September 1888]

To Vincent van Gogh

...Yes, you are right to want painting to have a colouring evocative of poetic ideas, and in that sense I agree with you, although with one difference. I am not acquainted with any *poetic ideas* – I'm probably missing a sense. I find *everything* poetic, and it is in the deepest recesses of my heart, that are sometimes mysterious, that I glimpse poetry. Forms and colours brought into harmony produce poetry by themselves. Without allowing myself to be distracted by the subject, contemplation of a painting by another artist induces in me a feeling, a poetical state that becomes more intense the more the painter's intellectual powers emanate from it. There's no point quibbling about it; we shall talk about it at greater length. In that connection, I am very sorry to be detained still in Pont-Aven; my debts increase each day, making my journey ever more unlikely. An artist's life is one long martyrdom!...

I am studying young Bernard, whom I know less well than you; I think you will do him good, which he needs. He has suffered, naturally, and he is starting out in life full of venom, accustomed to seeing the bad side of humanity. I hope that, with his intelligence and his love of art, he will realize one day that kindness is a force against others and a consolation for our own misfortunes. He loves you and holds you in high regard, so you may be a good influence on him. We need to be very united in both our hearts and our minds if we wish to be accorded in future the place due to us.

61 LETTER TO VINCENT VAN GOGH
 WITH SKETCH OF VISION AFTER
 THE SERMON, *c.*22 September
 1888

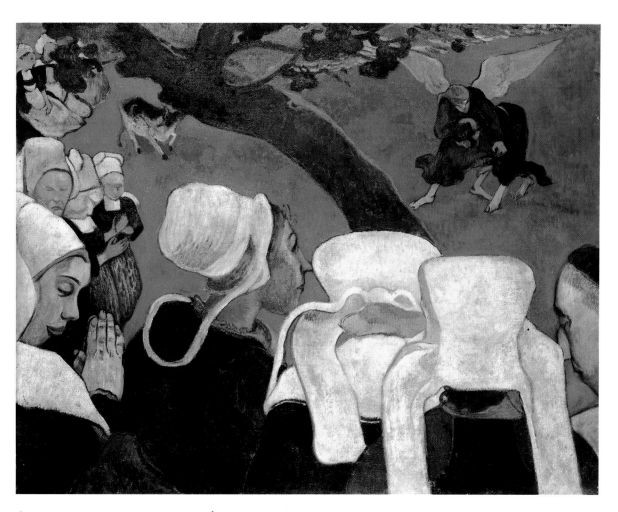

62 VISION AFTER THE SERMON (JACOB WRESTLING WITH THE ANGEL), 1888

[Pont-Aven, *c.*22 September 1888]

TO VINCENT VAN GOGH . . . I have just painted a religious picture, very badly done but it interested me and I like it. I wanted to give it to the church of Pont-Aven. Naturally they don't want it.

A group of Breton women are praying, their costumes very intense black. The coifs very luminous yellowy-white. The two coifs to the right are like monstrous helmets. An apple tree cuts across the canvas, dark purple with its foliage drawn in masses like emerald green clouds with patches of green and sun yellow. The ground (pure vermilion). In the church it darkens and becomes a browny red.

The angel is dressed in ultramarine blue and Jacob in bottle green. The angel's wings pure chrome yellow 1. The angel's hair chrome 2 and the feet flesh orange. I think I have achieved in the figures a great simplicity, rustic and *superstitious*. The whole thing very severe . . .

Laval expects to come and join me in the Midi around February. He has found someone who will give him 150 francs a month for a year.

Now my dear Vincent it seems to me that you've got your sums wrong. I know the prices in the Midi; keeping away from the restaurant I guarantee to run the house and feed *three* of us on 200 francs a month. I've run my own household and I know how to cope . . .

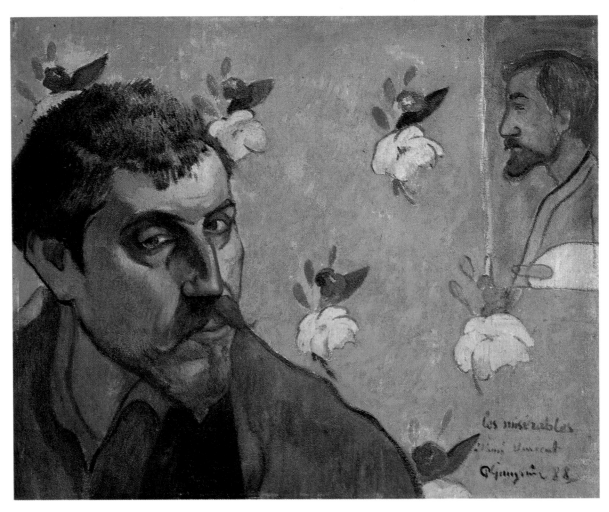

63 SELF-PORTRAIT, LES MISÉRABLES, 1888

[Pont-Aven, *c.*25 September 1888]

TO VINCENT VAN GOGH We have fulfilled your desire, in a different way, it is true, but never mind – the result is the same: our 2 portraits . . . I feel the need to explain what I was seeking to do, not that you would be unable to infer it by yourself, but because I don't think I've achieved what I set out to do: the guise of an ill-dressed, powerful outlaw like Jean Valjean, which has its own internal nobility and gentleness. The face is coloured by a rush of blood and the feverish tones surrounding the eyes suggest the fiery lava that inflames the souls of us painters. The delineation of the eyes and nose, like the flowers in Persian carpets, typifies an abstract, symbolic art. The yellow floral background, like the wallpaper in a young girl's bedroom, signifies our artistic purity. And this Jean Valjean, oppressed by society and placed outside the law, with his love and his strength, does he not symbolize the plight of the Impressionist today? . . .

*

Quimperlé, 16 October 1888

TO ÉMILE SCHUFFENECKER . . . you know my craze for paying as soon as I have some money. Well, I have paid the doctor and given something to Marie-Jeanne without thinking, and now I have nothing left for the journey.

So would you be so kind as to go to see van Gogh *immediately* and arrange for him to send me 50 francs. Telegraph me at once.

. . . I think that in a year's time I shall be out of the wood and able to settle my debts with you. In any case, I shall remain your grateful and devoted friend.

. . . So you talk of my *terrible* mysticism. Be an Impressionist to the bitter end and be afraid of nothing! Obviously this pleasant path is strewn with pitfalls, and I have only just begun to follow it, but it is in my nature to do so, and one should always be faithful to one's nature. I know I will be understood *less and less*. What does it matter if I become estranged from the others? For most people I shall be an enigma, for a few I shall be a poet and sooner or later merit will have its way.

. . . Mark this well, a wind is blowing among *artists* which is all in *my favour*. I have deduced this from a few indiscretions and rest assured, however passionately fond van Gogh may be of me, he would not be rushing to offer me board and lodging in the Midi just on account of my pretty face. He has surveyed the terrain like the cautious Dutchman he is and intends to push the matter to the utmost of his powers, and to the exclusion of all else . . .

*

[Pont-Aven, October 1888]

TO MADELEINE BERNARD If you want to wander *aimlessly* through life like most girls, at the mercy of all the hazards of fortune, good and bad, dependent on the *world* to which we sacrifice our all and which gives us so little in return, stop reading what I am writing now.

If, on the other hand, you wish to be *someone*, to find happiness solely in your independence and your conscience, it is now time to think about these things and to take action within *three years*.

Firstly, you have to consider yourself androgynous, without sex. By that I mean that the soul, the heart – in short all that is divine – must not be the slave of matter, that is of the body. The virtues of a woman are exactly the same as those of a man and are the Christian virtues – duty towards one's fellows based on kindness, and always sacrifice, with only your conscience for judge. You may raise an altar to your dignity and intelligence, but to nothing else.

Lying and venality are crimes . . . All chains are the insignia of the lower orders, and to commit any slavish act is to flout divine laws. Do proudly all that would help you to win the right to be proud, and do everything possible to earn your own living, which is the pathway to that right. But do away with *all vanity*, which is the hallmark of mediocrity, and, above all, the vanity of money . . .

Be my mediator with your mother, and accept a fraternal kiss from your elder brother.

PAUL GAUGUIN

Arles, 2 place Lamartine, from 22 October onwards.

[Arles, early November 1888]

TO ÉMILE BERNARD ...I hope you're not having too much trouble with those louts whom I left in such an overheated state. In any case, you're working and messing about, as we say. I fear cardboard is not a suitable support for glue-based paint, and the same applies to wood – its hard surface makes the glue peel off. But if you use a flexible material such as coarse-grained paper on canvas, which absorbs and retains the paint, you will achieve very good results. Stage scenery is made in this way and is very durable.

You have discussed shadows with Laval, and ask me whether I give a damn about them. As far as the analysis of light is concerned, no. Look at the Japanese, who are certainly excellent draughtsmen, and you will see life in the open air and sunshine without shadows. They use colour only as a combination of tones, various harmonies, giving the impression of heat, etc... Besides, I consider Impressionism as a completely new movement, a deliberate attempt to move away from everything mechanical, such as photography, etc... That is why I would avoid as far as possible everything that creates the *illusion* of something, and since shadow creates the *illusion* of sunshine, I am inclined to suppress it. If shadow constitutes a necessary part of your composition, then that's a different thing altogether. Thus instead of a figure you could just paint a person's shadow; that's an original starting point whose strangeness is quite deliberate...

It's strange, but Vincent sees opportunities here for painting in the style of Daumier, whereas I see in terms of coloured Puvis, mixed with the Japanese style. The women here, with their elegant coiffure, evoke Greek beauty. Their shawls that fall in folds like the primitives, evoke the parades of Ancient Greece. The girls walking the streets are as much ladies as any born, and as virginal in appearance as Juno. Anyhow, it must be seen. In any case, there is here a source of beauty, *modern style*. Greetings to you both, and be friendly to Laval; he has a fine and noble nature, despite his transcendent faults...

*

[Arles, mid-November 1888]

TO ÉMILE BERNARD Thank you for your interesting letter... You hold all the trumps in your hand. Having made good progress down the road to success at an early age, you will arrive fully prepared, in the full vigour of youth, at the moment when the road has been cleared of virtually all impediments. You are extraordinarily gifted and you would have reached your goal in any case, but at a different time, say 10 years ago, you would not have found a single person to admire or take notice of you. So much the better for you.

In this connection, van Gogh said something very curious in a letter to Vincent. I have, he says, seen Seurat, who has done some good studies which reveal a good workman who enjoys his job. Signac still seems rather cold to me, like a travelling salesman selling little dots! They are to start a campaign against us (with *La Revue indépendante* as the chief organ of their propaganda). Degas, Gauguin in particular, Bernard etc. are to be portrayed as worse than devils who have to be avoided like the plague. That's *roughly* what he says. You have been warned, but say nothing about it to van Gogh or you will make me seem indiscreet. I am as satisfied as possible with the results of my Pont-Aven studies. Degas is going to buy the one of

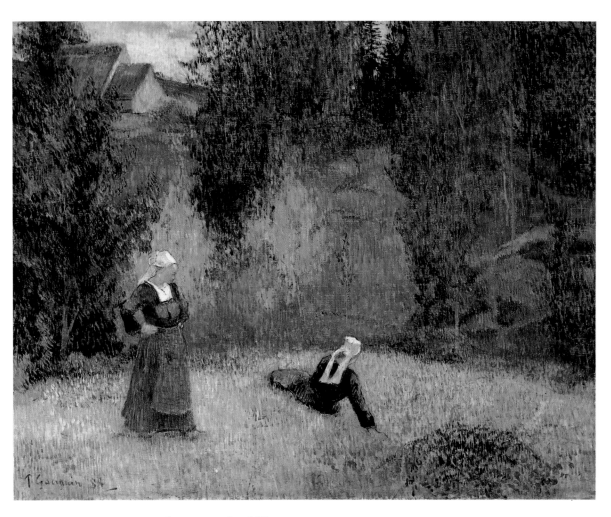

64 THE FIRST FLOWERS (BRITTANY), 1888

the two Breton women at les Avins [plate 64]. I consider that the greatest possible compliment: as you know, I have the utmost confidence in Degas's judgment – besides, it's an excellent starting point commercially. All Degas's friends have confidence in him. Van Gogh hopes to sell all my pictures. If I am that lucky, I shall go to Martinique, I am positive that now I can do some good work there. And if I could get hold of a larger sum I would even buy a house there and set up a studio where friends would find everything they need to hand at virtually no cost. I rather agree with Vincent, the future belongs to painters of the tropics, which have not yet been painted. (Novelty is essential to stimulate the stupid buying public)...

*

[Arles, *c.*16 November 1888]

To Theo van Gogh ...I have done a painting from memory of a really
bewitched poor wretch in the middle of a red vineyard [plate 67], and your brother who is very generous thinks it's good. My health is gradually improving and in a year's time I hope to be strong enough to go back to the tropics, and this time really get to work on the negresses, nude, clothed, etc....

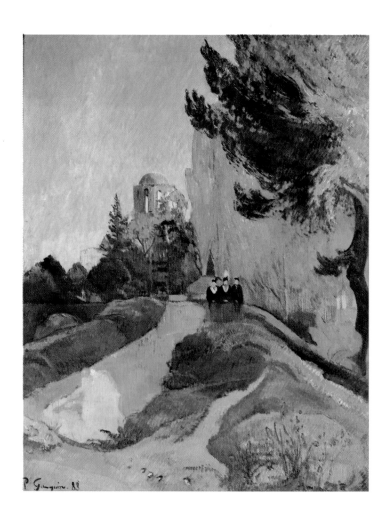

65 THE ALYSCAMPS, ARLES, 1888

[Arles, c.4 December 1888]

TO THEO VAN GOGH I've just dispatched a bundle of canvases. 1) The dancing
girls, on which I've changed the hand . . . [plate 57]
 2) A café at night [plate 95]
 3) A landscape, or the three graces at the temple of Venus [plate 65]
 4) The pigs [plate 66]
 5) The grape harvest, or the poor woman [plate 67].
 These last two canvases are, I think, fairly masculine, but perhaps a little vulgar – is it the
southern sun that brings us into rut? If you think they might upset the picture buyers, don't
be afraid to put them on one side, although I like them . . .

*

[Arles, early December 1888]

TO ÉMILE SCHUFFENECKER . . . For several years the *Vingtistes* have been inviting Signac,
Dubois, etc. and didn't even know I existed. That doesn't make me feel any more humiliated.
 To make up for it, I've received a very flattering letter of invitation this year, and I'm going
to organize a serious exhibition in Brussels, in opposition to the dotters.
 I've just sent van Gogh two canvases that I urge you to go to see. It's something different
again, painted simply on rough canvas with a full brush, with barely noticeable colour divisions
in an attempt to get a broader view of things [plates 66, 67].
 When you have time write to me with your critical impression of all this . . .

You can ask Pissarro if I am not talented. Personal hygiene and regular sex, together with work, are all a man needs to pull through.

I see you staring wide-eyed, my virtuous Schuff, at these rash words! Calm down, eat well, fuck well, work the same, and you will die happy.

*

[Arles, December 1888]

TO ÉMILE BERNARD ...I feel completely disoriented in Arles, I find everything so small and mean, both the landscape and the people. In general, Vincent and I do not see eye to eye, particularly on painting. He admires Daumier, Daubigny, Ziem and the great Rousseau, all of whom I cannot bear. And he hates Ingres, Raphael, Degas, all of whom I admire. I reply, 'Corporal, you're right,' just to get a bit of peace. He likes my pictures very much, but when I'm painting them he criticizes me for this and for that. He's a romantic, while I am more of a primitive. When it comes to colour he is interested in the accidents of the pigment, as in Monticelli's work, whereas I detest this messing about with technique, etc....

66 IN THE HEAT OF THE DAY (IN THE HAY), 1888

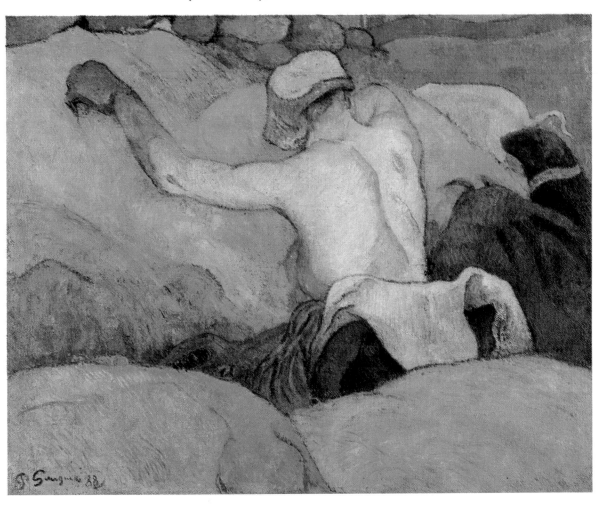

[Arles, *c*.8 December 1888]

To Theo van Gogh ... I have received an invitation from *La Revue indépendante* – I enclose a copy of my reply ...

I have replied in the affirmative tó the *Vingtistes*. I will write to tell you what you should send when they inform me it is time to dispatch the paintings ...

To *La Revue indépendante* Dear Sir, I am quite overwhelmed by the honour you do me in inviting me this time to show my work at the premises of *La Revue indépendante*. I regret that I am unable to accept an invitation that my friend Schuffenecker sought in vain for himself.

Since I have felt for the past 3 years that my strengths as an artist are nowhere near sufficient to keep up with the modern developments being introduced among the Impressionists who have so rapidly been replaced by the Neo-Impressionists, I have decided to work on my own, away from all group publicity. My studies of the tropics are inadequate as exact records of nature and I think that *La Revue indépendante* will be powerless to give them the clarity and luminosity they lack.

Yours etc.

*

[Arles, mid-December 1888]

To Mette Enclosed is 200 francs.

I would ask you to acknowledge *receipt* so I can be sure the money has not gone astray. And if it would not tire you too much, you could also use this opportunity to send me some news of the children.

I've had to do without news of them for a long time!

... I send you a letter from Schuffenecker that will explain better than I can what people think of my painting. I'm working myself to death, but my efforts will be rewarded one day.

Your husband.

Paul Gauguin
2 place Lamartine (Arles)

It is likely I will send you some more this winter if the exhibition I've been invited to hold in Brussels goes well, as seems probable.

*

[Arles, *c*.12 December 1888]

To Theo van Gogh I would be obliged if you could send me part of the money from the sale of the paintings. All things considered, I find myself compelled to return to Paris. Vincent and I find it absolutely impossible to live peacefully in each other's company; our temperaments are incompatible and we both need peace and quiet in order to work. He is a remarkable man of great intelligence for whom I have a high regard and whom I am sorry to leave, however, I repeat, it is essential. I appreciate the thoughtful way in which you have behaved towards me and beg you to excuse my decision.

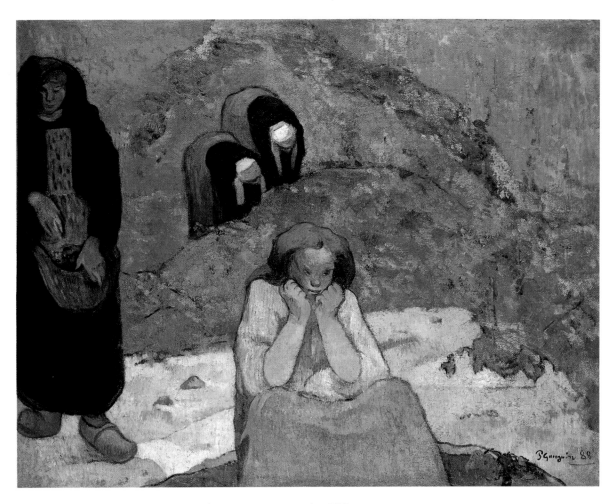

67 GRAPE HARVEST AT ARLES (HUMAN ANGUISH), 1888

[Arles, *c.*20 December 1888]

TO THEO VAN GOGH Please consider my journey to Paris as something imaginary,
and thus the letter I wrote to you as a bad dream.

... I feel increasingly nostalgic for the West Indies, so of course as soon as I have sold a few
things I shall be going there.

... I've recently completed a portrait of your brother on a size 30 canvas and given it the
theme *The painter of sunflowers* [plate 85]. From the geographical point of view, perhaps, it is not
a very good likeness, but I think it does convey something of his inner character and if you
have no objection, keep it, unless you do not like it.

We have been to Montpellier; Vincent is writing to you with his impressions.

*

[Paris, *c.*9 January 1889]

TO VINCENT VAN GOGH ... your sunflowers against a yellow background ... I
consider a perfect example of a style that is essentially your own. At your brother's I saw your
Sower, which is very good, as well as a still-life in yellow with apples and lemons ...

The picture of the grape harvest has totally flaked because of the *whiting*, which has
separated. I've stuck it down again completely, using a method recommended by the
mounter ... You stick newspapers on to your canvas with *flour paste*. Once they've dried, you
place your canvas on a smooth board and press down *hard* on it with very hot flat-irons. All the
flaws in your paint will remain, but they will be smoothed over and you will have a *very
beautiful* surface. Afterwards, you soak the paper covering well and completely remove it ...

68 PASTORALES MARTINIQUE, 1889

69 BRETONNES À LA BARRIÈRE (BRETON WOMEN AT THE GATE), 1889

[Paris, January 1889]

TO METTE
... This time the photograph does you a little justice, the others made you look uglier than you really are. But Aline's hair, neither long nor short, does not improve her. It would be better to cut it short until she's 15 and leave Clovis's thick crop longer to hide his ears a bit.

Little Paul is greatly changed. Emil looks more and more like a stiff Danish officer which I don't like at all. Otherwise they seem to me to be very well dressed. In my present clothes I would not dare to go out with them and this confirms my doubts about a trip to Denmark.

I had intended, if I could have scraped a little money together, to go to Brussels to see the exhibition I'm going to be in, and then go on to spend a month in Copenhagen to embrace the children, even if I cannot talk to them, as not one of them would be able to say 'Bonjour!' to me. Well, we shall see.

According to you, Schuffenecker undoubtedly flatters me far too much, and yet he is only more or less repeating what many others are saying, even Degas. I'm a pirate, he says, but damn it ... the very incarnation of art.

It could well be that these people discover in me something different from the impression you Danes seem to get. However, let's not discuss all that. I only sent it to you [Schuffenecker's letter] to keep you in touch from the point of view of business (which will follow later)...

*

[Paris, c.20 January 1889]

TO VINCENT VAN GOGH
Don't bother about the studies I deliberately left behind in Arles since they were not worth transporting. On the other hand, the drawing albums contain some notes that are of use to me and I accept your offer to send them on to me... Since my arrival in Paris, I've seen Bernard twice... It seems that his father is pestering him more and more about his painting and the unfortunate letter I wrote to his family.

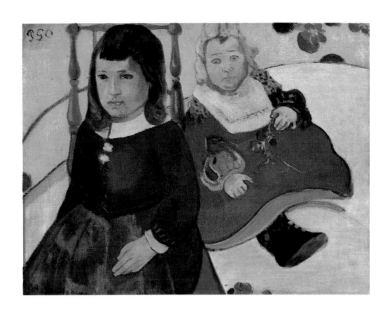

70 TWO CHILDREN (JEANNE AND
PAUL SCHUFFENECKER), 1889

... Now that I have a studio in which I sleep I'm going to get down to work. I've begun a series of lithographs that are to be published in order to establish my name. This is being done on the advice and under the auspices of your brother.

I'm going to work on portraits of the entire Schuffenecker family – him, his wife and their 2 children in scarlet smocks. It's dreadfully cold in Paris at the moment. I've been amusing myself doing some sketches in the Halles and I'm going to have some of the porters pose for me in their big hats, carrying sacks and quarters of beef ...

71 SCHUFFENECKER'S STUDIO/THE SCHUFFENECKER FAMILY, 1889

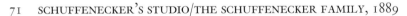

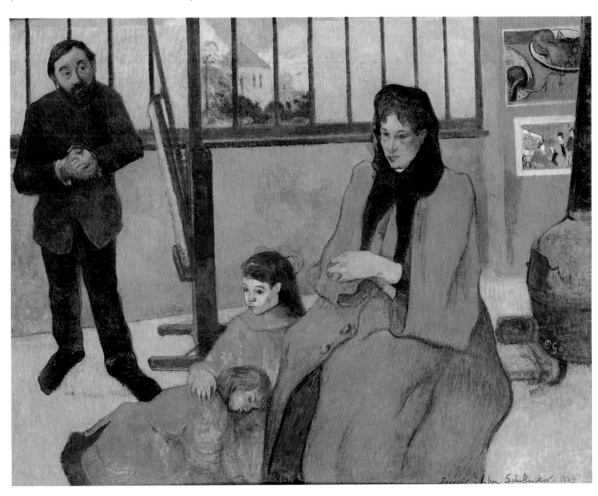

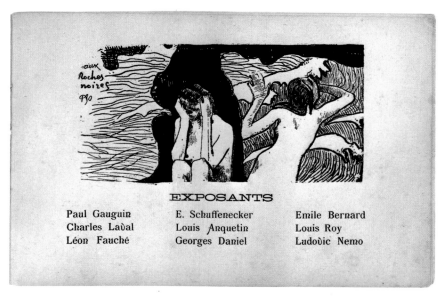

EXPOSANTS

Paul Gauguin	E. Schuffenecker	Emile Bernard
Charles Laval	Louis Anquetin	Louis Roy
Léon Fauché	Georges Daniel	Ludovic Nemo

72 AT THE BLACK ROCKS, 1889

[Pont-Aven, April 1889]

TO ÉMILE SCHUFFENECKER Bravo! You have brought it off. See van Gogh, arrange things until the end of my stay.

Only remember it is not an exhibition for the others. So let us arrange it for a little group of comrades, and from this point of view I want to be represented there as fully as possible.

Organize things in my best interests according to the space available.

1) Mangoes, Martinique [plate 23].
2) The tall Breton with the small boy in blue (size 30 canvas).
3) Breton Women (1 standing, 1 on the ground) [plate 64].
4) Winter (small Breton boy adjusting his clog with village in the background) [plate 91].
5) Presbytery (landscape of 1886).
6) The Dance of the little girls [plate 57].
7) The Arles landscape you have with bushes?
8) Farmhouses at Arles at van Gogh's [plate 99?].
9) The pastel ceramic.
10) Two boys wrestling [plate 93].

Remember it is we who are sending the invitations, consequently:

Schuff . 10 canvases		
Guillaumin 10 canvases		
Gauguin 10 canvases	} 40 canvases	
Bernard 10 canvases		
Roy . 2 canvases		
The man from Nancy 2 canvases	} 10 canvases	
Vincent 6 canvases		

50 canvases

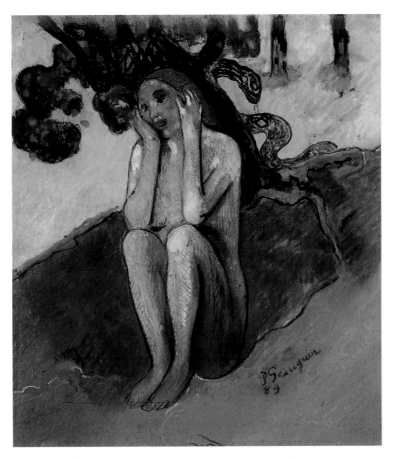

73 BRETON EVE, inscribed 'PAS écouter li li menteur', 1889

This will do. For my part, I refuse to exhibit with the *others*, Pissarro, Seurat, etc. It's our group!

I wanted to exhibit very little but Laval says it's my turn and that I would be wrong to work for the others. . . .

*

[Paris, end May 1889]

TO ÉMILE BERNARD You missed something in not coming the other day. In the Javanese village there are Hindu dances. All the art of India can be seen in them, and they give you a literal transcription of the photographs I have from Cambodia. I'm going back on Thursday as I have an appointment with a mulatto girl. Come on Thursday, but I mustn't be too late getting there, so either come at noon and have lunch or at 1 o'clock (to Schuff's). As for Buffalo we will go on Saturday.

I intend to leave next Tuesday and I must think about packing up my things.

On Saturday you must get to les Ternes by 3 o'clock, otherwise there's no chance of getting a seat.

[Pont-Aven, *c.*10 June 1889]

To Theo van Gogh Schuff has written to say that you think my exhibition is to be regretted. I'm very surprised. You yourself would have looked favourably upon an exhibition by the whole group. I tried last year. *Nobody* wanted to, etc... with all the usual disagreement. Claude Monet is showing at Petit's with some *foreigners*; this year at the Centennial. Guillaumin has had an exhibition at *La Revue Indépendante*, a little place of no merit. He will exhibit at the annual show of the *Indépendants*, with 200 nonentities.

And this year I organized that little show at the Universal Exhibition to show what we had to do as a group and to demonstrate it was possible. That deals with things in general. As for the particular instance, what harm can it do me? None, seeing that I'm unknown and that nobody is showing my work to the public. If my paintings are bad it will change nothing, and if they are good, which is *probable*, I will get myself known. I am in as good company as those gentlemen are at Petit's or alongside Baudry and company.

There remains the question of the venue! This seems to me infantile, and I don't think (knowing your ideas) that you will find anything wrong in that respect.

Our friends the *well-known* Impressionists are capable at any time of believing that other artists should be ignored, and it is not in their interests that Bernard and I, and the others, should seek to put on an exhibition. My interests are thus completely different, and I am sorry that Guillaumin has declined to take part, particularly since he's always demanding recognition and has now decided to miss an honourable opportunity to make his name. Still, that's his affair.

I was anxious to give you a frank explanation of all my reasons. There you are.

I've started on a series of drawings here that I think are interesting.

Greetings to Madame.

Best wishes, P. Gauguin

*

[Pont-Aven, *c.*1 July 1889]

To Theo van Gogh Thank you for your kind letter. Please find enclosed with mine the receipt for 225 francs. Although it is cheap, you did *well* to strike a bargain at that price with Lerolle, an artist. I think purchases by artists are the ideal solution, since they provide the public with a good demonstration of talent.

...Do you think this exhibition is of little use to me? On the surface yes! in reality *no*. Seeing that my real purpose is to demonstrate to Pissarro etc that I can function without them, that all their talk about artistic *fraternity* is not reflected in their actions...

The thing that pleases me most in your letter (is your brother's good health). Keep the picture available for me! And when you judge it's the right time for me to write to him *write to tell me and send his address*. Would you be so kind as to send me Mirbeau's article in the *Echo de Paris*?

*

July 1889

Of course this exhibition sees the triumph of iron, not only with regard to machines but also with regard to architecture. And yet architecture is at a new beginning in the sense that it lacks an artistic form of decoration consistent with the new material. Why, alongside this severe and rugged iron, do we have soft materials like underfired clay; why, alongside these geometric lines of a new type, do we get all this same old stock of antique ornaments modernized by naturalism? It is up to the architect-engineers to come up with a new art of decoration, such as ornamental bolts, iron corners jutting beyond the main outline, a sort of gothic lacework of iron. To some extent this is what we find in the Eiffel Tower. . . .

. . . Happy were the painters of ancient times who had no academy. For the past fifty years things have been different: the State increasingly protects mediocrity and professors who suit everyone have had to be invented. Yet alongside those pedants, courageous fighters have come along and dared to show: painting without recipes. . . .

. . . in 1889 as well, there is doubtless . . . a whole Pleiad of independent artists on whom the official painters have been keeping an anxious eye for the last fifteen years and whom all the sensitive people, thirsting for pure art, true art, watch with interest. And this movement is in everything, in literature just as it is in painting. All of XXth-century art will derive from them. And you, gentlemen of the *Institut*, you wish to pass over them in silence. We would have liked to see these independent artists in a separate section at the Exhibition.

. . . Decoration, which is appropriate to the material and to the place where that material is to be used, is an art which seems to be disappearing and requires study over a long period of time, a special genius. It is true that here too the official manner has distorted taste. Sèvres, not to name names, has killed ceramics. No one wants them, and when some Kanaka ambassador comes along, bang, they stick a vase in his arms, the way a mother-in-law would fling her daughter at you, to get rid of her. Everybody knows this, but Sèvres is inviolable: it's the glory of France.

Ceramics are not futile things. In the remotest times, among the American Indians, the art of pottery making was always popular. God made man out of a little clay. With a little clay you can make metal, precious stones — with a little clay, and also a little genius! So isn't it a worthwhile material? Nonetheless, nine out of ten educated people pass by this section without giving it so much as a glance. What can you do? There's nothing to be said: they don't know.

Let's take a look at the question. Let's take a little piece of clay. In its plain, raw state, there's nothing very interesting about it; but put it in a kiln, and like a cooked lobster it changes colour. A little firing transforms it, but not much. Not until a very high temperature is reached does the metal it contains become molten. I am certainly not about to give a scientific lecture on this, but by giving you a glimpse we are trying to make it clear that the quality of a piece of pottery lies in the firing. A connoisseur will say: this is badly fired or well fired.

So the substance that emerges from the fire takes on the character of the kiln and thus becomes graver, more serious the longer it stays in Hell. Hence all the junk on exhibit — because a brief firing is more stylish and easier to do. It follows that any ceramic decoration must be done in a character analogous to its firing. Because the vital element of beauty is harmony. Consequently pottery pieces with coy, insipid lines are not homogeneous with an austere material. Hollow colours alongside full colours are not in harmony. And look how artistic nature is. The colours obtained during the same firing are always in harmony. . . .

... *Post-Scriptum.* – I was mistaken when I wrote that there was no more pictorial art at the Universal Exhibition. Now that the Centennial Exhibition is open, I think differently. And yet, it amounts perhaps to the same thing, for that exhibition is the triumph of the artists I mentioned as having been reproved and scorned: Corot, Millet, Daumier and, above all, Manet. The *Olympia* which caused such an outcry is there like a morsel fit for a king and is already prized by more than one viewer.

The conclusion: Monsieur Huysmans drew it a long time ago. The talent of the independents and the example they set suffice to show the uselessness of a budget and the futility of an official Department of the Arts.

*

[Le Pouldu, *c.*15 August 1889]

To Theo van Gogh ... You ask me for some new canvases. My God! I've very little to show you ... Moreover, these canvases have been done without any hope of results, they're preparation for other things ...

*

[Le Pouldu, *c.*20 October 1889]

To Vincent van Gogh I have owed you a reply to your long letter for a long time. I know how isolated you are in Provence and that you like to receive news of friends who interest you, and yet circumstances have conspired to prevent me from writing. Among other things, a fairly big project that de Haan and I have jointly undertaken: decorating the inn where we take our meals. We're beginning with one wall and we'll finish by doing all four, including the stained glass window. We're learning a great deal, so it's a useful thing to do ...

I've done a peasant girl spinning on the seashore, with her dog and her cow. Our two portraits [plates 74, 75] adorn each door ...

I've only done one religious painting this year; it's a good idea sometimes to *experiment* with all kinds of things, in order to preserve one's imaginative powers. Afterwards, it's a pleasure to see the natural world again. Still, all that's a question of temperament. What I've been doing particularly this year is simple peasant children, walking unconcernedly by the sea with their cows. Only since I don't like the *trompe-l'œil* of the open air, or of anything else, I try to put into these desolate figures the savageness I see in them and that is also in me. Here in Brittany, the peasants have a medieval air about them and do not for a moment look as though they think that Paris exists and that it is 1889. Quite the opposite of the Midi. Everything here is harsh, like the Breton language, and impenetrable – for all time it would seem. The dress is also almost symbolic, influenced by the superstitions of Catholicism. Look at the bodices, shaped like a cross at the back, and the black kerchiefs with which the women cover their heads, like so many nuns. It makes their faces look almost Asian, yellow, triangular and severe ... At the moment I'm doing a size 50 canvas; women gathering seaweed along the seashore [plate 76]. They are like boxes laid out in tiers, with blue clothes and black headgear, despite the bitter cold. The seaweed they are gathering for fertilizing their land is reddish ochre in colour, with fawn

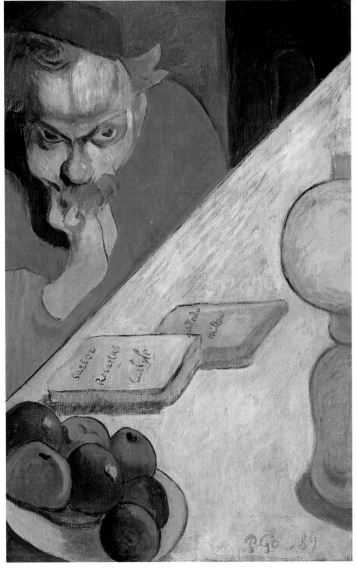

74 MEYER DE HAAN, 1889

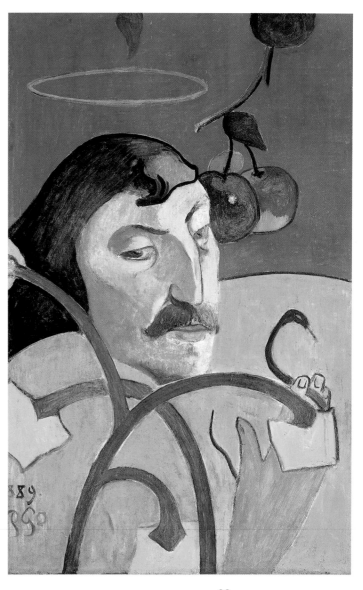

75 CARICATURE SELF-PORTRAIT, 1889

highlights. The sand is *pink* not yellow, probably because of the dampness – the sea is dark. Seeing this every day fills me with a sensation of struggle for survival, of melancholy and acquiescence in implacable laws. I am attempting to put this sensation down on canvas, not by chance, but quite deliberately, perhaps by exaggerating certain rigidities of posture, certain dark colours, etc . . . All this is perhaps *mannered* but what is natural in art? Ever since the most distant times, *everything* in art has been completely deliberate, a product of convention . . .

. . . in art, truth is what a person feels in the state of mind he happens to be in. Those who wish to or are able to can dream. Let those who wish to or are able to abandon themselves to their dreams. And dreams always come from the reality of nature. A savage will never see in his dreams a man dressed like a Parisian – etc . . .

*

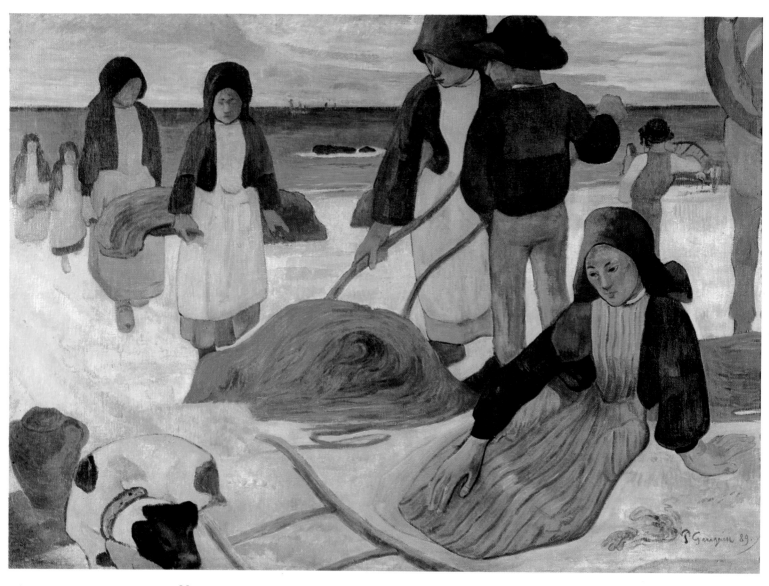

76 SEAWEED GATHERERS, 1889

[Le Pouldu, *c*.8 November 1889]

TO VINCENT VAN GOGH . . . I have something at home that I haven't sent and that I
 think will interest you.

It's Christ in the Garden of Olives. A greenish-blue twilight sky, trees all leaning together in
a crimsonish mass, purply earth and the figure of Christ, enveloped in dark ochre clothing and
with bright red hair. Since this painting is not destined to be understood I shall keep it for a
long time. The enclosed sketch will give you a vague idea of what it's like.

De Haan and I have established ourselves in a place where we can *work in peace*.

I found a *large house* right by the sea which is only let 2 months a year to holidaymakers –
and because of that I got it for a very low rent during the winter. The top part of the house is a
huge terrace, 15 metres by 12 and 5 metres high, glassed in on 2 sides. On one side we look
straight down over an immense seascape. The storms are magnificent, and we paint them
directly from the studio, revelling in the *sensation* of the terrible power of the waves as they beat

against the black rocks. On the other side, there are reddish sands, some fields and a few farms surrounded by trees. Every day there are models for us to paint – men and women coming to look after their cows or gather seaweed on the seashore. We can get them to pose as we wish for a franc. So you see there's everything we need for working...

I've been working for 2 months on a large (painted wood) carving [*Soyez amoureuses*, plate 78], and I'm bold enough to believe it's the best thing I've done up to now as far as strength and balance are concerned (although the literary side of it seems crazy to many people. A monster, who looks like me, is holding a naked woman by the hand – that's the main subject. The spaces are filled by smaller figures.) At the top there's a town, some sort of Babylon, and at the bottom the countryside with a few imaginary flowers (a desolate old woman) and a fox, the prophetic animal of perversity among the Indians... despite the inscription, the people look sad, in contradiction to the title. This waxed wood has highlights that illuminate the raised parts, adding richness to the whole.

I'm going to send it to Paris in a few days. Perhaps it will prove more popular than my paintings...

*

77 LETTER TO VINCENT VAN GOGH WITH SKETCHES OF SOYEZ AMOUREUSES AND CHRIST IN THE GARDEN OF OLIVES, *c.*8 November 1889

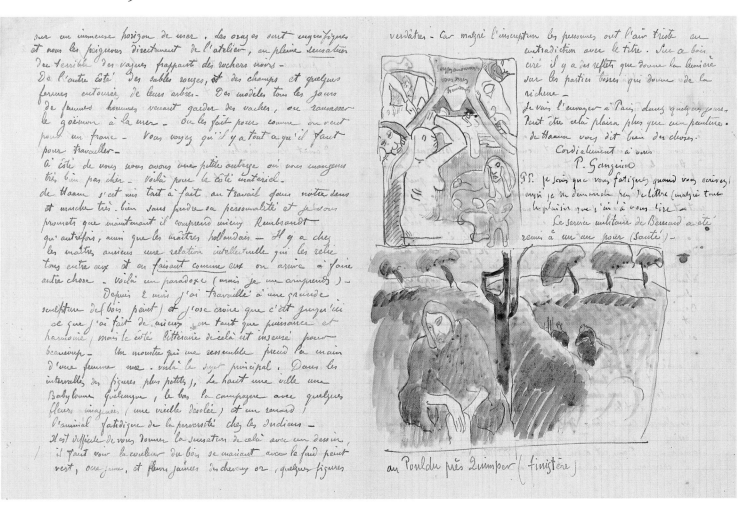

78 SOYEZ AMOUREUSES ET VOUS SEREZ HEUREUSES (BE IN LOVE AND YOU WILL BE HAPPY), 1889

Le Pouldu, 20 or 21 November 1889

TO THEO VAN GOGH

...For the past month de Haan and I have been investigating from all sides the furore caused by my latest paintings...

You have the feeling today that my latest works are better than the earlier ones. Be logical and draw the correct conclusion – that the artist is not in decline and that he has worked more for *art* than for *commerce*. That new explorations are more useful to the new generation than no exploration at all, since what has been done has been done more *strongly* than anything modern. A certain Dutchman says I resemble Bernard this year. I do not resemble him any more than he resembles me; it's just that we're conducting *different* investigations towards the same end. An end that I have been thinking about for a long time but that I have only recently begun to formulate...

Now, in order to enlighten you my dear M. van Gogh, I'm going to give you a glimpse of my paintings. Examine them closely, as well as the *wood carvings* and the ceramics. You will see they all belong together. I'm seeking to express a general state rather than a single thought, and at the same time to make another person's eye experience an indefinite, never-ending impression. *To suggest* suffering does not mean to specify what sort of suffering; purity in general is what I am seeking to express, not a particular kind of purity. Literature is one (and painting another). In consequence, the thought is suggested but not explained...

It's the same with the painting of the 3 stone women holding Christ. [*Breton Calvary*, plate 116] Brittany, simple superstition and desolation. The hill is guarded by a line of cows arranged in the form of the calvary. I've tried to make everything in this picture express belief and passive suffering in the traditional religious style, as well as the power of nature with its great scream. I am wrong not to be good enough to express it better – but I am not wrong to *conceive* it . . .

You know that I have Indian blood, Inca blood in me, and it's reflected in everything I do. It's the basis of my personality; I try to confront rotten civilization with something more natural, based on savagery . . .

The price of my wood carving. I'm racking my brains. I shall not assess its artistic value. But what a lot of manual labour, to say nothing of the cost of the wood, of dispatch, etc . . . If I ask 2000 francs for it I shall be giving it away, and de Haan is of the same opinion. And buyers are going to scream that it's too expensive. Just do what you *can* with it . . .

Do you have any better news of Vincent? I'm sorry he's not there with you sometimes to advise you on painting . . .

<div align="center">*</div>

<div align="right">[Le Pouldu, November 1889]</div>

To Émile Bernard Your disconsolate letter has reached an equally dismal countryside. I understand your being overcome with bitterness at the absurd reception you and your works have had. They should be very beautiful this year, Schuff wrote telling me they had a fine mystical quality. . . . As for me, nothing remains from all my efforts this year but the cries of protest from Paris which come and discourage me here to such a degree that I dare not paint any more and can only drag my old body about on the sea shore of Le Pouldu in the bleak North wind! Mechanically I make a few studies (if you can call brushstrokes in accord with the eye, studies). But the soul of me is absent and sadly fixes on the yawning chasm ahead – a chasm in which I see the devastated family without paternal help, and no heart on whom to unburden my suffering. Since January last, my sales have totalled 925 francs. At the age of 42, to live on that, buy colours etc, is enough to put the staunchest soul off his stride. . . .

. . . Of course Degas . . . does not find in my canvases what he sees (the model's bad smell). He senses in us a movement contrary to his. Ah! if only I had the means to take up the struggle, like Cézanne, I would do so with pleasure. Degas is behaving like an old man and fumes at not having had the last word. We are not the only ones who have had to struggle; look how Corot etc have been justified by time. But today what poverty there is, what difficulties. As for me, I own myself beaten – by events, by men, by the family, but not by public opinion. I scorn it and I can do without admirers. . . . But you, why do you suffer too? You are young, yet so early you begin carrying the cross. Do not rebel; one day you will feel a joy in having resisted the temptation to hate, and there is truly intoxicating poetry in the goodness of he who has suffered . . .

<div align="center">*</div>

79 AT THE BLACK ROCKS/ROCKS BY THE SEA, 1889

[Le Pouldu, December 1889]

TO METTE Yes, you have not heard from me for over 6 months, but it is more than 6 months since I received news of the children. It seems there must be a serious accident before I do hear....

What is it you want of me? Above all, what have you ever wanted? Whether in the Indies or elsewhere, I am, it appears, to be a beast of *burden* for wife and children whom I *must not see*. By way of return for this sacrifice, for this homeless existence, deprived of everything, *I am to be loved if I love, written to if* I write, etc... You know me. Either I calculate (and calculate well) or *I don't calculate at all*, and with heart in hand and eyes front, I fight with bared breast....

Despite the certainty which my conscience gave me, I wanted to consult others (men who also count) to ascertain if I was doing my duty. All are of my opinion, that art is my business, my capital, the future of my children, the honour of the name I have given them, all things which will be useful to them one day. When they have to find positions in the world, an honourably *famous* father will be able to present himself to set them up...

You will retort that it's taking a long time, but what do you want me to do about it? Is it my fault? I am the first to suffer from it... Can it be said that Millet failed in his duty and bequeathed a wretched future to his children?

You want my news? I am by the sea in a fisherman's inn near a village of 150 inhabitants. I am living here like a peasant under the name of savage. And I work here every day in canvas trousers (all those of 5 years ago are worn out) . . . I spend 1 franc a day on food and two sous on tobacco. So no one can accuse me of extravagance. I speak to nobody and I receive no news of the children. Alone – quite alone – I exhibit my works at Goupil's in Paris, and they create a great sensation, but it is very difficult to sell them. Nor can I say when they will sell, but what I can tell you is that today I am one of the artists who arouses the greatest astonishment. I enclose a few lines informing you about me. You have exhibited some of my old things in Copenhagen. You might have asked my opinion first.

The 7/6/89 passed without one of the children thinking of it. Anyhow, all's well that ends well. I am making enquiries through influential friends about a situation in Tonkin: that way I hope to be able to live for a while and await better times. As such posts are paid, you would be able to have a proportion of the proceeds from the pictures sold in Paris at Goupil's . . .

80 BONJOUR MONSIEUR GAUGUIN, 1889

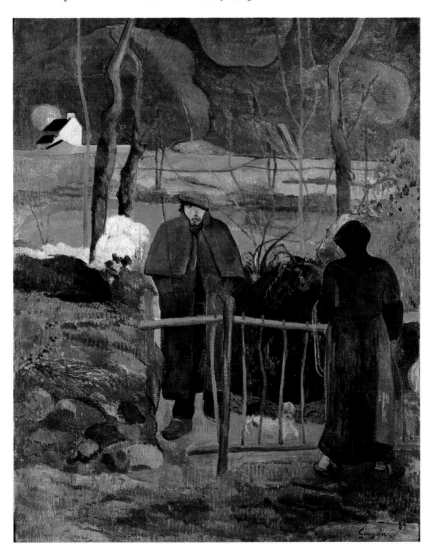

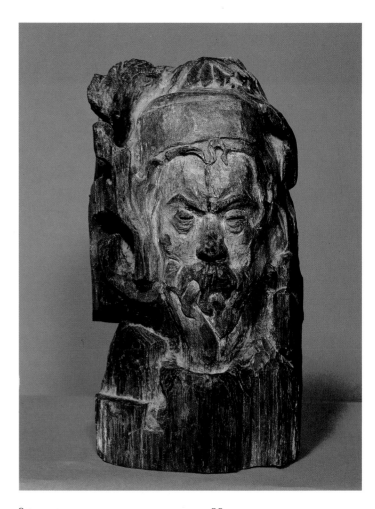

81 BUST OF MEYER DE HAAN, 1889

[Le Pouldu, *c.*16 December 1889]

TO THEO VAN GOGH . . . I have received a very sad letter from Copenhagen from
my wife. One of my boys has fallen from the third floor. They picked up the pieces and he's in
hospital, now almost out of danger . . .

 If you manage to sell the wood carving (you are quite free to do so), send 300 francs directly
to this address.

 Mme. Gauguin
 51 Nørregade
 Copenhagen. Denmark.

*

[Le Pouldu, January 1890]

TO ÉMILE SCHUFFENECKER There are moments when I ask myself whether I wouldn't
do better to bash my brains in: you must admit it's enough to make one give up in despair. I
have never been so discouraged as I am at present, moreover I am working very little, telling
myself 'What's the use and for what result?' . . . I go without smoking, which for me is a
deprivation; I do part of my laundry myself secretly; in short apart from ordinary food, I am
stripped of everything. What's to be done about it? Nothing, except wait, like a rat, on a barrel
in the middle of the ocean . . .

[Paris, *c.*1 April 1890]

To Vincent van Gogh I've been keeping a very close eye on your work since we parted company, firstly at your brother's and then at the *Indépendants'* exhibition . . . I offer you my sincere compliments, and for many artists yours is the most remarkable work in the exhibition. With things taken from nature, you're *the only one there who thinks* . . .

I've spoken at length about it to Aurier, Bernard and many others. They all offer you their compliments. Only Guillaumin shrugs when he hears people talking of it. I understand him actually, given that he looks at his subject matter with an unthinking eye. He says the same of my paintings of the last few years – he doesn't understand them at all. I was very hesitant about writing to you, knowing that you had just had a fairly long period of illness, so I beg you not to reply until you feel quite recovered . . .

*

[Le Pouldu, June 1890]

To Émile Bernard . . . What I want to do is to set up the studio of the *Tropics*. With the money I shall have I can buy a native hut like the ones you saw at the Universal Exhibition . . .

I shall go and live there like a man retired from the so-called civilized world mixing only with the so-called savages. And of my daily bread, I place precisely *half* at your disposition.

A woman out there is, so to speak, obligatory, which will provide me with an everyday model. And I can assure you that a Madagascan woman has quite as much heart as a Frenchwoman, and a far less calculating one.

As for money, you will need very little, just enough for your voyage. . . .

*

[Le Pouldu, late July 1890]

To Émile Bernard . . . Filiger . . . tells me that you have someone who intends to launch you. Splendid! In that event you may change your mind about Madagascar.

It is true that Tahiti is a paradise for Europeans. But the journey costs much more, as it is in Oceania.

Besides Madagascar offers more attractions by way of types, religion, mysticism and symbolism.

There you have Indians from Calcutta, black tribes, Arabs, and the Hovas, a Polynesian type.

But find out about the voyage via Panama anyway . . .

*

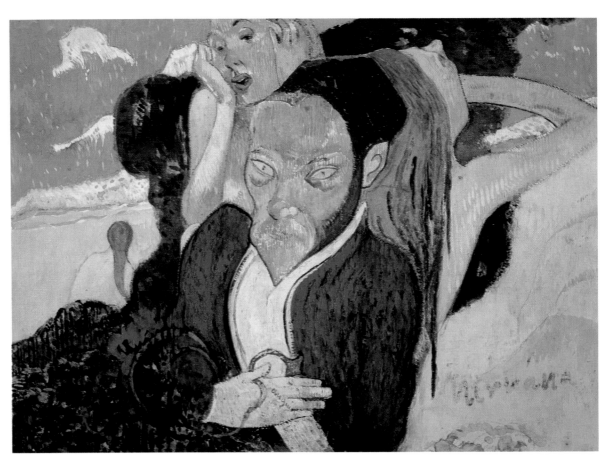

82 NIRVANA (PORTRAIT OF MEYER DE HAAN), *c.*1890

[Le Pouldu, August 1890]

TO ÉMILE BERNARD I am glad you saw Charlopin, in fact you should see him
again. These matters must be followed up until the money is forthcoming – God grant it may
be next month, as I am heartily sick of forever waiting and hoping in vain. Even if Charlopin
would just like to buy a little from you it would be so much profit for the firm P. Go and Co.,
but we must wait for one deal to be concluded before seeking another. Now another thing. You
must go back and get fuller information. Convoys leave for New [Caledonia] every 6 months,
but they take 3 to 4 months. I believe the Emigration Society makes use of the steam packet
for the journey. And in any case, it is essential for my calculations to know the dates of
departure, the fare and the length of the voyage.

De Haan, who is Dutch, can only travel by steam packet....

I can't imagine who told you that I go for walks on the beach with my disciples. As for
disciples there is de Haan, who goes off to work on his own, and Filiger who works indoors. I
go about as a savage, with long hair, and do nothing. I haven't even brought colours or palette.
I have cut some arrows and I practice shooting them on the sands like they did at Buffalo Bill's.
So there you have your so-called Jesus Christ....

What's become of van Gogh, I hear nothing of him?

*

[Le Pouldu, late summer 1890]

TO J. F. WILLUMSEN

Dear Sir, Your letter really surprised me, not in terms of its content but for the very fact that you thought of writing it. . . . it is a great pleasure to admit that I was mistaken and to make an exception to my decision to hate the inhabitants of Denmark. Now that we have established this, let's talk like good friends.

You are happy about your trip to Holland, and I have nothing to say about any of your judgments of the Dutch masters, except for Rembrandt and Hals. Of the two, you prefer Hals. We French are not very familiar with him; yet it seems to me that his portraits show life too vividly through cleverly (perhaps too cleverly) handled external things. I would advise you to go to the Louvre and have a close look at old Ingres's portraits. In the work of this French master, you find inner life; the seeming coldness that puts people off hides intense heat, violent passion. In addition, Ingres has a love for the lines of the whole which is grandiose, and he seeks beauty in its veritable essence – Form. And what should we say about Velasquez? Velasquez, the royal tiger. There's portraiture for you, with all its regal character written plain across the face. And by what means does he achieve this? By the simplest type of execution, a few touches of colour.

83 SKETCH FROM MEMORY AFTER REMBRANDT'S
 'ENTOMBMENT', enclosed with the above letter to
 J. F. Willumsen, late summer 1890.

Rembrandt, now – him I know thoroughly. Rembrandt, an awesome lion who dared everything. Of course *The night watch*, reputed to be a masterpiece, is of an inferior status, and I can see why you judge him badly from that. All the masters have their weak points and it's precisely those that pass for masterpieces.... A rough sketch reveals a master, and that master is of the first or second rank. In the Louvre you'll see very small Rembrandts, such as *The good samaritan* and *Tobias*! Have you seen Rembrandt's etchings?... Rembrandt left a personal, powerful imprint on everything he did, investing it with a mysticism which attains the highest pinnacles of the human imagination. And I admire his great intelligence.

In my opinion, an inferior artist always falls into the excesses of the so-called science of *facture*. That which is noble is simple, and all the supplest gestures of the brush merely take away from an imaginative work by reminding us of the *matter* of which it is made. The truly great artist is the one who can successfully, and in the simplest way, apply his most abstract precepts. Listen to Handel's music!...

You are right to say there is a certain kinship between us. In time we will acquire the strength to complete our work, if we manage to recognize one another and group together...

As for me, my mind is made up, in a little while I shall go to Tahiti, a small island in Oceania, where material life can be lived without *money*. There I want to forget all the bad things in the past and die unbeknownst to people here, free to paint without any glory for other people. And if my children are able[?] and wish to come and join me I declare myself completely in favour[?] Terrible times are in store for the next generation: gold will be king!! Everything is rotten, men and the arts alike. People are constantly being torn apart. Out there at least, beneath a winterless sky, on marvellously fertile soil, the Tahitian need only lift up his arms to pick his food; for that reason, he never works. In Europe, however, men and women can satisfy their needs only by toiling without respite, while they suffer the pangs of cold and hunger, a prey to poverty; the Tahitians, on the contrary, are the happy inhabitants of the unknown paradises of Oceania and experience only the sweet things of life. For them, living means singing and loving. (Lecture on Tahiti by van der Veene.)

Therefore once I've arranged things so that my daily needs out there are met, I'll be able to devote myself to the grand business of art, free of all artistic jealousies, without any need to engage in low dealings. In matters of art, one's state of mind is three-quarters of what counts, so it has to be carefully nurtured if you want to do something great and lasting...

Enclosed is something which is meant to represent a Rembrandt sketch for you but it's impossible to remember. Nevertheless it will give you a vague idea of the thing. A Dutchman's way of conceptualizing an entombment of Christ. What a rich imagination – and what mystery in that cave.

<p style="text-align:center">*</p>

<p style="text-align:right">[Le Pouldu, c.2 August 1890]</p>

To Theo van Gogh We have just received the sad news and are greatly distressed. In these circumstances I do not wish to offer you mere phrases of condolence. You know that he was for me a true friend, and that he was an *artist*, a rare thing in our time. You will continue to see him in his works. As Vincent often said – stone will perish, words will remain. And for myself, I will see him with my eyes and my heart in his works.

<p style="text-align:right">Kind regards, P. Gauguin</p>

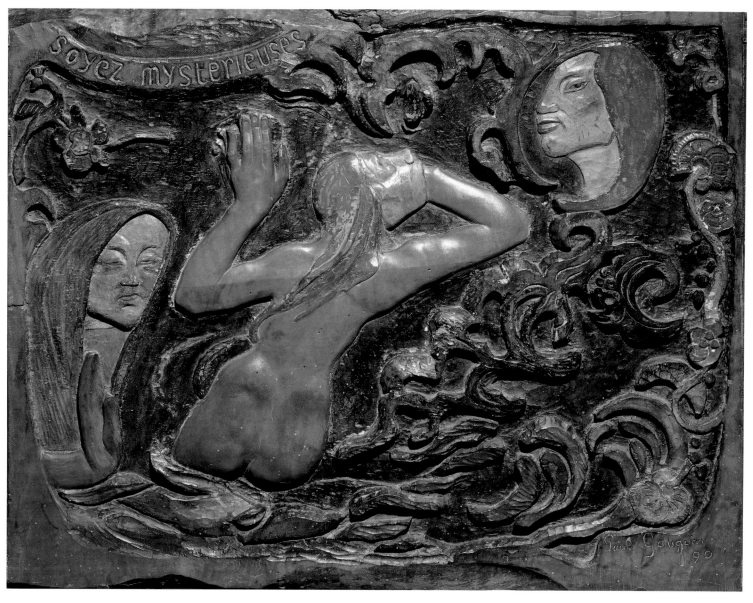

84 SOYEZ MYSTÉRIEUSES (BE MYSTERIOUS), 1890

[Le Pouldu, August 1890]

TO ÉMILE BERNARD . . . I have heard about Vincent's death, and I am glad that
you went to his funeral.

Sad though this death may be, I am not very grieved, for I knew it was coming and I knew
how the poor fellow suffered in his struggles with madness. To die at this time is a great
happiness for him, for it puts an end to his suffering, and if he returns in another life he will
harvest the fruit of his fine conduct in this world (according to the law of Buddha). He took
with him the consolation of not having been abandoned by his brother and of having been
understood by a few artists . . .

*

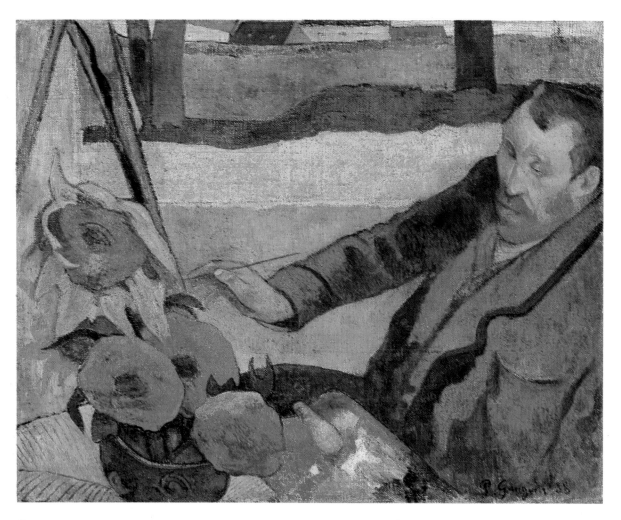

85 PORTRAIT OF VINCENT VAN GOGH PAINTING SUNFLOWERS, 1888

Atuona, 1903

...For a long time now I've been wanting to write about van Gogh...

Readers of the *Mercure* have seen, in a letter by Vincent which was published a few years ago, how much he insisted that I should come to Arles to found a studio according to his ideas and be its director.

At that time I was working in Pont-Aven in Brittany, and either because the studies I had begun there made me want to stay or because some vague instinct gave me a presentiment of something abnormal, I held out for a long time; but one day, overcome by Vincent's impulsive friendship, I set out for Arles.

...In every country I have to go through a period of incubation; each time I have to learn to recognize the essential qualities of plants and trees, of the whole of nature, so varied and so capricious, never willing to give away its secrets, to yield itself up.

So it was not until I had been there several weeks that I clearly perceived the harsh savour of Arles and its environs. All the same, we worked hard, especially Vincent. Between two human beings, he and myself, the one like a volcano and the other boiling too, but inwardly, there was a battle in store, so to speak.

First of all, everything was in such a mess that I was shocked. The paint box was barely big enough to contain all the tubes that had been squeezed but never recapped, and yet, in spite of the chaos and the mess, his canvases glowed; so did his words. Daudet, de Goncourt, the Bible

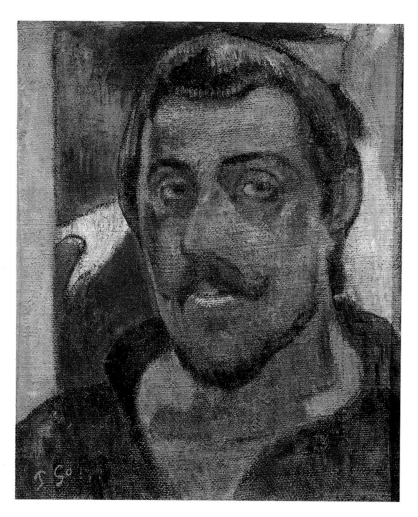

86 SELF-PORTRAIT WITH ONDINE, 1888–1889

were burning up this Dutchman's brain. For him, the wharves, bridges and boats of Arles, the entire Midi became Holland. He even forgot to write in Dutch and, as shown by the publication of his letters to his brother, he always wrote in French only, and wrote it admirably, too, with expressions like '*tant que*', '*quant à*' in abundance.

Despite my efforts to discern, in that chaotic brain, some logical reason for his critical views, I was unable to account for all the contradictions between his painting and his opinions. For instance, he felt boundless admiration for Meissonier and profoundly hated Ingres. Degas was his despair, and Cézanne was nothing but a humbug. The thought of Monticelli made him cry.

One thing that made him angry was having to acknowledge that I was very intelligent, for my forehead was too low, a sign of stupidity. And amid all this, a great tenderness, or rather, a Gospel-like altruism.

From the very first month I saw that our joint finances were becoming equally messy. What should we do? It was an awkward situation; the till was modestly filled by his brother, who worked in the Goupil firm; my share was paid in exchange for paintings. The matter had to be broached, at the risk of offending his excessive sensitivity. So very cautiously and with coaxing, quite out of character for me, I brought up the matter. I must admit that I succeeded much more easily than I had expected.

. . . Unbeknownst to the public, two men accomplished in that period a colossal amount of work, useful to both of them. Perhaps to others as well? Some things bear fruit.

. . . With all his combinations of yellow on purple, all his random work in complementary colours, all he achieved were soft, incomplete, monotonous harmonies: the clarion call was missing.

I undertook to enlighten him, which was easy enough, for I found rich and fertile soil. Like all independent natures that bear the stamp of personality, Vincent was not the least bit afraid of what people would say, nor the least bit stubborn.

...van Gogh, without losing an iota of his originality, received most helpful instruction from me. And every day he was grateful to me for it. And that is what he meant when he wrote to Monsieur Aurier that he owes a great deal to Paul Gauguin.

When I arrived in Arles, Vincent was still feeling his way, whereas I, much older, was already a mature man. Yet along with the knowledge that I helped Vincent, I in turn owe something else to him: for that experience helped me to consolidate my own earlier ideas on painting; and even in the most trying periods, I can remember that some people are unhappier still.

*

[Le Pouldu, September 1890]

To Odilon Redon ...The reasons you give me for staying in Europe are more flattering than they are likely to convince me. My mind is made up, and since I've been in Brittany I've altered my decision somewhat. Even Madagascar is too near the civilized world; I shall go to Tahiti and I hope to end my days there. I judge that my art, which you like, is only a seedling thus far, and out there I hope to cultivate it for my own pleasure in its primitive and savage state.

87 COPY AFTER MANET'S 'OLYMPIA', 1891

In order to do that I must have peace and quiet. Never mind if other people reap glory!

Here, Gauguin is finished, and nothing more will be seen of him. I am selfish, as you can see. I am taking along photographs and drawings, a whole little world of friends who will speak to me every day; as for yourself, in my head I carry the memory of just about everything you have done, and *one star*; when I see it, in my hut in Tahiti, I will not think of death, I promise you, but on the contrary, of eternal life. In Europe depicting death with a snake's tail is plausible, but in Tahiti it must be shown with roots that grow back bearing flowers. I have not said goodbye forever to the artists who are in harmony with me. I am reminded of a sentence of Wagner's which explains my thinking:

> I believe that the disciples of great art will be glorified and that enveloped in a celestial tissue made up of rays of light, perfumes and melodious chords, they will return to lose themselves for eternity in the bosom of the divine source of all harmony.

So, my dear Redon, we will see each other again . . .

*

[Pont-Aven, October 1890]

TO ÉMILE BERNARD

. . . Sérusier . . . tells me that you are organizing an exhibition of Vincent's works. What a tactless thing to do!

You know I like Vincent's art. But given the stupidity of the public, it is quite the wrong time to remind them of Vincent and his madness just when his brother is in the same boat. Many people say that our painting is mad. It will do us harm without doing Vincent any good etc. . . .

Go ahead if you must – but it is *idiotic*.

*

[Paris, October 1890]

TO ODILON REDON

. . . Unfortunately everything is misfiring for me at the moment. My departure; the planned deal did not come off. Van Gogh has gone mad and the Goupil firm no longer wants anything to do with us. It's an absolute disaster. I am writing to ask a very delicate favour of you. I believe I've heard you saying that your friend Fabre, the musician, knew Chausson. Couldn't he drop him a hint about making a speculation on my pictures? That is to say a block purchase of a large number of canvases at low prices. Through his contacts he would be able to resell a proportion at higher prices, which would completely offset his outlay on the remainder.

What's more he could go into this with his brother-in-law Lerolle who is rich too and has already bought one of my pictures. You are an artist (sadly not in the position you ought to be) and you can understand the situation? . . .

*

88 PORTRAIT OF STÉPHANE MALLARMÉ, January 1891

[Paris, 19 February 1891]

To METTE I am writing these few lines in haste as I am very nervous,
the day of my sale is approaching, next Monday. Everything has been well prepared and I am
waiting for all the articles to be published in order to send them to you. They are causing a
great stir in Paris, and in the art world there is great agitation which has even reached England,
where a newspaper talks about this as an event.

If my sale produces enough money then I will go to Copenhagen arriving about the 2nd or
3rd. I will wire you anyway 24 hours beforehand.

I will bring your corsets.

Kisses for everyone. PAUL GAUGUIN

*

[Paris, mid-March 1891]

To J. F. WILLUMSEN The symbolist poets, and my painter friends are getting
together on Monday next, the 23rd, for a farewell dinner for me. It would give me great
pleasure if you would come. I don't know Ballin's address nor that of the Dane who bought a
picture at my sale for Mme Bendix. Be so kind as to invite them.

Meeting at the Café Voltaire at 7 p.m. on Monday. The dinner costs 5 f a head. The Café
Voltaire is in Place de l'Odéon opposite the theatre.

[Paris, 24 March 1891]

TO METTE
My adored Mette, To be sure, an adoration pretty often tinged with bitterness . . . I know how difficult things are for you at present, but now the future is assured and I should be happy – very happy – if you want to share it with me.

In the absence of passion – with our hair turning white – we can move into a period of peace and spiritual happiness surrounded by our children, flesh of our flesh. As I've said over and over again, your family are wrong to set you against me, but in spite of that, I will not worry myself about them.

Yesterday a dinner was given for me at which forty-five people were present, painters and writers; Mallarmé presided. There were verses, toasts and the warmest homages to me. I tell you, three years from now I shall have won a battle which will enable us – you and me – to live a sheltered existence. You will rest and I shall work.

Perhaps one day you will understand the kind of man you chose as father for your children. I am proud of my name; and I hope – I am even certain – you will not sully it, even if you should meet a smart captain . . .

Adieu dear Mette, dear children, love me well. And when I return we will be re-married. It is therefore a betrothal kiss I send you today.

Your PAUL

89 DECORATIVE PLATE DESIGN (LES FOLIES DE L'AMOUR),
1890

90 YOUNG BRETON SHEPHERD, 1888

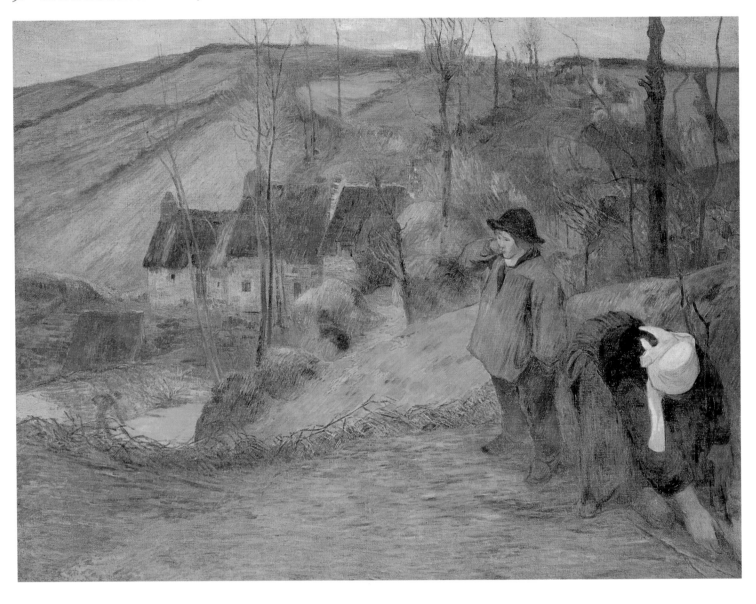

91 WINTER (YOUNG BRETON BOY ADJUSTING HIS CLOG), 1888

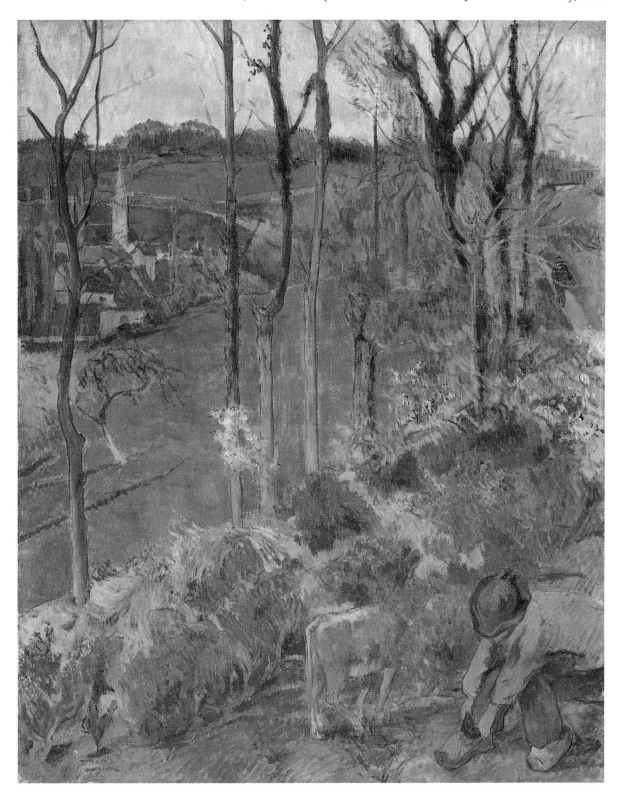

92 STUDY FOR BRETON BOYS WRESTLING, 1888

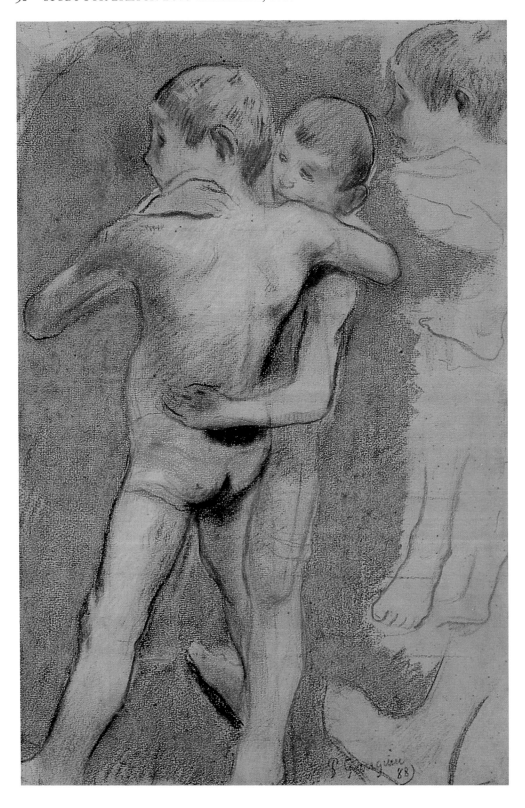

93 BRETON BOYS WRESTLING, 1888

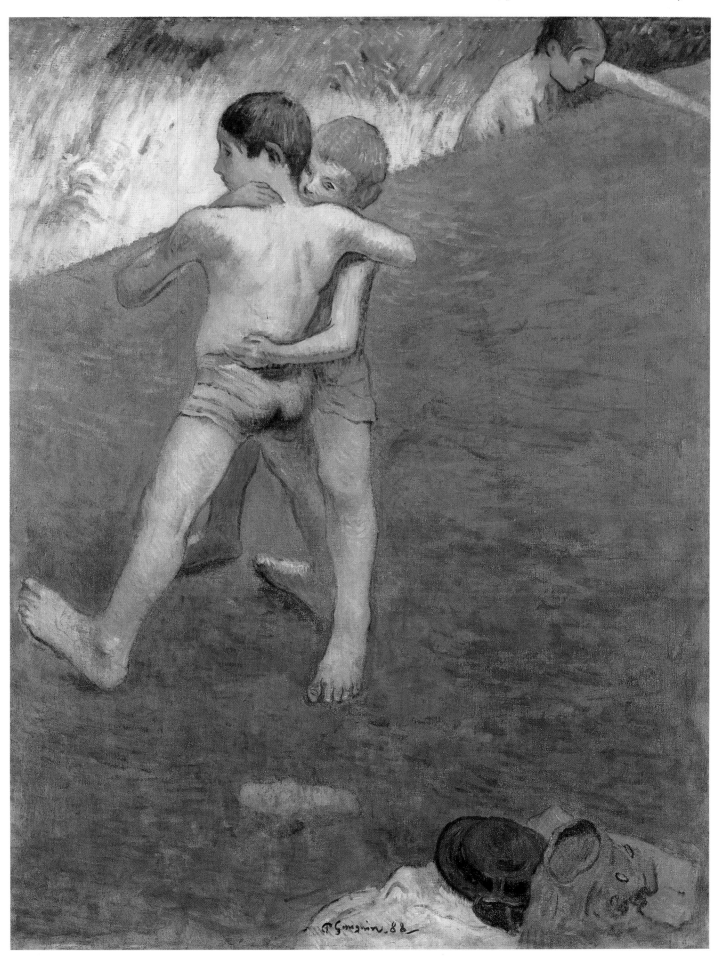

94 THE ARLÉSIENNE (MME GINOUX), 1888

95 CAFÉ AT ARLES, 1888

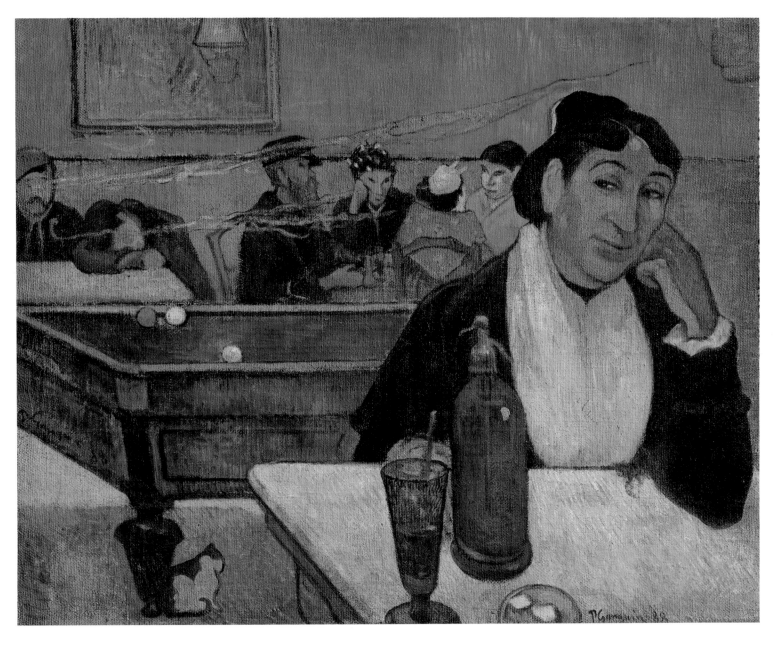

96 MADAME ROULIN, 1888

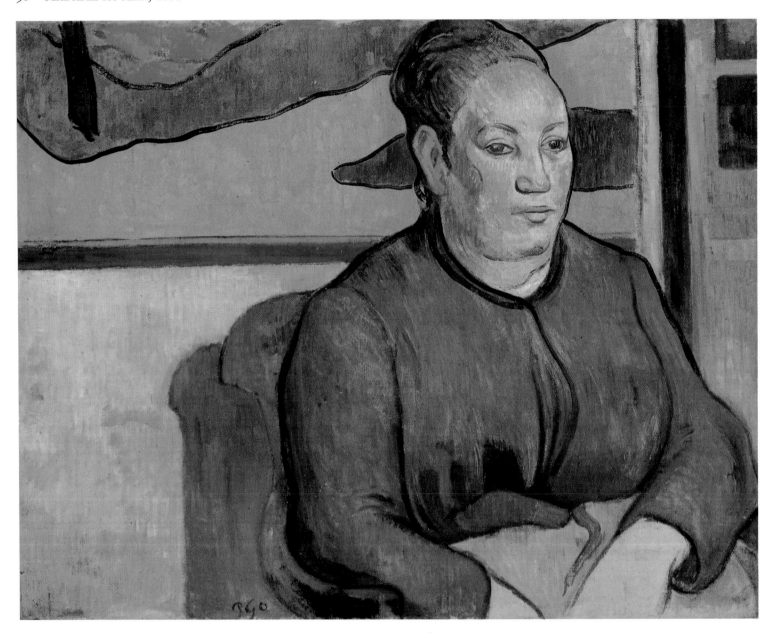

97 OLD WOMEN OF ARLES/GARDEN AT ARLES, 1888

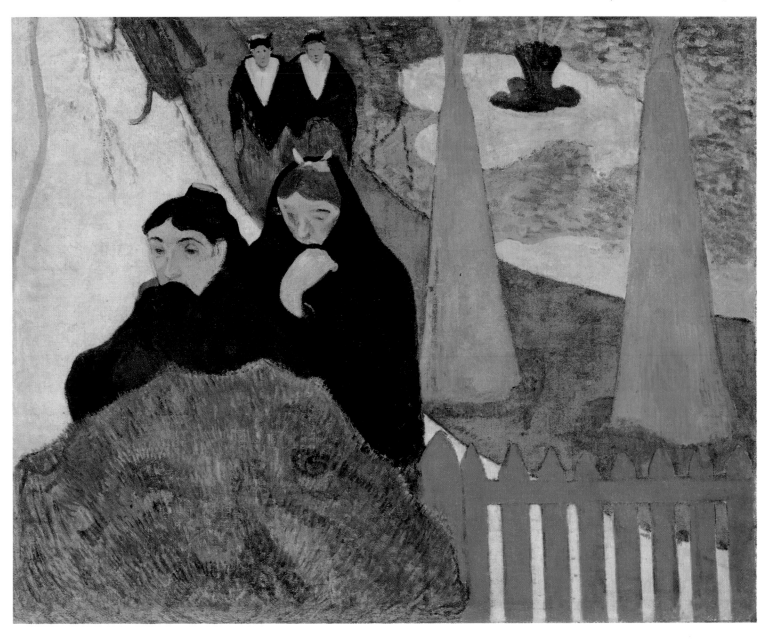

98 THE BLUE TREE TRUNKS, ARLES, 1888

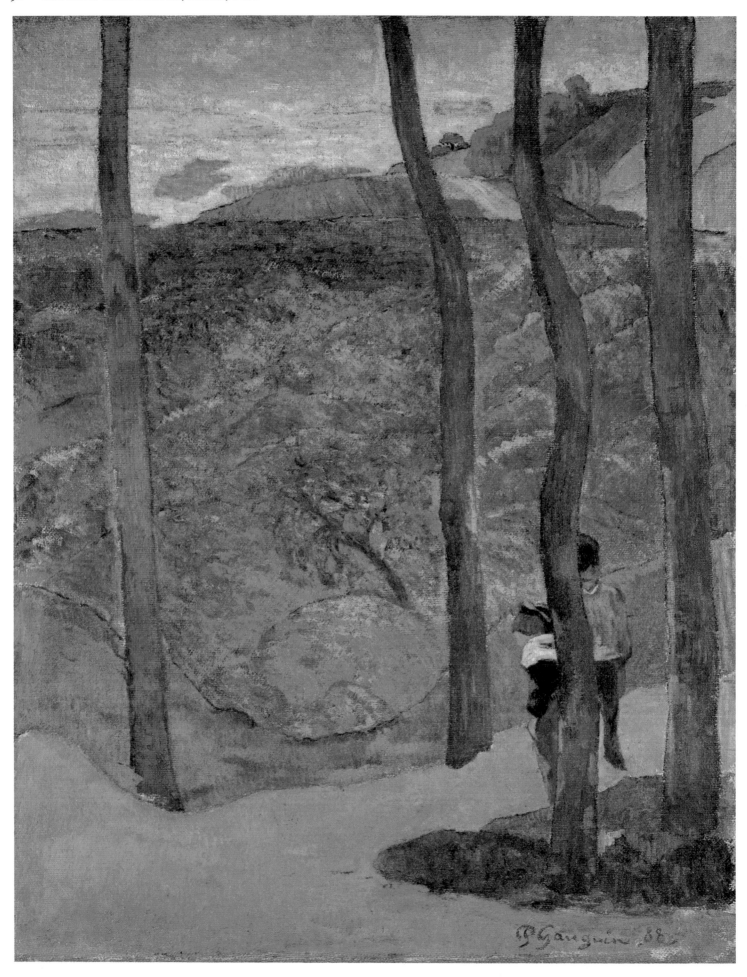

99 FARMHOUSE IN ARLES, 1888

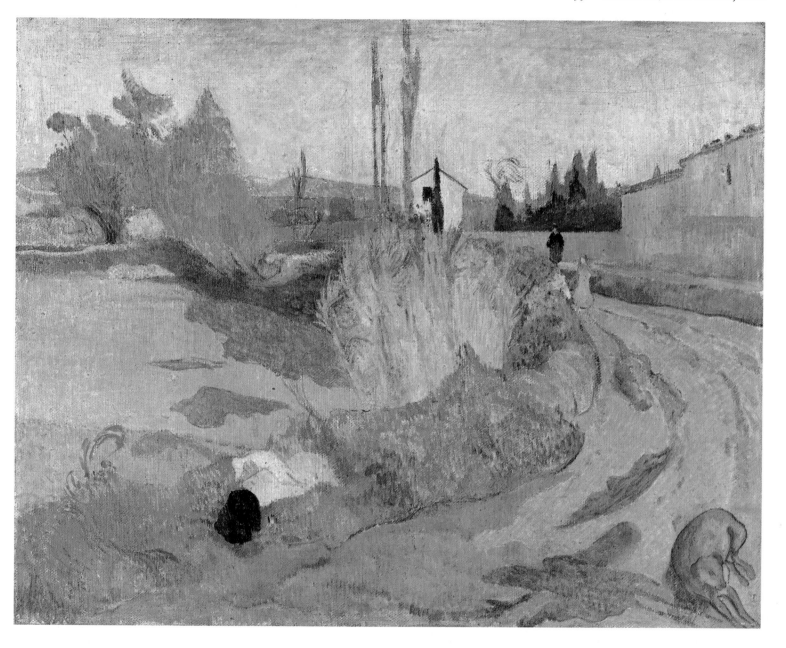

100 THE GATE, 1889

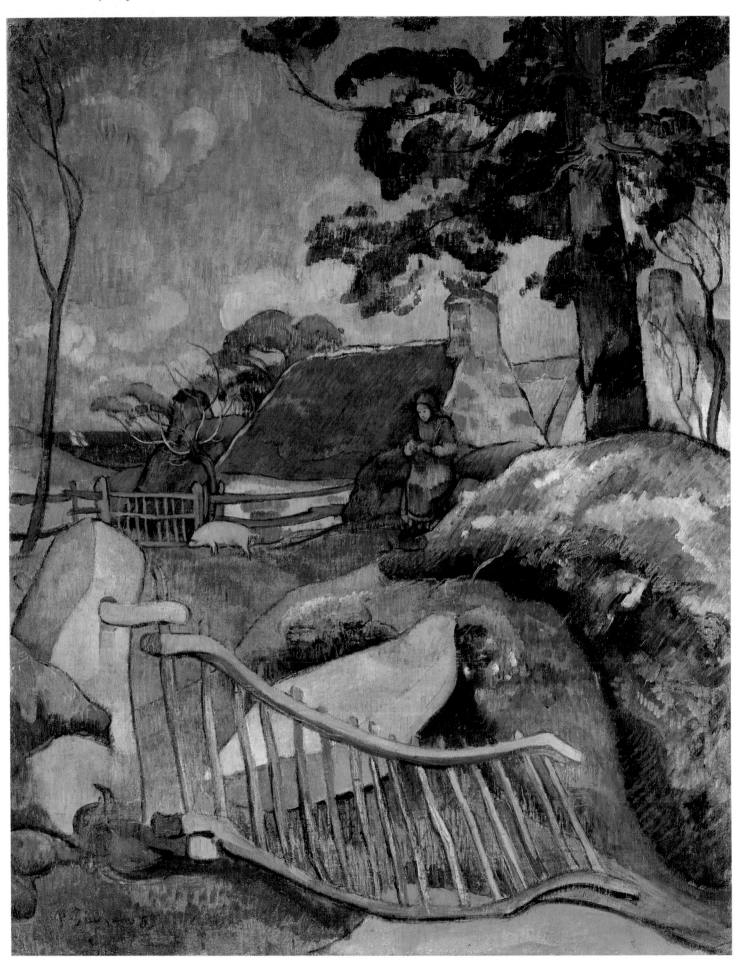

100 THE GATE, 1889

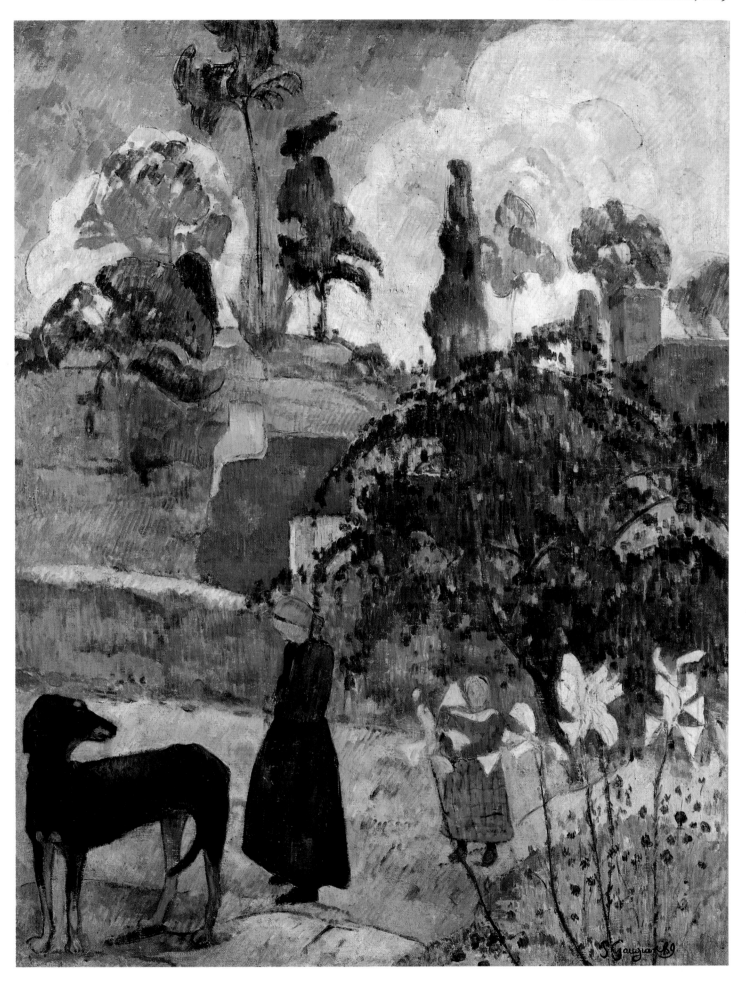

102 WOMAN IN THE WAVE (ONDINE I), 1889

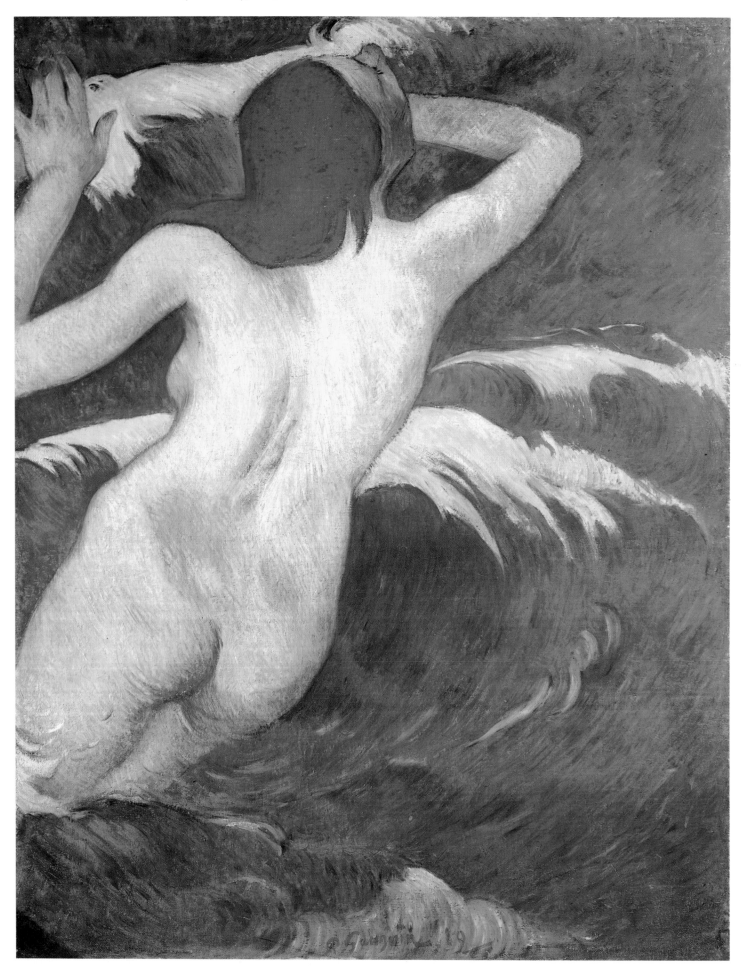

103 WOMAN IN THE WAVES (ONDINE II), 1889

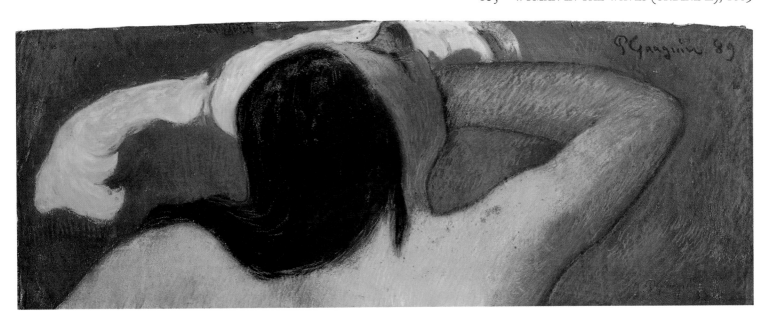

104 LA BELLE ANGÈLE (MADAME ANGÈLE SATRE, THE INNKEEPER AT PONT-AVEN), 1889

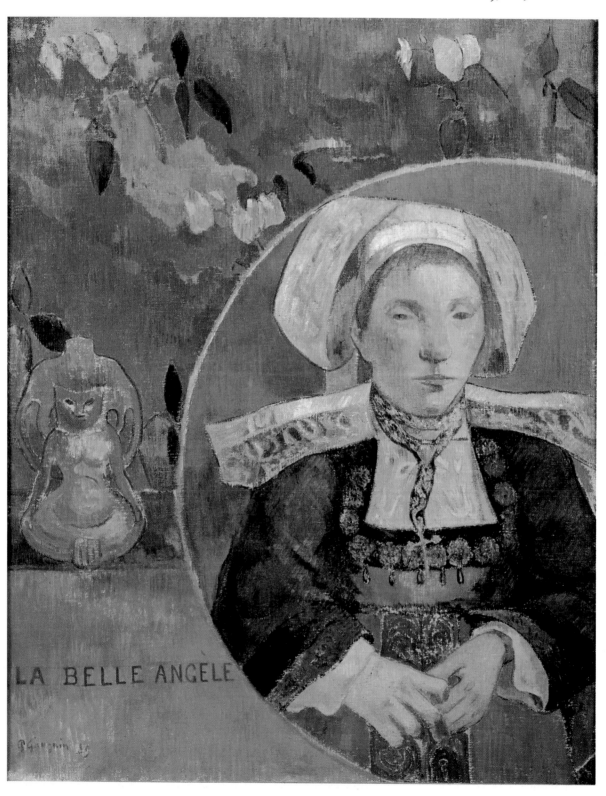

105 PORTRAIT OF A WOMAN WITH STILL LIFE BY CÉZANNE, 1890

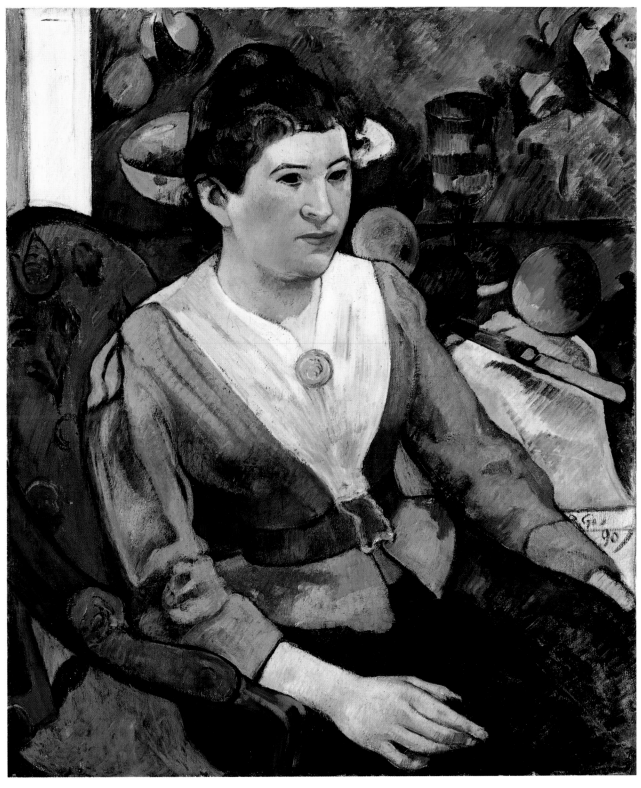

106 PORTRAIT VASE OF MME SCHUFFENECKER, 1889

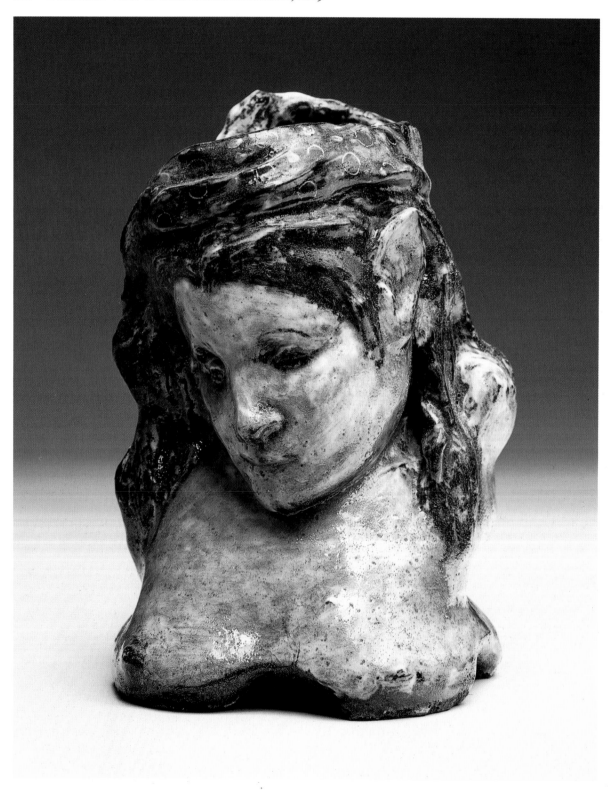

107 SELF-PORTRAIT POT, 1889

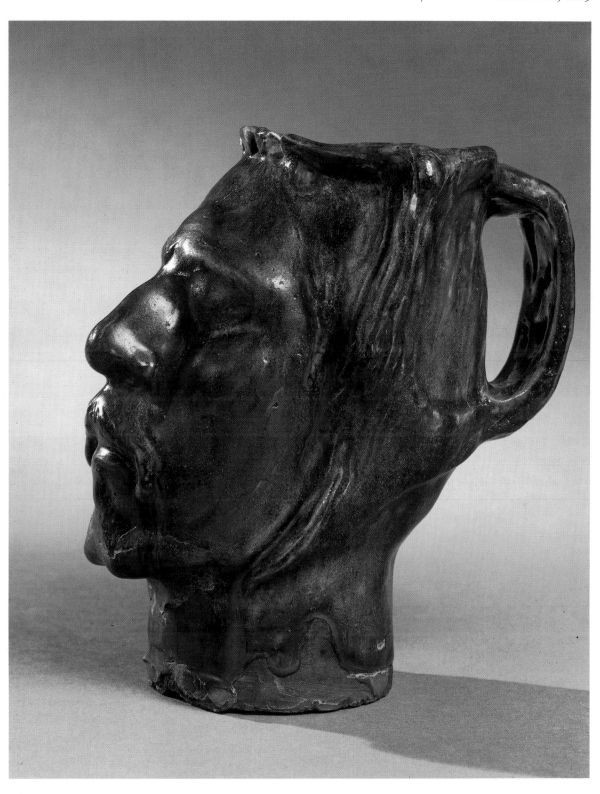

108 THE WILLOWS, 1889

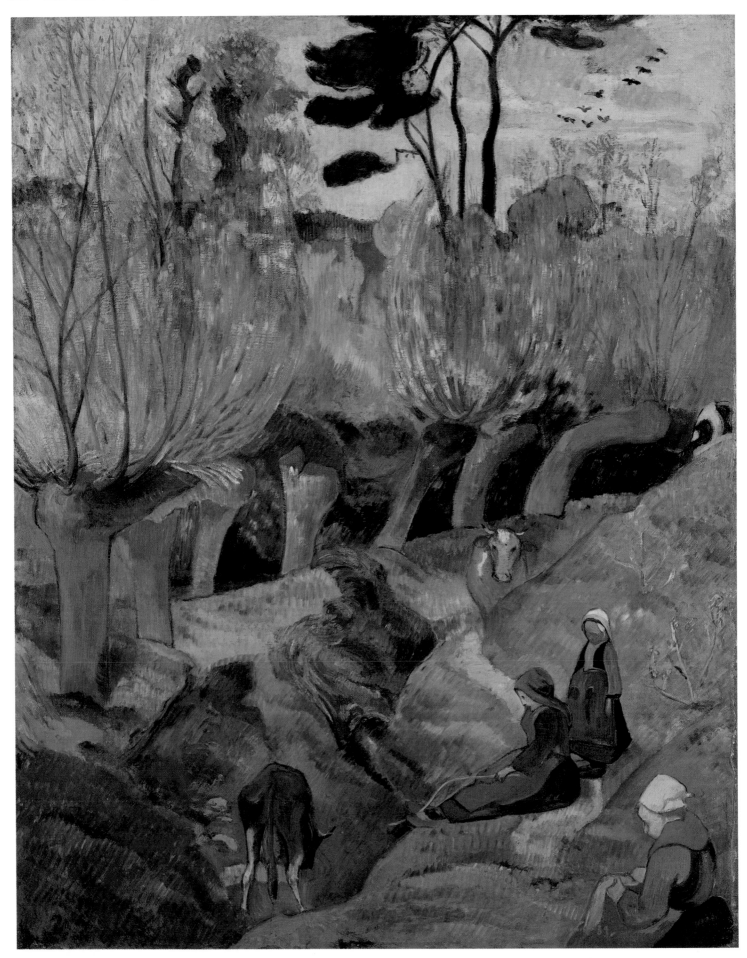

109 EN BRETAGNE (IN BRITTANY), 1889

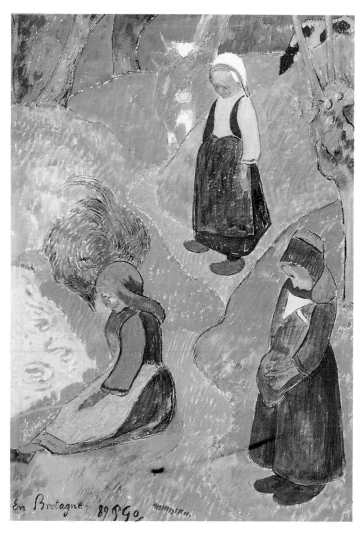

110 BRETONS AND COWS (PAGE FROM A BRITTANY SKETCHBOOK), *c*.1889

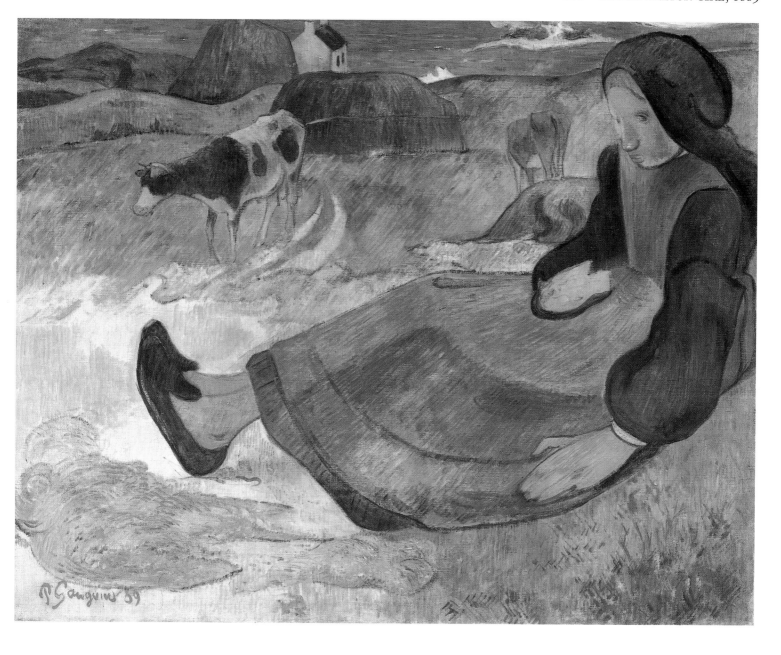

112 YELLOW HAYSTACKS/GOLDEN HARVEST, 1889

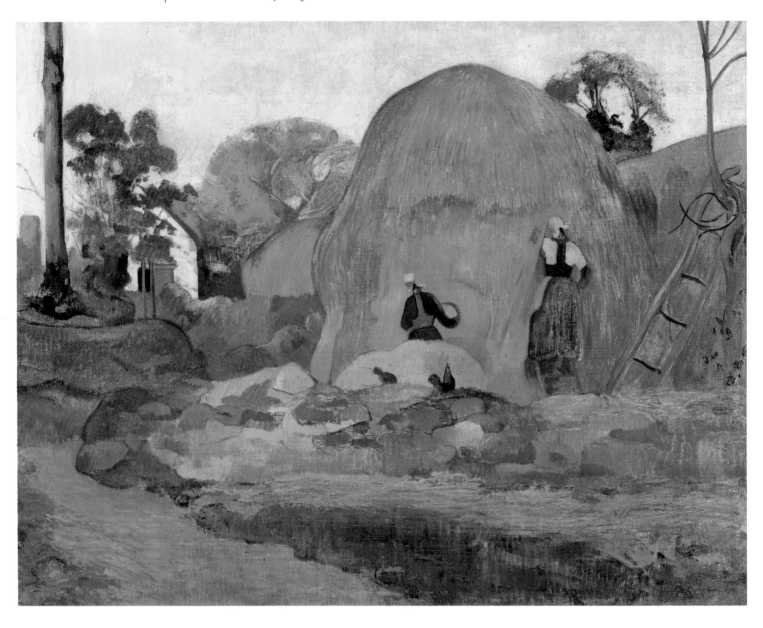

113 LITTLE GIRLS/LANDSCAPE WITH TWO BRETON GIRLS, 1889

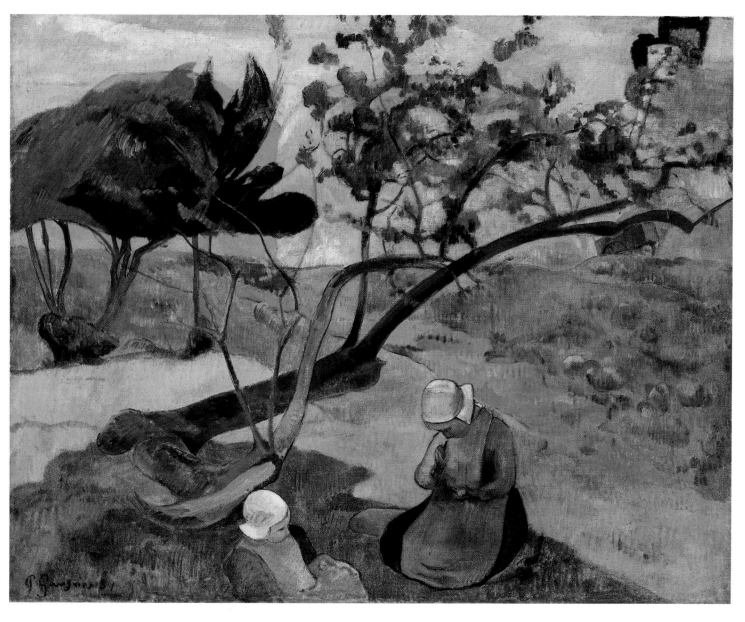

114 SELF-PORTRAIT WITH YELLOW CHRIST, 1889–1890

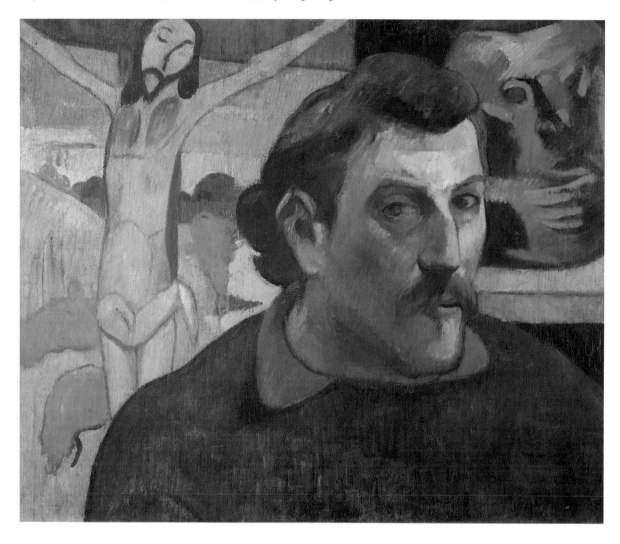

115 YELLOW CHRIST, 1889

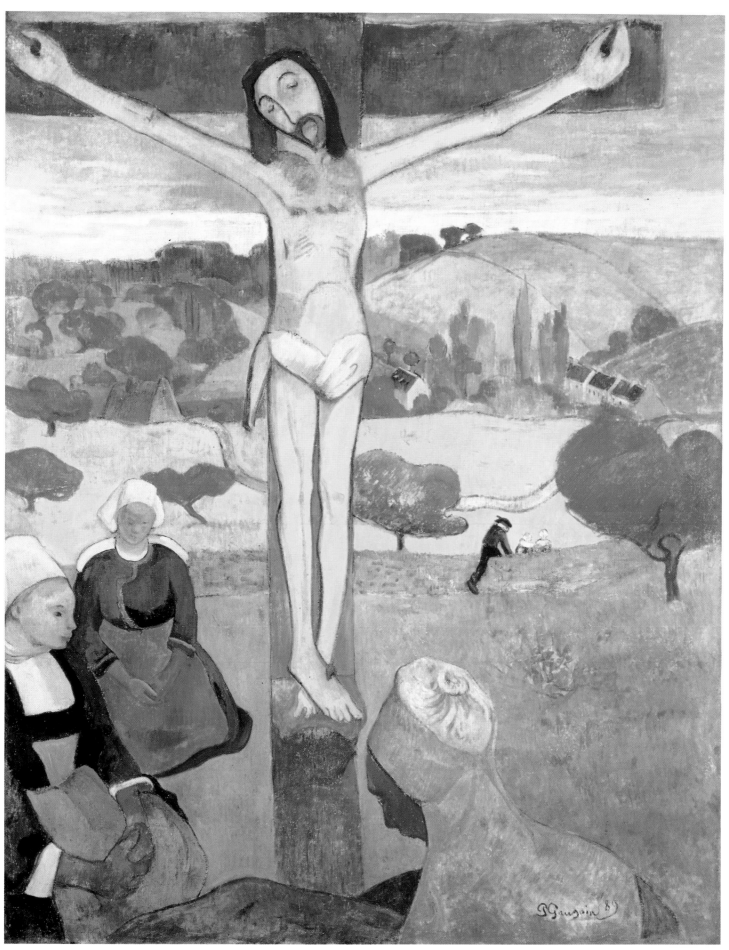

116 BRETON CALVARY/GREEN CHRIST, 1889

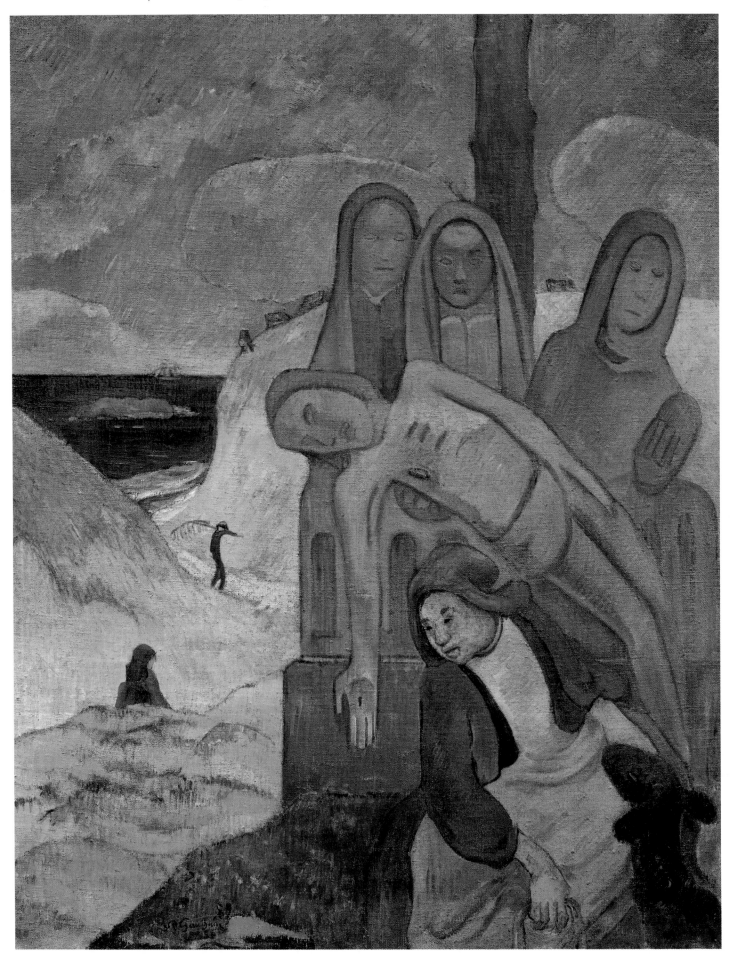

117 THE AGONY IN THE GARDEN (CHRIST IN THE GARDEN OF OLIVES), 1889

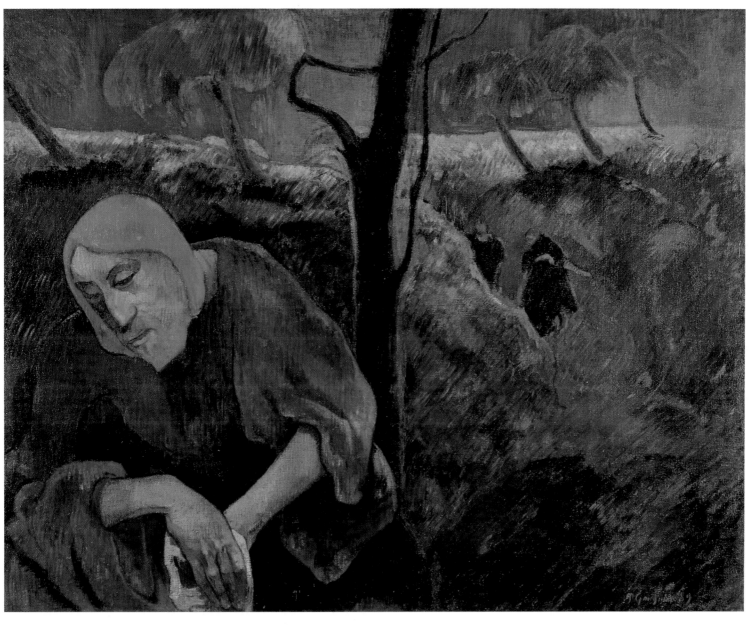

118 THE CREEK, LE POULDU, 1889–1890

119 BEACH AT LE POULDU, 1889

120 LANDSCAPE FROM BRITTANY (LE POULDU)/FIELDS BY THE SEA, 1889

121 LANDSCAPE AT LE POULDU/HARVEST BY THE SEA, 1890

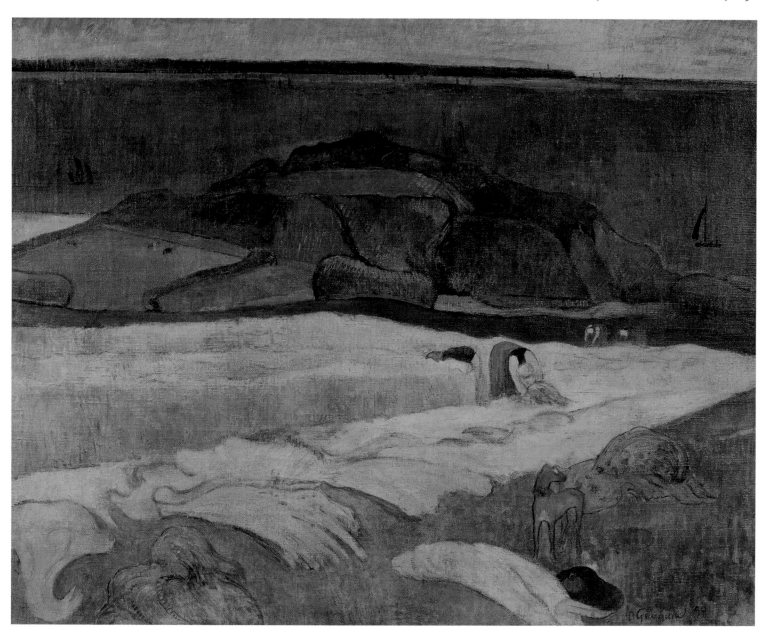

122 LANDSCAPE AT LE POULDU/THE ISOLATED HOUSE, 1889

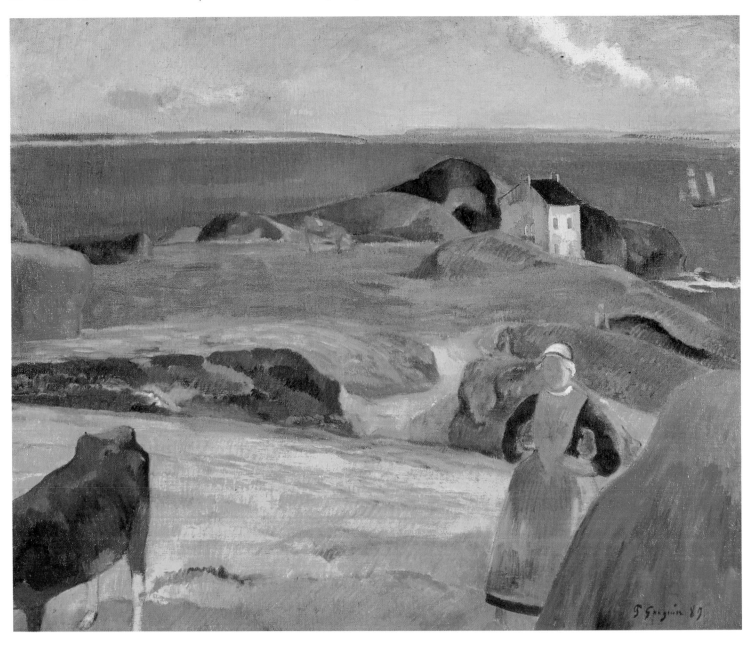

123 FARMYARD NEAR LE POULDU, 1890

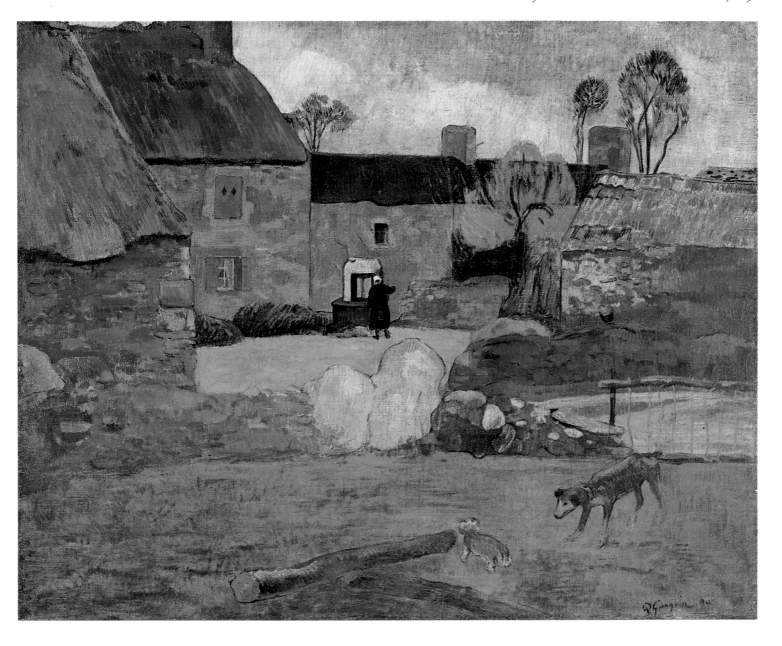

124 THE LOSS OF VIRGINITY, 1890–1891

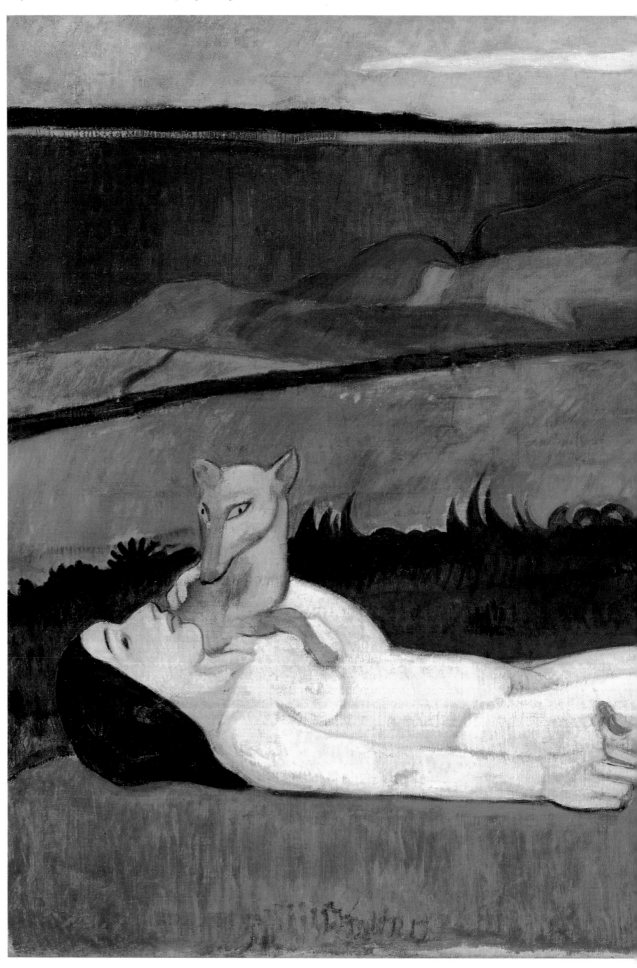

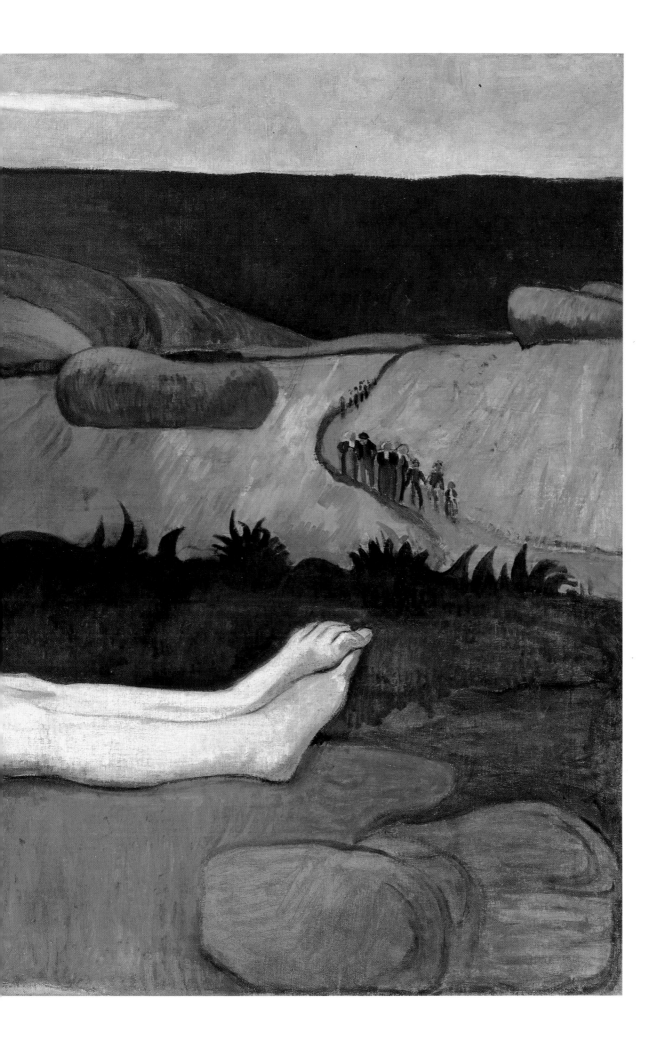

125 FIELDS AT LE POULDU/LANDSCAPE AT LE POULDU, 1890

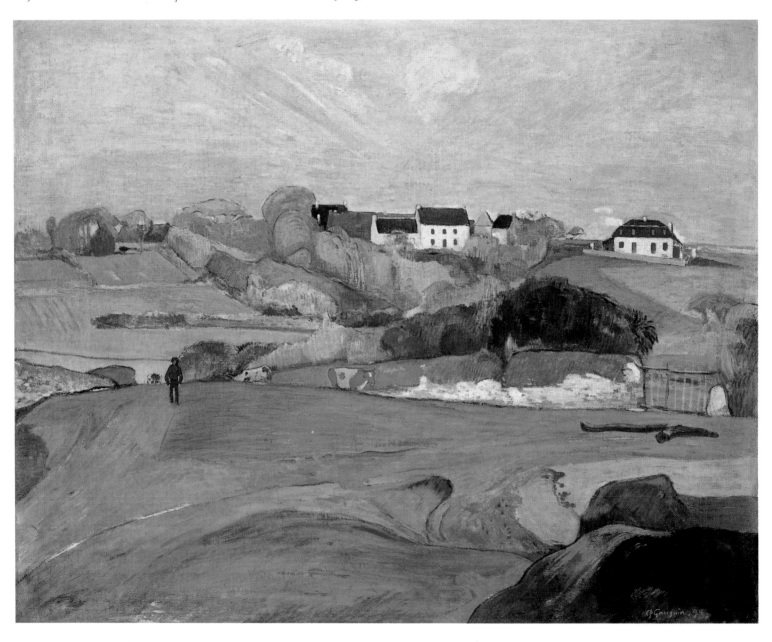

126 HAYSTACKS/THE POTATO FIELD, 1890

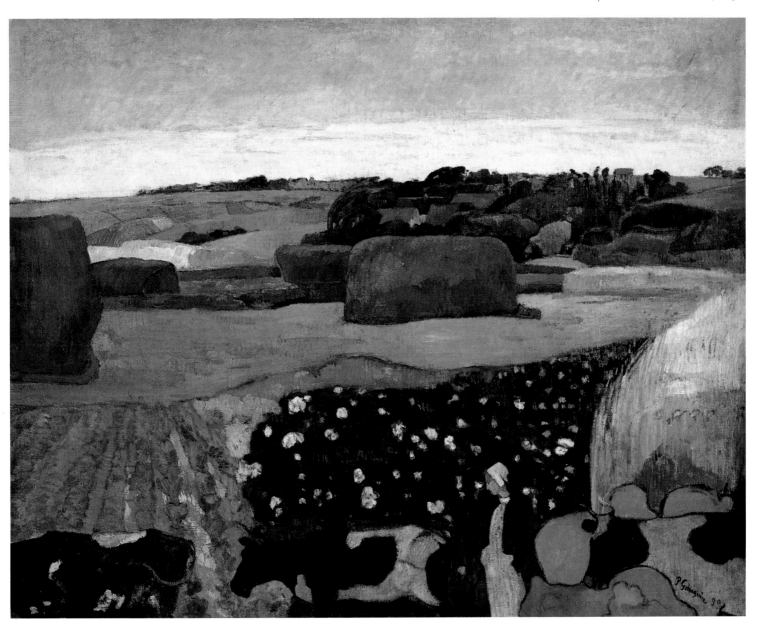

Armed with an official letter solicited from the Ministry of Fine Arts, Gauguin set out from Marseilles in April and travelled to Tahiti, via the Suez canal, Australia and New Caledonia. His first letters home were posted in June 1891; it took an average of four months for a reply to reach him, a time-lag that would considerably complicate the practical arrangements for repatriation when he fell ill and his money began to run out a year later.

Tahiti had been successively colonized by the English and the French and its native culture all but eradicated. It boasted rival Protestant and Catholic missions, and a sizeable immigrant Chinese population as well as the last vestiges of an indigenous royal family: King Pomaré V died within days of Gauguin's arrival. The shanty-town appearance of Papeete was a far cry from the untouched paradise Gauguin had longed for. His letters home make clear that it took him time to accustom himself to the island whose tropical delights he only began to sample when he moved to less populous settlements around the coast.

What Gauguin's letters omit to mention is that by the spring of 1892 he had begun copying out sections from a useful historical account of Tahitian lore and legend by J. A. Moerenhout, Voyage aux îles du grand océan *(1837), in a notebook which he entitled* Ancien culte mahorie, *embellishing it with sketches. He had also set up home with a 13-year-old Tahitian 'bride', Tehamana, the equivalent of Loti's Rarahu, who served as his model. Thus equipped, he enjoyed arguably the most productive period of his whole career, composing pictures whose powerful drawing, bold coloration and symbolic content outclassed his first studies of Tahiti, relatively straightforward genre and landscape scenes.*

Vairaumati, *sketched in a letter to Sérusier, was the first painting to incorporate images of the ancient Tahitian divinities (others were evoked in his 'ultra savage' wood carvings), while* Manao tupapau, *which Gauguin considered the most important painting in a consignment he sent for exhibition in Copenhagen in 1893, dealt with the theme of the Tahitians' irrational fear of ghosts, described at length in Loti's story. He explained the picture's genesis on more than one occasion, most comprehensively in the* Cahier pour Aline, *a wide-ranging compilation of reflections and justifications dedicated to the daughter he longed, but scarcely knew how, to address.*

Financial problems forced Gauguin to return to Paris in the summer of 1893, curtailing his plans to visit the remoter Polynesian islands of the Marquesas. He was satisfied with his productivity and convinced that he had outstripped all his followers and rivals. He fully expected to be greeted as the hero of the hour. Preparations were made for a one-man exhibition at the Durand-Ruel gallery in November 1893, for which Charles Morice composed a laudatory preface, and Gauguin spent lavishly on a studio in Montparnasse where he could entertain journalists, clients and acolytes.

Although the Durand-Ruel show was a critical success, it produced no sales and once again money problems loomed. Gauguin jealously guarded the major portion of a timely inheritance from his uncle, to his wife's intense annoyance, feeling Mette had already benefited enough from recent sales of his works in Denmark. He spent the winter teaching in an informal art academy, writing the odd article and drafting Noa Noa, *a semi-fictionalized récit of his experiences in Tahiti, intended to aid the understanding of his latest pictures. The manuscript was given to Charles Morice who was to add his own 'civilized' poems as a counterpoint to the 'barbarous' narrative of Gauguin.*

Apart from Morice and de Monfreid, few of Gauguin's former friends rallied to his cause and he seems to have struck up new friendships in Paris amongst a cosmopolitan artistic circle. From these years date his friendship with the musician William Molard and encounters with the painters Alphonse Mucha and Edvard Munch and the playwright August Strindberg. Back in Brittany it was Armand Seguin, Roderic O'Conor and Robert Bevan who participated in his hard-drinking bouts rather than his former acquaintances. Gauguin seems to have conducted himself with a certain transgressive hauteur *throughout his two years back in France. In exotic attire with Annah, a Javanese model, and her monkey in tow, he provoked a crowd of sailors in Concarneau. In the ensuing brawl his ankle was broken, which kept him immobilized in Pont-Aven for the duration of the summer. While there he embarked on a series of woodcuts to accompany* Noa Noa *which exploited the essential nature of the medium with remarkable force and simplicity.*

In early 1895 Gauguin was diagnosed as suffering from syphilis. Having severed all family ties, feeling cheated of the success he knew his works deserved, his decision to return definitively to the South Seas was taken in a new spirit of doomed renunciation.

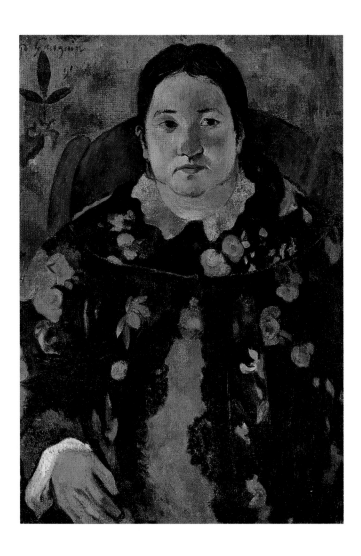

127 PORTRAIT OF SUZANNE
BAMBRIDGE, 1891

Oceania, 250 miles from Sydney [4 May 1891]

TO METTE ... I've had an excellent and rapid crossing with superb
weather created specially for me. But what extraordinary passengers there are on these ships.
I'm the only one who's paying. They are all Government employees...

We've had many stopovers on the way. The last two were truly astonishing. Melbourne and
Sydney. Imagine two towns hardly 50 years old, of 500,000 inhabitants with twelve-storey
houses, steam trams and cabs as in London. The same smart clothes and extravagant luxury.
Fancy coming 12,000 miles to see that. In Sydney a dock labourer earns 20 to 25 francs a day
and meat costs 4 sous a pound. Earning money is very easy in Australia. But! even spending
25,000 francs a year you can only live moderately. In spite of all these caustic remarks I have to
admit that the English have truly extraordinary gifts for colonizing and improvising great
ports. The grandiose mixed with the burlesque.

On the bridge of our ship, in the midst of all these civil servants in stiff collars with their
children, etc... I really am the odd man out with my long hair...

I have been here at Nouméa for two days and am leaving on the 21st for Tahiti in a warship.
La Vire the governor received me very well here and granted me a passage on the vessel with
the officers: my official letter is opening doors. What a funny colony Nouméa is. Very pretty
and amusing. Officials and their wives; households with their 5000 francs salary manage to
travel by carriage and their women in wonderful toilettes. How is one to solve this problem!...
Impossible! The released convicts are the richest and one day they will be at the top of the pile.
It's enough to make you want to enjoy life by committing crimes; if you're condemned before
long you'll be leading a happy life...

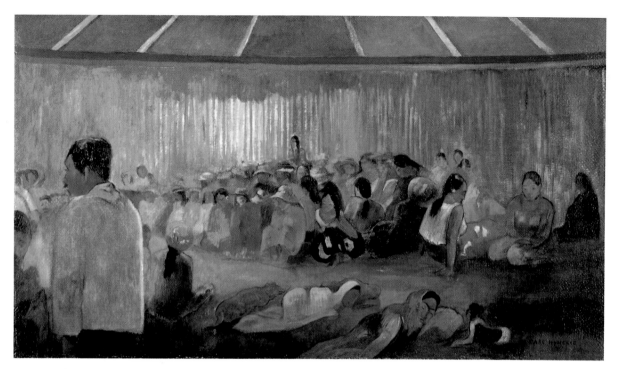

128 TE FARE HYMENEE (THE HOUSE OF HYMNS), 1892

[Tahiti, late June 1891]

TO METTE I've been here now for 20 days and I've already seen so
many new things that I am quite unsettled. I shall need some further time before I can paint a
good picture. I am gradually getting into things, studying a little every day. The King died a
few days after my arrival; his funeral had to wait until everybody in the island and the
neighbouring islands had been informed. You cannot imagine what the burial was like; each
village grouped itself on the grass in the evening and sang in turn their famous *hyménées* (choral
chants in several parts), and this went on all night long. For anyone who loves music it was a
real treat as the people here are extraordinarily gifted in music...

I am writing this in the evening. The silence of the Tahitian night is even stranger than
anything else. It can be found only here, with not even a birdcall to disturb it. Here and there,
a large dried leaf falls but does not give you the impression of noise. It's more like a rustling in
the mind. The natives often go about at night, but barefoot and silent. Always this silence. I
understand why these people can remain seated for hours, days at a time, without saying a
word, gazing sadly at the sky. I feel all of this is going to invade my being and I am now
wonderfully at rest.

It seems to me as if all the turmoil of life in Europe no longer exists and that tomorrow it
will be the same, and so on until the end. Don't conclude from this that I am selfish and that
I'm abandoning you. But let me live like this for a while. Those who reproach me don't know
everything there is in an artist's nature, and why should they seek to impose on us duties
similar to theirs? We don't thrust ours on them...

...I look on this death of King Pomaré with much sadness. The Tahitian soil is becoming
completely French and little by little the old order will disappear.

Our missionaries had already introduced a good deal of protestant hypocrisy and wiped out
some of the poetry, not to mention the pox which has attacked the whole race (without
spoiling it too much, I must say). For a lover of handsome men like you there's no shortage
here, much taller than I am with limbs like Hercules...

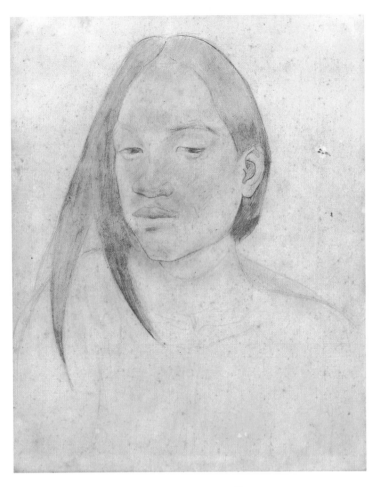

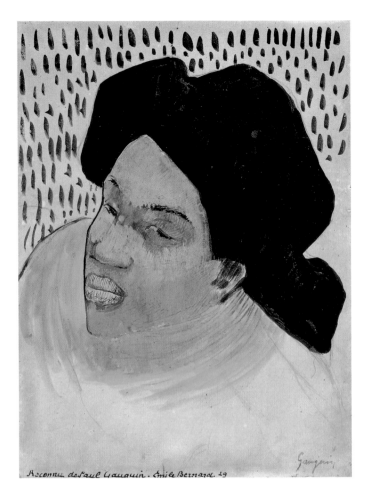

129 HEAD OF A TAHITIAN WOMAN, 1891

130 HEAD OF A TAHITIAN WOMAN, inscribed 'Reconnu de Paul Gauguin. Émile Bernard. 29', 1891

[Tahiti, November 1891]

TO PAUL SÉRUSIER

. . . I am working hard and earnestly. I can't tell if it's good, for I'm doing a lot and at the same time it amounts to nothing. Not one painting as yet, but a great deal of research that may lead to something, many notes that will be of use to me for a long time, I hope, in France. Indeed, I've simplified so much that I don't now know how to judge the result. It seems disgusting to me. Once I'm back, with carefully dried canvases, frames, etc, all the eloquent accoutrements, then I'll judge.

Yes, my dear Séruse, I am quite alone in the country, forty-five kilometres from town; no one with whom to talk art, nor even French, and I'm still not very good at the local language, despite all my efforts. You see, I can't memorize, and, above all, I'm always lost in something else, plunged into endless dreams . . . Ah! if only I could still knock off a *trompe-l'œil* picture, like the Americans, I would perhaps manage to sell a few canvases at good prices, but you know what I am and what I can do. However, enough moaning: what are you up to? . . .

It's very good of you to give me the credit for your intellectual progress; perhaps a small part is due to me, but you see I am convinced that artists only do what is in them to do. Seeds only germinate in fertile soil. You are making progress: that must mean you had some to make.

When you receive my letter, I beg you to attend to the things I ask of you, Morice, Goupil, etc, and write at length to tell me what's going on, for letters to and fro take four to five months.

When I'm in Paris myself I always find a way of sorting things out, but I'm not in Paris. Any news of the Champ-de-Mars Exhibition? Was my sculpture shown there and did it make a good impression? . . .

Mataiea, Tahiti, 7 November 1891

To Daniel de Monfreid I'm beginning to think that everybody in Paris has
forgotten me since I have not received any news from there and I'm leading a very solitary life,
speaking just the very little Tahitian I know.

Yes my dear friend, not a single word of French.

That poor Juliette with the child – how can I help her at the moment? I'm not surprised the
little one is not very well. Still, she came into the world, that one, despite everything, . . .

As far as coming home is concerned, you know that the concert that was given partly for my
benefit produced nothing.

I was counting on getting 1500 francs. And I'm certainly in desperate need of it here. . .

Men in Tahiti have invented a word: *No atou*, which means 'I don't give a damn', a phrase
which has a perfect naturalness and tranquillity about it. You wouldn't believe how I'm getting
used to that word. I use it a lot now, and I understand it.

131 WOMEN OF TAHITI (ON THE BEACH), 1891

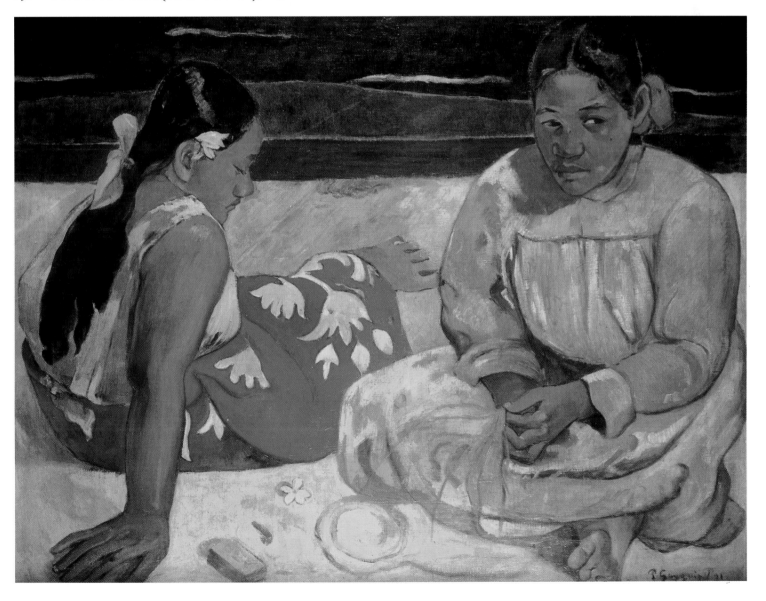

[Tahiti, *c.*March 1892]

To METTE … I am an artist and you are right, you're not mad, I am a great artist and I know it. It's because I know it that I have endured such sufferings. To have done what I have done otherwise I would consider myself a brigand – which is what many people think I am … You tell me I am wrong to stay far away from the artistic centre. No, I am right; I've known for a long time what I am doing and why I am doing it. My artistic centre is in my brain and nowhere else, and I am strong because I am never sidetracked by others and do what is in me.

Beethoven was deaf and blind, he was cut off from everything, which is why his work gives the impression of an artist living on his own planet. Look what has happened to Pissarro: by dint of always wanting to be in the forefront, abreast of everything, he has lost every ounce of personality and his work as a whole lacks unity …

132 MOUNTAINS IN TAHITI, *c.*1891

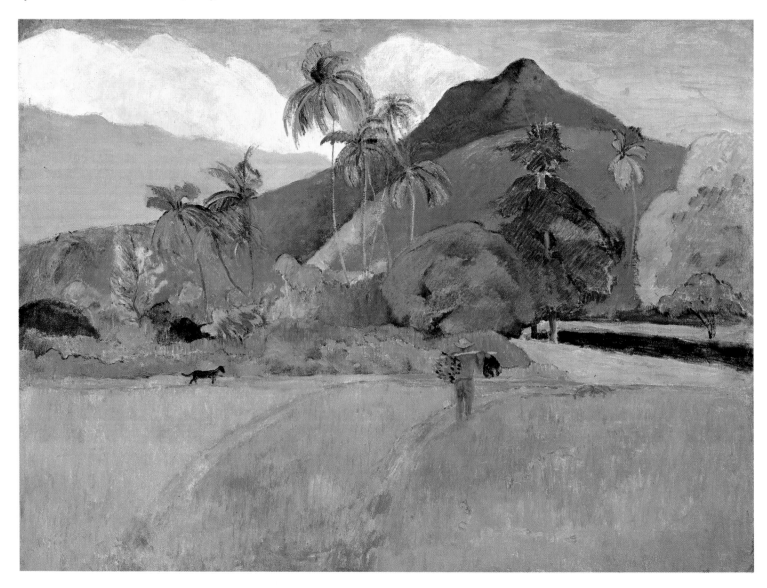

No, I have an aim and I am always pursuing it, building up material. True, there are transformations every year, but they always follow each other in the same direction. I alone am logical. Accordingly, I find very few people who follow me for long.

Poor Schuffenecker who reproaches me with being wholehearted in my determinations. But if I didn't act that way, would I be able to stand, even for one year, the out-and-out struggle I have undertaken? My acts, my painting, etc, are always contradicted when they are first seen, but in the end I am acknowledged to be right... The conditions in which I am working are unfavourable and anyone who does what I am doing in these circumstances has to be a *colossus*.

...in the end a fine day will dawn for art. It's not much, it is true. But admit that deep down you are flattered to be the wife of somebody...

I am glad to know that *Suzanne* [plate 33] is going to Philipsen, an artist. This proves to me that at that time I had a little talent and it's a little money in the pocket. You made enough outcry in the past when I bought pictures. What do husbands generally do, especially stockbrokers? On Sundays they either go to the races, or to the café, or with whores, for men need a few distractions, otherwise they cannot work and besides it's only human nature. For my part I worked and that was my distraction. Add all this up over the years and see if I didn't make savings which have been useful to you. In short, I am pleased you have sold this painting.

The more you sell, the greater the proceeds and the more you assure yourself a bright future. For one buyer brings along another....

*

Tahiti, 11 March 1892

To Daniel de Monfreid ...I haven't received anything yet from Morice and that's causing me considerable difficulties, seeing that I haven't received the money I was counting on and I really don't know where I stand...

Actually I've been quite seriously ill. Just imagine spitting blood, a quarter of a litre every day. It was impossible to stop it; mustard poultices on my legs, cupping glasses on my chest, nothing seemed to do any good. The doctor at the hospital was quite worried and thought I was a goner. My chest was quite unaffected, even quite robust, he said; it was my heart that was playing up. It's had so many shocks, it's hardly surprising. Once I'd stopped vomiting blood I took a course of digitalis and now I'm completely recovered, without any signs of a relapse. All the same, I shall have to take care. I am now living the life of a savage, walking around naked except for the essentials that women don't like to see (or so they say). I'm working more and more, but just studies up to now, or rather documents that are piling up. If they are no use to me later, they will be of use to others. Still, I've done one painting, a size 50 canvas. An angel with yellow wings is pointing out to two Tahitian women, Mary and Jesus, Tahitians also – partially naked, dressed only in a *pareu*, a sort of flower-patterned cotton rectangle that can be attached around the waist as the wearer pleases. In the background, very dark mountains and trees in flower – A dark purple path and an emerald foreground; on the left some bananas – I'm quite happy with it [plate 166].

*

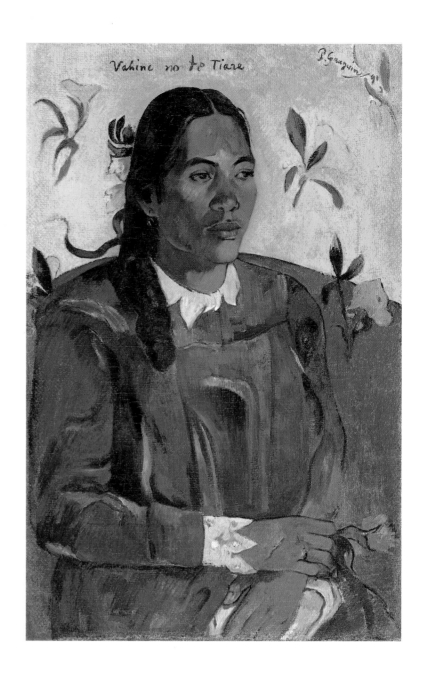

133 VAHINE NO TE TIARE
(WOMAN WITH A
FLOWER), 1891

[Tahiti, March 1892]

TO DANIEL DE MONFREID ...At the same time as my letter you will receive a study of
a Tahitian woman [plate 133]; take it to Goupil – perhaps its novelty will make it sell. That
Joyant is another one who's all talk and no action. He hasn't sold anything for me since he's
been with the firm.

　　　And nothing from Portier either!...

*

Papeete, 25 March 1892

TO PAUL SÉRUSIER Your letter finds me in one of those terrible moments in life
when a man has to take a decision, knowing that whichever way he turns there are some hard
blows to be taken. In a word, thanks to Morice's desertion, I am stony-broke and I shall have
to come home. But how can I travel *with no money*? On the other hand I want to stay, I haven't
finished what I set out to do, in fact I've hardly started, and I feel I'm on the way to really
achieving something...

... I see that things aren't going well in Paris: when I'm not there it's always like that. I do not understand how that thing I did in Arles has been put on display at a dealer's; Bernard pinched it from Schuff's studio just so that he could put something bad of mine on show. That young reptile is most decidedly good for nothing ...

I daren't say too much about what I'm doing here. My canvases terrify me – the public will never accept them. They're ugly in every respect, and I won't really know how to judge them until I return to Paris and you've all seen them.

By the time you receive this letter, Daniel will have a study of mine I did when I got here: I've sent it not as a typical model but as a typical example of the women here. That's all.

What I'm doing now is very ugly and quite crazy. My God, why did you make me this way? I am cursed.

What a religion the ancient Oceanian religion is. What a marvel! My brain is bursting with it and all it suggests to me will certainly frighten people. If they are afraid to hang my earlier works in an exhibition, what will they say of these new ones?

I see that Filiger has taken up his work again, and that La Rochefoucauld is helping him. Good for him.

I'm the only one who's not getting any help.

And yet I'm not envious.

Best wishes to everybody and kind regards to yourself. P. GAUGUIN

*

[Tahiti, late April–early May 1892]

TO METTE
 ... Don't be put out by my determination to stay another year. I am in the midst of work, and now I know the soil, its odour and the Tahitians whom I draw in a very enigmatic manner are Maoris for all that and not like the Orientals of the Batignolles ... It has taken me nearly a year to understand things, and now that I've got there (my foot in the stirrup) I'm going to have to leave. It's maddening.

*

Tahiti, 12 June 1892

TO HENRI ROUJON, DIRECTEUR DES
BEAUX-ARTS
 At my request you were good enough to do me the honour of granting me a mission for Tahiti, with a view to studying the customs and landscapes of this country.

I trust that my efforts will be judged favourably by you on my return. However prudent one is, life in Tahiti is very expensive and voyages very burdensome.

I have the honour, Monsieur le Directeur, of requesting my repatriation to France.

Counting on your good offices to assist my return, I remain, Monsieur le Directeur, with the greatest respect your devoted servant.

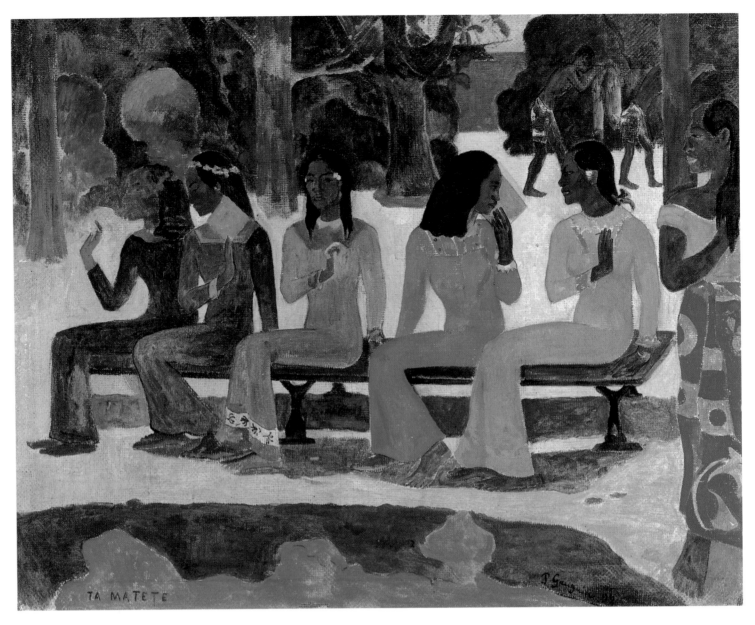

134 TA MATETE (WE SHALL NOT GO TO MARKET TODAY), 1892

[Tahiti, September 1892]

To Daniel de Monfreid ... The study I sent you (God be praised that you received it) – I was very much afraid that the gentleman in question, a policeman incidentally, would cheat me out of it – that study is one stage on the road to other, better works; you thought it superb, and that's all to the good. You know, it's my work, not Bernard's. I have about fifty canvases that will really amaze you, since many of them are much better than that study. At the moment I'm carving various sorts of primitive trinkets out of tree trunks. I have a piece carved in ironwood to bring back; it wore my fingers out, but I'm happy with it, and you know, it's not by Bernard ...

I'm going to be a father again soon, here in Oceania. Damn it! I have to scatter my seed around everywhere. It's true it's no disgrace here; children are welcomed and accepted in advance by all the relatives. The only question is who is to be the foster father and mother. In Tahiti, you know, the most beautiful present you can give anyone is a child. So I'm not worried about the child's fate ...

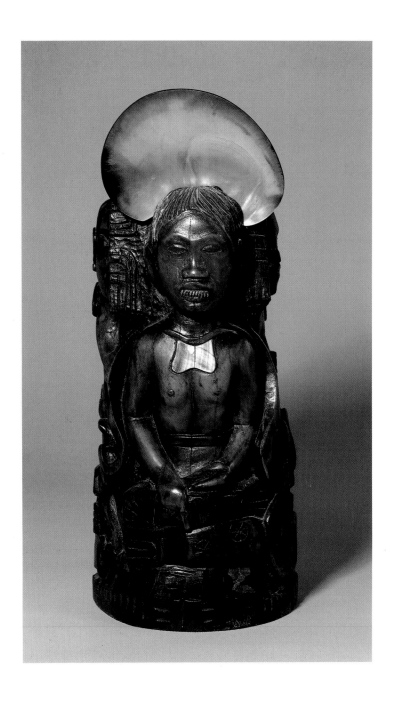

135 IDOL WITH A SHELL, 1892

[Tahiti, September 1892]

To Mette

... from every point of view I am satisfied with the result you have obtained with my canvases; in the first place it's relieved you a little and assured you a peaceful summer, and secondly it gives you a little confidence ...

... I am making every effort to obtain a 1000 franc note. If I succeed I shall go to the Marquesas, to La Dominique, a little island which has only three European inhabitants and where Oceania is not yet swamped by European civilization ...

... And this will be the end of my wanderings. A little more patience, dear Mette, for the sake of us all.

I have done 11 months of effective work and 44 fairly important canvases, amounting to a year's income of at least 15,000 francs, provided the clients buy ...

P.S. You mention a good article by Aurier on the Symbolists. In which review? ...

I know Aurier and I imagine he gives me some credit. I created this new movement in painting and many of the young are reaping the benefit not without talent but once again it is I who have shaped them. And nothing in them comes from themselves, but through me ...

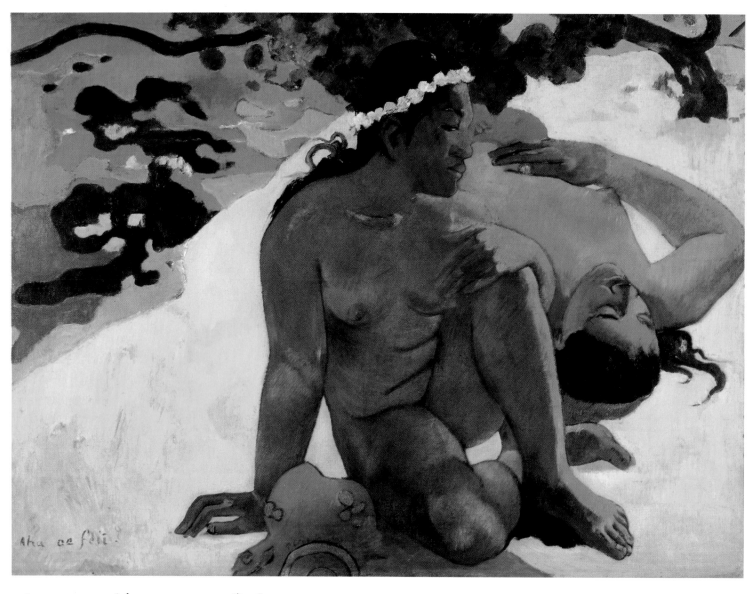

136 AHA OE FEII? (ARE YOU JEALOUS?), 1892

[Tahiti, October–November 1892]

TO DANIEL DE MONFREID . . . I have recently made two wood carvings which I
managed to sell for 300 francs and I can stay here another three months . . .

I have had no canvas for a month and dare not buy any. I have so little money. So I'm not
painting. But I study with the brain and eyes, then I rest a little, which won't do me any
harm . . . To think that I was born to practise an art industry and that I cannot succeed. Stained
glass, furniture, faience, etc, deep down my aptitudes are for these things much more than for
painting in the strict sense.

. . . Recently I did a fine nude, two women at the water's edge, I think it is my best thing to
date. [*Aha oe feii?*, plate 136]

*

[Tahiti, 5 November 1892]

To Mette

. . . Why worry about the children's future? When one has reared boys up to the age of 18 one has more than done one's duty; not everyone has money to give to their children. Let them make their own way in the world as their parents did before them. We haven't bequeathed infirmities to ours, nor fettered them with a bad name. They are intelligent and healthy, which is more than is necessary for their future . . .

. . . I must go on with the struggle, always, always . . . You have no confidence in the future? I have confidence *because I want to have it*. Without it I should long since have blown my brains out. To hope is almost to live. I have to live in order to do my duty to the end and I can only do that by forcing my illusions, by creating hopes out of dreams . . .

. . . I have . . . instructed Joyant to deal directly with me. But that poor fellow is not much of a business man. Since the death of van Gogh he hasn't yet been able to sell anything. If you had known van Gogh, you would have known a responsible man devoted to the right cause. If he hadn't died like his brother I would by now be completely out of this mess. And it was thanks to him that the Goupil firm did anything for us.

Every month I receive a letter from Daniel or from Sérusier, two pupils who are very devoted to me . . .

*

Tahiti, 8 December 1892

To Daniel de Monfreid

. . . At the same time as my letter, I think you will receive a consignment of canvases. I found a way of sending them. An artillery officer is going to look after them, and he will put them on the train. There'll be carriage to pay. I'm sorry, I had no other option. I'm worried about the canvases during the journey, and there may be a few repairs to be done. You should wash them carefully, taking great pains not to wash off the paint and the preparatory ground, and then wax them. Please show them to friends and write to my wife to find out when you should send them to her for the Danish exhibition; please add *Vahine no te tiare*. Ask her whether the exhibition organizers will pay the carriage, in which case you should send them to her mounted on stretchers. If not, send them in a roll and send her the exact measurements in advance so that she can have the frames made. Anyway I'll write to her as well . . .

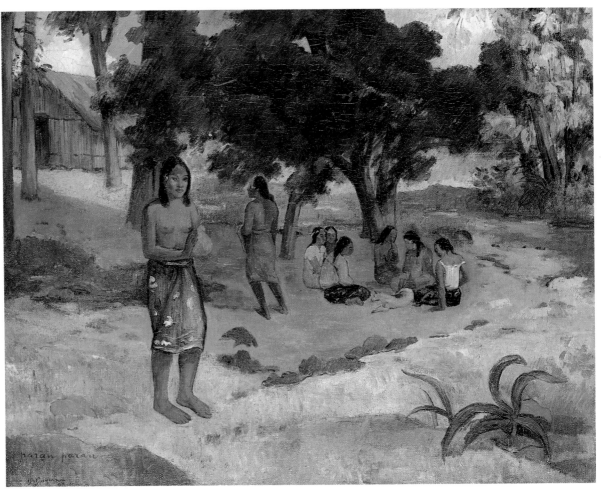

137 PARAU PARAU (CONVERSATION), 1892

Tahiti, 8 December 1892

To Mette ...I have had an opportunity to send eight canvases to
France. They will be in the charge of M. Daniel, 55 rue du Château. Write to him for advice
regarding the Danish exhibition. If by good fortune you managed to sell any of these canvases
you MUST put the money aside for my return to France.
 Once back in France I will need it to set me on my feet. Below is the translation of the titles
I'm going to put on the canvases. This translation is for you alone so you can give it to those
who ask for it. But in the catalogue I want the titles given as they are on the pictures. This
language is strange and has several meanings.

1) Parau Parau (Word, Word) [plate 137]
2) Eaha oe feii What, you are jealous, envious [plate 136]
3) Manao tupapau Manao Think, believe
 Think, or believe in the ghost
 tupapau [plate 140]
 (Spirit of the, or Ghost keeping
 watch over the, Dead
 she)

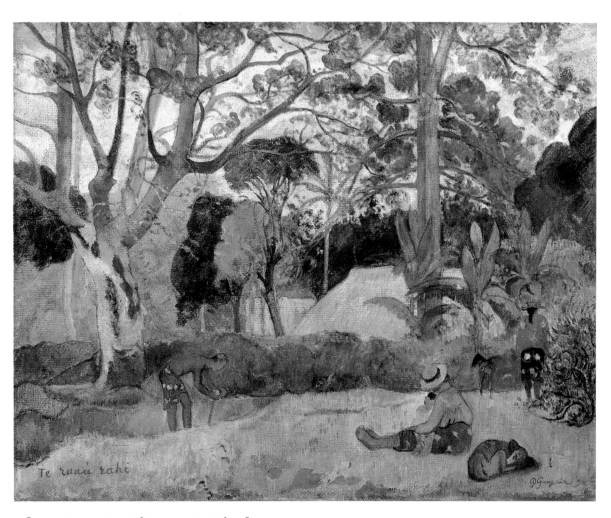

138 TE RAAU RAHI (THE BIG TREE), 1891

4) Parahi te Marae	There lies the Marae
	(Marae) temple, place reserved
	for the cult of the Gods
	and for human sacrifices [plate 176]
5) Te faaturuma	Silence, or Mournful Spirit [plate 160]
6) Te Raau Rahi	The big tree [plate 138]
7) I Raro te Oviri	Under the Pandanus [plate 170]
8) Te fare Maorie	The Maori Dwelling
9) Te vahine note tiare	Woman with a flower [plate 133]

I am sending you a mixture of landscapes, genre figures and nudes. Some easy (relatively, some difficult).

I am very afraid that the canvases will be damaged on such a long journey. Now listen to me. With the exception of three canvases, I leave it to you to fix the prices, but I want them to be higher than my canvases from France.

As for no. 2, not less than 800 francs

” 3 ” 1500 ”

I would even keep back the latter for much later on.

As for no. 4, not less than 700 francs.

139 SKETCH OF MANAO TUPAPAU, *from Cahier pour Aline*, 1892–1893

Naturally many of the pictures will be incomprehensible and you're going to have work on your hands. So that you will understand and be able to show off, as they say, I am going to give you an explanation of the most difficult one, which, in fact, is the one I want to keep – or sell for a very good price: the *Manao tupapau*. I did a nude of a young girl. In that position, a mere hint, and it is indecent. Yet that is the way I want it, the lines and movement interest me. So when I do the head I put in a little fear. For this fear I have to give a pretext, if not an explanation, and it has to be in keeping with the character of the person, a Maori girl. The Maoris have a very great, traditional fear of the spirit of the dead. A girl from our own part of the world would be afraid of being caught in that position (women here not at all). I have to explain this fright with the fewest possible literary devices, as in olden times. So this is what I do. Dark, sad, terrifying general harmony that rings in the eye like a funeral bell. Purple, dark blue, and orangey yellow. I make the cloth greenish yellow (1) because the linen of these savages is different from our linen (beaten treebark), (2) because it creates, suggests artificial light (a Kanaka woman never sleeps in the dark) and yet I do not want any suggestion of lamplight (that's ordinary), and (3) because this yellow linking the orangey yellow and the blue completes the musical chord. There are a few flowers in the background but they mustn't be real, since they are imagined. I make them look like sparks. The Kanakas think that the phosphorescences of the night are the souls of the dead and they believe in this and are afraid. To finish up, I do the ghost very simply, a small figure of a woman; because the girl, not being familiar with the French spiritist theatres, can't help seeing the actual dead person, that is, a person like herself, linked to the spirit of the dead. This little text will make you look very scholarly when the critics start to fire their mischievous questions at you. And finally, the painting has to be done very simply since the subject matter is primitive, childlike.

All this must be very boring, but I am sure it is necessary for you over there.

Kisses for you and the children.

<div align="right">PAUL GAUGUIN</div>

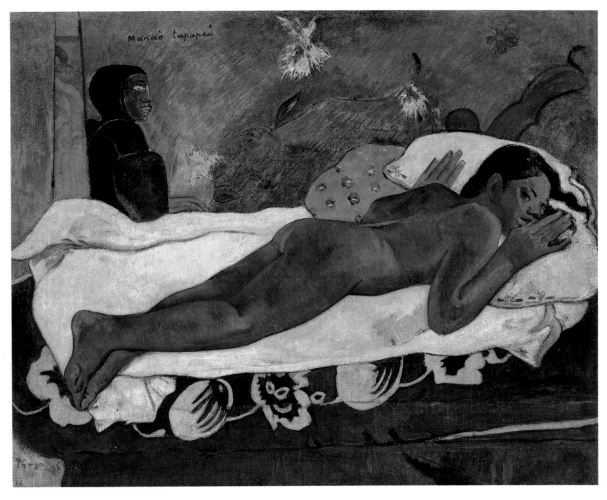

140 MANAO TUPAPAU (THE SPIRIT OF THE DEAD WATCHES), 1892

Tahiti, 1892–1893

FROM *CAHIER POUR ALINE* This notebook is dedicated to my daughter Aline... These meditations are a reflection of myself. She, too, is a savage, she will understand me. Will my thoughts be useful to her? What does it matter. I know she loves her father, whom she respects, so I give her a remembrance... Who is right, the crowd or me? Who knows. In any event, Aline has, thank God, a heart and mind lofty enough not to be frightened and corrupted by contact with the demonic brain that nature gave me.

... Is it not a miscalculation to sacrifice everything for the children, and doesn't that deprive the nation of the genius of its most active members? You sacrifice yourself for your child who, in turn, becomes an adult, and will sacrifice himself. And so on. There will be nothing but sacrificed people. And this stupidity will go on for a long time.

... I have known what absolute poverty means – being hungry, being cold – and everything that it implies... it is true that suffering sharpens genius. Yet too much suffering kills you.

... It is said that God took a little clay in his hands and made every known thing. An artist, in turn (if he really wants to produce a divine creative work), must not copy nature but take the natural elements and create a new element.

My political views! I haven't any, but because of universal suffrage, I am supposed to have some.

I am a republican because I believe that society should live in peace. The majority of people in France are strict republicans; therefore I am republican, and, besides, so few people like what is great and noble that a democratic government is necessary.

141 COVER OF *CAHIER POUR ALINE*, 1893

Long live democracy! That's all there is. Philosophically speaking, I think the Republic is a *trompe-l'œil* (to borrow a term used in painting) and I hate *trompe-l'œil*. I become *anti republican* again (philosophically speaking), intuitively, instinctively, without thinking about it. I like nobility, beauty, delicate tastes, and this motto of yesteryear (*Noblesse oblige*). I like good manners, politeness, even that of Louis XIV. So (instinctively and without knowing why) I am a SNOB. As an artist. Art is only for the minority, therefore it has to be noble itself. Only the great lords have protected art, out of instinct, out of duty (out of pride perhaps). It doesn't matter; they caused great and beautiful things to be made. The kings and the popes dealt with artists as equals, so to speak.

The democrats, bankers, ministers and art critics masquerade as protectors and don't protect anything; they haggle like fish buyers at the market. And you would like artists to be republicans!

There you have all my political views. I believe that in a society every man has the right to live, and to live well in proportion to his work. Since an artist cannot live, it follows that society is criminal and badly organized.

. . . You will always find vital sap coursing through the primitive arts. In the arts of an elaborate civilization I doubt it.

*

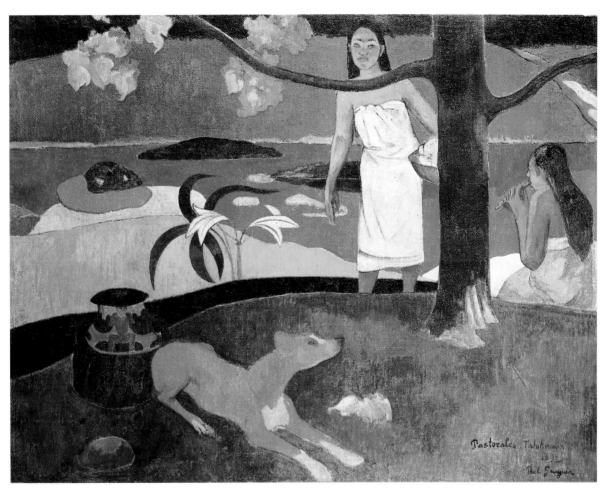

142 PASTORALES TAHITIENNES, 1893

Tahiti, late December 1892

To Daniel de Monfreid I have very little to tell you in this letter. I'm in a state of utter depression . . .

When I think hard about it, I shall have to abandon painting when I return — I just can't make a living from it. I left Paris after a victory, a small one, but a victory all the same. In 18 months I've not received a penny from my painting, that is to say I've sold less than before. The conclusion is easy to draw. And since I have no large inheritance to look forward to, how am I going to eat or even buy paints? It is true that I shall be bringing back a few canvases, but then afterwards these canvases will keep on piling up, so that they are less saleable than before . . .

I've just done 3 canvases, 2 size 30s and one 50. I think they're my best, and since it will be 1 January in a few days, I've dated one, the best one, 1893 [plate 142].

For once I've given it a French title, *Pastorales tahitiennes*, because I couldn't find a suitable title in the Tahitian language. I don't know why — but even using pure Veronese green and vermilion — it seems to me that it's an old Dutch painting — or an old tapestry — why is that? What's more, all my canvases seem lacking in colour: I think that's because I no longer have sight of any of my old canvases or a picture of the École des Beaux Arts as a point of reference or comparison. What a memory, I've forgotten everything. Too much smoking, I think. When I get back, I shall be able to judge . . .

. . . You know I'm not going to congratulate you on becoming a father; you can say the same to me, but I'm never there, I'm so detached it's not the same thing; it's less serious . . .

[Tahiti, February 1893]

To Mette ...I have your photographs nicely arranged on a shelf
hanging in the hut and they give rise to lots of questions from the Kanakas who come to see
and admire my painting, if astonishment can be said to pass for admiration. Are they yours
those children, they say, what are they doing? And the vahine she's pretty, why is her hair like
that of a tane (man). Why isn't she with you, etc... So to cut a long story short I've told them
she was dead and that trouble made her dead; why you no stay always in Tahiti, soil good here,
you give children to kanaka woman. You see I am set to come back a savage...

*

Tahiti, 11 February 1893

To Daniel de Monfreid Your letter this month finds me in a complete mess: I'm
running around trying to raise some money and it will be at least 3 months before I can hope to
leave, even assuming that the minister will repatriate me...

My wife has sold some more paintings for 850 francs, but she needs the money and she
apologizes for not being able to send me any. What can I say!

It seems that my reputation is really growing apace in the North. An artist from London
told her we absolutely had to put on an exhibition in London. I shall have to come back and
investigate all this. My God, how angry I am! In fact it's my anger that keeps me going...

...By now you should have received my canvases and my wife will be able to work in
Denmark.

That poor Aurier is dead. What rotten luck we have to be sure. Van Gogh then Aurier, the
only critic who really understood us and who would have been very useful to us one day.

*

[Tahiti, March 1893]

To Daniel de Monfreid I've now received 700 francs, which adds a little to the
kitty. If I had received them a few months ago I would have gone to the Marquesas Islands to
complete what would have been the most interesting part of my work. But I am tired, and the
boat to the Marquesas doesn't leave for another month and a half. And anyway, I'm expecting
my travel arrangements etc. to be confirmed in the next post...

...today, there's a whole pack of young people following *in my footsteps*, prospering even, *so
they say*: since they are younger, have more resources available to them and greater skill, I shall
perhaps get squeezed out in the rush. I'm counting on this stay in Tahiti: it will be a change
from the work I produced in Brittany and it will take them a little while to follow me along
this new path...

*

[Marseilles, 3 August 1893]

To Mette Here I am at last in Marseilles safe and sound and I'm
wiring Daniel to send me, if possible, some money to pay my train fare and the hotel. The
money I had was used up in the course of the voyage. As soon as you receive this letter write *at
length telling me how everything is at home* (it will be 5 months since I've had any news from you).
Also tell me where we're up to with our finances so that I can do my calculations . . . I've heard
nothing about the canvases I sent you (apart from the fact that they arrived safely). But what
impression did they make at the exhibition in Denmark? To enable me to organize my affairs in
Paris you must write at length bringing me up to date with everything . . .

*

Paris, 4 September 1893

To Daniel de Monfreid . . . I've just returned from Orléans, where I had to go to
attend my uncle's funeral. Now I'm back in Paris, there's nothing but problems to be sorted
out and errands to be run. The letter from my wife was not very reassuring; my Tahitian
paintings have had a moral success among artists, but the result among the ordinary public: *not
a penny*. It is fortunate my uncle had the wit to die and that his *very* small inheritance will
enable me to get myself back on an even keel and will help considerably towards the cost of my
exhibition. I don't know yet exactly how much my uncle has left, but I'm counting on about
10,000 francs: at the moment, that's salvation.

 There's another thing I wanted to ask you. When I told you to prepare for my return by
looking for some money, did you speak to Schuffenecker? I *need to know* whether you did so that
I know how to handle him when he gets back . . .

*

[Paris, October 1893]

To Mette Not until the day before yesterday did I receive the case of
pictures in good condition sent by Express delivery. Two of the best pictures are missing. I
should be glad if you would tell me what has happened to them. From now on I need to keep
an account of all this so when you have time write me out a list of the pictures you have and a
list of those you have sold since my departure for Tahiti, with the prices.

 . . . Still no news from the lawyer in Orléans, and I am overwhelmed by the expenses *necessary*
for my installation and my exhibition, which will open on 4 November, at Durand-Ruel's.

 I am also preparing a book on Tahiti which will be very useful in helping people understand
my painting. What a lot of work!

 At long last I'll soon know whether it was *madness* to go to Tahiti.

*

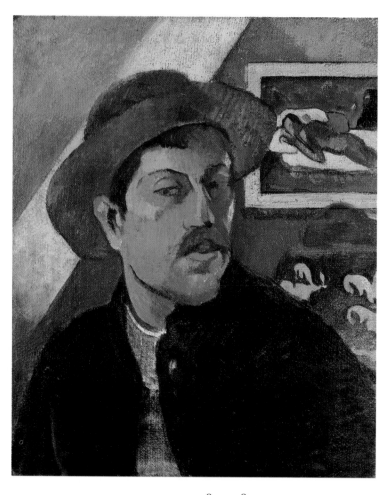

143 SELF-PORTRAIT IN A HAT, 1893–1894

[Paris, October 1893]

To J. F. WILLUMSEN Would you be so kind as to find out which *pictures* of mine
were sold at the Denmark Exhibition with their approximate prices. *It is very much in my interest
to know*: but of course, and I will explain why, my wife mustn't find out I'm getting hold of this
information.

 . . . I am planning to have an exhibition of my works from Tahiti, in November. I hope you'll
be here in Paris at that time.

*

Paris, 3 November 1893

To STÉPHANE MALLARMÉ I gathered you were back in Paris but I wasn't sure whether
you had resumed your Tuesdays. I was very keen, however, to come and shake your hand. On
the offchance I will call next Tuesday to tell you a little about my travels.

*

[Paris, November 1893]

TO METTE

. . . It is extraordinary that I should be obliged to make out an account for you and convince you that I must live other than in the street and that, coming home ill after living in a warm climate, I cannot walk about naked and go without heating. What's more, convince you that for our children's future I have to make a certain outlay if I'm to be in a position finally to earn our livelihood . . . When the time comes, I will send you 1000 francs to cover immediate necessities . . .

*

Paris, December 1893

TO METTE

. . . My exhibition did not, in fact, produce the result one might have expected, but one must face up to the facts. I had fixed my prices very high: 2 to 3000 francs on average. At Durand-Ruel's one could scarcely do otherwise . . .

. . . The crucial thing is that my exhibition was a very great success from the artistic point of view, and even provoked passion and jealousy. The press treated me as it has never yet treated anybody, that's to say rationally and with words of praise. For the moment I am considered by many people to be the greatest modern painter.

Thanks for your suggestion to come to Denmark, but I shall be kept here all winter by an immense amount of work. Many receptions. Visitors who want to see my pictures. And buyers, I hope. A book about my voyage which is giving me a lot of work . . .

*

1893

FROM *NOA NOA* I

For 63 days I have been on my way, and I burn to reach the longed-for land. On 8 June we saw strange fires moving about in zigzags – fishermen. Against a dark sky a jagged black cone stood out. We were rounding Moorea and coming in sight of Tahiti. A few hours later the dawn twilight became visible, and slowly we approached the reefs of Tahiti, then entered the fairway and anchored without mishap in the roads. To a man who has travelled a good deal this small island is not, like the bay of Rio de Janeiro, a magic sight. A few peaks of sub[merged] mountain [were left] after the Deluge; a family climbed up there, took root, the corals also climbed, they ringed round the new island.

At ten in the morning I called on Governor Lacascade, who received me as a man of consequence entrusted by the Government with a mission – ostensibly artistic but mainly consisting of political spying. I did all I could to undeceive the political people, it was no good. They thought I was paid, I assured them I was not.

At that time the king was fatally ill, and every day an end was expected. The town had a strange look: on the one hand the Europeans – traders, officials, officers and soldiers – continued to laugh [and] sing in the streets, while the natives assumed grave expressions [and] gossiped in low voices around the palace.

And in the roadstead an unusual stir of boats with orange sails, upon the blue sea frequently crossed by the silvered ripples from the line of the reefs. The inhabitants of the neighbouring islands were coming in, each day, to be present at their king's last moment, at the final taking-over of their islands by the French. For their voices from on high brought them warning – (every time a king is dying, their mountains, they say, have sombre patches on some of their slopes at sunset).

The king died and lay in state in his palace, in the full-dress uniform of an admiral.

...Having only just arrived, rather disappointed as I was by things being so far from what I had longed for and (this was the point) imagined, disgusted as I was by all this European triviality, I was in some ways blind....

Shall I manage to recover any trace of that past, so remote and so mysterious? and the present had nothing worthwhile to say to me. To get back to the ancient hearth, revive the fire in the midst of all these ashes. And, for that, quite alone, without any support.

...My mind was soon made up. To leave Papeete as quickly as I could, to get away from the European centre. I had a sort of vague presentiment that, by living wholly in the bush with natives of Tahiti, I would manage with patience to overcome these people's mistrust, and that I would know.

...At noon we reached the 45th kilometre – the Mataiea district. I visited the district and in the end found rather a fine hut, which the owner consented to let to me; he would build another next door, to live in.

...The few young girls of Mataiea who do not live with a *tane* [man] look at you with such frankness, [such] utterly fearless dignity, that I was really intimidated. Also, it was said that many of them were sick. Of that sickness which the civilized Europeans have brought them in return for their generous hospitality...

II

...Near my hut there was another hut [*Fare amu*, house to eat in]. Nearby, a *pirogue* – while the diseased coconut-palm looked like a huge parrot, with its golden tail drooping and a huge bunch of coconuts grasped in its claws –

The nearly naked man was wielding with both hands a heavy axe that left, at the top of the stroke, its blue imprint on the silvery sky and, as it came down, its incision on the dead tree, which would instantly live once more a moment of flames – age-old heat, treasured up each day. On the ground purple with long serpentine copper-coloured leaves, [there lay] a whole Oriental vocabulary – letters (it seemed to me) of an unknown, mysterious language. I seemed to see that word, of Oceanic origin: *Atua*, God.

...A woman was stowing some nets in the *pirogue*, and the horizon of the blue sea was often broken by the green of the waves' crests against the coral breakers [plate 168] –

...I had imagined that with money I would find all that is necessary for nourishment. The food is there, certainly, on the trees, on the mountain-slopes, in the sea, but one has to be able to climb a high tree, to go up the mountain and come back laden with heavy burdens; to be able to catch fish [or] dive and tear from the sea-bottom the shells firmly attached to the rocks. So there I was, a civilized man, for the time being definitely inferior to the savage, and as, on an empty stomach, I was pondering sadly on my situation, a native made signs to me and shouted, in his language, 'come and eat'. I understood. But I was ashamed and, shaking my head,

144 VASE OF FLOWERS AFTER DELACROIX,
frontispiece from *Noa Noa* (Louvre ms), *c*.1897

145 FRAGMENT OF TE ATUA (THE GODS) AND
PHOTOGRAPH OF A TAHITIAN GIRL PASTED ONTO
WATERCOLOUR OF HIRO, page 57 from *Noa Noa*
(Louvre ms), *c*.1897

refused. A few minutes later a child silently laid at the side of my door some food cleanly done up in freshly picked leaves, then withdrew. I was hungry, so silently I accepted. A little later the man went by and with a kindly expression, without stopping, said to me a single word: '*Paia?*' I understood vaguely. 'Are you satisfied?'

On the ground under some clusters of broad pumpkin leaves I caught sight of a small dark head with quiet eyes. A little child was examining me, then made off timorously when its eyes met mine . . . These black people, these cannibal teeth, brought the word 'savages' into my mouth.

For them, too, I was the savage. Rightly perhaps.

I began to work – notes, sketches of all kinds. Everything in the landscape blinded me, dazzled me. Coming from Europe I was constantly uncertain of some colour [and kept] beating about the bush: and yet it was so simple to put naturally on to my canvas a red and a blue. In the brooks, forms of gold enchanted me – Why did I hesitate to pour that gold and all that rejoicing of the sunshine on to my canvas? Old habits from Europe, probably – all this timidity of expression [characteristic] of our bastardized races –

IV

Every day gets better for me, in the end I understand the language quite well, my neighbours (three close by, the others at various distances) regard me almost as one of themselves; my naked feet, from daily contact with the rock, have got used to the ground; my body, almost always naked, no longer fears the sun; civilization leaves me bit by bit and I begin to think simply, to have only a little hatred for my neighbour, and I function in an animal way, freely . . . I have a native friend, who has come to see me every day naturally, without any interested motive . . .

146　BLACK PIGS AND HEAD OF A TAHITIAN WOMAN,
　　page 63 from *Noa Noa* (Louvre ms), *c*.1897

147　PAPE MOE (MYSTERIOUS WATER), 1893–1894

One day I wished to have a tree of rosewood for sculpture, a piece of considerable size and not hollow. 'For that,' he told me, 'you must go up the mountain to a certain place where I know several fine trees that might satisfy you. If you like, I'll take you there and we'll carry it back, the two of us.'

We left in the early morning.

The Indian paths in Tahiti are quite difficult for a European: between two unscalable mountains there is a cleft where the water purifies itself by twisting between detached boulders, rolled down, left at rest, then caught up again on a torrent day to be rolled down further, and so on to the sea. On either side of the stream there cascades a semblance of a path: trees pell-mell, monster ferns, all sorts of vegetation growing wilder, more and more impenetrable as you climb towards the centre of the island.

We went naked, both of us, except for the loincloth, and axe in hand ... Complete silence – only the noise of water crying against rock, monotonous as the silence. And two we certainly were, two friends, he a quite young man and I almost an old man in body and soul, in civilized vices: in lost illusions. His lithe animal body had graceful contours, he walked in front of me sexless ...

From all this youth, from this perfect harmony with the nature which surrounded us, there emanated a beauty, a fragrance (*noa noa*) that enchanted my artist soul ...

I had a sort of presentiment of crime, the desire for the unknown, the awakening of evil ...

... He had not understood. I alone carried the burden of an evil thought, a whole civilization had been before me in evil and had educated me.

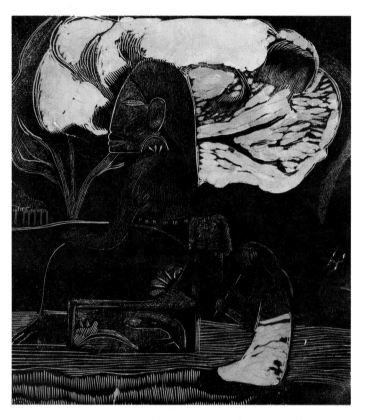

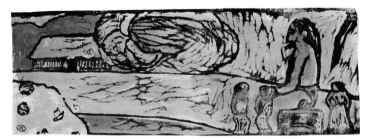

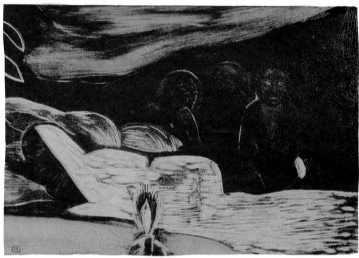

148 MARURU, page 59 from *Noa Noa* (Louvre ms),
 1894/1897

149 FRAGMENTS OF MANAO TUPAPAU (top) AND TE PO
 (THE NIGHT), unnumbered page from *Noa Noa* (Louvre
 ms), 1894/1897

We were reaching our destination. – At that point the crags of the mountain drew apart, and behind a curtain of tangled trees a semblance of a plateau [lay] hidden but not unknown. There several trees (rosewood) extended their huge branches. Savages both of us, we attacked with the axe a magnificent tree which had to be destroyed to get a branch suitable for my desires. I struck furiously and, my hands covered with blood, hacked away with the pleasure of sating one's brutality and of destroying something . . .

Well and truly destroyed indeed, all the old remnant of civilized man in me. I returned at peace, feeling myself thenceforward a different man, a Maori. The two of us carried our heavy load cheerfully, and I could again admire, in front of me, the graceful curves of my young friend – and calmly . . .

VI

Journey round the island

. . . I ride along the East coast, not much frequented by Europeans. Arrived at Faone, the small district that comes before that of Itia, a native hails me. 'Hey! man who makes men' (he knows that I am a painter), 'come and eat with us' . . . I go into a house where several men, women and children are gathered, sitting on the ground chatting and smoking – 'Where are you going?' says a fine Maori woman of about forty. 'I'm going to Itia.' 'What for?' An idea passed through my brain. I answered: 'To look for a wife. Itia has plenty, and pretty ones.' 'Do you want one?' 'Yes.' 'If you like I'll give you one. She's my daughter.'

'Is she young?' 'AE' –

'Is she pretty?' 'AE' –

'Is she in good health?' 'AE' –

'Good, go and fetch her for me.'

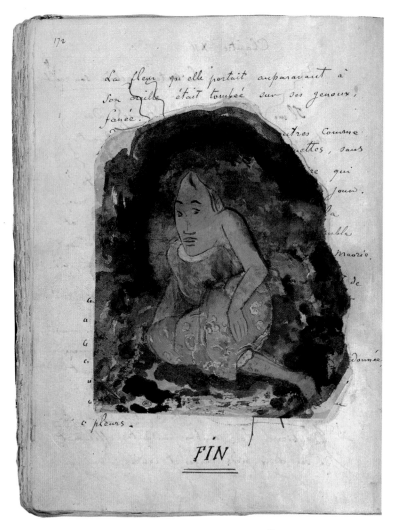

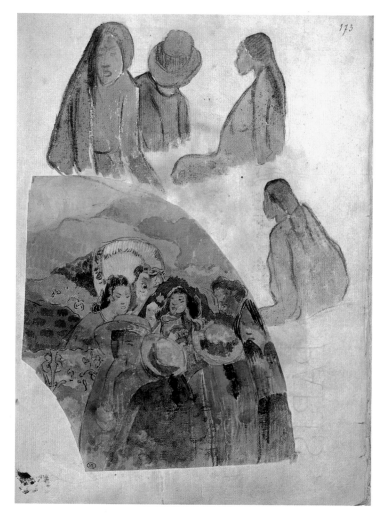

150 SEATED TAHITIAN WOMAN, page 172 from *Noa Noa*
(Louvre ms), *c.*1896–1897

151 TAHITIAN FIGURES, page 173 from *Noa Noa*

She went away for a quarter of an hour; and as they brought the Maori meal of wild bananas and some crayfish, the old woman returned, followed by a tall young girl carrying a small parcel. Through her excessively transparent dress of pink muslin the golden skin of her shoulders and arms could be seen. Two nipples thrust out firmly from her chest. Her charming face appeared to me different from the others I had seen on the island up to the present, and her bushy hair was slightly crinkled. In the sunshine an orgy of chrome yellows. I found out that she was of Tongan origin.

When she had sat down beside me I asked her some questions:

'You aren't afraid of me?' '*Aita* (no).'

'Would you like to live always in my hut?' '*Eha.*'

'You've never been ill?' '*Aita.*'

That was all. And my heart throbbed as, impassively, she laid out on the ground before me, on a large banana-leaf, the food that was offered me. Though hungry, I ate timidly. That girl – a child of about 13 – enchanted me and scared me: what was going on in her soul? and at this contract so hastily thought of and signed I felt a shy hesitation about the signing – I, nearly an old man.

VII

My new wife was not very talkative, [she was] melancholy and ironic. We observed each other: she was impenetrable, I was quickly beaten in that struggle – in spite of all my inward resolutions my nerves rapidly got the upper hand and I was soon, for her, an open book . . .

...The life of every day – Tehamana yields herself daily more and more, docile and loving; the Tahitian *noa noa* pervades the whole of me; I am no longer conscious of the days and the hours, of Evil and of Good – all is beautiful – all is well. Instinctively, when I am working, when I am meditating, Tehamana keeps silent, she always knows when to speak to me without disturbing me.

Conversations about what happens in Europe, about God, about the Gods. She learns from me, I learn from her...

X

I had to go back to France – imperative family duties called me back. – Goodbye, hospitable soil. – I went away two years older, younger by twenty years; more of a barbarian, too, and yet knowing more.

When I left the jetty to go aboard, Tehamana, who had wept for several nights [and was now] tired [and] melancholy, had sat down on the stone; her legs dangled, letting both her sturdy feet brush the salt water. The flower she had been wearing over her ear had fallen into her lap, faded...

*

[Paris, 5 February 1894]

To METTE

The mishap I had in Tahiti was almost fatal; due to privations and anguish, my heart had become very weakened... The doctor says a relapse would be permanent and I must take great care of myself in the future.

So if you are going to carry on writing me letters in the future like the ones you have written since my return I beg you to desist. My work is not finished and I must live. Consider that...

Try to see if it's possible to exchange the Cézanne with the red roofs for one of my canvases. You told me some time ago that Brandès bought them from you with the option of your taking them back at the purchase price. In this case I would prefer to buy it back with the interest on the money. *I would dearly love* to have that picture. In which case you could send it to me with the pair of swords which I may need one day or another.

I await a reply to all these questions.

PAUL GAUGUIN

*

[Paris, February 1894]

To DANIEL DE MONFREID

I've finally received a letter from you...

I've just been to Belgium for 6 days; a lovely trip: I saw some Memlings in Bruges. What wonders, my friend, and then afterwards, when you see Rubens (the beginning of naturalism), everything falls apart.

I'm writing to you in haste in order to send you a reply immediately and tell you that I'm living fairly well and that my lawyer has finally deposited the money in my chaste hands. I'm writing to tell you this so that you know not to *worry about the brass*...

152 PARIS IN THE SNOW, 1894

Paris, 29 March 1894

To Jo van Gogh-Bonger For some years now I have been constantly travelling, and
as a result I have not bothered to retrieve the paintings by Vincent that *belonged* to me; they
include, among other things, a *berceuse* (a woman sitting in an armchair), the head of a woman
of Arles, done after a drawing of mine, and a sunset over Arles... You will understand, I hope,
that being an intimate *friend* of Vincent's, his memory is most dear to me, and I am most eager
to have these pictures in my possession...

*

Pont-Aven [May 1894]

To William Molard ... I am in too much pain to be able to concentrate on
writing...
My leg is broken close to the ankle and the bone came right through the skin.
Because of Anna, they threw stones at us in Concarneau. With two punches I knocked down
a pilot who had attacked me, then he went to fetch the crew of his boat and fifteen men fell on
me. I took them all on, and kept the upper hand, until my foot caught in a hole and in falling I
broke my leg. Whilst I was on the ground they went on kicking me with their clogs, until at
last I was extricated. I had to be carried to Pont-Aven, and am nursing my wounds.
Fini ... can't more.

P. Go

153 BRETON VILLAGE IN THE SNOW, 1894

[Pont-Aven, late August 1894]

TO WILLIAM MOLARD . . . Yes, I'm managing to limp with a stick and it's desperate
for me not to be able to venture out to paint a landscape; nevertheless over the last week I've
started to pick up my brushes again. This whole succession of misfortunes, the difficulty of
earning a *regular* living in spite of my reputation, together with my taste for the exotic, have
led me to take an irrevocable decision. And this is it.

In December I will return [to Paris] and every day I'll work at selling everything I own,
either 'en bloc' or piecemeal. Once I have the capital in my pocket, I will set out again for the
South Seas, this time with two comrades from here, Seguin and an Irishman . . .

*

Paris, 16 January 1895

TO DURAND-RUEL I have a business proposition to put to you which you can
think over . . . I am absolutely determined to go back to the islands of Oceania for many years
so I can study there seriously and in peace. I think that such a disappearance is the equivalent
of a death. It would follow, don't you agree, that the few pictures I leave behind in France will
quickly increase in value?

Given that, first, my name is well known and well thought of among artists – second, that
the movement in this direction is gaining strength daily, placed as you are I believe you could
easily push my pictures up to the sort of price that I have obtained for several in any case.

154 AHA OE FEII? (WHAT ARE YOU JEALOUS?), 1894

So I am making you an offer of thirty-five canvases (most of which you know), which you can look over carefully, for the sum of 21000 frs. which is the minimum sum I need for my enterprise. That makes an average of 600 frs. which isn't a high price relatively speaking...

I hope, Monsieur Durand, that you would be good enough to give me an answer in the next few days.

*

[Paris, 5 February 1895]

TO AUGUST STRINDBERG I received your letter today; your letter which is a preface
for my catalogue. I thought of asking you for that preface the other day, when I saw you
playing the guitar and singing in my studio. Your Nordic blue eyes looked attentively at the
paintings hanging on the walls. I felt stirrings of rebellion: a whole clash between your
civilization and my barbarism.

Civilization from which you suffer. Barbarism which for me is a rejuvenation.

Seeing Eve as I choose to paint her, using shapes and harmonies of another world, your most
vivid memories may have evoked a painful past. The Eve of your civilized conception makes
you and almost all of us in fact misogynists; the ancient Eve who frightens you in my studio
might well smile at you less bitterly one day...

The Eve whom I have painted (and only she) can logically remain naked before your eyes. Your Eve, in that natural attire, would not be able to walk without immodesty, and, too beautiful (perhaps) would conjure up evil and pain.

To make my thoughts clear to you, I will no longer compare these two women directly; instead I will compare the Maori or Turanian language, which my Eve speaks, with the language spoken by the woman you have chosen among all others, an inflected language, a European language.

... Excuse this long digression on philology; I think it is necessary to explain the savage kind of drawing I have had to use in order to decorate a Turanian country and Turanian people.

It remains for me to thank you, dear Strindberg ...

*

[Paris, early March 1895]

To Maurice Denis

You have just written an excellent article on Seguin in *La Plume*. I might quarrel with certain details but I'll take care not to ...

... The reason I am writing to you is that it gives me pleasure to see painters taking their own affairs in hand. I believe you wrote something in *La Revue indépendante* a few years ago, but that was all, and it was not very much.

For some time, and especially since my plan to bury myself in the Pacific islands, I have been conscious of the obligation which rests on you young painters to write sensibly on artistic matters ...

... Go on fighting all of you, with the brush as well as with the pen; in my retreat this will be my fervent wish.

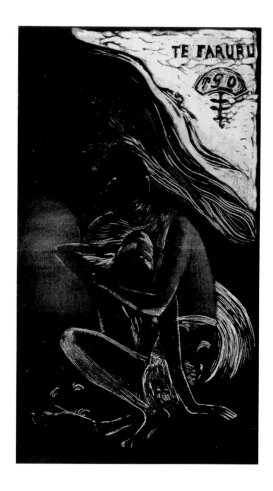

155 TE FARURU (TO MAKE LOVE), 1893–1895

156 VAHINE NO TE VI (WOMAN WITH A MANGO), 1892

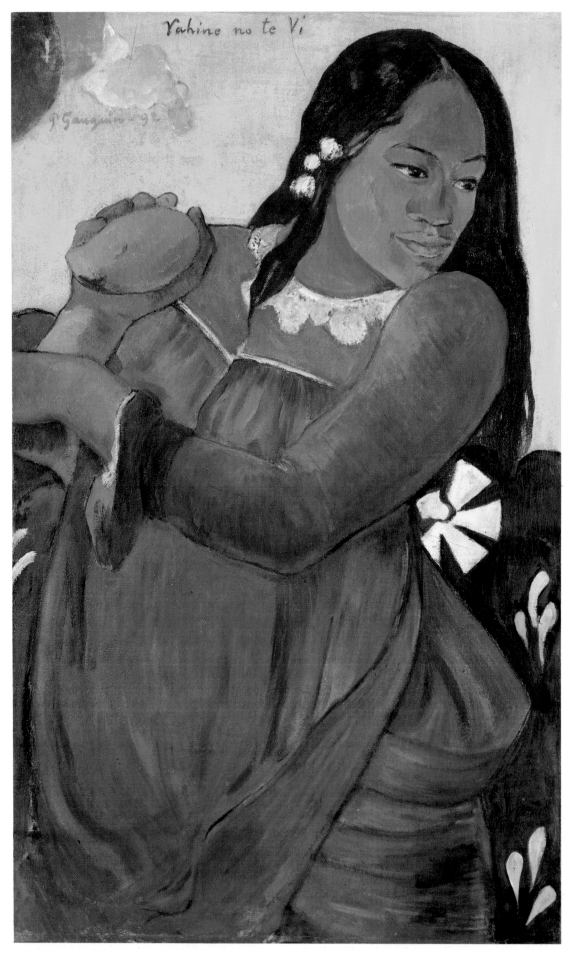

156 VAHINE NO TE VI (WOMAN WITH A MANGO), 1892

157 FAATURUMA (MELANCHOLIC), 1891

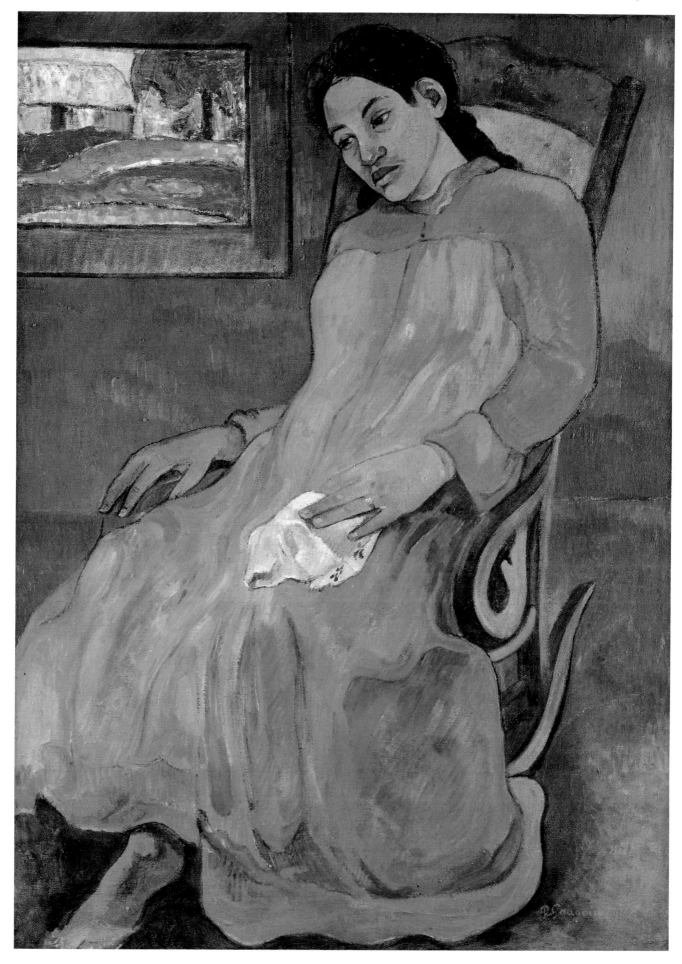

158 THE BLACK PIGS, 1891

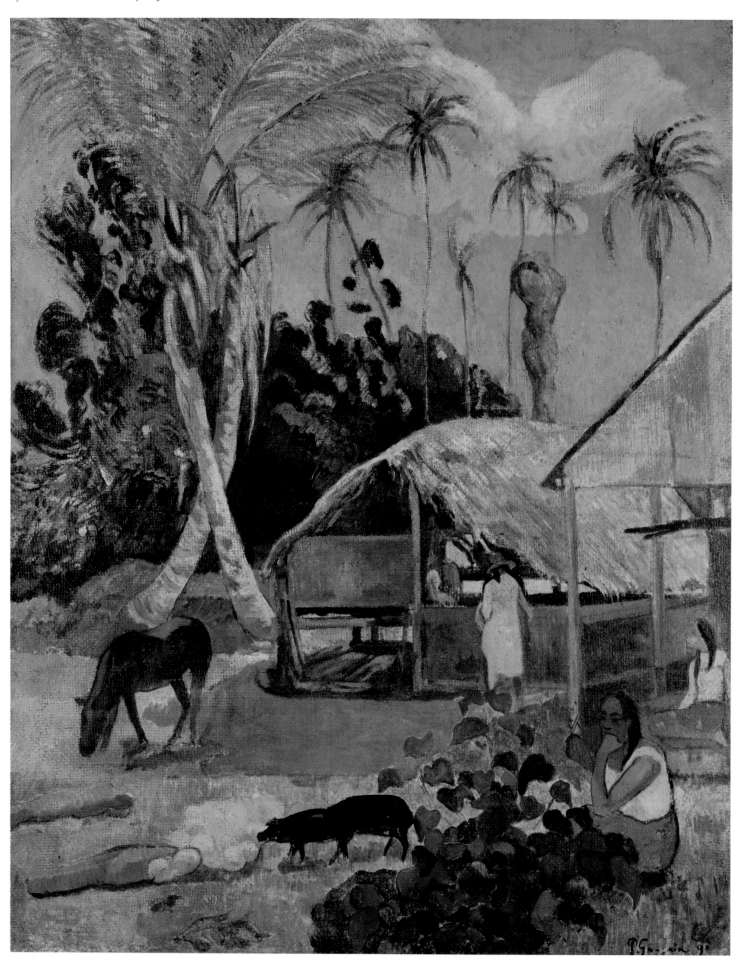

158 THE BLACK PIGS, 1891

159 ROAD IN TAHITI (LANDSCAPE PAPEETE), 1891

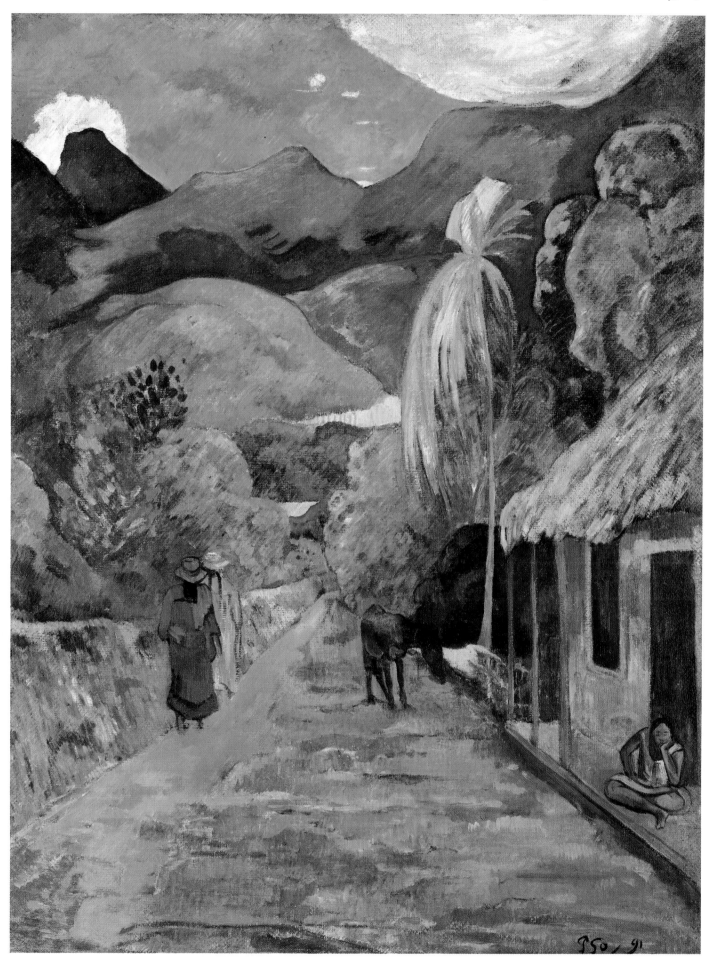

159 ROAD IN TAHITI

160 TE FAATURUMA (THE BROODING WOMAN), 1891

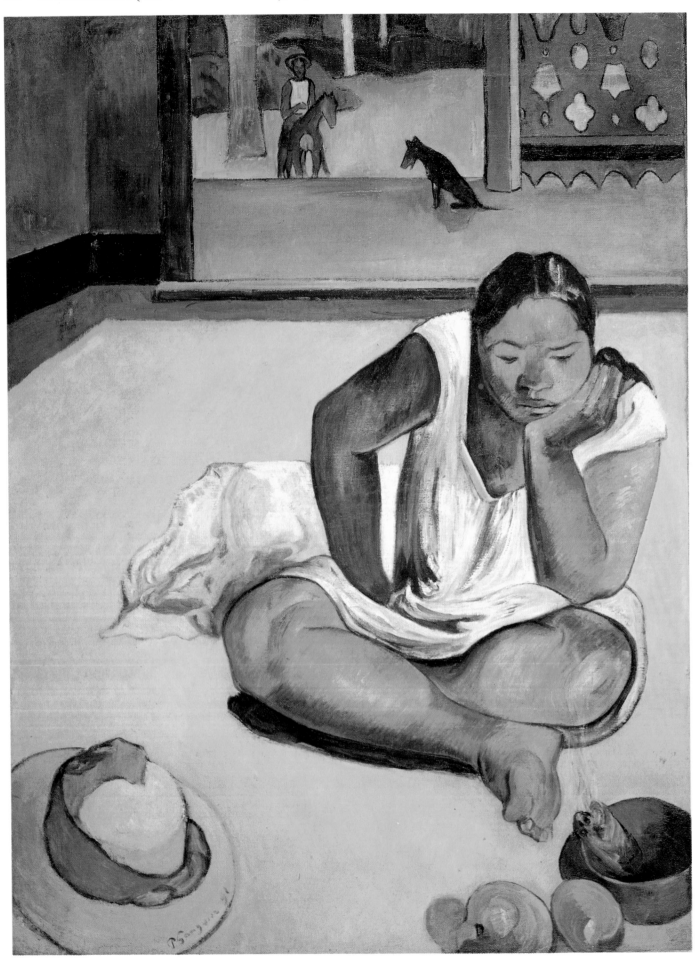

161 PARAU API (NEWS OF THE DAY), 1892

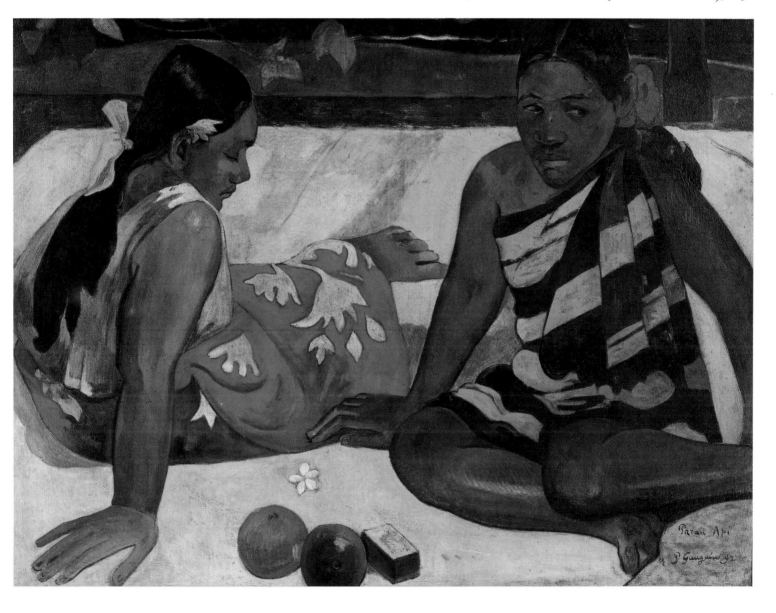

162 THE MEAL (WITH THREE TAHITIANS)/BANANAS, 1891

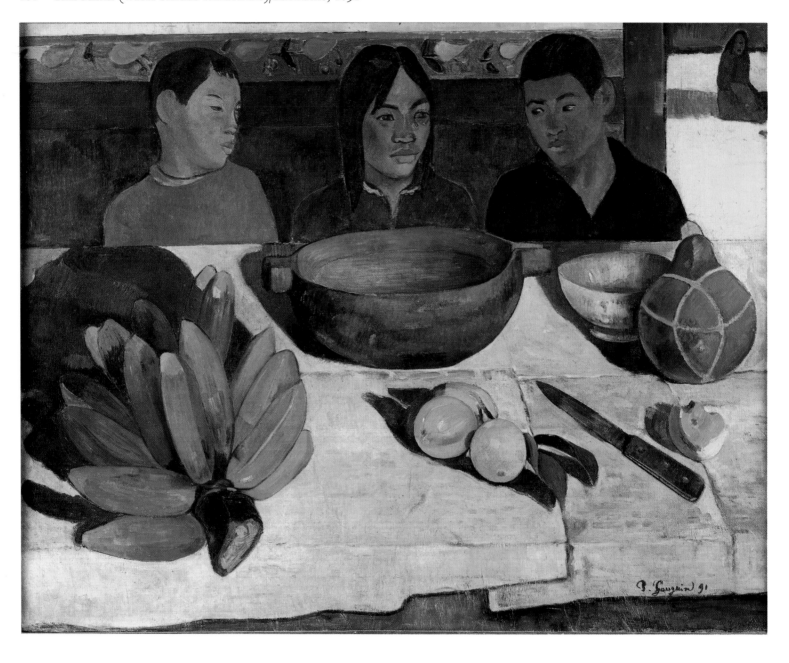

163 TE TIARE FARANI (FLOWERS OF FRANCE), 1891

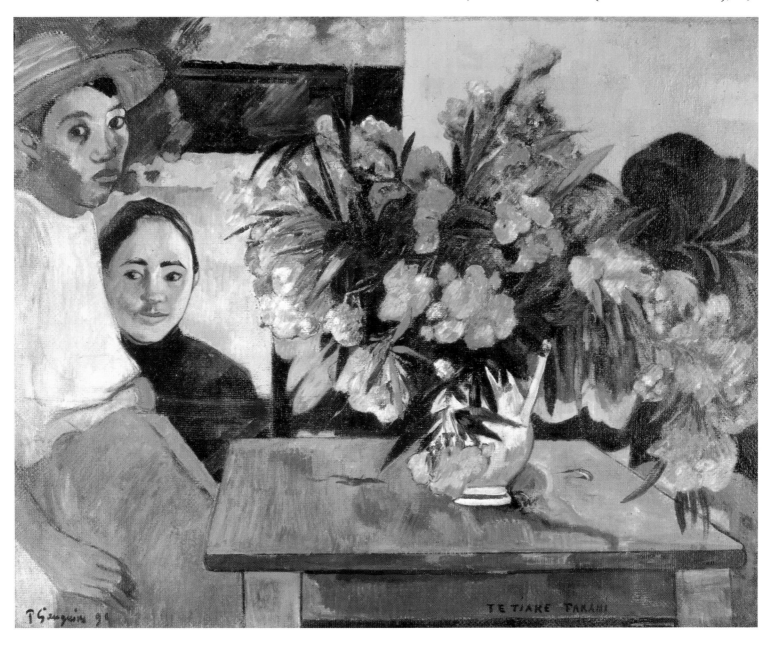

164 TAHITIANS AT REST, *c.*1891

165 THE SIESTA, 1891–1892

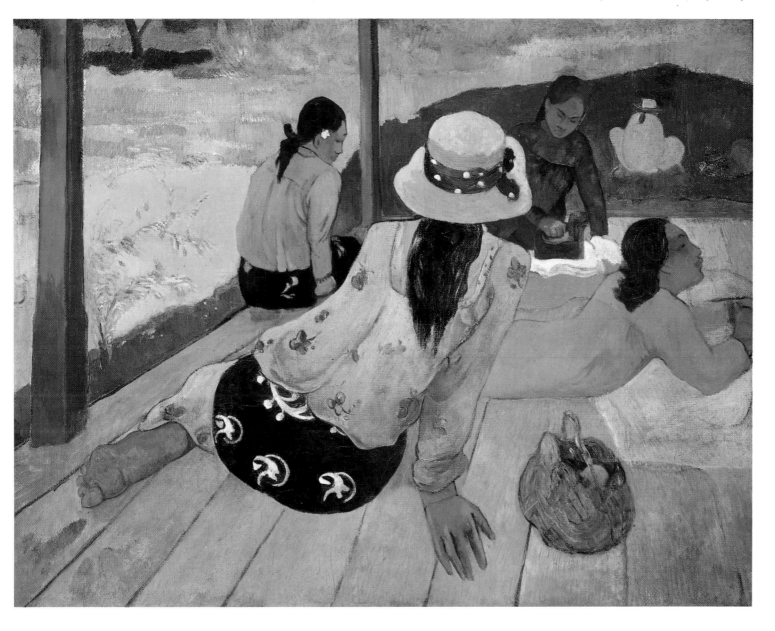

166 IA ORANA MARIA (HAIL MARY), 1891

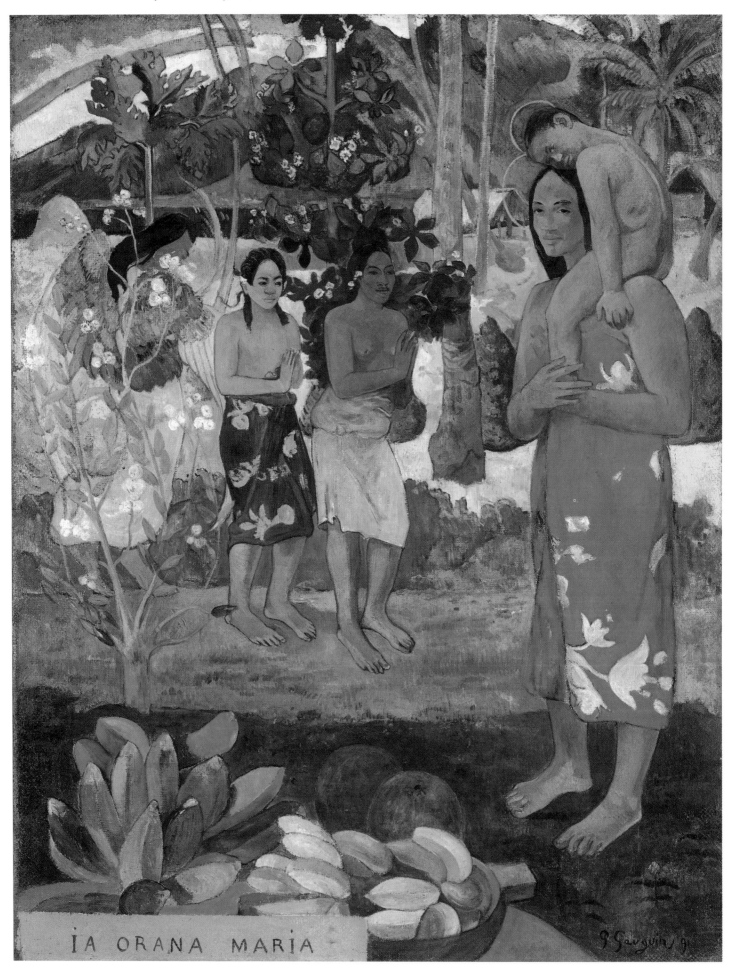

IA ORANA MARIA

P. Gauguin 91

167 VAIRAUMATI TEI OA (HER NAME IS VAIRAUMATI), 1892

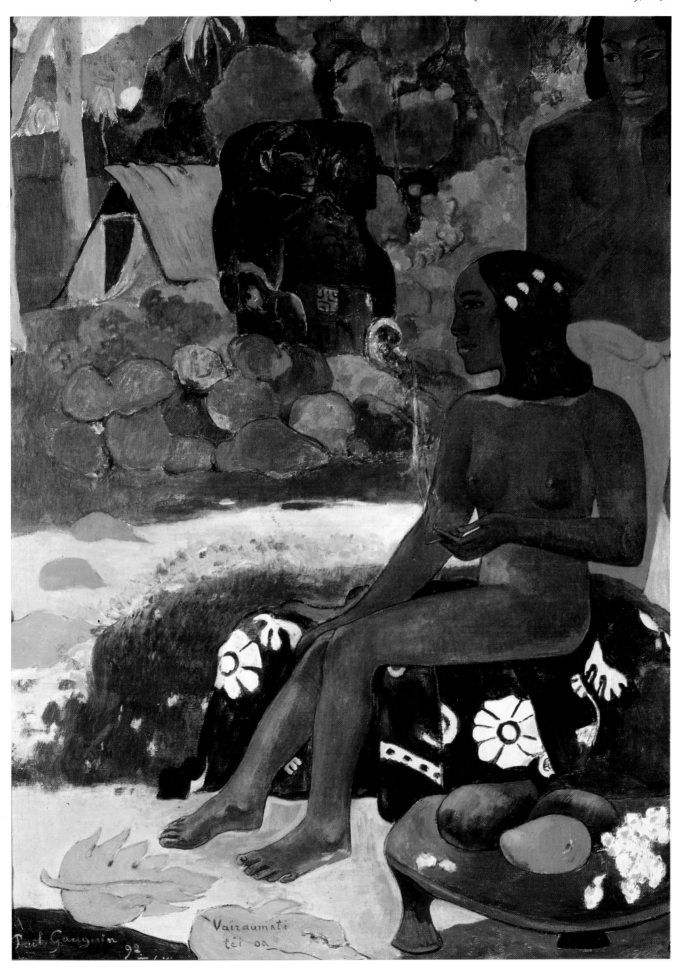

168 MAN WITH AN AXE, 1891

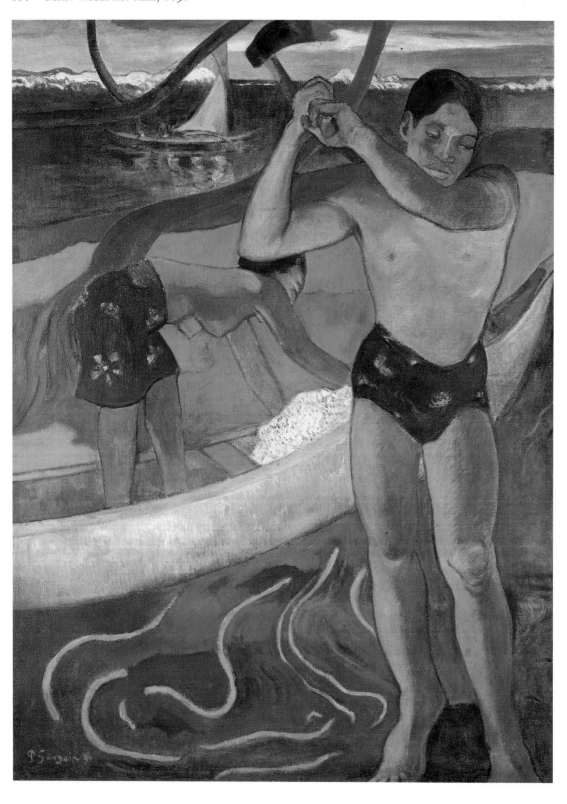

169 MATAMOE (LANDSCAPE WITH PEACOCKS), 1892

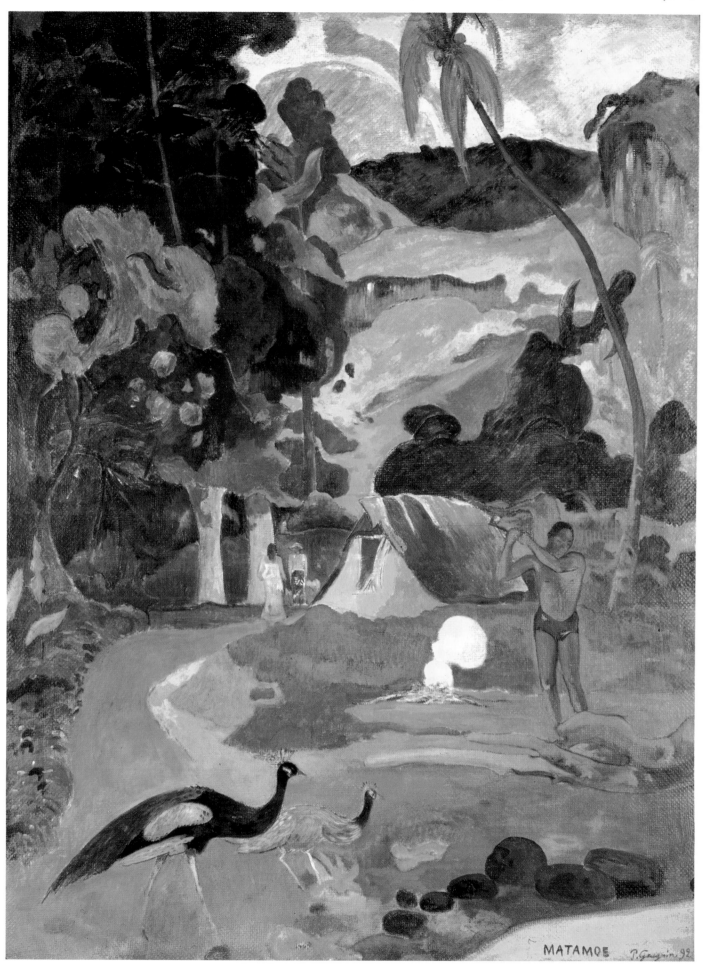

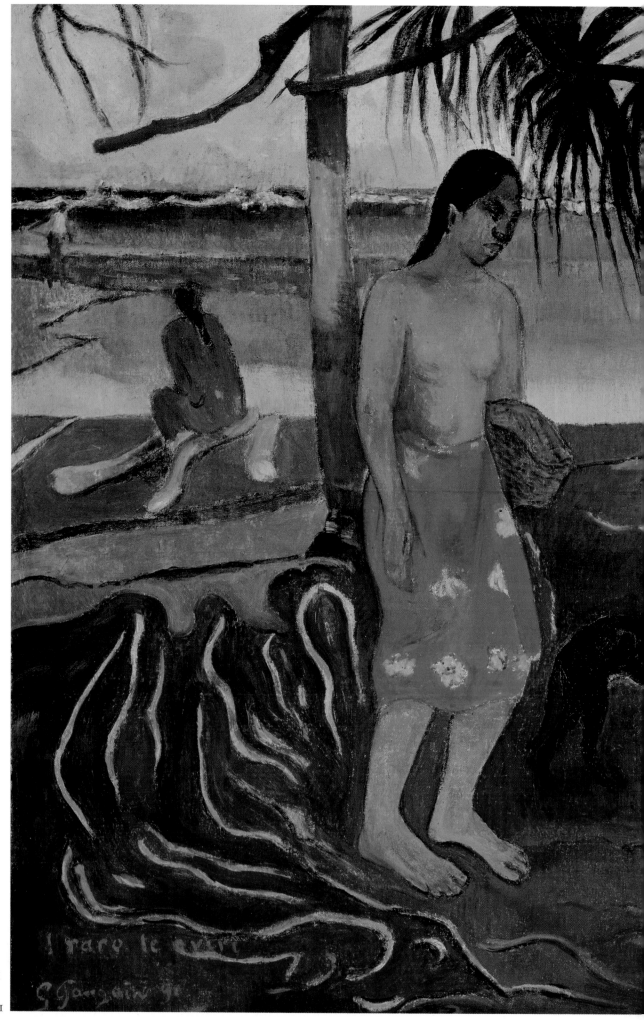

170 I RARO TE OVIRI
 (UNDER THE
 PANDANUS), 1891

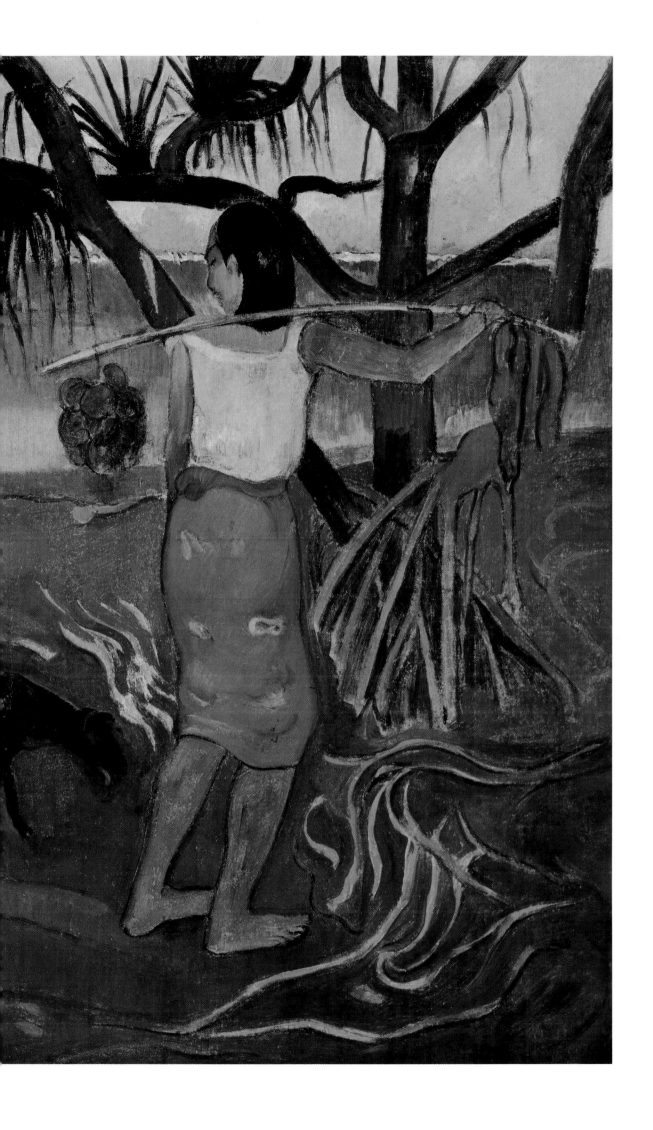

171 PETITES BABIOLES TAHITIENNES (LITTLE TAHITIAN CURIOS), 1892

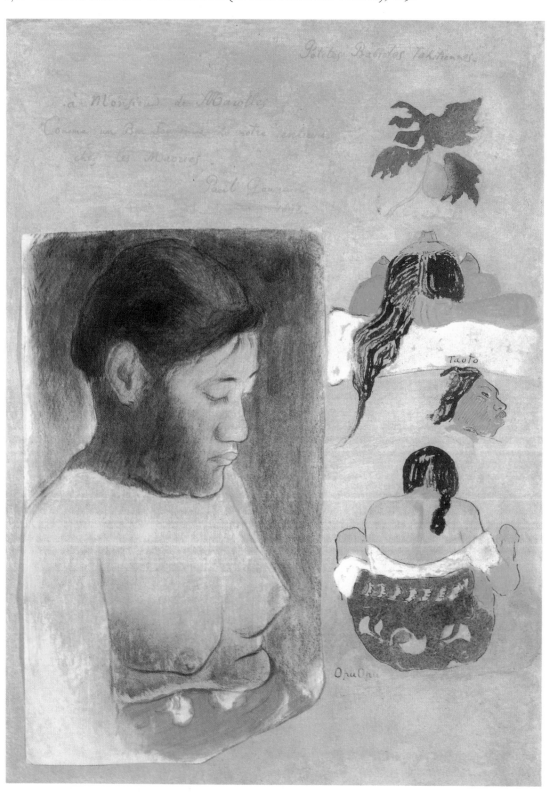

172 TAHITIAN WOMEN BATHING, 1891–1892

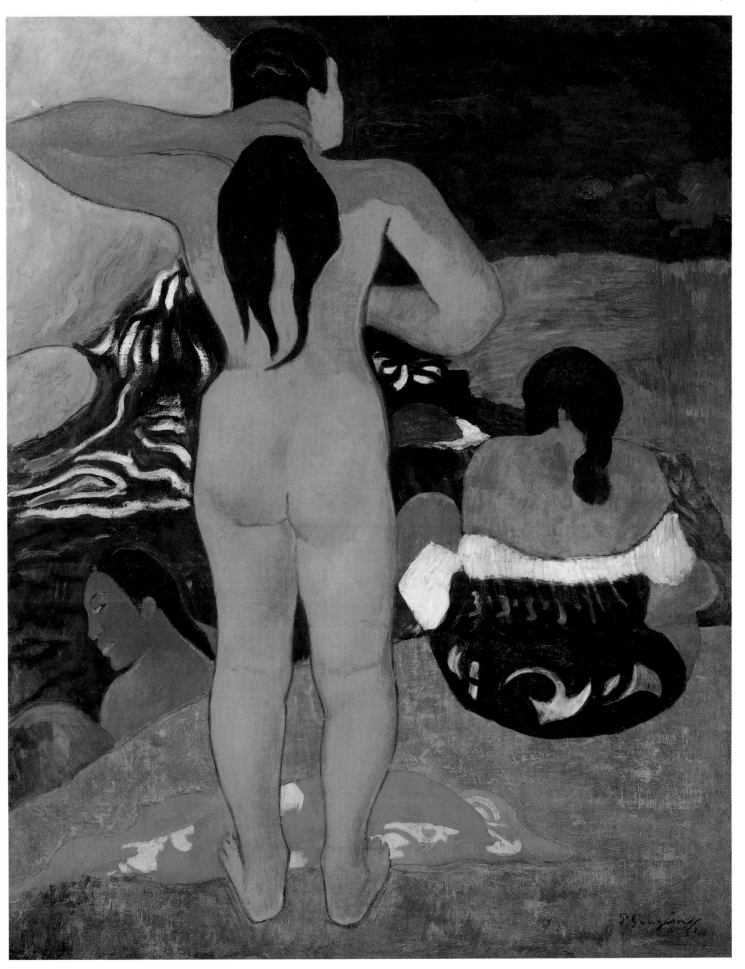

173 ILLUSTRATION TO LEGEND OF ROUA HATOU, 'The God told him to go with all his family . . .'
from *Ancien culte mahorie* (*Ancient Maori Cult*), page 36, 1892–1893

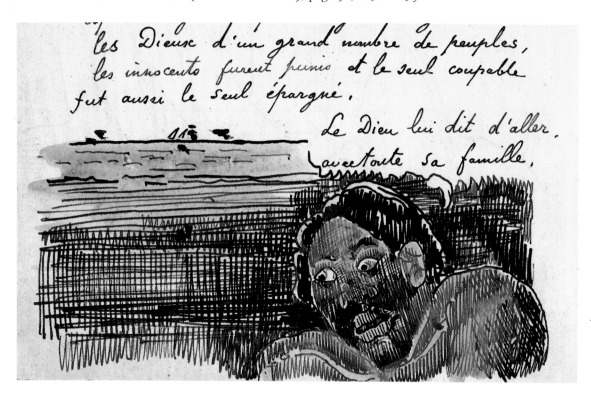

174 ILLUSTRATION TO 'BIRTH OF THE STARS', from *Ancien culte mahorie*
(*Ancient Maori Cult*), page 40, 1892–1893

175 PARAU NA TE VARUA INO (WORDS OF THE DEVIL), 1892

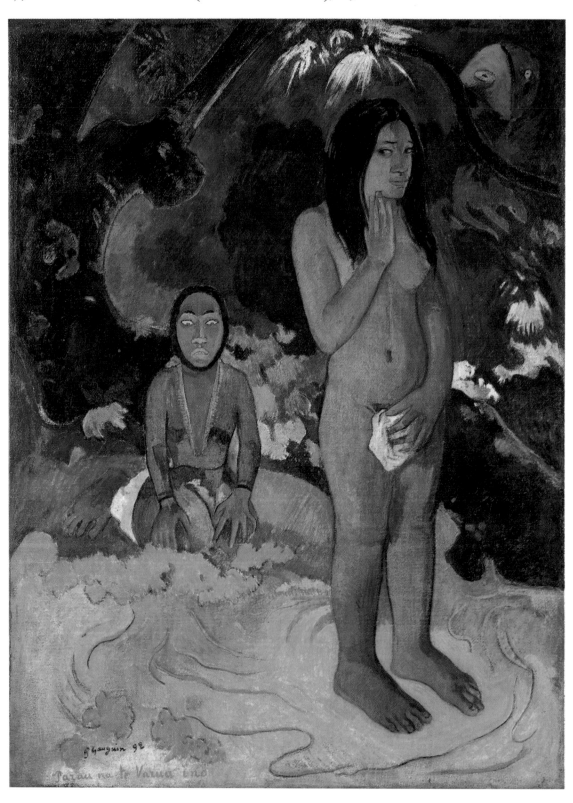

176 PARAHI TE MARAE (THERE LIES THE TEMPLE), 1892

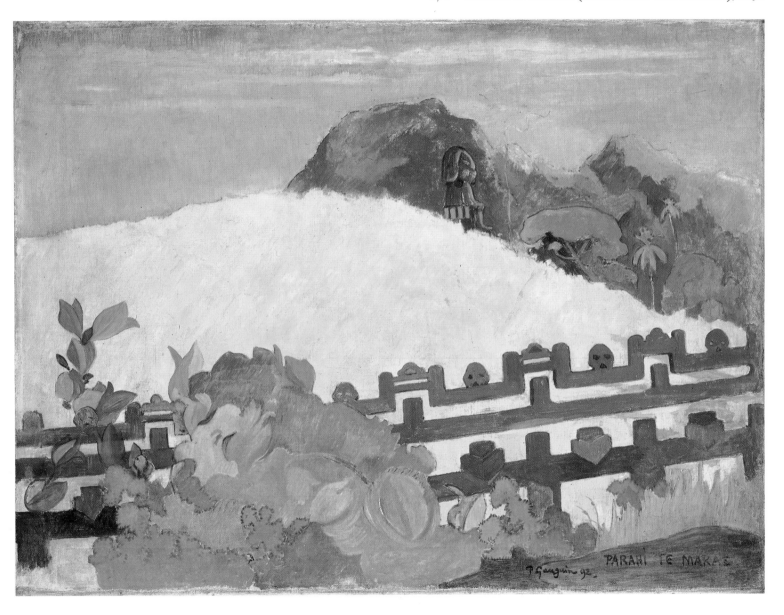

177 TAHITIAN SKETCHES (STUDIES OF TAHITIANS' HEADS), *c.*1892

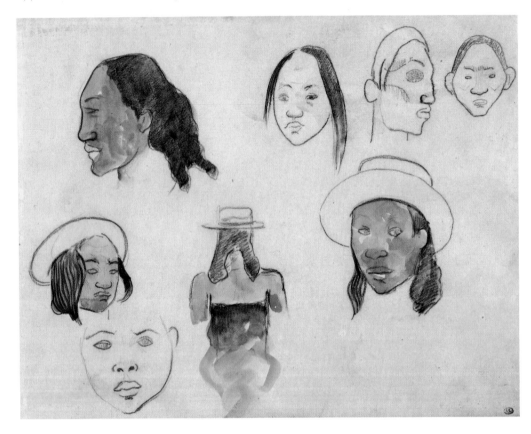

178 TAHITIAN VILLAGE, 1892

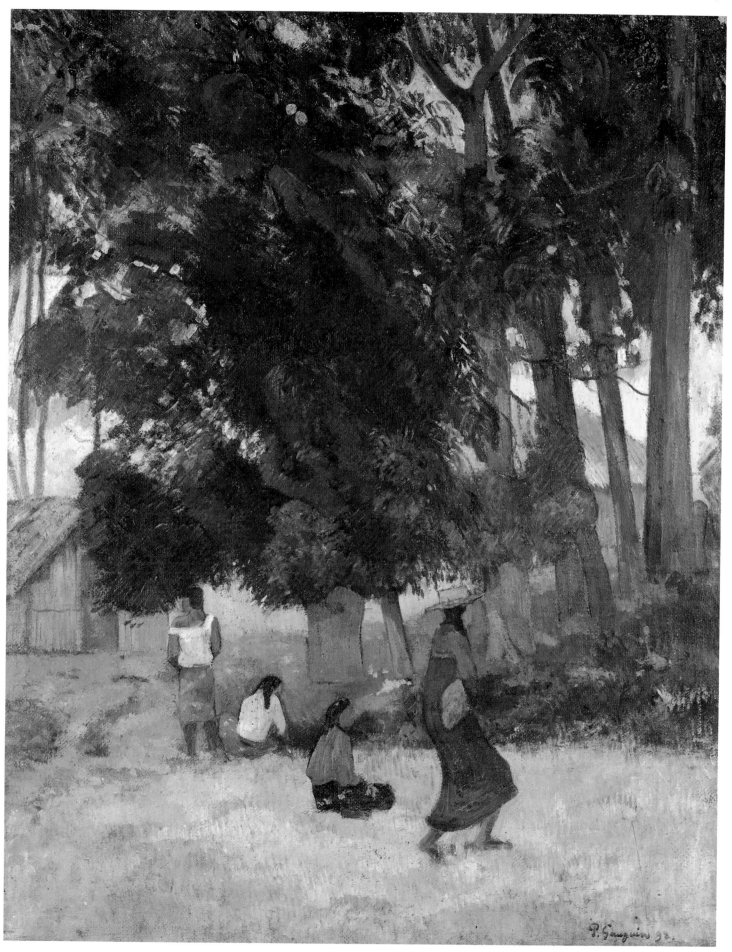

179 CROUCHING TAHITIAN WOMAN, STUDY FOR NAFEA FAAIPOIPO, 1892

180 NAFEA FAAIPOIPO (WHEN ARE YOU GETTING MARRIED?), 1892

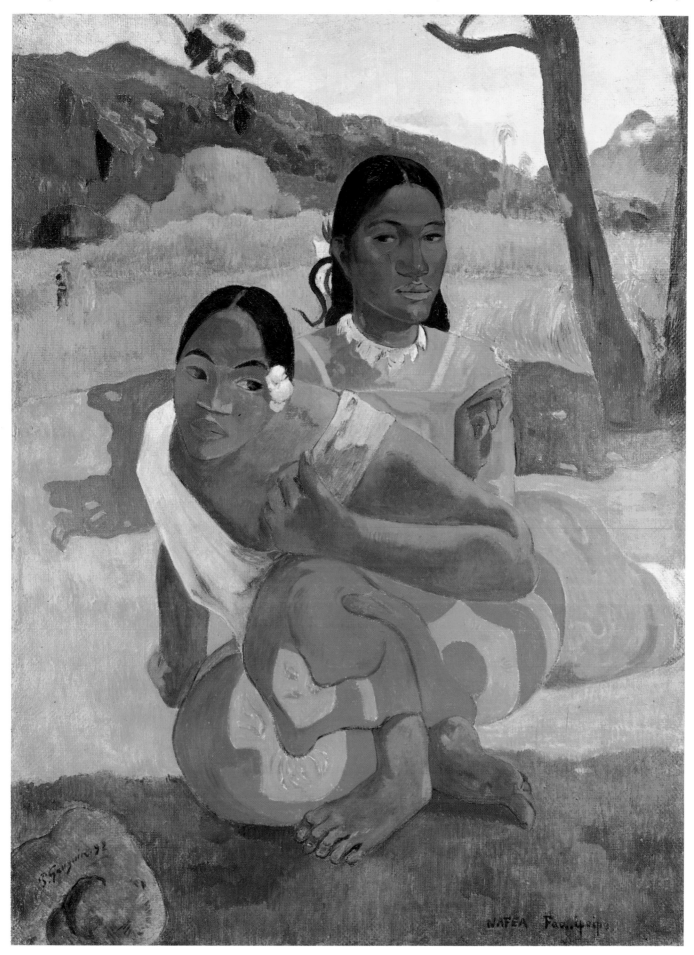

181 HINA AND TE FATOU, 1892

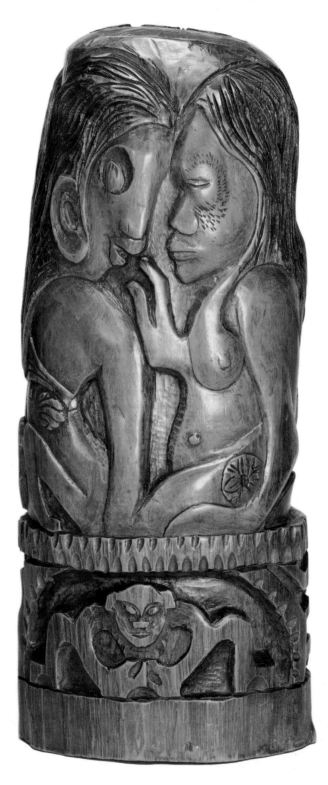

182 IDOL WITH A PEARL, *c.*1892

183 MATAMUA (TIMES GONE BY), 1892

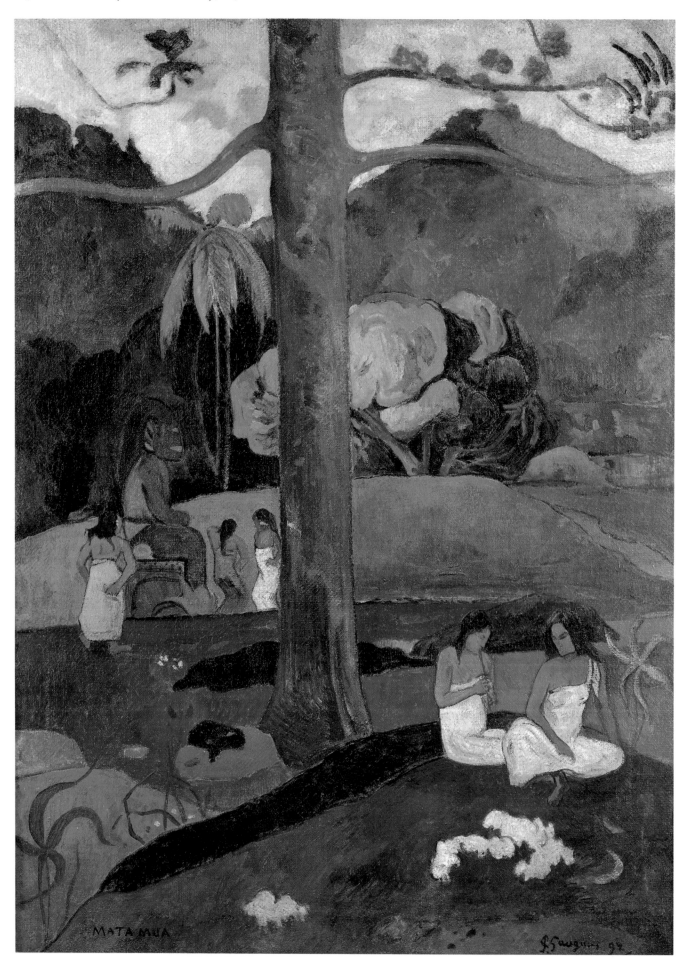

184 AREAREA (THE RED DOG), 1892

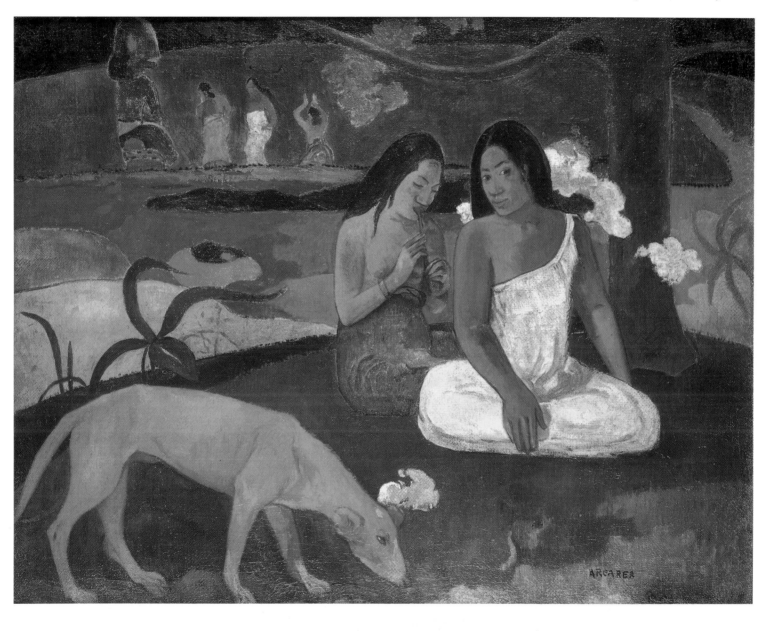

185 E HAERE OE I HIA? (WHERE ARE YOU GOING?), 1892

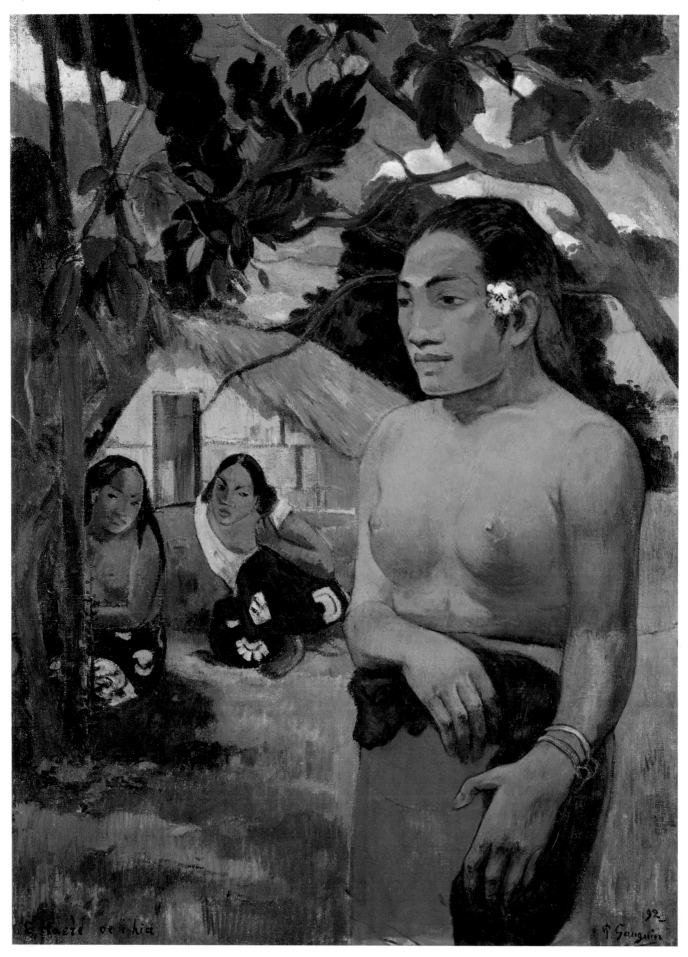

186 EA HAERE IA OE! (WOMAN WITH MANGO), 1893

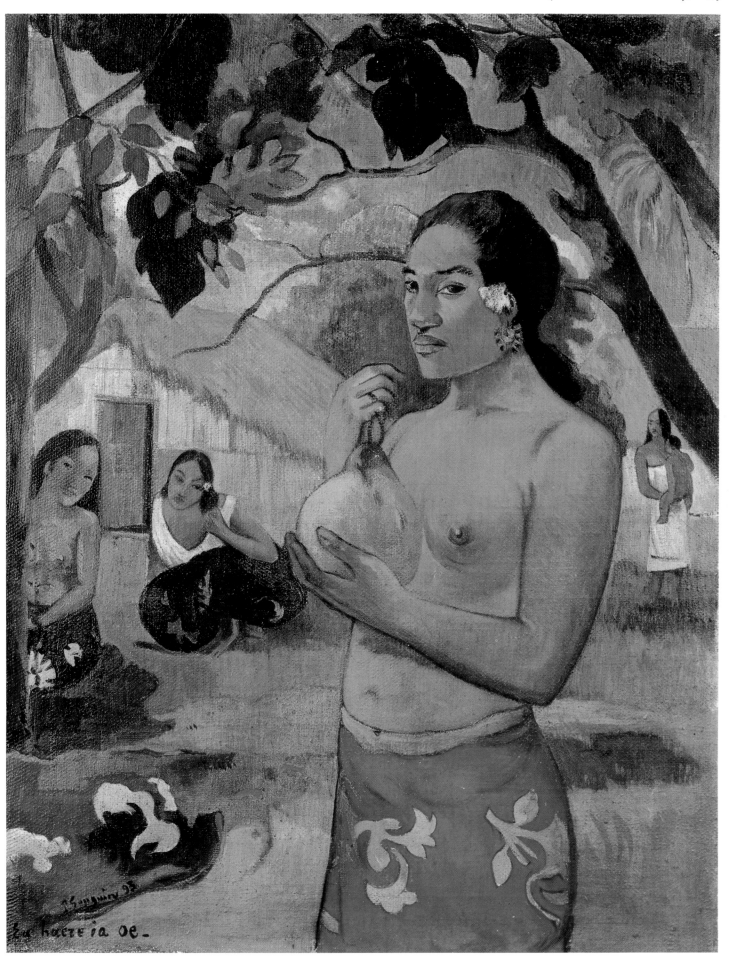

187 FATATA TE MITI (NEAR THE SEA), 1892

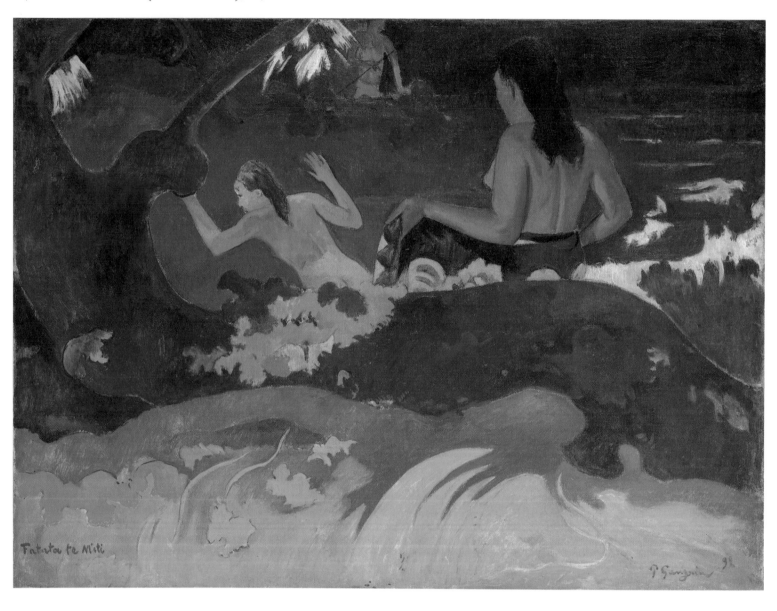

188 OTAHI (ALONE), 1893

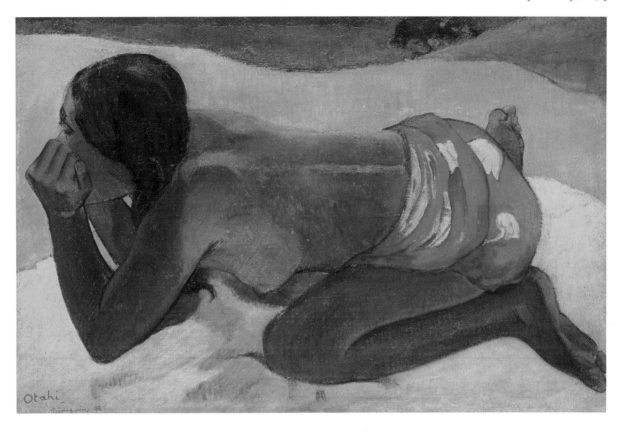

189 MAU TAPORO (THE LEMON PICKER), 1892

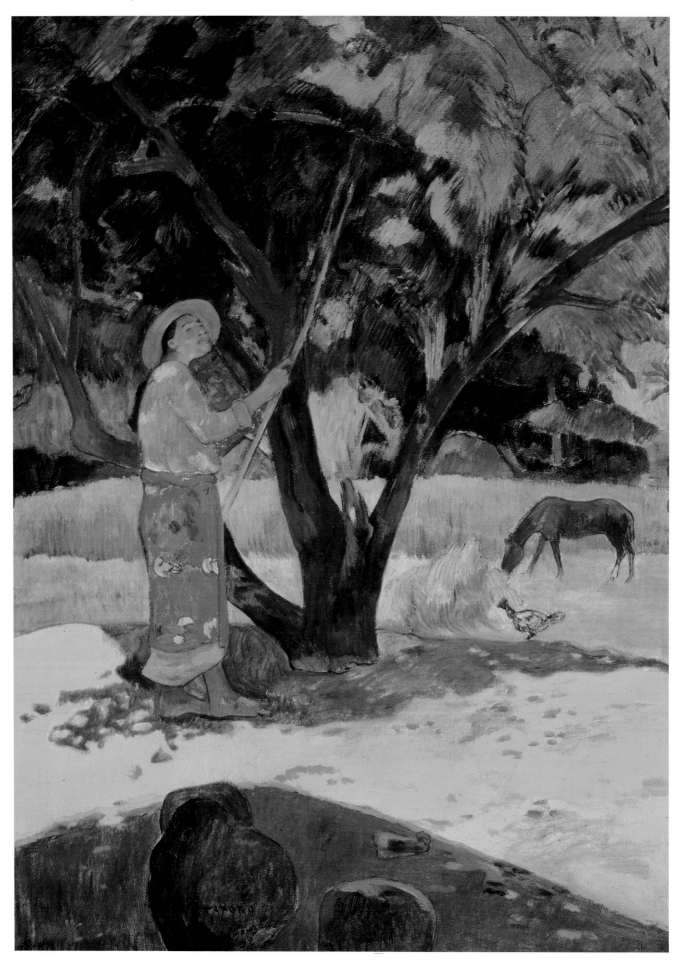

190 PAPE MOE (MYSTERIOUS WATER), 1893

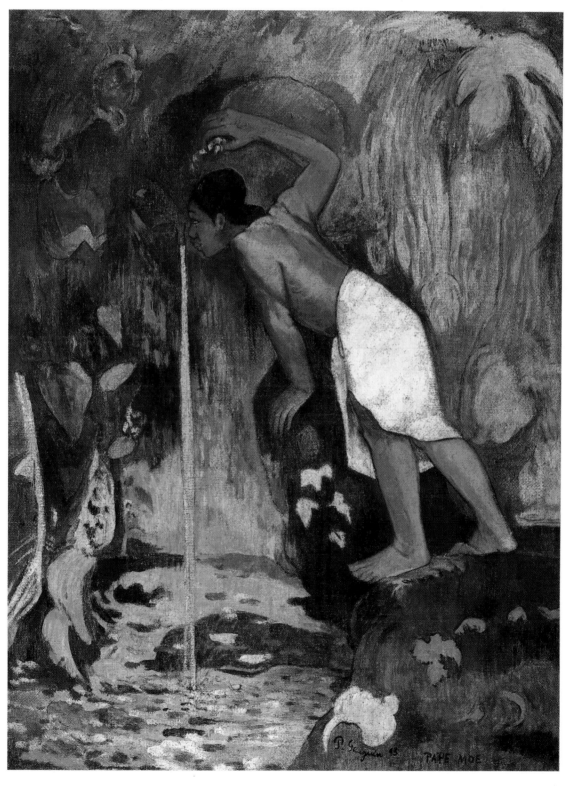

191 CYLINDER DECORATED WITH HINA AND TWO
ATTENDANTS, 1892–1893

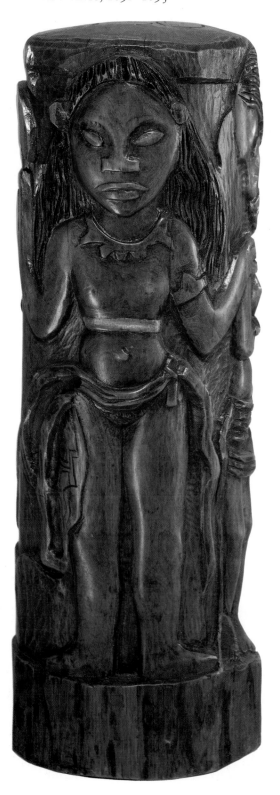

192 MERAHI METUA NO TEHAMANA (ANCESTORS OF TEHAMANA), 1893

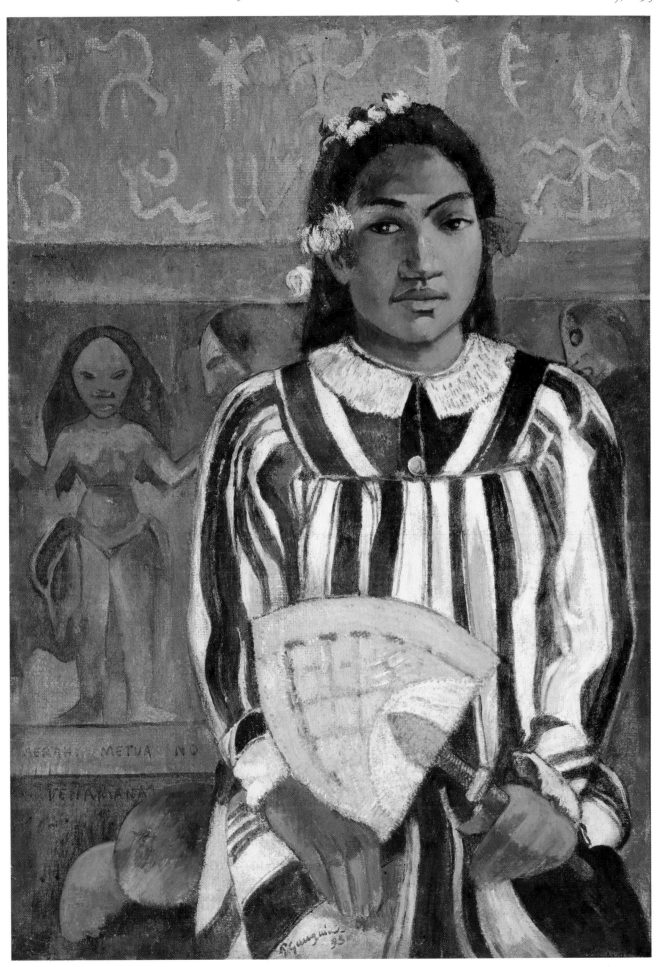

193 AREAREA NO VARUA INO (WORDS OF THE
 DEVIL), 1894

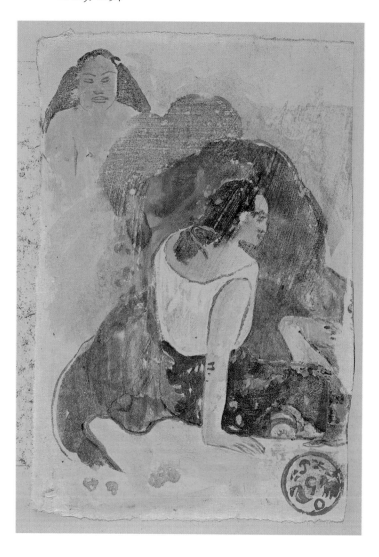

194 AREAREA NO VARUA INO, 1894

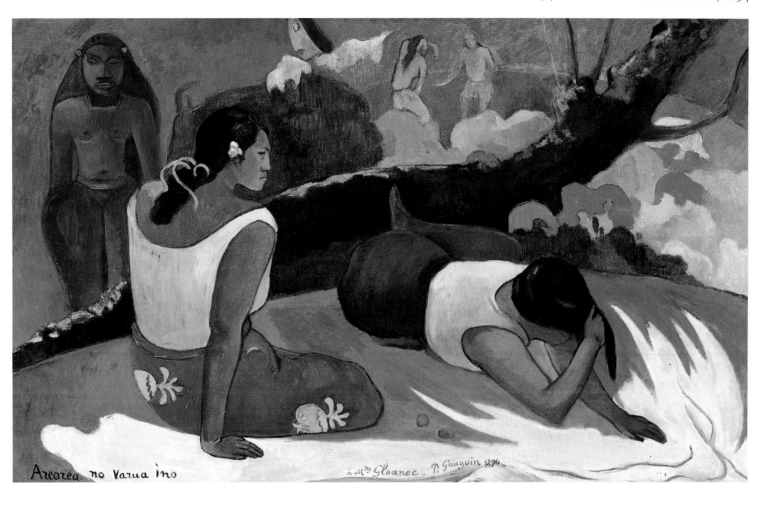

195 NOA NOA (FRAGRANCE), 1894

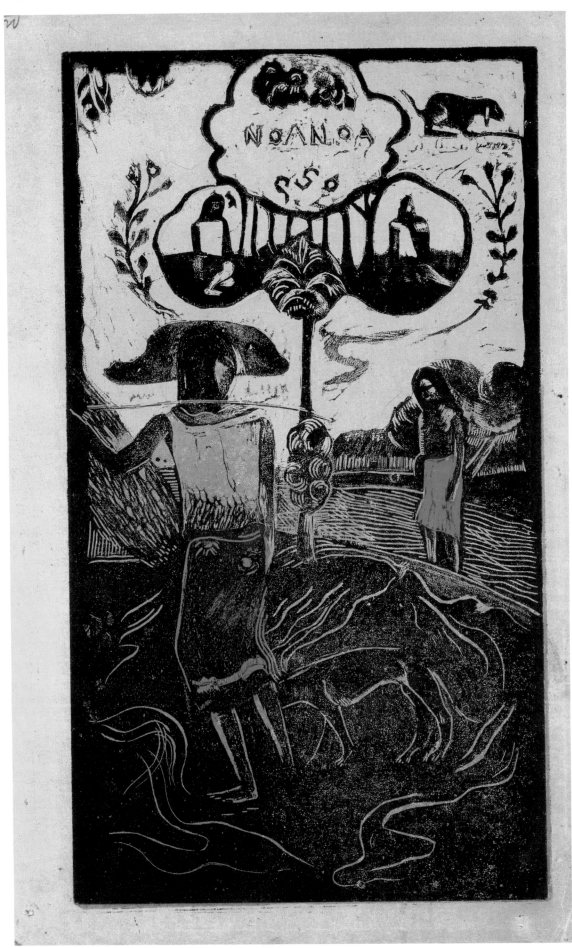

195 NOA NOA (FRAGRANCE), 1894

196 NAVE NAVE FENUA (DELIGHTFUL LAND), 1894

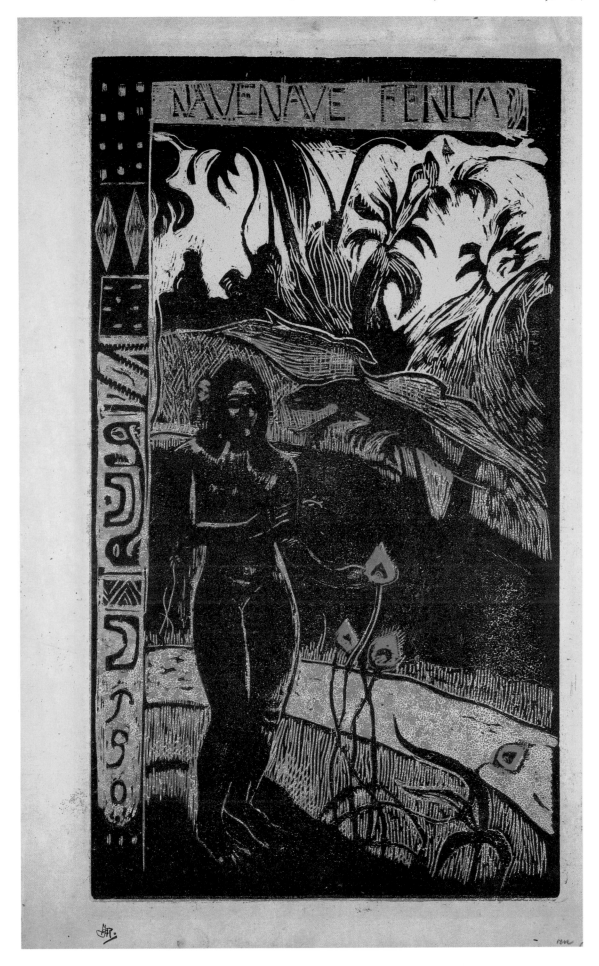

197 NAVE NAVE MOE (SACRED SPRING), 1894

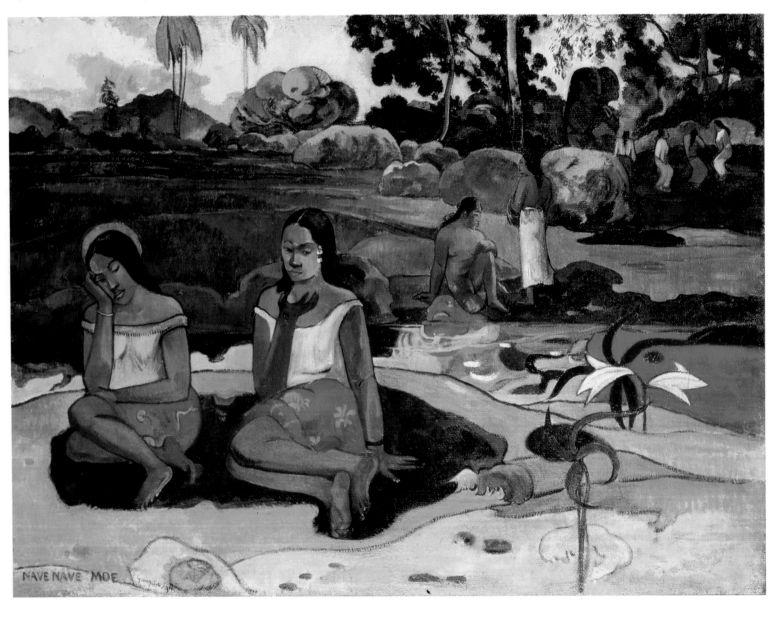

198 MAHANA NO ATUA (THE DAY OF THE GOD), 1894

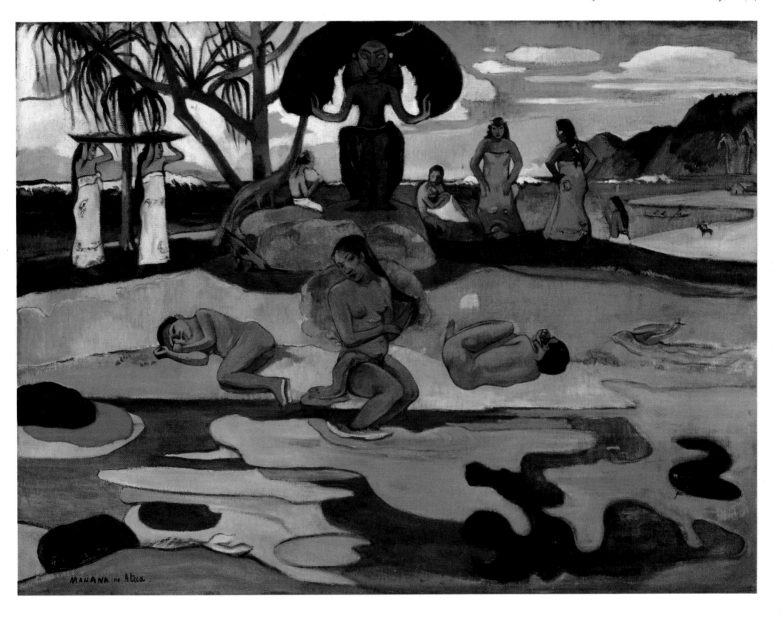

199 BRETON PEASANT WOMEN, 1894

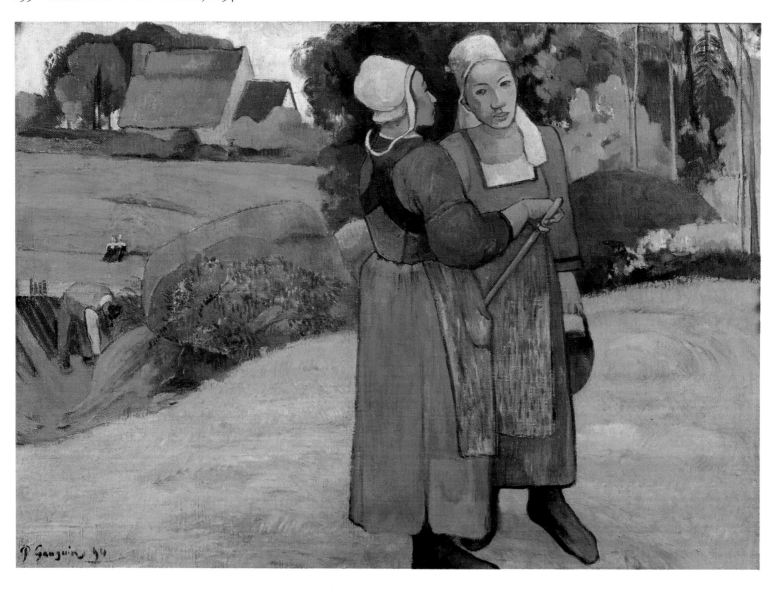

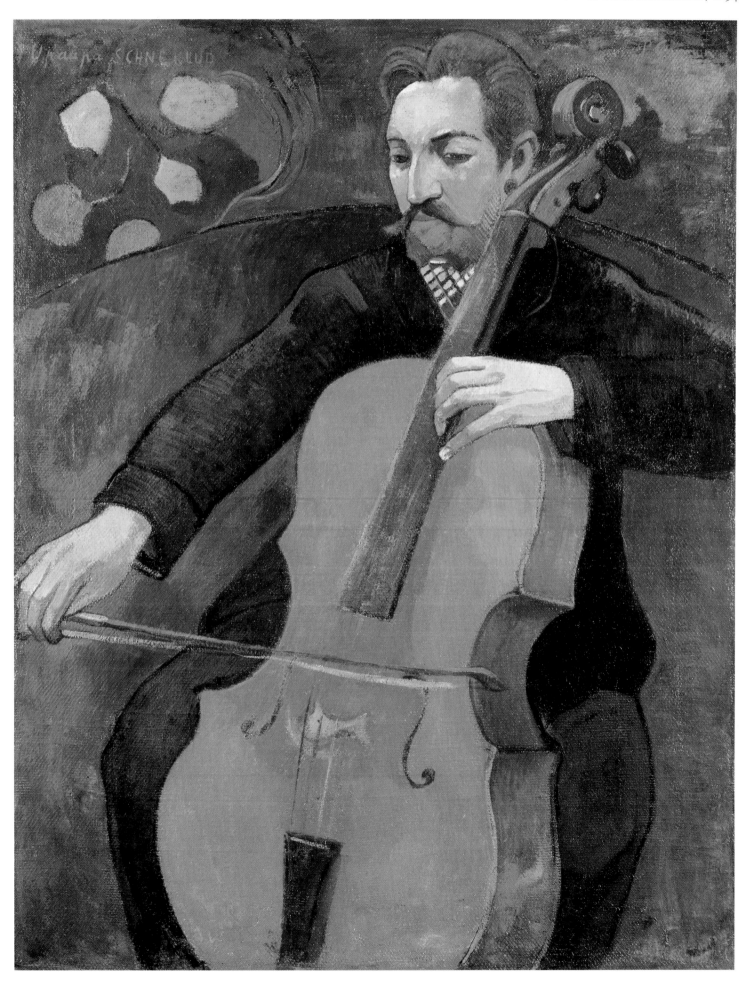

To judge from his regular correspondence with Daniel de Monfreid, the last eight years of Gauguin's life were dominated by problems: after a brief spell of optimistic spending, a chronic shortage of money and worsening health progressively sapped Gauguin's energies. Sales of his work in Paris were scant and friends seemed to renege on their promises to keep him in funds: the publication date of Noa Noa was repeatedly postponed. Gauguin, meanwhile, lavishly embellished his copy of the manuscript.

Several major paintings date from these years nevertheless, in which figures and settings seem more harmoniously interwoven. A deepening tonality and pervading atmosphere of melancholy characterize Nevermore *and* Where do we come from? What are we? Where are we going?, *the latter a grandiose mural-scale painting. With its ambitious philosophical theme it was intended by Gauguin to be his last testament and resulted from a major effort of will, as he subsequently described. The wish to end his life, often expressed, was undoubtedly strengthened by news of his daughter Aline's death in early 1897. However, the suicide attempt at the end of the year was unsuccessful and never repeated. Plans for getting his major painting back to Paris and seen by the right people in the right circumstances gave Gauguin a positive focus. The concern he showed in his letters to the critic André Fontainas for the canvas's correct interpretation was revived in 1901 following Morice's proposal to have the work bought by subscription. However, Gauguin resisted invitations to participate in further group exhibitions organized by his younger followers.*

Increasingly, writing provided an outlet for Gauguin's anger and recrimination and a repository for his restless imagination. He not only resorted to working at a clerical job in Papeete in 1898, but between 1899 and 1901 contributed articles to Les Guêpes *and produced his own satirical newspaper,* Le Sourire, *circulated to a small group of colonials with a taste for oppositional opinion. Although space does not allow coverage of Gauguin's journalism, the views he waspishly propounded on Catholicism, on world politics, on the corruption of colonial administration and local miscarriages of justice, and on more general artistic subjects testify to the wide range and characteristic cynicism of his thinking, only slightly tempered by an apparently restored faith in the mystery and wonder of Creation which he strove to express in symbolic form in his woodcuts.*

The turn of the twentieth century provided a new impetus to work, particularly after an agreement with the dealer Ambroise Vollard was reached in March 1900. Gauguin was to send Vollard each year canvases to a maximum of 25, and such drawings and prints as he was able to produce, in exchange for a regular monthly income of 300 francs and a supply of materials. Gauguin had long wished for a secure arrangement of this kind and it worked quite smoothly but gave him a low return on each picture. He remained extremely wary in his dealings with Vollard. Nevertheless, he was finally able to make a long-planned move to the Marquesas islands in September 1901 and the stimulus of the new terrain and its people led him to produce a last series of important paintings. But the tribulations were only temporarily staved off and by late 1902 Gauguin was often confined to his bed. He took solace in reading the Mercure de France, *which was sent out to him free of charge, providing his main diet of cultural and intellectual news from Europe. He drafted* Racontars de rapin *and* Avant et après, *the latter a loose assemblage of material, including elements of autobiography, reflections on key aspects of his past and scabrous anecdotes about life in the Marquesas. In March 1903 he sent it to France and in an accompanying letter to Fontainas, the art editor of the* Mercure, *Gauguin admitted to having a 'malicious' desire to see it appear and be read by 'a few' during his lifetime. The work was not published until 1921.*

Gauguin's own embattled life came to an end in May 1903, rescuing him from a court summons in which he was to have answered charges of inciting native unrest. His final letter to Charles Morice was written when very ill. In it he surveys recent upheavals in the visual arts, and with unabated self-assurance sums up the significance of his own career for future generations of artists — that of sending them back to their neglected productive sources of 'savagery', 'instinct' and 'imagination'.

[Tahiti, September 1895]

To WILLIAM MOLARD ... Arrived in good health. What a change here since I left. Papeete, the capital of this Eden, Tahiti, is now lighted by electricity. The big lawn in front of the old garden of the King is spoiled by a roundabout, which costs 25 centimes a ride, a phonograph, as well...

Next month I will be at La Dominique [also known as Hiva-Oa], a little island of the Marquesas, a delightful place where one can live for almost nothing and where I shan't find any Europeans. I shall live like a lord there with my little fortune and my studio well set up.

*

Tahiti, November 1895

To DANIEL DE MONFREID I have received your kind letter; I have not yet so much as touched a brush, except for doing some stained glass in my studio. I had to stay in Papeete, living out of a suitcase, while making a decision, which was, finally, to have a big Tahitian hut built out in the country. It's beautifully located, I must say, in the shade, by the side of the road, and behind me there is a gorgeous view of the mountain. Just picture a large sparrow cage made of bamboo grillwork and having a coconut-thatch roof, divided in two by the curtains from my old studio. One of the two parts makes a bedroom, with very little light, so as to keep it cool. The other part, with a large window up high, is my studio. On the floor, some mats and my old Persian rug; and I've decorated the rest with fabrics, trinkets and drawings.

As you can see, it's not such a bad life at the moment. Every night frenzied young girls invade my bed; last night I had three of them to keep me company. I'm going to stop leading this wild life and install a more responsible woman in the house and work like mad, especially as I feel in tiptop shape and I think I'm going to do better work than before.

The woman I lived with before has got married in my absence and I've been obliged to make a cuckold of her husband, but she can't live with me, although she did run away for a week.

That's how things stand at the moment, although in other respects the outlook is less promising. As always when I feel I have some money in my pocket and some expectations, I'm spending wildly, putting my faith in the future and my talent, and in no time at all I shall run short again...

...I see from your letter that you've been in the Midi and that you're going through a divorce... What trouble marriage always creates – it's such a ridiculous institution!...

Look at what I've done to my family: I've just abandoned them without warning. They'll just have to manage on their own, because if I'm all they've got to rely on, well! I firmly intend to live my life out here in my hut, altogether peacefully. Oh yes, I'm a great criminal. What does it matter? So was Michelangelo – and I'm not Michelangelo.

*

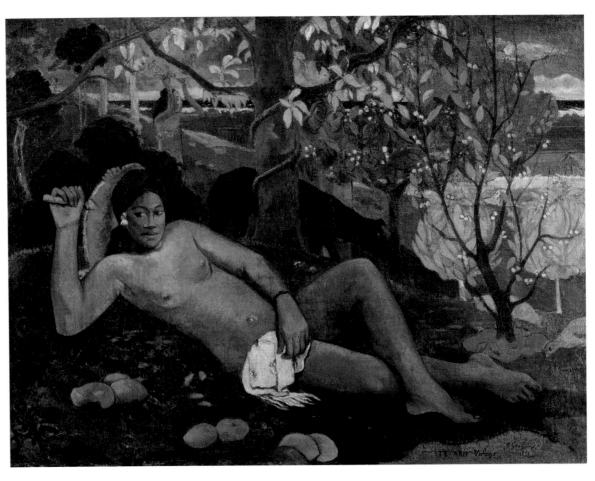

201 TE ARII VAHINE (THE KING'S WIFE), 1896

Tahiti, April 1896

TO DANIEL DE MONFREID ...I've just done a canvas 1.30 × 1 metre that I think is
even better than anything I've done before [plate 201]: a naked queen lying on a carpet of
greenery, a servant picking fruit, two old men, near the big tree, discussing the tree of
knowledge, and in the background the seashore. This brief, tremulous sketch will only give you
a vague idea. As far as colour is concerned, I don't think I've ever done anything of such deep
sonority. The trees are in flower, the dog is keeping watch, and the two doves on the right are
cooing...

I've just borrowed 500 francs so that I can eat for the next few months; with the 500 francs I
owe for the house, that makes 1000 francs' worth of debt. And I am not unreasonable: I live on
100 francs a month, for myself and my vahine, a girl of thirteen and a half; as you can see, it's
not much, and out of that I have to pay for my tobacco, soap and a dress for the girl, 10 francs'
worth of finery a month...

*

Tahiti, 10 April 1896

TO ÉMILE SCHUFFENECKER I've just received your letter and last month a letter from
my wife who is content to give me her usual affected New Year's greetings in order to get some
money, but otherwise not a word of affection nor a single remembrance from the children. You
believe her to be unhappy my poor Schuff. Grave mistake: I know from a reliable and Danish

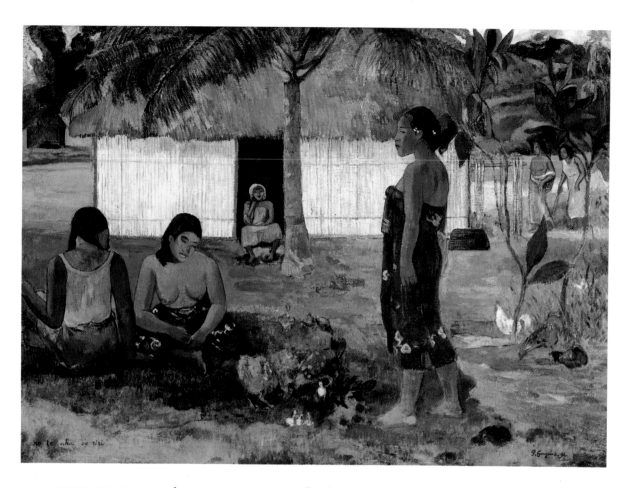

202 NO TE AHA OE RIRI (WHY ARE YOU ANGRY?), 1896

source that on the contrary her existence is extremely happy, supported and favorized... In sending pictures to my wife you thought you were doing the best thing and I can't blame you for it... it's just that you were mistaken, that's all, or rather my wife deceived you with her jeremiads...

I may not have given the younger generation teaching, so to speak, but I have given them *freedom*: through my boldnesses everyone nowadays dares to turn their back on nature and they *all* reap the profits, selling their work alongside mine because, once again, everything looks comprehensible now next to my work...

*

[Tahiti, May 1896]

TO CHARLES MORICE ...Seguin tells me that he heard *from you* that the book *Noa Noa* was *sold in Brussels*, and it did not occur to you that this news coming from others rather than you might severely upset me, for you know the abject poverty in which I am living. Left in the lurch by Lévy, by *everybody*. And if the book is sold, who has the proceeds?... Believe me, I am on the verge of suicide (a foolish act admittedly) but probably unavoidable, it's only a question of a few months. It'll depend on the replies I am awaiting, replies backed up by money. ...What does the death of an artist matter! Think of all this, Morice, and remember, there are cruel moments when words are totally worthless.

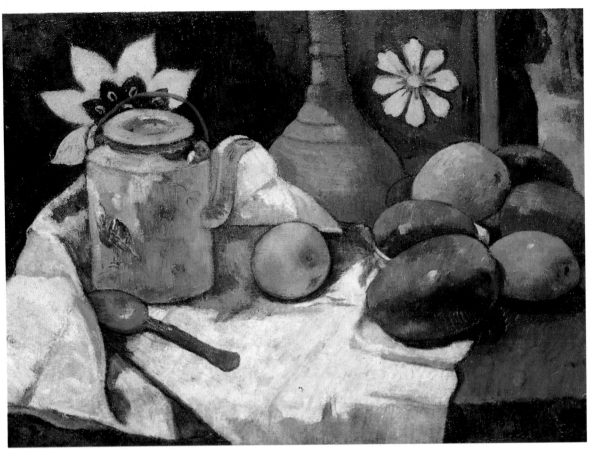

203 STILL LIFE, TEAPOT AND FRUIT, 1896

Tahiti, June 1896

To Daniel de Monfreid I've just had an idea... Gather together fifteen people who understand my painting or who *want to earn money*, and put the following proposition to them. Every year I will send (in good time) fifteen good canvases like those I've already done, and several drawings of my own choice. In exchange for these consignments, those fifteen people will send me 2400 francs per year, which is 160 francs per person... Here is a list of people you might go to see (and talk to persuasively):

– Portier, art dealer –

– Thomas, ditto –

– Lerolle, painter –

– Rouart, ditto, and engineer –

– Jean Dolent – see Schuffenecker, he knows him –

– Sérusier!!!

– His pupil from Versailles who carves in wood, like me –

– Meilheurat –

– The Comte de la Rochefoucauld – ... He gave Bernard and Filiger a private income of 1200 francs each – I've already written to Schuffenecker in order to enlist his aid...

...Hang it, I'm hardly greedy, wanting to earn 200 francs a month (*less* than an ordinary worker) at the age of nearly 50 and with a fairly good reputation... And if I resign myself to living *in poverty*, it's because I want only to produce art.

...You say in your letter: 'You, the strong one, sound very downcast.'... I have no strength left, exhausted by days and nights without sleep because of the pain my foot is causing me. My whole ankle is just one big wound, and it's been like that for 5 months now. Working distracts me and makes me feel strong again...

[Tahiti, June? 1896]

To Émile Schuffenecker
. . . An important point in your letter concerns Madame Gauguin . . . I'm going to tell you the truth about this woman whom you defend. When we got married her dowry consisted of a few shirts and 6 table settings and yet she has demanded far more money than a woman raised in luxury. The disputes rained down on our household, more and more of them, over this wretched question. Later on when I managed to earn 35,000 francs in a single year I didn't spend it on myself apart from a few pictures I bought cheaply . . . and yet Madame Gauguin contrived to run up debts throughout the *quartier* . . . I wrote to her mother asking for a divorce. My wife went to Denmark for a few days . . . On Madam's return, since she didn't want a divorce, we talked everything over, there were tears, and forgiveness. Men forgive so easily. I went to Denmark, and found everyone against me there. I returned to France leaving everything in the house, arriving in Paris with 15 francs in my pocket . . . Madam has sold off my collection to her brother-in-law for 15,000 francs, several pieces of furniture for 2000 francs, and pictures of mine, old and recent ones, for almost 20,000 francs . . . That, Schuff, is Madam's position, whining and lying as she's always done . . .

*

Tahiti, 13 July 1896

To Daniel de Monfreid
. . . I am writing to you because an officer is leaving for France this month and is taking with him some canvases of mine, very clumsy ones, because of the condition I'm in; but I have a temperament that makes me want to do a canvas all at one go, feverishly . . .

Well, such as they are, I'm sending them to you. They may be good; so much suffering and anguish have gone into them, and that may make up for the awkwardness of their execution . . .

*

Tahiti, July 1896

To Alfred Vallette
My dear editor, I am in a colonial hospital . . . writing to thank you, first of all, for sending me the *Mercure*. When I read your review each month I forget the isolation in which I live, and although I am not up-to-date on the gossip in political circles and on the boulevards (for which I have no use), I take great pleasure in keeping up to date with the work of the intellectual world.

. . . let me . . . ask you a question: what do you think of a body of work whose admirers include such men as Degas, Carrière, St.[éphane] Mallarmé, J.[ean] Dolent, Alb[ert] Aurier, Rémy de Gourmont, while its antagonists are nonentities like Camille Mauclair?

. . . without any of the knowledge you need in order to judge painting, he says bad things about everything that has the courage to express an idea, everything that is not official, not 'Salon' type of work . . .

Believe me, my dear editor (and it is as a shareholder that I am saying this), Mauclair does not belong on the *Mercure* . . .

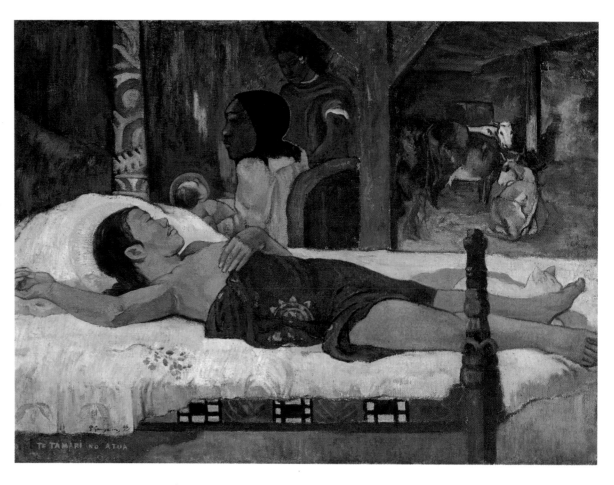

204 TE TAMARI NO ATUA (THE BIRTH OF CHRIST), 1896

Tahiti, August 1896

TO DANIEL DE MONFREID ... Schuffenecker has written me a nonsensical and unjust letter ... he is more unfortunate than I who have glory, strength, health. Rubbish! I have so much talent, he says, I make others jealous – and he adds 'If you had been prudent and farsighted you could now be living at your ease; and with a bit more foresight and a bit more good will and a more sociable attitude towards your contemporaries, you would have a very happy life.' –

Well, I've interrogated my conscience and found nothing. I have never committed an act of meanness, even to an enemy; and yet, at the most difficult moments of my life, I've more than shared with the unfortunate ... I helped Bernard with my contacts and money. You know what came of that ... Schuff has just got up a petition, which I think will be useless, to have the State come to my aid. That is the kind of thing that offends me more than anything else ... I have never had any intention of begging from the State. All my struggles to succeed outside the official channels, and the dignity that I have striven to keep all my life – all this is now meaningless ... Decidedly I was born under an unlucky star ...

*

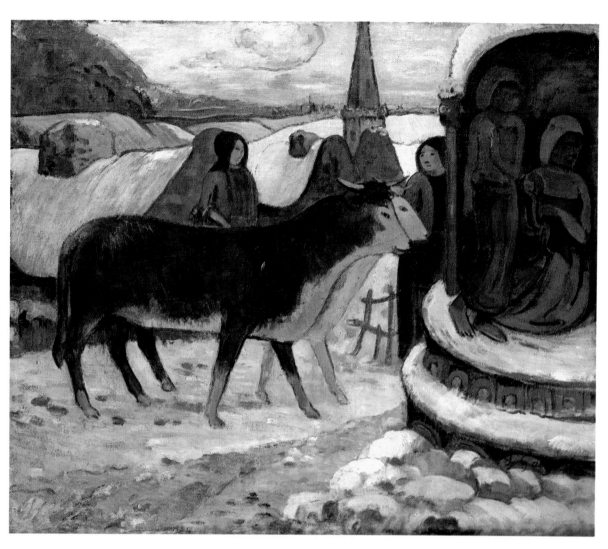

205 CHRISTMAS NIGHT, 1896

Tahiti, November 1896

To Daniel de Monfreid I've received just one letter – yours. I've received nothing from Chaudet in the last three deliveries, which means that my precarious situation is becoming more and more intolerable ... Ah! if my health wasn't much better, I would be going crazy, I can tell you ...

Yes, I'm beginning to get better, and have taken advantage of that to get a lot of work done. Sculpture ... I put it everywhere, all over the grass. Clay covered with wax. First of all a female nude, then a superb imaginary lion playing with its cub. The natives, who have never seen any wild animals, are astounded.

The priest of course did everything he could to make me get rid of the female nude, which doesn't have any clothing. The law laughed in his face, and I told him in no uncertain terms to go to hell. Ah! if only I had what is owing to me, my life would be extraordinarily calm and happy. I'm soon to be the father of a half-caste: my charming lady has decided to give birth. My studio is quite splendid, and I can assure you time passes quickly. Believe you me, from six in the morning to midday I can do a lot of good work. Ah, my dear Daniel, what a pity you have never tasted life in Tahiti! You would never want to live any other way ...

Tahiti, 15 January 1897

To Armand Seguin

...You loved or *would have liked to love* Madame...but you see I prefer fat women, even Julia. *It's not love*, it's *meat*; that's quite sufficient...All a painter's love goes into his work...women are nothing but meat...

...I will send you a photo of my studio as soon as I have taken one, showing the polychrome wooden panels, the statues among the flowers, etc. Just to sit here at the open door, smoking a cigarette and drinking a glass of absinth, is an unmixed pleasure which I have every day. And then I have a fifteen-year-old wife who cooks my simple everyday fare and gets down on her back for me whenever I want, all for the modest reward of a frock, worth ten francs, a month...You have no idea how far 125 francs will go here. I can ride or drive around in a trap as often as I feel like it. The horse and trap are my own, like the house and all the rest. If I could sell 1800 francs' worth of pictures I would stay here for the rest of my days. I want no other life, only this.

*

[Tahiti, *c.*15] January 1897

To Charles Morice

...Speaking of hospitals, I have just tried to get in for treatment. I had to suffer all manner of insults from the officials, and, after much effort, in return for a payment of 5 francs a day, they handed me, what do you think, an entrance ticket marked 'Pauper'! I'm sure you will understand that, although in great pain, I had to refuse to go in among the soldiers and servants. Besides, there is a section here, as in France, that takes me for a rebel, and like everywhere, here more than elsewhere, a man who is hard up is very badly treated. Of course, I am only referring to the Europeans, in Papeete, because the natives here in my part of the island are, as always, very kind and respectful towards me.

Paul Gauguin

*

Tahiti, 14 February 1897

To Daniel de Monfreid

...I would like to say that I am not at all in favour of exhibitions. That idiot Schuffenecker dreams of nothing but exhibitions, publicity, etc. and doesn't realize that they have a disastrous effect. I have many enemies and I am fated always to have a good many, in fact more and more of them; every time I exhibit my work, it arouses them and they all begin to yelp and discourage art lovers by wearing them out. When all is said and done, the best way of selling is by keeping quiet, while working on the art dealers. Van Gogh was the only one who knew how to sell and build up a clientele: nobody today knows how to tempt the art lover. Those who deny this is so, thinking themselves too clever, should be shown how wrong they are by hanging a picture for six months or a year in the house of a serious art lover, after which time, when he has compared it, looked at it again and again and come to love it, he will either buy it or give it back. That's the best way of exhibiting my pictures. Try to persuade the dealers that this is a good system...

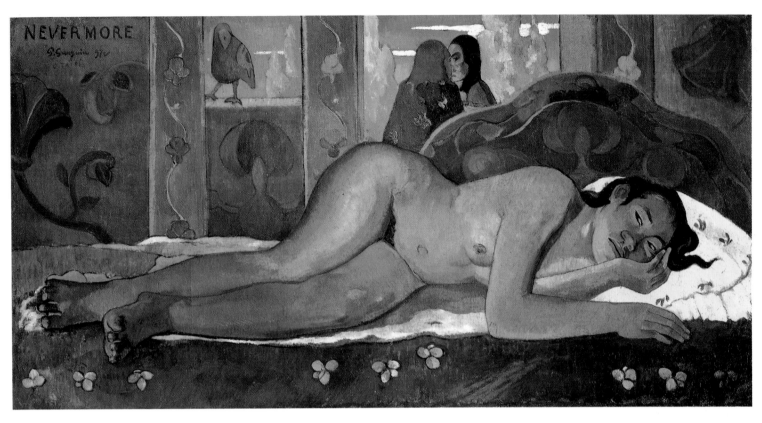

206 NEVERMORE, inscribed 'O TAHITI', 1897

You will soon receive a few canvases: my physical and moral suffering makes me incapable of judging them. Your opinion will be sounder than mine –

Nave nave mahana. Delightful days. [plate 210]

Bouquet of flowers. [plate 231]

Note aha oe riri. Why are you angry? [plate 202]

Barbaric poems.

Still life. [plate 203]

Study of myself. [plate 1]

for the sake of something to paint – I offer it to you as a feeble expression of friendship in recognition of all your devotion. And if you like one of the canvases a great deal, please take it: I would be very happy to give it to you.

I'm trying to finish a canvas so that I can send it with the others . . . With a simple nude I intended to suggest a certain savage luxuriousness of a bygone age. The whole painting is bathed in deliberately sombre, sad colours; it is neither silk nor velvet, neither batiste nor gold that creates this luxury, but rather the paint surface, enriched by the artist's hand . . .

The title is *Nevermore*; it is not Edgar Poe's raven keeping watch, but the Devil's bird. It's badly painted (I'm so nervous and I'm working in short bursts) – never mind, I think it's a good canvas . . . [plate 206]

*

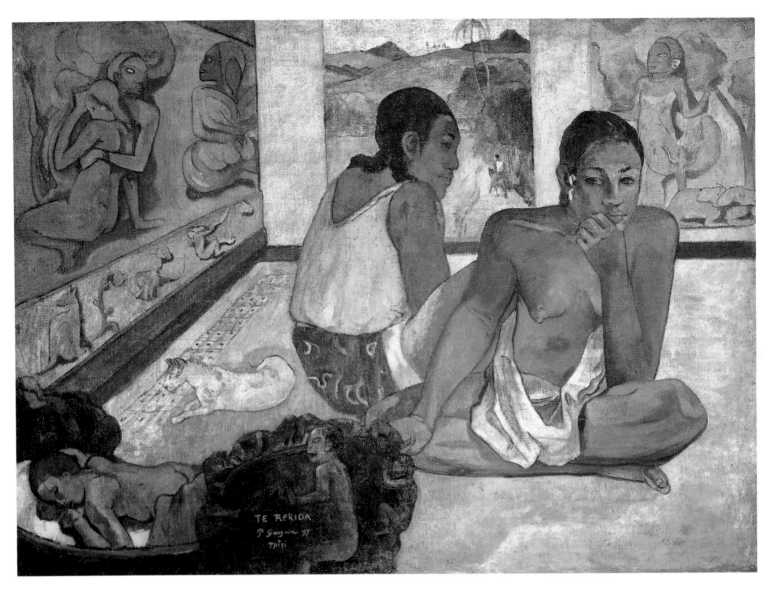

207 TE RERIOA (DAY DREAMING), 1897

Tahiti, 12 March 1897

TO DANIEL DE MONFREID . . . I've taken advantage of the postponement of the naval
vessel's departure for ten days to do another canvas that I think is even better than the
previous ones, despite being executed in haste. *Te rerioa*, (The dream), that's the title
[plate 207]. Everything is dream-like in this canvas; is it the child, is it the mother, is it the
horseman on the path? Or is it the painter's dream! . . .

I received 1035 and then 1200 francs from Chaudet two months ago; I've paid all my bills
and bought several things from the pharmacy, as well as several items for painting, canvas,
white lead, etc . . .

I have enough money to live on for 3 or 4 months, which enables me to work; however,
that's hardly indulging in extravagant expenditure . . .

*

Tahiti, April 1897

TO DANIEL DE MONFREID Your letter arrived at the same time as a short but dreadful letter from my wife. She informed me bluntly of the death of my daughter, who was snatched from us in just a few days by a fatal attack of pneumonia. This news did not distress me at all, hardened as I have been for a long time to suffering; and then each day, as thoughts kept piling in, the wound opened up, becoming deeper and deeper, until now I am completely overwhelmed . . .

I've received a letter from Vollard, who would like a lot of things, drawings and models of sculptures to be cast in bronze. I wrote him a somewhat ironic reply, telling him that all that has been available for a long time, and without any profit for me. I also told him that if he were to buy the ceramic statue and mask, a bronze casting would provide a good return for a clever man like him – *So look into that*.

I've been amusing myself trying out wood engraving, with any old wood, without a press. You can see one of them on the back.

*

Tahiti, 14 July 1897

TO DANIEL DE MONFREID . . . The canvases I sent you have arrived and you like them; that's good, I was rather anxious – because of the state I'm in I really didn't know how to assess their true worth. You level some serious reproaches at me: according to you, I pay insufficient attention to my paint surface. That's just not true, I pay a great deal of attention to it. However, the preparation leaves something to be desired, that's true. But what do you expect, given the state I've been in, so nervous and impatient that the preparation obsessed and tired me. And then the canvases you're talking about were rolled up by a naval officer (I was in hospital) ignorant of the correct way to do it; they ended up loosely rolled for 2 months, without air and in extreme heat, and were at enormous risk of damage. Once they've been stretched and waxed there will be less risk. In case of real disaster, Portier has an excellent chap who relines paintings for about twenty francs . . .

*

[Tahiti, August? 1897]

TO METTE I'm reading over the shoulder of a friend who is writing: . . . 'I have just lost my daughter, I no longer love God. Like my mother, her name was Aline. We all love in our own way: for some, love is kindled at the coffin, for others . . . I don't know. Her tomb over there, the flowers, that's all pretence. Her tomb is here beside me; my tears are living flowers'.

*

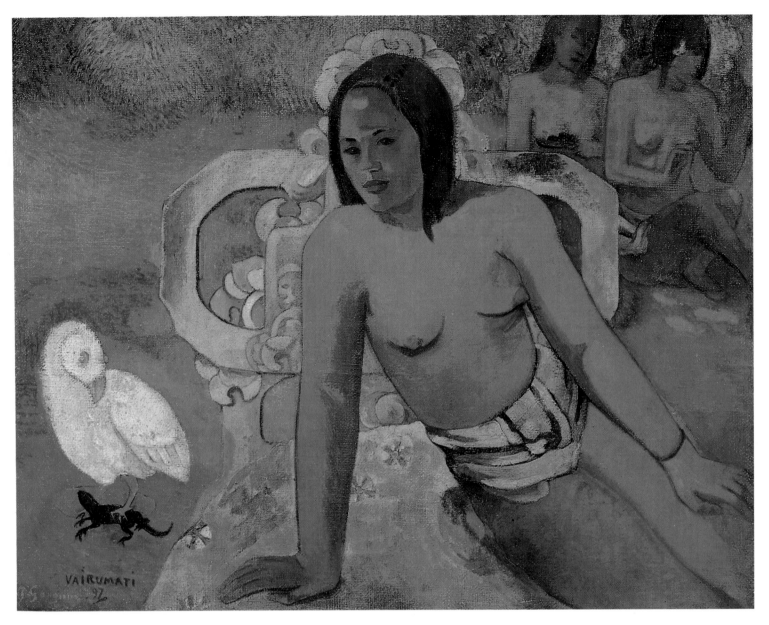

208 VAIRUMATI, 1897

Tahiti, October 1897

To Daniel de Monfreid . . . What I want is for there to be *silence* [on my account] in France and above all for M. Schuffenecker not to go around crying: 'That poor Madame Gauguin!' And since my pictures are unsaleable, let them go on being unsaleable. There will come a time when people will believe I am a myth, or rather something the newspapers have made up. They will ask where my pictures are . . .

I see you're in a productive vein: sculpture! . . . Always keep in mind the *Persians*, the Cambodians and to a small extent the Egyptians. The big mistake is Greek art, no matter how beautiful it is. I'm going to give you a little bit of *technical advice*, do with it what you will. Mix a *lot* of fine sand with your clay; it will give you some valuable difficulties and will prevent you from looking only at the surface and succumbing to the atrocious affectations of the École des Beaux Arts . . .

*

Tahiti, November 1897

To Charles Morice ...I probably won't live to see the book [*Noa Noa*] printed, my days being numbered. God has finally heard my voice imploring, not for a change, but for total deliverance... And this would be better than killing myself to which I was being driven by the lack of food and means to procure it...

*

Tahiti, 1896–1898

From *Diverses choses* ...Since the advent of the snapshot, said one horse lover, painters have been able to understand horses, and Meissonnier, one of the glories of France, has been able to depict that noble animal from all angles. As for myself, my art goes way back, further [back] than the horses on the Parthenon – all the way to the dear old wooden horsy of my childhood.

...At my Tahiti exhibition at Durand-Ruel's... the crowd and then the critics howled before my canvases, saying they were too dense, too nondimensional. None of their beloved perspective: no familiar vanishing point... Well, I want to defend myself.

Did they expect me to show them fabulous Tahiti looking just like the outskirts of Paris, everything lined up and neatly raked? What is actually the fruit of deep meditation, of deductive logic derived from within myself and not from any materialistic theories invented by the bourgeois of Paris, puts me seriously in the wrong, they believe, for I do not howl with the pack....

Any receding perspective would be an absurdity. As I wanted to suggest a luxuriant and untamed type of nature, a tropical sun that sets aglow everything around it, I was obliged to give my figures a suitable setting.

It is indeed the out-of-door life – yet *intimate* at the same time, in the thickets and the shady streams, these women whispering in an immense palace decorated by nature itself, with all the riches that Tahiti has to offer. This is the reason behind all these fabulous colours, this subdued and silent glow.

'But none of this exists!'

'Oh yes it does, as an equivalent of the grandeur, the depth, the mystery of Tahiti, when you have to express it on a canvas measuring only one square metre...'

*

Tahiti, February 1898

To Daniel de Monfreid ...As soon as the mail came, seeing that there was nothing from Chaudet and having suddenly almost recovered my health, that is, without any more chances of dying a natural death, I wanted to kill myself. I went to hide in the mountains, where my corpse would have been eaten up by ants. I didn't have a revolver but I did have arsenic that I had hoarded during the time I had eczema. Was the dose too large, or was it the fact of vomiting, which overcame the effects of the poison by getting rid of it? I know not...

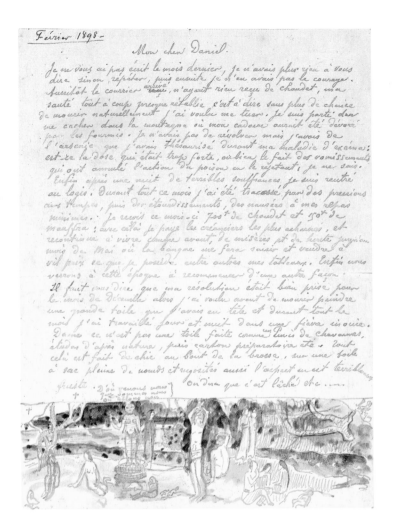

209　LETTER TO DANIEL DE MONFREID WITH SKETCH OF
D'OÙ VENONS-NOUS?, February 1898

Before I died I wanted to paint a large canvas that I had worked out in my head, and all month long I worked day and night at fever pitch. [The painting referred to is *Where do we come from?*, plate 221.] I can assure you it's nothing like a canvas by Puvis de Chavannes, with studies from nature, then a *preparatory cartoon*, etc. No, it's all done without a model, feeling my way with the tip of the brush on a piece of sackcloth that is full of knots and rough patches; so it looks terribly unpolished.

People will say it is slipshod, unfinished. True, it is hard for anyone to judge his own work, but even so I do believe that not only is this painting worth more than all the previous ones but also that I will never do a better one or another like it. I put all my energy into it before dying, such painful passion amid terrible circumstances, and such a clear vision without corrections that the hastiness of it disappears and life bursts from it . . .

*

Tahiti, March 1898

To Daniel de Monfreid　　　　　　　　　　　. . . I am in such a state of exhaustion that I have not been able to hold a brush all month. I haven't done anything. Besides, for some time, my big canvas has drained away all my energy; I look at it constantly and (I must admit) I do indeed admire it. The more I see it the more I realize its enormous mathematical defects, but not for anything will I fix them; it will remain just as it is, a sketch if you like. But at the same time this question arises and I am perplexed: where does the painting of a picture begin and where does

it end? At the instant when extreme feelings are merging in the deepest core of one's being, at the instant when they burst and all one's thoughts gush forth like lava from a volcano, isn't that where the suddenly created work erupts, brutally perhaps, but in a grand and apparently superhuman way? Reason's cold calculations have not led to this eruption; but who can say exactly when the work was begun in one's heart of hearts? Perhaps it is unconscious . . .

*

[Tahiti, March 1898]

TO WILLIAM MOLARD . . . Don't lose sight of the fact, my dear Molard, in spite of your preoccupations, that I left you powers of attorney for the publication of *Noa Noa* which is still getting nowhere with Morice. Keep your eye on him, otherwise with that rascal the money will slip through his fingers.

*

Tahiti, 15 March 1898

TO DR GOUZER It is already a long time since your letter arrived. It was very kind of you to think of writing, reminding me of some pleasant moments I spent aboard the *Duguay-Trouin*. Kinder still the things you said and I would have liked to reply sooner, but not having your address I was unable to do so.

Daniel, to whom I write regularly every month, has just repaired the omission. Is not Daniel a fine kind of man as well as artist? Since I have known him he has shown me nothing but loyalty and affectionate devotion . . .

. . . I could not possibly return to France as you advise, even if I had the money for the journey. Every day – my most recent important works testify to it – I perceive that I have not said all I have to say about Tahiti, that there is much more, whereas in France, given the disgust I have for it, my brain would perhaps become sterile; the cold shatters me physically and morally, everything turns ugly in my eyes.

It is true that when I am on the spot, the struggle becomes easier from a political point of view, and that I can produce more *commercial* painting; all considerations that I cannot contemplate without horror and revulsion. It would be unworthy of me and of the career which I've followed (nobly, I believe).

[It would be] ending badly when one has begun well. But I would live, you'll argue. Why live at the expense of losing the reasons one has for living?

No, and let there be no more question of it!

Moreover, the martyr is often necessary to every revolution – my work considered as an immediate and pictorial result, has little importance compared to its long-term moral result: the *emancipation* of painting, freed henceforth of all its fetters, of that vile tissue woven by the schools, the academies, and especially the mediocrities.

Look what people dare to do today, compared with the timidity of 10 years ago. Some jokers are reaping the benefits, much good may it do them; what does it matter – there are others, and at the moment a whole plethora of signatures. My name may and must disappear, what does it matter!

Tahiti, July 1898

TO DANIEL DE MONFREID ...This month I'm sending you the pictures I've done this
year via a naval officer; there's not much, as you will see, and now that I've taken a job as a
clerk I'm not doing anything.

The large picture has patches of pastel that I covered it with in order to take a photograph –
it will wash off. I'm really ashamed to give you so much to worry about – you're going to have
a lot of work to do. These last pictures should be put on show at Bing's or Durand-Ruel's, or if
not there, then in Chaudet's studio, or in yours, which would be a very good idea I think. And
then you should send out invitation cards. In this way you will get the people you want, rather
than the masses, and you will build up some contacts which can't do you any harm. I'm
sending you a list of people I have in mind; of course you can add to it *those you consider suitable.*

DEGAS, RENOIR	PUVIS DE CHAVANNES
PORTIER	MALLARMÉ
ROUART AND SON	DELAROCHE (writer for *La Plume*)
COCHIN (municipal councillor)	CHAPLET
JEAN DOLENT	ARSÈNE ALEXANDRE
CARRIÈRE	M. & MME. BRACQUEMOND
COQUELIN	ANATOLE FRANCE
ROGER MARX	PAUL GALLIMARD, 79, r[ue] Saint-Lazare
OCTAVE MIRBEAU	DE GROUX
MERCURE DE FRANCE	FRANZ JOURDAIN, 40 b[oulevard] Haussmann
REVUE BLANCHE	O. REDON
MICHELET	RODIN
GEOFFROY	VIGNÉ D'OCTON
MANZI	
JOYANT	
REVUE ENCYCLOPÉDIQUE	
DE LA ROCHEFOUCAULD	

Would you please give cards to Portier and Vollard, so that they can give them *to customers*
likely to buy paintings...

*

Papeete, 15 August 1898

TO DANIEL DE MONFREID ...I am very happy that you've made Degas's acquaintance
and that in trying to further my cause you've also made some useful connections for yourself. Oh
yes! Degas has the reputation of being ill-natured and caustic (*me too*, says Schuffenecker).

But Degas is not that way with people he considers worthy of his attention and esteem. He
is instinctively drawn to good-hearted, intelligent people... In terms of both *talent and
behaviour*, Degas is a rare example of what an artist should be. As colleagues and admirers he has
had all those who are now in power: Bonnat, Puvis, etc. Antonin Proust... but he has *never*

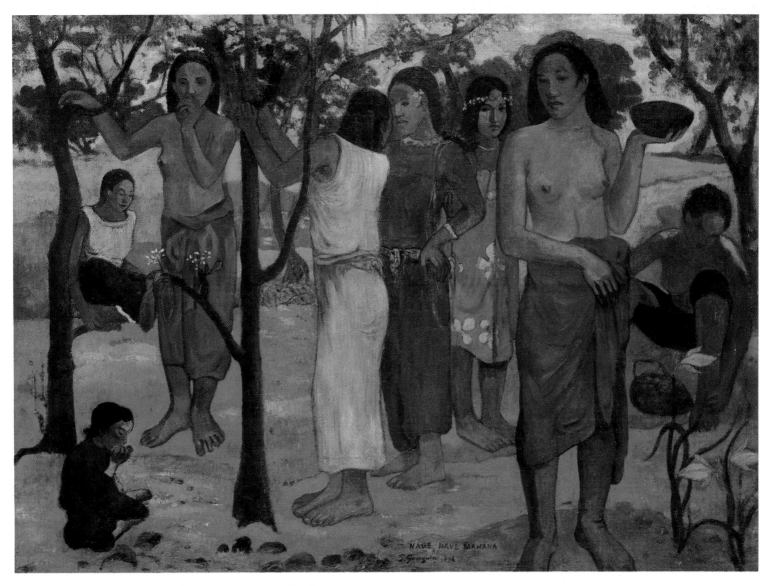

210 NAVE NAVE MAHANA (DELIGHTFUL DAYS), 1896

sought any favours. No one has *ever heard or seen him* commit one dirty trick, one tactless action, do one ugly thing. Art, and dignity. Obviously Rouart, who is a millionaire, did not pay a great deal for the big canvas [plate 210], but if I *sold* them all at that price, I would be able to work and live in *perfect* happiness. Moreover, he has a lot of contacts and his collection is said to be *choice*, which may subsequently bring in some customers . . .

*

Tahiti, October 1898

TO DANIEL DE MONFREID . . . I'm not at all up-to-date on Parisian taste. Perhaps it's a good thing – I don't know. I sometimes say to myself: the old masters – some of them at least – used to paint a bit like me, in solitude, without worrying about what was going on around them. Yes, but on the other hand, unlike me, they didn't have the terrible examples we all had before our very eyes at the beginning, whose influence it has been so difficult to shake off subsequently, to say nothing of the famous art critics who lead one astray.

. . . I would like you to send me some tubers and flower seeds. Simple dahlias, nasturtiums, a variety of sunflowers, flowers that will grow in hot countries – I'll leave you to choose. I would like to make my little patch of land more attractive, and as you know I adore flowers . . .

To André Fontainas

Un grand sommeil noir
Tombe sur ma vie
Dormez, tout espoir
Dormez, toute envie
 VERLAINE

In the January number of the *Mercure de France* you have two interesting articles, 'Rembrandt' and 'The Vollard Gallery'. In the latter you mention me . . .

Without departing from my habitual reserve, I have an irresistible desire to write to you, a caprice if you will . . .

We painters, we who are condemned to penury, accept the material difficulties of life without complaining, but we suffer from them insofar as they constitute a hindrance to work. How much time we lose in seeking our daily bread, in the most menial tasks, dilapidated studios, and a thousand other obstacles! All these create despondency, followed by impotence, rage, violence. Such things do not concern you at all, I mention them only to convince both of us that you have good reason to point out numerous defects, violence, monotony of tone, clashing colours, etc. Yes, all these probably exist, do exist. Sometimes, however, they are intentional – are not these repetitions of tones, these monotonous colour harmonies (in the musical sense) analogous to oriental chants sung in a shrill voice to the accompaniment of pulsating notes which intensify them by contrast? Beethoven uses them frequently (as I understand it) in the *Sonata pathétique*, for example. Delacroix, too, with his repeated harmonies of brown and dull violet, a sombre cloak suggesting tragedy. You often go to the Louvre; with what I have said in mind, look closely at Cimabue. Think also of the musical role colour will henceforth play in modern painting. Colour, which is vibration just as music is, is able to attain what is most universal yet at the same time most elusive in nature: its inner force.

Here near my cabin, in complete silence, amid the intoxicating perfumes of nature, I dream of violent harmonies. A delight enhanced by I know not what sacred horror I divine in the infinite. An aroma of long-vanished joy that I breathe in the present. Animal figures rigid as statues, with something indescribably solemn and religious in the rhythm of their pose, in their strange immobility. In eyes that dream, the troubled surface of an unfathomable enigma.

. . . In praise of certain pictures that I considered unimportant you exclaim, 'If only Gauguin were always like that!' But I don't want to be always like that.

. . . To go back to the panel [*Where do we come from?*]: the idol is there not as a literary symbol, but as a statue, yet perhaps less of a statue than the animal figures, less animal also, an integral part, in my dream before my cabin, of the whole of nature, dominating *our primitive soul*, the unearthly consolation of our sufferings to the extent that they are vague and incomprehensible before the mystery of our origin and of our future.

And all this sings with sadness in my soul and in my design while I paint and dream at the same time with no tangible allegory within my reach – due perhaps to a lack of literary education.

Awakening with my work finished, I ask myself, 'Where do we come from? What are we? Where are we going?' A thought which no longer has anything to do with the canvas, expressed in words quite apart on the wall that surrounds it. Not a title but a signature.

You see, although I understand very well the value of words – abstract and concrete – in the dictionary, I no longer grasp them in painting. I have tried to interpret my vision in an appropriate décor without recourse to literary means and with all the simplicity the medium permits: a difficult job. You may say that I have failed, but do not reproach me for having tried, nor should you advise me to change my goal, to dally with other ideas already accepted, sanctified. Puvis de Chavannes is the perfect example. Of course Puvis overwhelms me with his talent and experience, which I lack; I admire him as much as you do and more, but for entirely different reasons . . .

At my exhibition at Durand-Ruel's [in 1893] a young man who didn't understand my pictures asked Degas to explain them to him. Smiling, he recited a fable by La Fontaine. 'You see,' he said, 'Gauguin is the thin wolf without the collar' [that is, he prefers liberty with starvation to servitude with abundance] . . .

*

Tahiti, May 1899

To Daniel de Monfreid
 . . . You say, 'Why don't you paint *lavishly*, in such a way as to give the paint surface a richer texture? . . .'

I don't reject that suggestion completely, and sometimes I would really like to do that. However, it's becoming more and more impossible for me, particularly since I have to count the cost of the paint. I've hardly got any left, despite using it frugally, and I can't ask you for any more until I know when my living expenses will be met. If you find someone who will guarantee me 2400 francs a year for five years, plus a plentiful supply of paint, I will do everything asked of me, I will really lay on the paint, even if it takes 3 times longer.

Now I don't know whether in a few years, when the paint surface has hardened sufficiently, and the oil has disappeared, you will not find the surface rich, . . .

During the short time that I advised students at the Montparnasse studio, I used to say to them, 'Don't expect me to correct you outright if your arm is too long or too short (who knows whether it is, in any case?), but I will correct mistakes in art, mistakes in taste, etc. You can always learn to achieve accuracy, if that's what you want; technique comes all by itself, in spite of yourself, with practice, and all the more easily when you're thinking of something other than technique'.

That's my opinion, my dear Daniel; rereading my letters it always strikes me that I must really irk you, that I'm taking advantage of your kindness, for you are truly good-natured.

Your life is not a bed of roses, so you hardly need the additional work I'm always giving you . . .

So forgive me for everything . . .

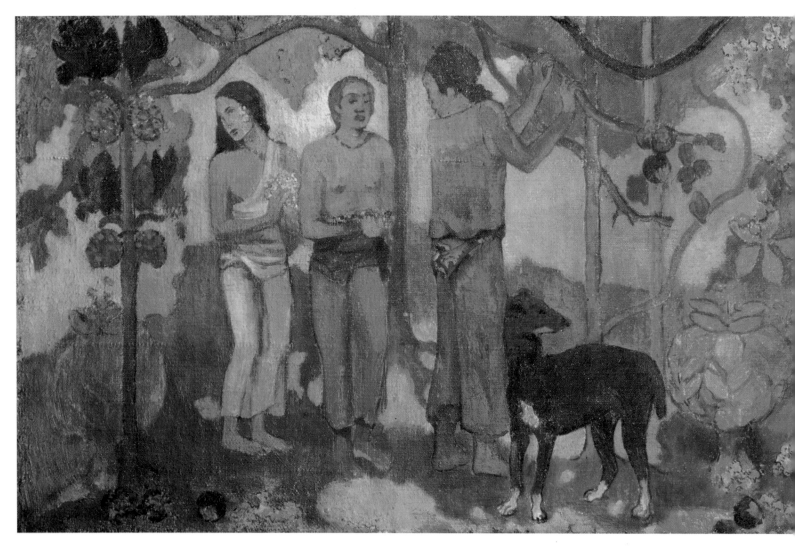

211 FAA IHEIHE (TAHITIAN PASTORAL), 1898

[Tahiti, June 1899]

TO MAURICE DENIS In reply to your letter I regret I am unable to reply Yes. To
be sure, it will be interesting to see the artists who exhibited at the Café Volpini brought
together, after an interval of ten years, along with the young fellows I admire, but my
personality of ten years ago is of no interest today. At that time, I wanted to dare everything,
to liberate, as it were, the new generation and then to work to acquire a little talent. The first
part of my programme has borne fruit: today you are free to dare everything and what is more
nobody is astonished.

The second part, alas, has been less successful. What's more I am an old fogey, the pupil of
many in your exhibition; *in my absence* that would become only too clear. Much has been written
on this subject . . .

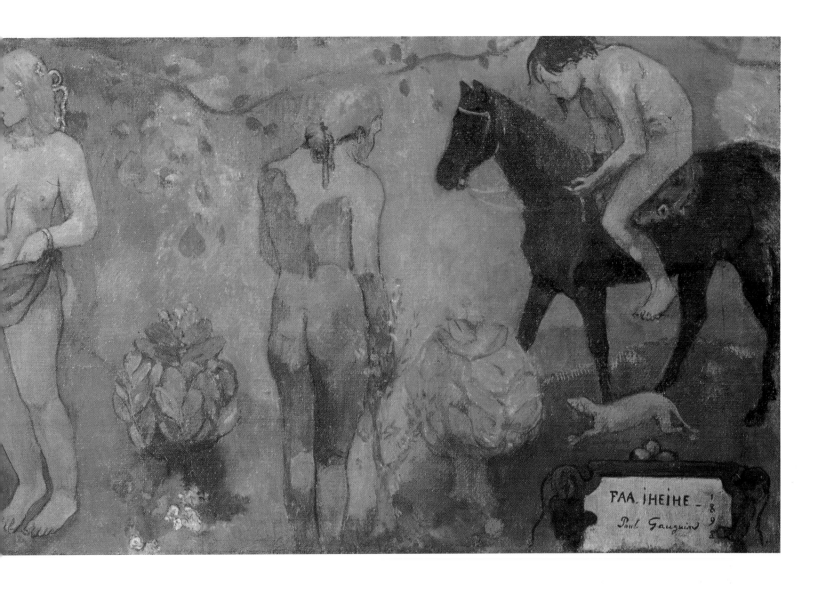

Another reason, and this is the real one.

My work is finished; . . . I paint no longer, except on Sundays and holidays, and therefore would be unable to provide you with recent specimens which, moreover, could not be properly framed and would not be sufficiently in the movement. My Papuan art would have no meaning by the side of the symbolists, the idealists; I am sure your exhibition will be very successful. Nearly all of you having means, a numerous clientele and powerful friends, it would be astonishing if you were unable to reap the legitimate fruit of your talent and your discoveries . . .

*

Tahiti, August 1899

TO ANDRÉ FONTAINAS
...I act as my intellectual nature dictates, somewhat in the manner of the Bible in which doctrine (especially in connection with Christ) expresses itself in a *symbolic form* presenting a double aspect, a form which, on the one hand, materializes the pure idea so as to make it more perceptible and assumes the guise of the supernatural; this is the literal, superficial, figurative, mysterious meaning of a parable. And on the other hand, there is the spirit of the parable: not its figurative but its representational, explicit meaning.

As I have never attempted to explain my art except through my pictures themselves, I have always been misunderstood until now; and yet there is one writer – and that astonishes me, as I had not suspected that he was interested in painting (A. Delaroche, author of the remarkable article entitled 'D'un point de vue esthétique') – who seems to have understood me in his description of one of my pictures:

'*In a ring of strange colours, like the waves of a liquid brew, diabolic or divine, one knows not which, the waters of mystery spout into the parched lips of the unknown.*'

...Of course I read your articles. Because of my extreme poverty the *Mercure* is sent to me without charges... reading... is one of the ornaments of my solitude....

*

Tahiti, September 1899

TO DANIEL DE MONFREID
...You wouldn't happen to know an anarchist who would be able to blow up Roujon, the director of the Beaux Arts: if you do, don't hesitate, because his replacement by Geffroy, for example, might help to improve my situation. For example, I would enjoy working on a large order for designs for stained-glass windows, and it would also allow me to eat...

*

Tahiti, January 1900

TO AMBROISE VOLLARD
...I have just done a series of experiments in drawings with which I am fairly well pleased, and I am sending you a tiny sample. It looks like a print, but it isn't. I used a thick ink instead of pencil, that's all.

You mention flower paintings. I really don't know which ones you mean, although I have done only a few, and that is because (as you have doubtless perceived) I do not copy nature – today even less than formerly. With me, everything happens in my exuberant imagination, and when I tire of painting figures (which I like best), I begin a still-life and finish it without any model...

You say if you dwell on the question of price it is because my work is so different from that of other painters that nobody wants it. The statement is harsh, if not exaggerated. I am a little sceptical about it...

... when I was in Paris my pictures sold for from 2000 down to, at the lowest, 500 francs. No! The truth is, it is the dealer who fixes the prices, if he knows his business, if he is really enthusiastic, and above all, if the work is good. *Good painting always has a value.*

And I have had a letter from *Maurice Denis*, who keeps closely in touch with what goes on in Paris. He tells me that Degas and Rouart are bidding against each other for my pictures and that my work brings pretty good prices at auction. So much for your statement that *nobody will buy them.* It would stagger anyone, no matter how inured to shocks he might be.

... Well, despite the fact that nobody wants my work... you want to do business with me – which is not easy *at this distance* – and you ask for an understanding with regard to prices. You know very well that if I had cared to make a business of my art I could have earned plenty of money by being shrewd, by exploiting the Breton vein and similar lines which deaden the talent. But I should not have become what I am and *what I intend to remain, a great artist.* By this I mean to tell you that you must work in harmony with me and rely on my word. I am willing to accept low prices (*an average of 200 francs for each canvas, pictures such as I am accustomed to paint, of various subjects – a maximum of 25 pictures* a year). You will send me canvas and colours at your expense (according to the instructions I shall give Daniel). And for drawings, an average of 30 francs each, whatever their dimensions, whether in watercolour or not (the few small drawings of mine that Theo van Gogh sold at Goupil's cost an average of 60 francs and the lowest price for a picture was 300 francs, but people *did want to buy them* from him). This is my *formal proposition...*

I have always said, and Theo van Gogh used to think so too, that a dealer could make a great deal of money out of my work. Because, first, I am 51 years old and have one of the best artistic reputations in France and other countries, and, having begun to paint very late in life, my pictures are *very few in number*, and most of them are *privately owned* in Denmark and Sweden. ... So from the standpoint of a dealer it is only a matter of goodwill and patience, not of a large investment as in the case of Claude Monet. I estimate the number of canvases I have done *since I first began to paint* at not more than 300, a hundred of which do not count because they were immature works. In this total are included about fifty pictures in foreign collections and a few in France belonging to people of real taste who will not sell them. As you see, there are *only a few* to be disposed of...

*

Tahiti, January 1900

TO DANIEL DE MONFREID As I had foreseen, and as I feared, Chaudet has fallen by the wayside, and now you are required to live outside Paris, so we must *at all costs* find someone of goodwill to replace Chaudet... There's another thing that will perhaps settle matters once and for all. I mean the Vollard letter; *there* too, Degas may have some influence. I'm sending you my reply, so you can read it carefully and deal with him by repeating the contents of my letter to him, with a *very indifferent* air, for I feel that Vollard intends to exploit me...

The last Lefranc paints you sent me are dreadful. The *ultramarines* and the *lakes* have thickened and turned into a sticky jelly, and the Veronese greens *have white in them*, which turns extremely ugly when it dries and the white comes to the surface. If Vollard reaches an agreement with you, here's the list of things I need (*good paints!*), even it means sending them *in two or three consignments*:

25 tubes of white	3 cadmium no. 2
10 ultramarine	4 emerald green
5 Prussian blue	20 good quality Veronese green
5 cobalt blue	5 verditer
5 chrome yellow	5 light vermilion
10 yellow ochre	3 madder (not pink)
5 reddish ochre	5 crimson lake
3 dark cadmium	

If possible, have 5 tubes of *bleu charron* and 5 tubes of *red lead* (*not* the orange lead) ground for me.

If possible, buy some canvas, 2 metres wide (*heavy* and a little *hairy* – knots don't matter, they can be cut off), and have it prepared with glue size with just a little bit of whiting, *not pipeclay*. Very flexible. Otherwise, I need some heavy canvas like Puvis de Chavannes, with as little covering as possible, but it's *so expensive! so expensive!* . . .

*

Tahiti, 27 January 1900

To Daniel de Monfreid . . . In my last letter, I forgot about the brushes. I need one and a half dozen sable brushes for doing outlines, and twenty other brushes of assorted sizes.

Another thing. If the Vollard deal comes off, I would like you to send me a little homeopathic *pharmacy*, with a very simple guide . . . Not only will it be useful for me, but also for the natives, who unfortunately are too haphazard in their use of herbs for medicinal purposes . . .

*

Tahiti, April 1900

To Daniel de Monfreid . . . If Vollard decides to put on a show [of my things] during the Universal Exhibition, I want it to be done very discerningly. That is to say, it would be important to choose some good old paintings along with the more recent things. Among other things, the *Ia orana Maria* from Manzi's [plate 166], one or two canvases from Degas, and the big painting *Where are we going?* . . . [plate 221]

*

212 OVIRI, 1891

Tahiti, October 1900

TO DANIEL DE MONFREID . . . On the subject of sculptures, . . . *it would please me greatly* if you were to accept (not as a present but as a token of friendship) all the wood carvings I did in Tahiti. I would like to have the large ceramic figure [plate 212] . . . to place on my tomb in Tahiti and, before that, to adorn my garden with. Which is to say that I would like you *to send it to me, carefully wrapped, as soon as you have sold something to pay for the packaging and dispatching* . . .

*

Tahiti, November 1900

TO DANIEL DE MONFREID . . . I recommend that you maintain relations with Bibesco, because I'm going to get rid of Vollard any moment now if he continues to play tricks on me . . .

*

TO DANIEL DE MONFREID ... In the Marquesas, where it is so easy to get models (something which is becoming harder and harder in Tahiti) and there are landscapes still to be discovered – in short, completely new and wilder elements – I think I'll do some fine things. My imagination was beginning to go cold here, and also the public was getting too used to Tahiti. People are so stupid that when they are shown paintings containing new and terrifying elements, Tahiti will become comprehensible and charming. My Breton canvases have become milk-and-water stuff because of Tahiti, and my Tahitian work will seem tame compared with the things I plan to do in the Marquesas.

*

Tahiti, July 1901

TO CHARLES MORICE After a long silence, a few words from you.

I confess that the publication of *Noa Noa* at quite the wrong time has no interest for me today. Why send me a hundred copies: here they'll become paper to burn ...

Another thing, and this is very important: I refer to the purchase of the big picture; but isn't this yet another of your enthusiasms which end in disillusion; these days there are so few patrons of the arts.

To be sure, it is more than owed me by all those young people who are profiting today ...

They have much talent; much more than I, who didn't have, as they did, every facility for learning and working. But perhaps without me they would not exist, without me the world would not accept them?

Today I am down, defeated by poverty and above all by illness, in essence premature old age. That I shall have some respite to finish my work I dare not hope: in any event I am making a final effort by going next month to settle in Fatu-iva, a still almost cannibalistic island of the Marquesas. I believe that there, that savage element, and that complete solitude will revive in me, before I die, a final spark of enthusiasm which will rejuvenate my imagination and form the culmination of my talent.

... In this big picture:

Where are we going?
Near to death an old woman.
A strange stupid bird concludes the poem ...
What are we?
Day to day existence. The man of instinct wonders what all this means.
Where do we come from?
Source.
Child.
Life begins.

[The bird concludes the poem] by comparing the inferior being with the intelligent being in this great whole which is the problem indicated by the title.

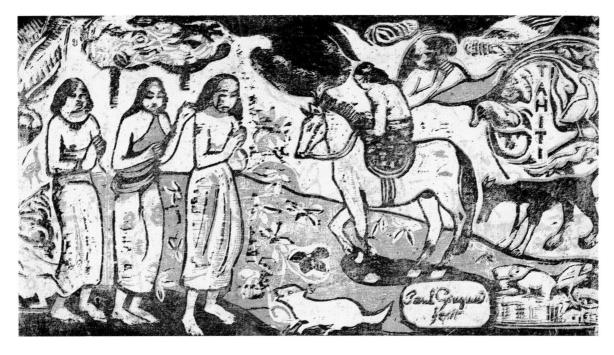

213 CHANGE OF RESIDENCE, 1899

Behind a tree two sinister figures, cloaked in garments of sombre colour, introduce, near the tree of knowledge, their note of anguish caused by that very knowledge in contrast to some simple beings in a virgin nature, which might be paradise as conceived by humanity, who give themselves up to the happiness of living.

Self-explanatory attributes – well-known symbols – would freeze the composition into a melancholy reality, and the problem indicated would cease to be a poem.

In a few words I explain the painting to you. Few are required by a man of your intelligence. But as for the public, why should my brush, free from all constraint, be obliged to open everyone's eyes?...

*

Tahiti, August 1901

TO DANIEL DE MONFREID ...You are going to say that the more money I have, the more I want, but *right now I would like you to sell as much as possible*. And this is the reason why. As soon as I have *enough money to keep me going for a year or two*, I shall stop dealing with Vollard...

One of these days, the next time you make a sale, use 150 to 200 francs of the proceeds to have suitable frames made for some of my wood engravings, which you can obtain from Vollard...

...Only 30 copies have been made of each block, and each one is *numbered*. It's precisely because these prints look back to the early days of woodcut engraving that they are interesting; like illustration, wood engraving is becoming more and more like photogravure, loathsome. A Degas drawing compared with a typical hatched drawing!!! I'm sure that in time my wood engravings, that are so different from all other engravings that are being done, will have some value...

214 LETTER TO DANIEL DE MONFREID WITH SKETCH OF
NEW STUDIO ON STILTS, November 1901

La Dominique (Hiva-Oa), Marquesas Islands, November 1901

TO DANIEL DE MONFREID . . . I have everything a modest artist could wish.

A huge studio with a bed tucked away in one corner; everything to hand, arranged on shelves; the whole thing raised two metres above the ground for eating, doing carpentry and cooking. A hammock for taking a siesta in the shade, cooled by breezes from the sea 300 metres away blowing gently through the coconut palms. I obtained half a hectare of land from the mission for 700 francs, though not without some difficulty. It was expensive, but that's all there was, and the mission *owns everything* here.

. . . Poetry emerges here of its own accord, and it can be evoked simply by allowing oneself to dream while painting. I ask for just two years of good health and not too many money worries, which now have an excessive hold over my nervous temperament, in order to reach a certain maturity in my art . . .

*

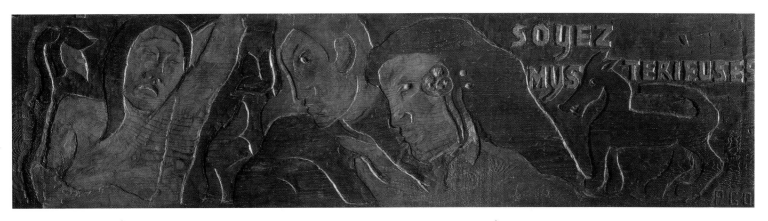

215 SOYEZ MYSTÉRIEUSES (LOWER LEFT PANEL FROM DOOR FRAME OF GAUGUIN'S LAST RESIDENCE IN ATUONA), 1902

Hiva-Oa, Marquesas Islands, May 1902

TO DANIEL DE MONFREID ... What you say about Morice's collaboration on *Noa Noa*
does not displease me.

As far as I was concerned, that collaboration had *two purposes*. It is not like other cases of
collaboration, that is, two authors working jointly. The idea had occurred to me, when
speaking about non-civilized people, to bring out their character alongside our own, and I
thought it would be rather original for me to write (quite simply, like a savage), and next to
that to have the *style* of a civilized man, which is what Morice is. So I *conceived* our collaboration
and *arranged* it to that end; then too, writing is not my line of work, so it was rather difficult to
know *which of the two of us* was the better: the naive and rough-spoken savage or the man rotted
by civilization. Morice decided to publish the book anyhow, and at an inappropriate time; that
does not dishonour me, after all. ...

*

Hiva-Oa, Marquesas Islands, 25 August 1902

TO DANIEL DE MONFREID ... By the way, Fayet has written to say he hopes to put on
a major exhibition of my work next year. Perfect! I'm not keen to have a large number of
canvases, but I am most concerned about *quality* (thank goodness you're there to keep an eye
on things). If possible, include the *large canvas that* is in Bordeaux [plate 221]. Schuffenecker
doesn't have much apart from the *wood carving* [plate 78]. If possible, the painting *Nevermore*
from Delius's [plate 206]. None of my Breton stuff (Brittany has been digested, whereas Tahiti
still has to be accepted and sold to the public) ... If I am to remain incurable, with this chronic
eczema on both feet, which makes me suffer so much, it will be better for me to return home
for a change of air. I will settle down near you in the Midi, even if it means going to Spain to
look for new elements ...

*

Marquesas Islands, September 1902

TO ANDRÉ FONTAINAS I am sending you this short manuscript written in haste, in the hope that if, after having read it, you approve of it, you will ask the *Mercure de France* to publish it.

...What I have written has no literary pretensions, only a profound conviction which I should like to communicate to others...

...If my manuscript is not published I should be grateful if you would send it to my friend the painter M. G. Daniel...

If I, the artist with sealed lips, have had reason to be proud of my influence upon van Gogh's noble nature, the situation is quite different with respect to my relationships with many of the Brittany painters, especially the young Émile Bernard. At that time he was 19 years old and very clever at imitating the Middle Ages one day, then the neo-Impressionists, the Florentines the day after that, etc.

After having admitted to van Gogh, to all of the Brittany group, and to me – in a letter I have carefully saved – that he had drunk from my spring, Bernard took it into his head to publish, in my absence, that I derived all my inspiration from his work.

Today he is a full-grown man and exhibits nice things, and for that I thank heaven.

From the very beginning until now my work (as one can see) forms one indivisible whole, with all the gradations due to the education of an artist. I have remained silent about all that and shall continue to do so, as I am convinced that truth becomes manifest not through controversy, but in the work one has produced.

Moreover, my completely isolated existence proves sufficiently how little I seek elusive glory. My pleasure is to recognize talent in others.

And if I write to you about all this, it is because I value your esteem and would not want you to misunderstand my manuscript nor see in it an attempt to achieve notoriety. No. Only I become angry when I see a man like Pissarro abused and ask myself whose turn it will be tomorrow.

When someone abuses me that is another thing. It doesn't annoy me, and I say to myself, 'Well! Perhaps I am somebody after all.'

*

Atuona [Marquesas Islands], September 1902

FROM *RACONTARS DE RAPIN* I am going to try to talk about painting, not as a man of letters but as a painter...

There will be much, possibly too much, about criticism, but it will be up to the critics and the public to take into account the exaggerations of an unruly mind.

...An artist must look to the future, whereas the so-called learned critic has learned only from the past....

The plastic arts do not easily give away their secrets; in order to guess them you must scrutinize those arts unceasingly while inwardly scrutinizing yourself. Complex arts if ever there were any. They include everything – literature, observation, virtuosity (I did not say dexterity), visual gifts, music...

Does anyone remember the Puvis de Chavannes banquet? All the cities, the guilds, and the State sent representatives who were to make speeches. Monsieur Brunetière, who was already signed up, represented art criticism. Now, everybody knows that Monsieur Brunetière is a remarkable and learned man, a writer, a logician, etc. a man whose words carry weight in polite society. He spoke:

'Monsieur Puvis . . . I must congratulate you on having produced great painting with pastel tones, without being carried away and using gaudy colours.'

That was all but it was enough. I was there and I protested.

The word 'Impressionism' was not spoken, but it was there, between the lines. Do you notice the dogma of light-toned painting without colours? Monsieur Brunetière does not like rubies and emeralds, only pearls! I see the pearl, but also the shell.

Perhaps Monsieur Brunetière will read this. He will smile disdainfully and will say: 'Monsieur Gauguin must attend the École Normale first, and then we will talk.' Will he be right?

First, government by men of arms; now, government by men of letters.

. . . Knowing how to draw does not mean drawing well. Let's have a look at that much-vaunted science of drawing. But it's a science that all the Prix de Rome winners have mastered, as have even the contestants who came out last . . .

One painter who has never known how to draw but who draws well is Renoir . . .

. . . If we look at Pissarro's art as a whole, despite its fluctuations . . . we find not only an enormous artistic determination which never wavers but, in addition, an essentially intuitive thoroughbred art. . . . He has looked at everyone, you say! Why not? Everyone has looked at him too but disowns him. He was one of my masters and I do not disown him.

. . . Mr Critic, you can't claim to have discovered Cézanne. Today you admire him. Admiring him (which calls for understanding) you say 'Cézanne is monochromatic.'

You could have said polychromatic or even polyphonic. You must have an eye and also an ear! 'Cézanne doesn't have antecedents; he is content to be Cézanne.' There you are mistaken, otherwise he would not be the painter he is. Unlike Loti he has read; he knows Virgil; he has looked with understanding at Rembrandt and Poussin . . .

. . . No, no, a thousand times no; an artist is not born as such all at once. If he adds one new link to the chain that has already been begun, that in itself is a great deal.

. . . What did Delacroix mean when he talked about the music of a painting? Make no mistake about it, Bonnard, Vuillard and Sérusier, to mention a few of the young painters, are musicians, and you can be sure that coloured painting has entered a musical phase. Cézanne, to mention an 'old' painter, seems to be a pupil of César Franck; he is constantly playing the organ, which is what made me say that he was polyphonic.

. . . Our feelings, when we see or read a work of art, are due to a number of things . . . If a critic wants to accomplish his real task as a critic, then, above all, he must mistrust himself instead of trying to find himself in the work.

In the nineteenth century

The events of the Revolution put an end to eighteenth-century art. Then came the many years of destruction, the soldiers, the bureaucracy. Throughout this whole period the arts came to a complete standstill . . .

. . . Napoleon I, who is supposed to have reconstituted everything, reconstituted art as well in the form of a code. There were no more painters, only professors.

216 RIDERS ON THE BEACH, 1902

... When the State backs something, it does it thoroughly. Everywhere, patented professors guaranteeing perfection, and enormous mediocrity ... Although it was convenient for the mediocre, on the other hand it was a terrible torment for men of genius.

Among them, Delacroix, always in conflict with the schools and their attitude: how could such vile drawing be married to so beautiful a fiancée as the use of colour he had begun to glimpse? Hence this maxim they still intone at the École des Beaux-Arts: 'Delacroix is a great colourist but he does not know how to draw.'

At about the same time, the obstinate and strong-willed Ingres ... simply set about reconstructing a logical and beautiful language for his own use, keeping one eye on the Greeks and the other on nature.

Since in Ingres's work drawing was a matter of line, people did not notice the change so much. Yet he took a considerable step. No one in his entourage understood this . . .

Ingres and Cimabue have points in common, among them the ridiculous, the beautifully ridiculous, the kind of thing that would make you say: 'Nothing looks more like a bit of daubing than a masterpiece.'

. . . In spite of his official status, Ingres was certainly the most misunderstood painter of his day; possibly it was for that very reason that he was the official painter. People did not see the revolutionary in him, the reconstructor; in that very respect the École did not follow him.

. . . After the events of 1870, the numbers coming back to the Salon were tremendous.

Defeated soldiers filled with hate for the Prussians, and proud of their vile reprisals against the Commune . . . French painters, salute! Here is your commander ordering you, 'Attention, Forward, March!' . . .

Everyone was involved – the State, for one thing, with all its fake luxury, its decorations and purchases . . . For another, the Press and high finance: speculation. And also the large number of artists, and the influence of women . . .

. . . the first exhibition by a little group, since called 'Impressionists', took place . . .

People laughed uncontrollably . . .

Yet it was a serious matter and the Salon did not realize it . . . I will not go into their history; everybody knows it. I point it out only as a way of noting one of the most influential efforts ever made in France, only a handful of men with only one weapon, their talent, successfully doing battle against a fearsome power made up of Officialdom, the Press, and Money.

But it was merely the pictorial triumph of a certain type of painting – which by now has more or less cleverly fallen into the public domain . . .

So it was necessary, with due consideration for the efforts made and for all the research . . . to attempt complete liberation, to smash windows, even at the risk of cutting one's fingers, and leave it up to the next generation, independent henceforth, free of all hindrance, to solve the problem brilliantly.

I will not say 'definitively', for what we are talking about is actually an endless art: it uses a wealth of different techniques and is capable of rendering all natural and human emotions, fitting itself to the joys and sufferings of each individual and each era.

This meant giving oneself over body and soul to the struggle, fighting against all the schools . . .

Not having a wife any more, or children who disown you – disregarding insults, disregarding poverty . . . Doing everything that is forbidden, and then rebuilding more or less successfully without being afraid to exaggerate – exaggerating, in fact. Learning anew, then, once that has been assimilated, learning again; overcoming all bashfulness, regardless of the ridicule which that brings you.

When a painter stands before his easel, he is a slave neither to the past nor to the present, neither to nature nor to his neighbour.

. . . This effort I'm talking about was made about 20 years ago; it was made secretly, in ignorance, but with determination . . .

Let everyone claim credit for what has been achieved! It doesn't matter. What does matter is what exists today and what will pave the way for the art of the 20th century . . .

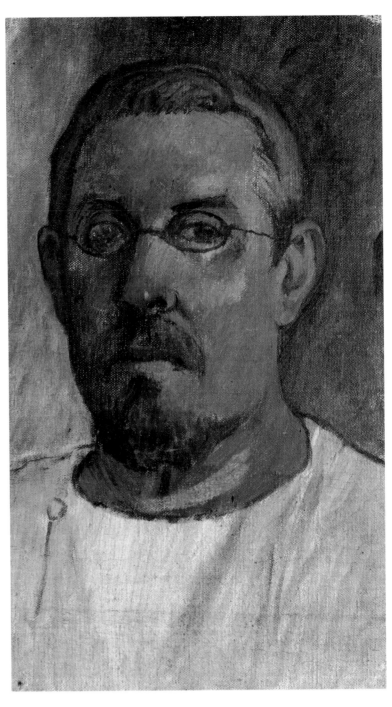

217 SELF-PORTRAIT WITH SPECTACLES, 1903

Hiva-Oa, Marquesas Islands, October 1902

TO DANIEL DE MONFREID . . . Your wife is dying: it makes me think of mine, who is not dying. I still have no news of her, and I'm increasingly becoming a stranger to the children. Still, the wounds are gradually healing in my solitude. All the same, I don't think anyone would dare to do as much to a father who was in prison.

Perhaps, apart from the four who bear my name, there are wives and grandchildren who also bear it; and if, after my death, I am famous, people will say: Gauguin *had a large family*, he was a patriarch – bitter derision.

Or they might say: he was a heartless man who abandoned his children, etc . . .

What does it matter! Let's leave those nasty bourgeois in their wretched place – even if they are our children – and continue the work we have begun . . .

You have known for a long time what I wanted to establish: the *right* to dare everything. My capacities . . . have not led to any great result, but at least the machine is in motion . . .

*

Atuona, Hiva-Oa, February 1903

To André Fontainas . . . I have just written a whole collection of notes – childhood memories, the whys and wherefores of my intuitions, of my intellectual evolution; also what I have seen and heard (including my opinions of people and things); my art, that of others, my likes and dislikes. It is not a literary work in a particular form chosen among others, but something quite different: the civilized man face to face with the barbarian . . .

. . . when you read between the lines you will understand my personal and malicious desire to have the book published. I WANT it done, no matter how unpretentiously; I do not care to have it read by many, only a few.

I should be very grateful (whatever happens) if in remembrance of me you would accept the manuscript with its sketches to be kept in some odd corner as a barbaric curio, not treasured among your valued possessions . . .

. . . No, I don't underrate myself, quite the contrary . . . from time to time I send just enough pictures to Vollard to enable me to buy a hard-earned crust of bread and a few medicines. I believe Vollard hides the pictures, no doubt with an eye to speculation. But I think that if you should ask to see them sometime, he would show them to you . . .

*

Atuona, Hiva-Oa, 1903

AVANT ET APRÈS *On drawing*

. . . A critic at my house sees some paintings. Breathing heavily, he asks for my drawings. My drawings? Never! They are my letters, my secrets. The public man, the private man.

You wish to know who I am: my works are not enough for you? Even at this moment, as I write, I only reveal what I want to reveal. But often you see me completely naked; that is no argument. It is the inner man you need to see. Besides, I do not always see myself very well.

On Marquesan art

. . . People in Europe do not seem to realize that both the Maoris of New Zealand and the Marquesans had evolved a very advanced type of decorative art. Mr Know-it-all-Critic is wrong when he dismisses it all as 'Papuan art!'

218 RUBBINGS FROM MARQUESAN CARVED ORNAMENT, 1892–1893,
pasted onto page 168 of *Noa Noa* (Louvre ms), *c*.1897

The Marquesans especially have an extraordinary sense of decoration. Give a Marquesan an object of any geometric shape, even hump-backed, rounded geometry, and he will manage to make everything harmonious without leaving any shocking and disparate empty place. The basis of this art is the human body or face. The face especially. You're astonished to find a face where you thought there was a strange geometrical figure. Always the same thing and yet never the same thing.

Today, even if you offered their weight in gold, you would not find any more of those beautiful objects that they used to make out of bone, tortoise shell, or ironwood. The gendarmerie has filched everything and sold these objects to collectors, and yet the administration never once thought of doing what would have been so easy for it: creating a museum in Tahiti of all Oceanic art.

None of these people who claim to be so educated had any idea of the value of the Marquesan artists. There was not one official's wife who did not exclaim, on seeing examples of that art: 'But it's dreadful! It's just plain barbaric!' Barbaric! That's their favourite word.

219 RUBBING FROM MARQUESAN CARVED ORNAMENT,
1892–1893, pasted onto page 126 of *Noa Noa* (Louvre
ms), *c.*1897

... Any of the women can make her own dress, plait her hat, bedeck it with ribbons in a way that outdoes any milliner in Paris, and arrange bouquets with as much taste as on the Boulevard de la Madeleine. Their beautiful bodies, without any whalebone to deform them, move with sinuous grace under their lace and muslin chemises. From the sleeves emerge essentially aristocratic hands. Their feet, on the contrary, which are wide and sturdy, and wear no laced boots, offend us but only at first, for later it is the sight of laced boots that would offend us.

... What makes the Maori woman different from all other women, and often makes her resemble a man, are her bodily proportions. Diana the huntress with broad shoulders and narrow hips.

... In Maori women, the entire leg from hip to foot forms an attractive straight line. The thigh is very heavy, but not widthwise, and the heaviness makes it very round and avoids that gap between the thighs that makes some women in our countries remind us of a pair of tweezers.

... Let's get back to Marquesan art. It has disappeared, thanks to the missionaries. The missionaries looked on carving and decorating as fetishism, offensive to the Christian God. That's the crux of the matter, and the poor wretches gave in. From the cradle onward, the new generation sings hymns in incomprehensible French and recites the catechism... If a girl has picked flowers and artistically makes a pretty wreath of them and places it on her head, Monsignor becomes angry!

Soon the Marquesan natives will be incapable of climbing up coconut trees, incapable of going into the mountains to look for the wild bananas that can provide them with food. The children are kept in school, deprived of physical exercise, their bodies always clothed (for decency's sake); so they become frail, unable to spend the night in the mountains. They have all begun to wear shoes, and their feet, being sensitive from now on, will not be able to run along the rugged paths, or cross streams by stepping from stone to stone.

So what we are witnessing is the sad sight of a race becoming extinct...

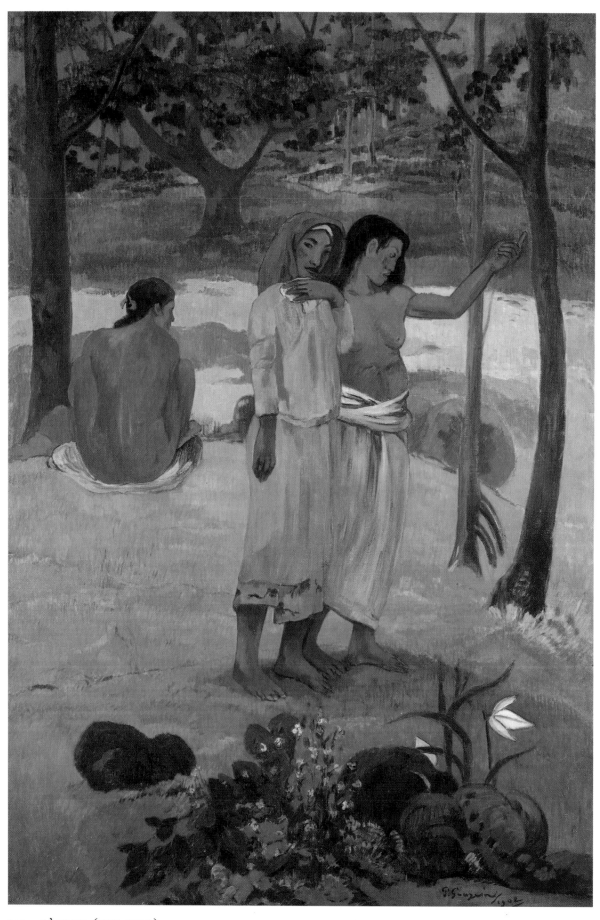

220 L'APPEL (THE CALL), 1902

Atuona, Hiva-Oa, April 1903

To Charles Morice

... I am down, but not yet defeated. Is the Indian who smiles under torture defeated? No doubt about it, the savage is certainly better than we are. You were mistaken one day when you said I was wrong to say that I am a savage. For it is true: I am a savage. And civilized people suspect this, for in my works there is nothing so surprising and baffling as this 'savage in spite of myself' aspect. That is why it is inimitable ... In art we have just undergone a very long period of aberration due to physics, mechanical chemistry, and the study of nature. Artists have lost all their savagery, all their instincts, one might say their imagination, and so they have wandered down every kind of path in order to find the productive elements they hadn't the strength to create; as a result, they act only as undisciplined crowds and feel frightened, lost as it were, when they are alone. That is why solitude is not to be recommended to everyone, for you have to be strong in order to bear it and act alone. Everything I learned from other people merely stood in my way. Thus I can say: no one taught me anything. On the other hand, it is true that I know so little! But I prefer that little, which is of my own creation. And who knows whether that little, when put to use by others, will not become something big? ...

[Gauguin died on 8 May 1903.]

221 D'OÙ VENONS-NOUS? QUE SOMMES-NOUS? OÙ ALLONS-NOUS?
 (WHERE DO WE COME FROM? WHAT ARE WE? WHERE ARE WE GOING?), 1897

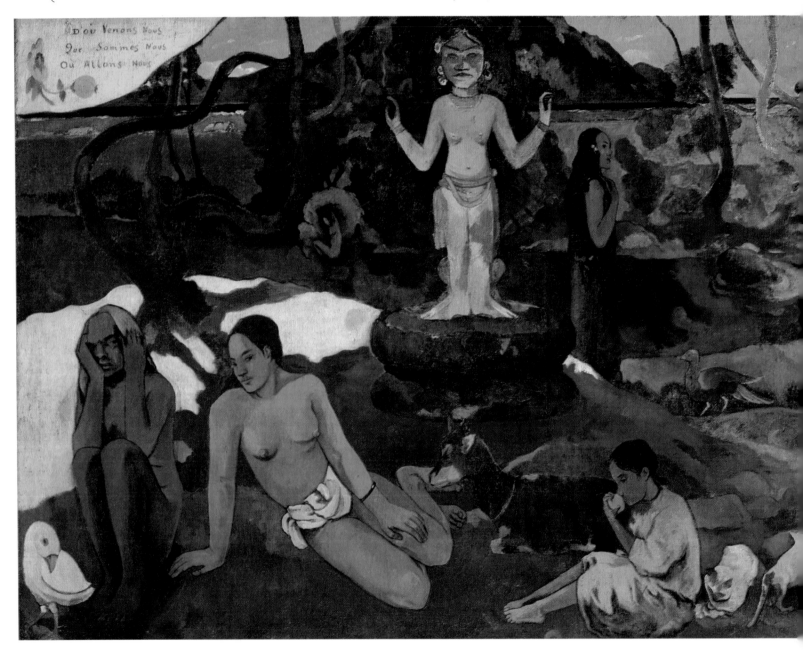

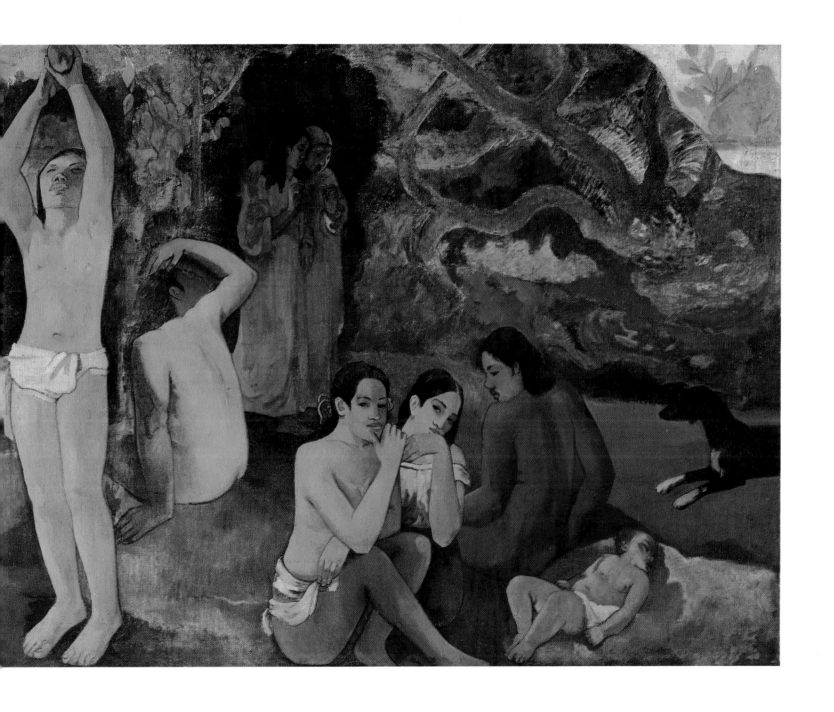

222 PORTRAIT OF A YOUNG WOMAN, VAITE (JEANNE) GOUPIL, 1896

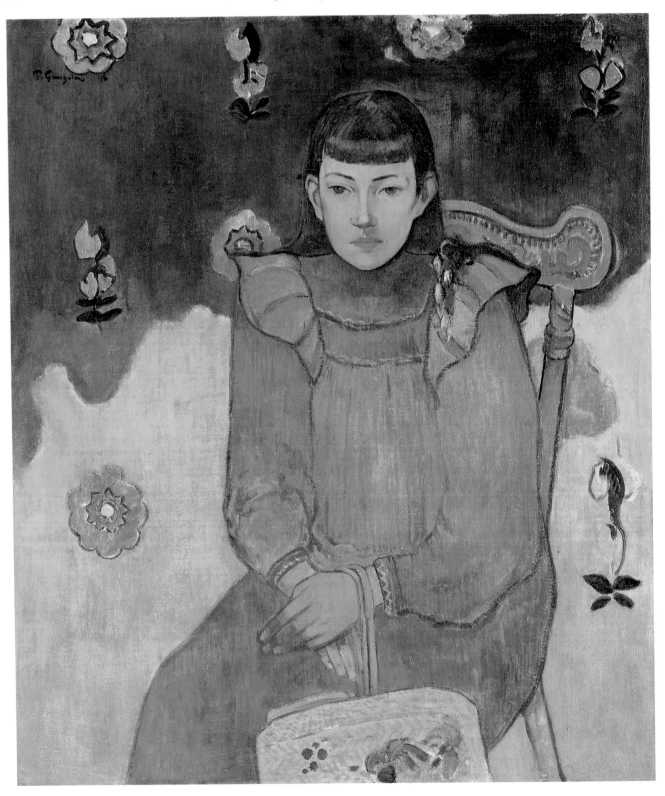

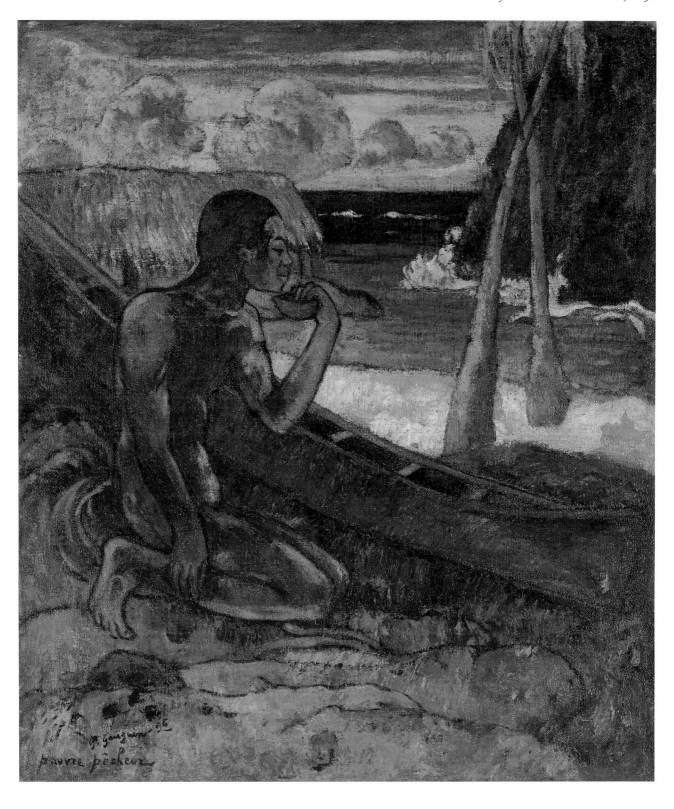

224 THATCHED HUT UNDER PALM TREES, page 181 of *Noa Noa* (Louvre ms), *c.* 1896–1897

THATCHED HUT UNDER PALM TREES, page 181 of *Noa Noa* (Louvre ms), *c.* 1896–1897

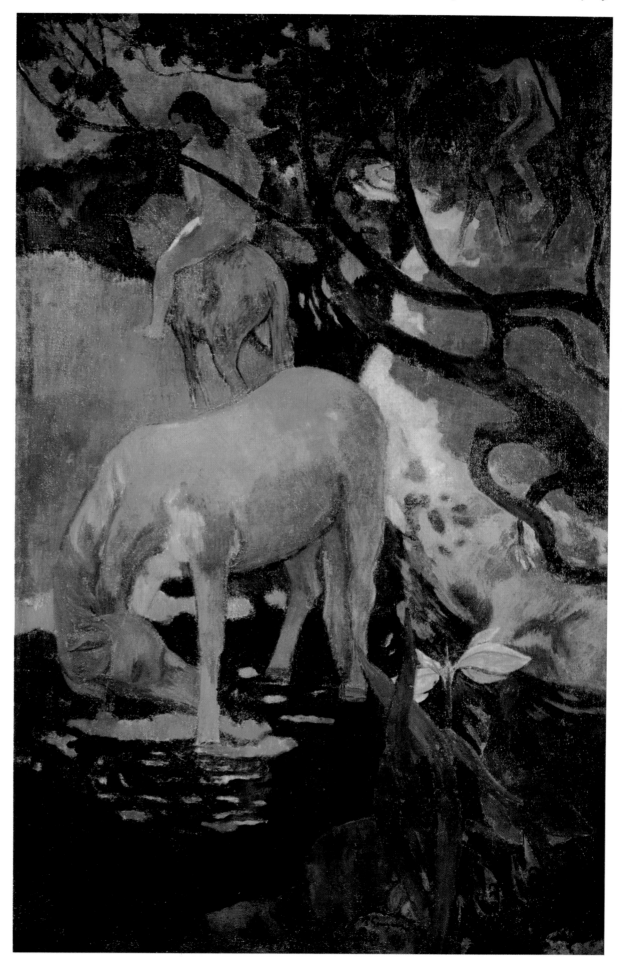

226 RUPE RUPE (FRUIT GATHERING), 1899

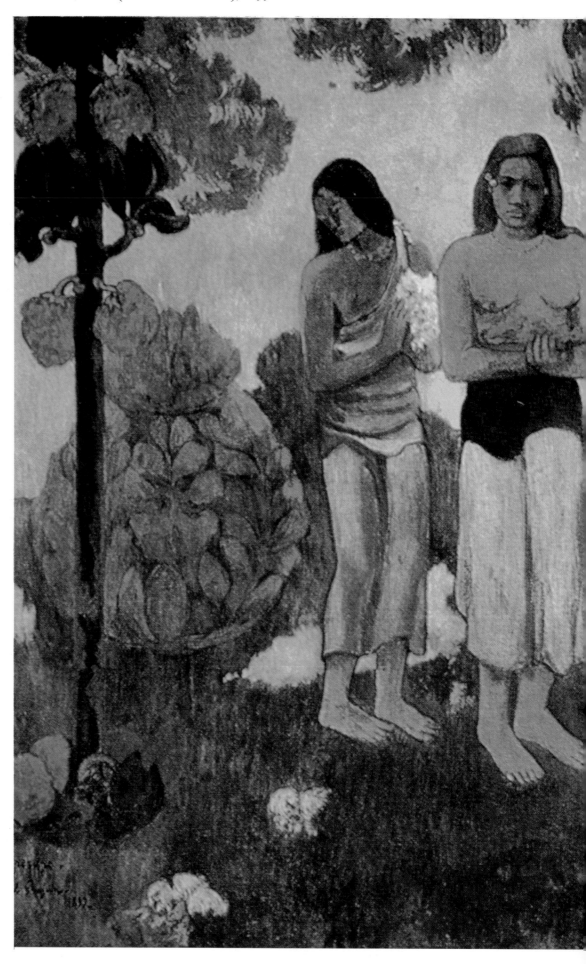

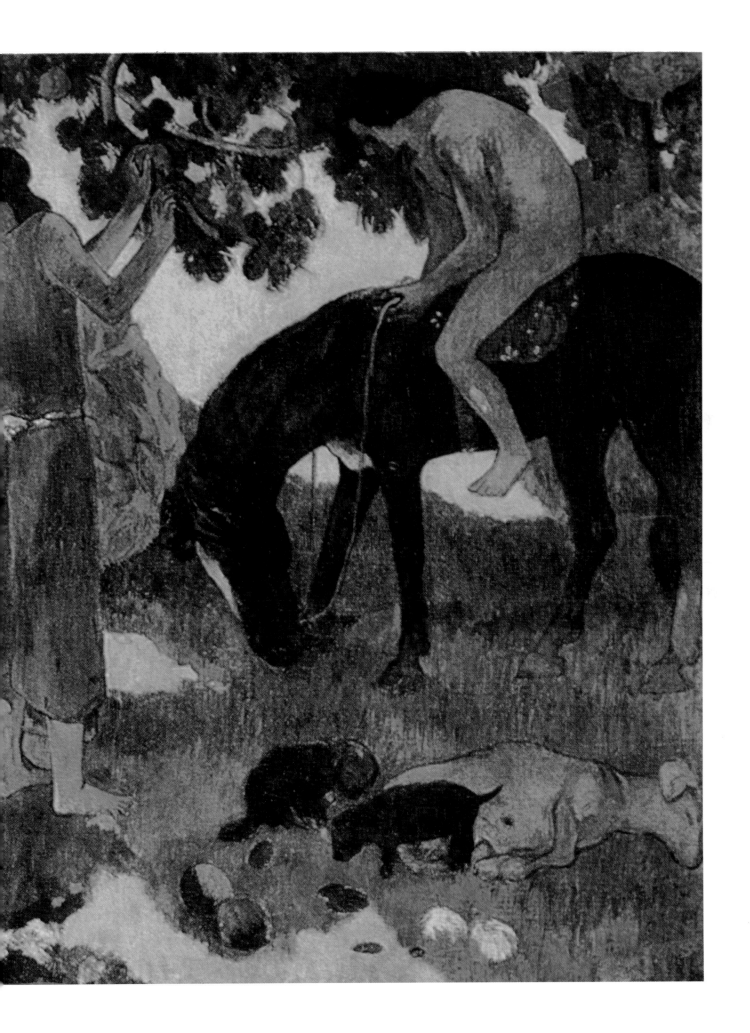

227 IDYLL IN TAHITI, 1901

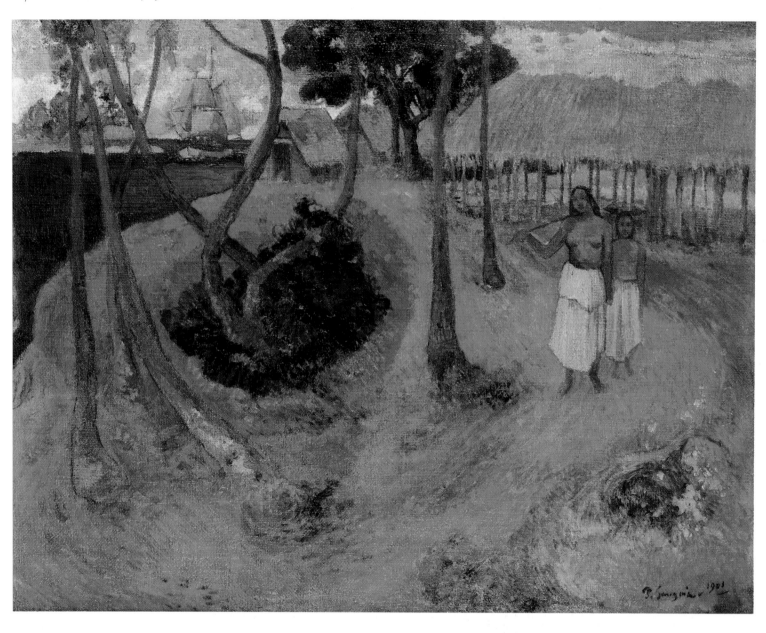

228　LANDSCAPE WITH THREE FIGURES, 1901

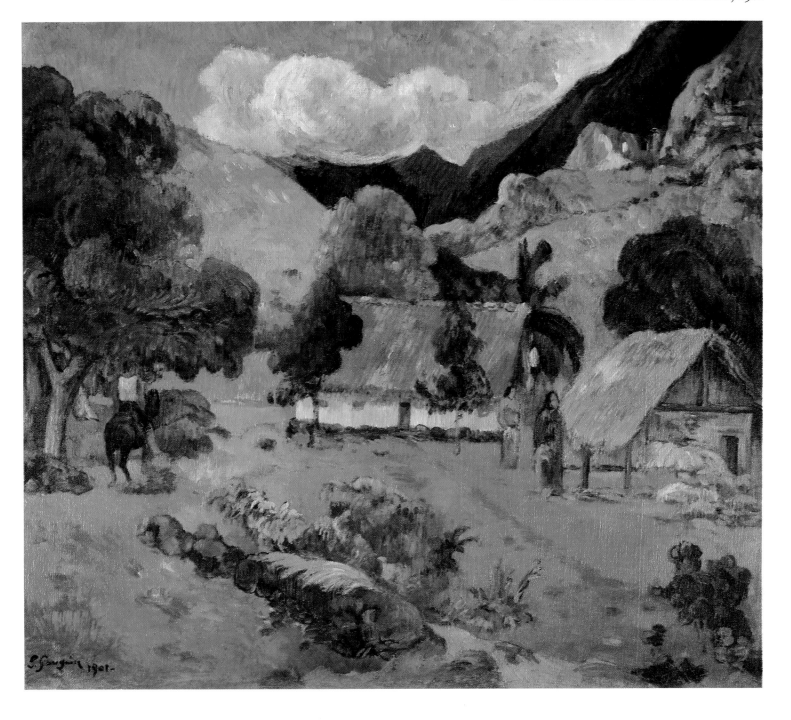

229 MATERNITY (THREE WOMEN ON THE SEASHORE), 1899

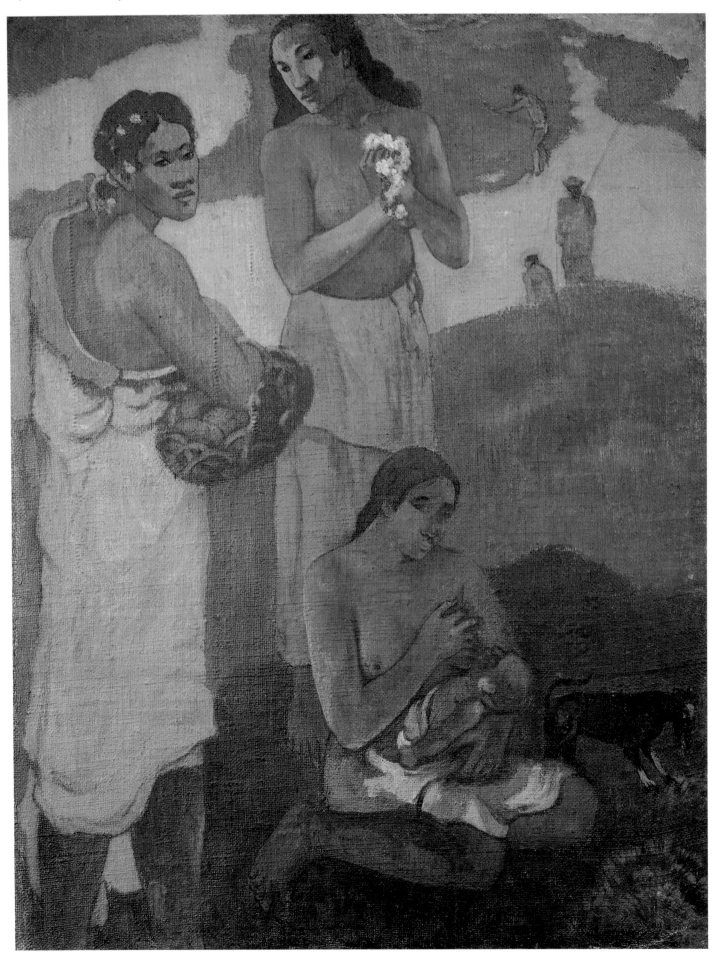

229 MATERNITY (THREE WOMEN ON THE SEASHORE), 1899

230 CONTES BARBARES, 1902

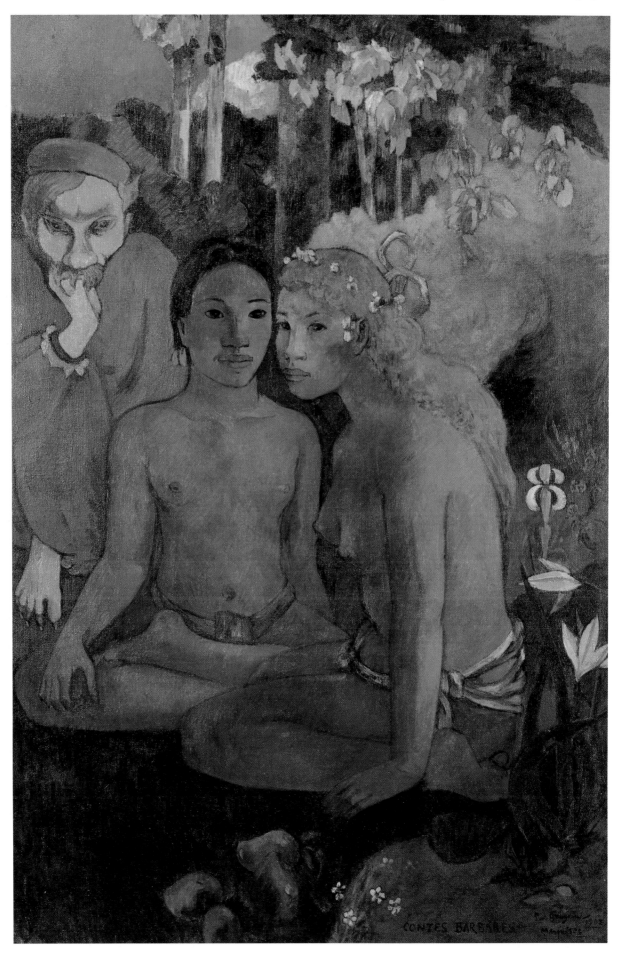

231 FLOWER PIECE, 1896

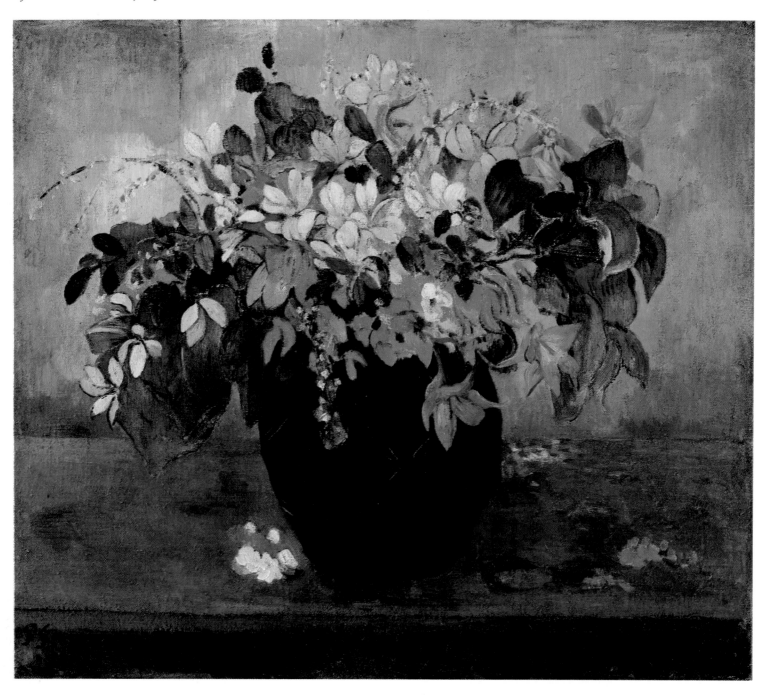

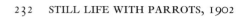

232 STILL LIFE WITH PARROTS, 1902

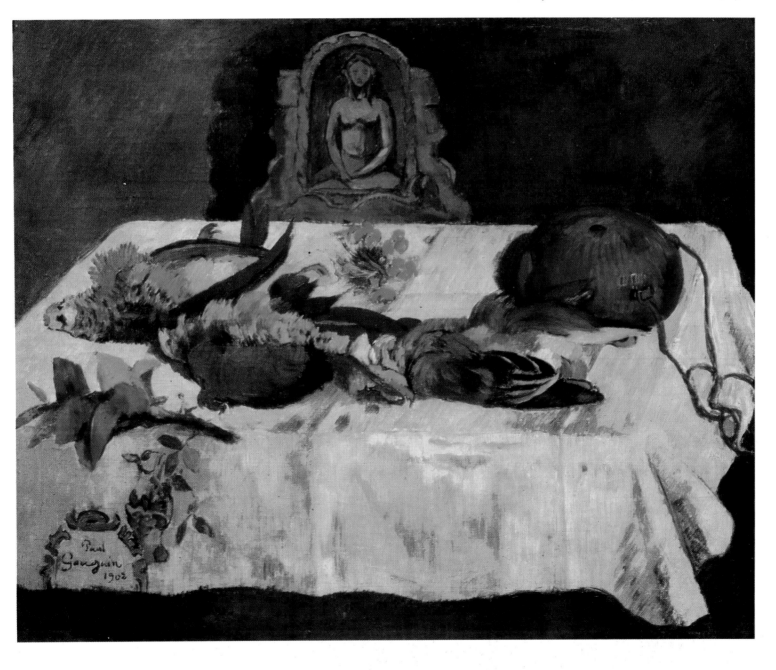

233 THE OFFERING, 1902

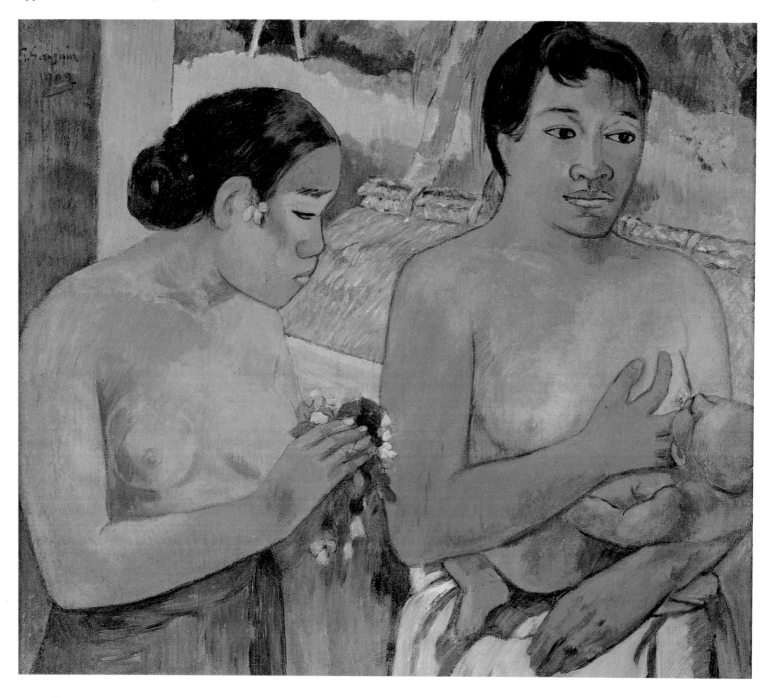

234 MOTHER AND DAUGHTER (PORTRAITS OF WOMEN), 1901–1902

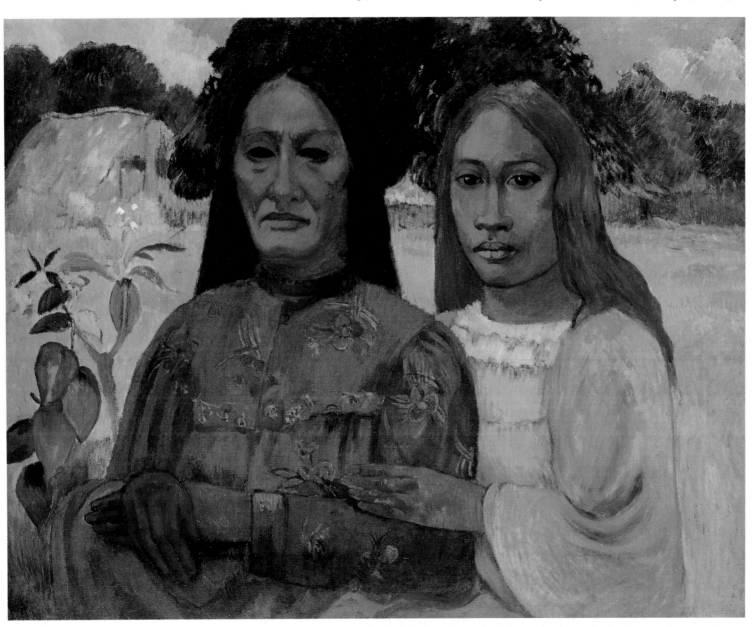

235 TAHITIAN WOMAN WITH CHILDREN, 1901

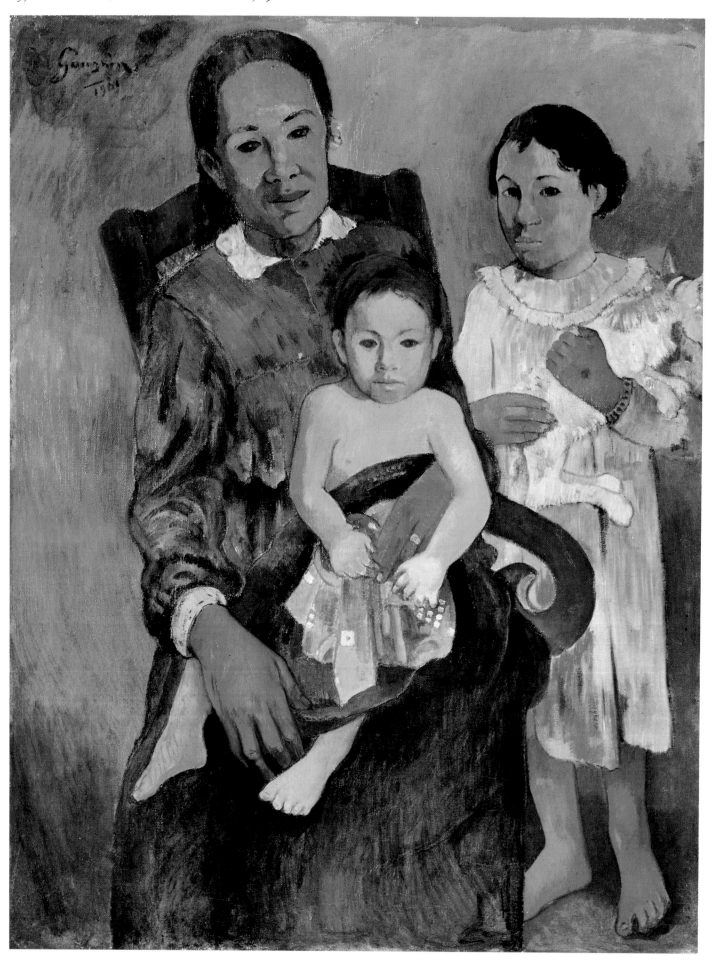

235 TAHITIAN WOMAN WITH CHILDREN, 1901

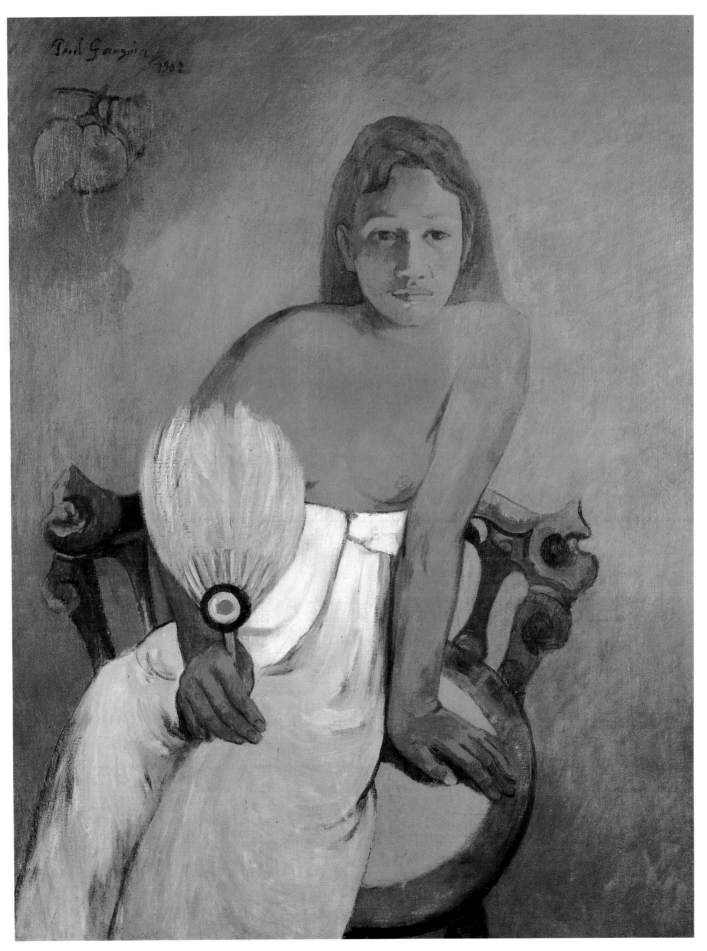

237 FOUR CARVED PANELS FROM DOOR FRAME OF GAUGUIN'S FINAL RESIDENCE IN ATUONA, 1902

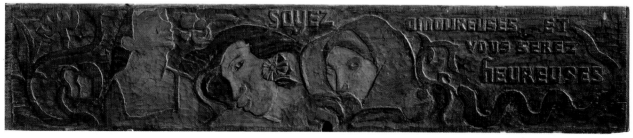

List of Plates

Key to abbreviations of frequently cited catalogues

B: Bodelsen, Merete, *Gauguin's Ceramics: A Study in the Development of his Art*,
London, 1964
Field: Field, Richard S., *Paul Gauguin: Monotypes*, exhibition catalogue,
Philadelphia Museum of Art, 1973
G: Gray, Christopher, *Sculpture and Ceramics of Paul Gauguin*, Baltimore, 1963;
revised edition, New York, 1980
GU: Guérin, Marcel, *L'Œuvre gravé de Gauguin*, Paris, 1927
W: Wildenstein, Georges (ed. Raymond Cogniat and Daniel Wildenstein),
Gauguin, vol. 1, catalogue raisonné of the paintings, Paris, 1964

1 SELF-PORTRAIT, inscribed 'à l'ami Daniel', 1897
 Oil on canvas, 39 × 35 cm W 556
 Museé d'Orsay, Paris © *Photo RMN*

2 THE MOTHER OF THE ARTIST, *c.*1890
 Oil on canvas, 41 × 33 cm W 385
 Staatsgalerie Stuttgart (Inv. 2554)

3 SELF-PORTRAIT, dedicated to E. Carrière, 1888 and 1895
 Oil on canvas, 46.5 × 38.6 cm W 384
 Collection of Mr and Mrs Paul Mellon © *1992 National Gallery of Art,
 Washington*

4 THE ARTIST'S INFANT SON, EMIL, *c.*1875–1876
 Charcoal on paper, altogether measuring 9.8–10.3 × 29.5 cm
 The Cleveland Museum of Art. Gift of Leonard C. Hanna, Jr, 36.658–36.661

5 PORTRAIT BUST OF METTE GAUGUIN, 1879
 White marble, h. 34 cm G 1
 Courtauld gift 1932. Courtauld Institute Galleries, University of London

6 PORTRAIT BUST OF EMIL GAUGUIN, 1879
 Marble, h. 41 cm G 2
 *The Metropolitan Museum of Art, New York. Gift of the Joseph M. May Memorial
 Association, Inc. 1963* (63.113)

7 THE MARKET GARDENS OF VAUGIRARD, 1879
 Oil on canvas, 66 × 100.3 cm W 36
 Smith College Museum of Art, Northampton, Massachusetts. Purchased 1953

8 PORTRAIT OF GAUGUIN BY PISSARRO, PORTRAIT OF PISSARRO
 BY GAUGUIN, *c.*1880
 Coloured chalk and charcoal on blue paper, 35.8 × 49.5 cm
 Musée du Louvre (Orsay), Département des Arts Graphiques (RF 29538)
 © *Photo RMN*

9 THE FAMILY IN THE GARDEN, RUE CARCEL, 1882
 Oil on canvas, 87 × 114 cm W 67
 Ny Carlsberg Glyptotek, Copenhagen (Inv. 898). *Photo: Ole Woldbye*

10 WOMAN WALKING (THE LITTLE PARISIENNE), 1880
 Bronze, h. 27 cm G 4
 Josefowitz collection

11 THE SINGER/PORTRAIT OF VALÉRIE ROUMI, 1880
 Mahogany and plaster medallion, partially polychrome and heightened in
 gold, d. 53 cm G 3
 Ny Carlsberg Glyptotek, Copenhagen. Photo: NCG

12 VILLAGE STREET, OSNY, 1883
 Oil on canvas, 76.5 × 101 cm W 87
 Ny Carlsberg Glyptotek, Copenhagen. Photo: NCG/Hans Petersen

13 CHILD ASLEEP, 1884
 Oil on canvas, 46 × 55.5 cm W 81
 Josefowitz collection

14 FAN, VIEW NEAR ROUEN, 1880–1885
 Gouache, 13 × 52 cm W 119
 Ny Carlsberg Glyptotek, Copenhagen. Photo: NCG/Ole Haupt

15 SKATING IN FREDERIKSBERG PARK, 1884
 Oil on canvas, 65 × 54 cm W 148
 Ny Carlsberg Glyptotek, Copenhagen. Photo: NCG November 1991

16 FAN, PROVENÇAL LANDSCAPE AFTER CÉZANNE, 1885
 Gouache, 28 × 55 cm W 147
 Ny Carlsberg Glyptotek, Copenhagen. Photo: NCG/Ole Haupt

17 METTE GAUGUIN IN EVENING DRESS, 1884
 Oil on canvas, 65 × 54.3 cm W 95
 Nasjonalgalleriet, Oslo (Inv. 771). *Photo: Jacques Lathion*

18 SELF-PORTRAIT IN FRONT OF AN EASEL, 1885
 Oil on canvas, 65 × 54 cm W 138
 Private collection, Switzerland

19 STILL LIFE WITH MANDOLIN, 1885
 Oil on canvas, 65 × 53 cm W 173
 Musée d'Orsay, Paris (MNR 219) © *Photo RMN*

20 EDGE OF THE POND, 1885
 Oil on canvas, 81 × 65 cm W 158
 Civica Galleria d'Arte Moderna, Raccolta Grassi, Milano

21 COTTAGES, LE CHAMP DEROUT-LOLLICHON, 1886
 Oil on canvas, 73 × 92 cm W 199
 Josefowitz collection

22 VASE DECORATED WITH FIGURE OF A BRETON WOMAN,
 1886–1887
 Unglazed brown stoneware, h. 13.6 cm G 36, B 28
 Kunstindustrimuseet, Copenhagen. Photo: Ole Woldbye

23 MANGO PICKERS, MARTINIQUE, 1887
 Oil on canvas, 89 × 116 cm W 224
 Vincent van Gogh Foundation/Rijksmuseum Vincent van Gogh, Amsterdam

24 MARTINIQUE (WOMAN WITH MANGOES), 1888–1889
 Carved relief, 30 × 49 cm G 60
 Ny Carlsberg Glyptotek, Copenhagen. Photo: NCG

25 LANDSCAPE, 1873
 Oil on canvas, 50.5 × 81.5 cm W 5
 Fitzwilliam Museum, Cambridge (Inv. PD 20–1952)

26 THE SEINE AT THE PONT D'IÉNA, SNOW, 1875
 Oil on canvas, 65 × 92.5 cm W 13
 Musée d'Orsay, Paris (RF 1941–27) © *Photo RMN*

27 LANDSCAPE WITH POPLARS, 1875
 Oil on canvas, 81 × 101 cm W 11
 © *1991 Indianapolis Museum of Art, Estate of Kurt F. Pantzer, Sr*
 (IMA 82.54)

28 WINTER LANDSCAPE, 1879
 Oil on canvas, 60.5 × 80.5 cm W 37
 *Reproduced by courtesy of the Board of Directors of the Budapest Museum of Fine
 Arts* (Inv. 204B)

29 APPLE TREES AT L'HERMITAGE, NEAR PONTOISE, 1879
 Oil on canvas, 65 × 100 cm W 33
 Aargauer Kunsthaus, Aarau

30 INTERIOR OF THE PAINTER'S HOUSE, RUE CARCEL, 1881
 Oil on canvas, 130 × 162 cm W 50
 Nasjonalgalleriet, Oslo (Inv. 1153). *Photo: Jacques Lathion*

31 PORTRAIT OF METTE GAUGUIN, 1878
Oil on canvas, 115 × 80.5 cm W 26
Foundation E. G. Bührle, Zurich. Photo: W Dräyer, Zurich

32 STILL LIFE, CLAY JUG AND IRON JUG, 1880
Oil on canvas, 89 × 72 cm W 47
Sara Lee Corporation, Chicago, Illinois, Nathan Cummings collection

33 STUDY OF A NUDE, SUZANNE SEWING, 1880
Oil on canvas, 115 × 80 cm W 39
Ny Carlsberg Glyptotek, Copenhagen. Photo: NCG/Ole Haupt

34 YOUNG GIRL DREAMING, STUDY/CHILD ASLEEP. THE
PAINTER'S DAUGHTER ALINE, RUE CARCEL, 1881
Oil on canvas, 59.5 × 73.5 cm W 52–53
The Ordrupgaard Collection, Copenhagen

35 THE SCULPTOR AUBÉ AND A CHILD, 1882
Pastel on wove paper, 53.8 × 72.8 cm W 66
*Musée du Petit Palais (PPD 13480) © Photothèque des Musées de la Ville de
Paris, by SPADEM*

36 THE POPLARS, 1883
Oil on canvas, 73 × 54 cm W 88
Ny Carlsberg Glyptotek, Copenhagen. Photo: NCG/Hans Petersen

37 DRONNINGENS MILL, OSTERVALD, 1885
Oil on canvas, 92.5 × 73.4 cm W 141
Ny Carlsberg Glyptotek, Copenhagen

38 THE BLUE ROOFS, ROUEN, 1884
Oil on canvas, 74 × 60 cm W 100
The Oskar Reinhart Collection, Am Römerholz, Winterthur

39 LANDSCAPE WITH COWS IN AN ORCHARD, 1885
Oil on canvas, 64 × 80 cm W 160
Museum Boymans-van Beuningen, Rotterdam (Inv. 2605)

40 BATHING, DIEPPE, 1885
Oil on canvas, 73 × 73 cm W 166
Ny Carlsberg Glyptotek, Copenhagen. Photo: NCG

41 WOMEN BATHING, DIEPPE, 1885
Oil on canvas, 38 × 46 cm W 167
*The National Museum of Western Art, Tokyo. Matsukata collection
(Inv. P 1959–104)*

42 STILL LIFE, THE WHITE BOWL, 1886
Oil on canvas, 59.5 × 72 cm W 211
Kunsthaus Zurich (Inv. 1986/2)

43 STILL LIFE WITH PROFILE OF LAVAL, 1886
Oil on canvas, 46 × 38 cm W 207
Josefowitz collection

44 WASHERWOMEN AT PONT-AVEN, 1886
Oil on canvas, 71 × 90 cm W 196
Musée d'Orsay, Paris (RF 1965–17) © Photo RMN

45 BRETON SHEPHERDESS, 1886
Oil on canvas, 61 × 73.5 cm W 203
Laing Art Gallery, Newcastle upon Tyne, England (Tyne and Wear Museums)

46 SEATED BRETON GIRL, 1886
Charcoal heightened with watercolour, 30.5 × 42.2 cm
Musée des Arts Africains et Océaniens, Paris © Photo RMN

47 BRETON GIRL, 1886
Charcoal and pastel on paper, 48 × 32 cm
The Burrell Collection, Glasgow Museums and Art Galleries (Inv. 35.264)

48 VASE DECORATED WITH BRETON SCENES, 1886–1887
Enamelled stoneware with incised decoration, h. 29.5 cm G 45, B 9
Musées Royaux des Beaux-Arts et d'Histoire, Brussels

49 FOUR BRETON WOMEN, 1886
Oil on canvas, 72 × 90 cm W 201
Bayerische Staatsgemäldesammlungen, Neue Pinakothek

50 TROPICAL VEGETATION, MARTINIQUE, 1887
Oil on canvas, 115.5 × 89 cm W 232
National Gallery of Scotland, Edinburgh (1960 reg. no. 2220)

51 MARTINIQUE LANDSCAPE (COMINGS AND GOINGS), 1887
Oil on canvas, 72.5 × 92 cm W 230–232
Thyssen-Bornemisza Collection, Lugano, Switzerland

52 SEASHORE, MARTINIQUE, 1887
Oil on canvas, 46 × 61 cm W 218
Private collection, Paris

53 BY THE SEASHORE, MARTINIQUE, 1887
Oil on canvas, 54 × 90 cm W 217
Ny Carlsberg Glyptotek, Copenhagen

54 BATHER (STUDY FOR LA BAIGNADE), 1887
Charcoal and pastel with traces of brush and ink on buff laid paper.
Irregular form, 58.8 × 35.8 cm
*Gift of Mrs Gilbert W. Chapman in memory of Charles B. Goodspeed, 1946.292.
© The Art Institute of Chicago. All rights reserved*

55 LA BAIGNADE, 1887
Oil on canvas, 87.5 × 70 cm W 215
National Museum of Fine Arts, Buenos Aires/Bridgeman Art Library, London

56 THE DANCE OF THE BRETON GIRLS, 1888
Pastel on paper, irregular oval with torn edges, 24 × 41 cm
Vincent van Gogh Foundation/Rijksmuseum Vincent van Gogh, Amsterdam

57 BRETON GIRLS DANCING, PONT-AVEN, 1888
Oil on canvas, 73 × 92.7 cm W 251
*Collection of Mr and Mrs Paul Mellon © 1992 National Gallery of Art,
Washington*

58 LETTER TO VINCENT VAN GOGH WITH SKETCH OF BOYS
WRESTLING, c.25 July 1888
Vincent van Gogh Foundation/Rijksmuseum Vincent van Gogh, Amsterdam

59 LETTER TO ÉMILE SCHUFFENECKER WITH SKETCH OF BOYS
WRESTLING, c.8 July 1888
Vincent van Gogh Foundation/Rijksmuseum Vincent van Gogh, Amsterdam

60 STILL LIFE WITH THREE PUPPIES, 1888
Oil on wood, 91.8 × 62.6 cm W 293
Collection, The Museum of Modern Art, New York. Mrs Simon Guggenheim Fund

61 LETTER TO VINCENT VAN GOGH WITH SKETCH OF VISION
AFTER THE SERMON, c.22 September 1888
Vincent van Gogh Foundation/Rijksmuseum Vincent van Gogh, Amsterdam

62 VISION AFTER THE SERMON (JACOB WRESTLING WITH THE
ANGEL), 1888
Oil on canvas, 73 × 92 cm W 245
National Gallery of Scotland, Edinburgh (1925 reg. no. 1643)

63 SELF-PORTRAIT, LES MISÉRABLES, 1888
Oil on canvas, 45 × 55 cm W 239
Vincent van Gogh Foundation/Rijksmuseum Vincent van Gogh, Amsterdam

64 THE FIRST FLOWERS (BRITTANY), 1888
Oil on canvas, 73 × 92 cm W 249
Kunsthaus, Zurich (Inv. 1980/16)

65 THE ALYSCAMPS, ARLES, 1888
Oil on canvas, 91 × 72 cm W 307
Musée d'Orsay, Paris (RF 1938–47) Ⓒ *Photo RMN*

66 IN THE HEAT OF THE DAY (IN THE HAY), 1888
Oil on canvas, 73 × 92 cm W 301
Private collection

67 GRAPE HARVEST AT ARLES (HUMAN ANGUISH), 1888
Oil on canvas, 73 × 92 cm W 304
The Ordrupgaard Collection, Copenhagen

68 PASTORALES MARTINIQUE, 1889
Zincograph on yellow wove paper, 21.3 × 26.3 cm GU 9
Bibliothèque d'Art et d'Archéologie, Fondation Jacques Doucet, Paris

69 BRETONNES À LA BARRIÈRE (BRETON WOMEN AT THE GATE),
1889
Zincograph on yellow wove paper, 16.2 × 21.6 cm GU 4
Bibliothèque d'Art et d'Archéologie, Fondation Jacques Doucet, Paris

70 TWO CHILDREN (JEANNE AND PAUL SCHUFFENECKER), 1889
Oil on canvas, 46 × 61 cm
Ny Carlsberg Glyptotek, Copenhagen. Photo: NCG

71 SCHUFFENECKER'S STUDIO/THE SCHUFFENECKER FAMILY, 1889
Oil on canvas, 73 × 92 cm W 313
Musée d'Orsay, Paris (RF 1959–8) Ⓒ *Photo RMN*

72 AT THE BLACK ROCKS, 1889
Letterpress illustration from front page of catalogue of the Café Volpini
exhibition
Josefowitz collection

73 BRETON EVE, inscribed 'PAS écouter li li menteur', 1889
Pastel and watercolour on paper, 33.7 × 31.1 cm W 333
*Bequest of Marion Koogler McNay. Marion Koogler McNay Art Museum, San
Antonio, Texas* (1950.45)

74 MEYER DE HAAN, 1889
Oil on wood panel, 80 × 52 cm W 317
Private collection. Photo by Malcolm Varon, NYC Ⓒ *1982*

75 CARICATURE SELF-PORTRAIT, 1889
Oil on wood, 79.2 × 51.3 cm W 323
Chester Dale Collection Ⓒ *1992 National Gallery of Art, Washington*

76 SEAWEED GATHERERS, 1889
Oil on canvas, 87 × 122.5 cm W 349
Museum Folkwang, Essen

77 LETTER TO VINCENT VAN GOGH WITH SKETCHES OF SOYEZ
AMOUREUSES AND CHRIST IN THE GARDEN OF OLIVES,
*c.*8 November 1889
Ink and watercolour on squared paper
Vincent van Gogh Foundation/Rijksmuseum Vincent van Gogh, Amsterdam

78 SOYEZ AMOUREUSES ET VOUS SEREZ HEUREUSES (BE IN LOVE
AND YOU WILL BE HAPPY), 1889
Polychrome linden wood, 97 × 75 cm G 76
Arthur Tracy Cabot Fund. Courtesy Museum of Fine Arts, Boston

79 AT THE BLACK ROCKS/ROCKS BY THE SEA, 1889
Watercolour and gouache with ink and metallic paint on paper,
25.3 × 40.6 cm
Josefowitz collection

80 BONJOUR MONSIEUR GAUGUIN, 1889
Oil on canvas, 113 × 92 cm W 322
National Gallery, Prague. Photo: Oto Palan

81 BUST OF MEYER DE HAAN, 1889
Oak, painted, h. 57 cm G 86
National Gallery of Canada, Ottawa

82 NIRVANA (PORTRAIT OF MEYER DE HAAN), *c.*1890
Oil and turpentine on·silk, 20 × 29 cm W 320
*Wadsworth Atheneum, Hartford, Connecticut. The Ella Gallup Sumner and Mary
Caitlin Sumner Collection.* Ⓒ *Wadsworth Atheneum*

83 SKETCH FROM MEMORY AFTER REMBRANDT'S
'ENTOMBMENT', enclosed with letter to J. F. Willumsen, late summer
1890
Brown wash on paper
J. F. Willumsens Museum, Frederikssund

84 SOYEZ MYSTÉRIEUSES (BE MYSTERIOUS), 1890
Polychrome linden wood, 73 × 95 cm G 87
Musée d'Orsay, Paris (RF 3405) Ⓒ *Photo RMN*

85 PORTRAIT OF VINCENT VAN GOGH PAINTING SUNFLOWERS,
1888
Oil on canvas, 73 × 92 cm W 296
Vincent van Gogh Foundation/Rijksmuseum Vincent van Gogh, Amsterdam

86 SELF-PORTRAIT WITH ONDINE, 1888–1889
Oil on canvas, 46 × 38 cm W 297
Pushkin State Museum of Fine Arts, Moscow

87 COPY AFTER MANET'S 'OLYMPIA', 1891
Oil on canvas, 89 × 130 cm W 413
Private collection, London. Photo: O. Vaering, Oslo

88 PORTRAIT OF STÉPHANE MALLARMÉ, January 1891
Etching heightened with pen and ink and brown grey wash on wove paper,
15 × 11.7 cm GU 13
Collection of Dr and Mrs Martin L. Gecht, Chicago. Photo: Michael Tropea

89 DECORATIVE PLATE DESIGN (LES FOLIES DE L'AMOUR), 1890
Crayon and gouache on paper coated with gesso laid down on cardboard,
c. 27.3 cm
Private collection

90 YOUNG BRETON SHEPHERD, 1888
Oil on canvas, 89 × 116 cm W 256
National Museum of Western Art, Tokyo. Matsukata Collection (P 1959–105)

91 WINTER (YOUNG BRETON BOY ADJUSTING HIS CLOG), 1888
Oil on canvas, 90 × 71 cm W 258
Ny Carlsberg Glyptotek, Copenhagen. Photo: NCG 1992

92 STUDY FOR BRETON BOYS WRESTLING, 1888
Pastel on paper, 60 × 40 cm
Private collection, Paris

93 BRETON BOYS WRESTLING, 1888
Oil on canvas, 93 × 73 cm W 273
Josefowitz collection

94 THE ARLÉSIENNE (MME GINOUX), 1888
Coloured chalks and charcoal with white chalk heightening on paper,
56.1 × 49.2 cm
*The Fine Arts Museums of San Francisco, Achenbach Foundation for Graphic Arts,
Memorial Gift from Dr T. Edward and Tullah Hanley, Bradford, Pennsylvania*
(69.30.78)

95 CAFÉ AT ARLES, 1888
Oil on canvas, 72 × 92 cm W 305
Pushkin State Museum of Fine Arts, Moscow (Inv. 3367)

96 MADAME ROULIN, 1888
Oil on canvas, 48.8 × 62.2 cm W 298
The Saint Louis Art Museum. Gift of Mrs Mark C. Steinberg

97 OLD WOMEN OF ARLES/GARDEN AT ARLES, 1888
Oil on canvas, 73 × 92 cm W 300
Mr and Mrs Lewis Larned Coburn Memorial Collection (1934.391)
© The Art Institute of Chicago. All rights reserved

98 THE BLUE TREE TRUNKS, ARLES, 1888
Oil on canvas, 92 × 73 cm W 311
The Ordrupgaard Collection, Copenhagen

99 FARMHOUSE IN ARLES, 1888
Oil on canvas, 72.5 × 92 cm W 309
National Museum, Stockholm

100 THE GATE, 1889
Oil on canvas, 92.5 × 73 cm W 353
Kunsthaus Zurich. Bequest of Frau H. Hausammann, 1981

101 AMONG THE LILIES, 1889
Oil on canvas, 92.5 × 73.5 cm W 366
Kunstmuseum Basel. Colorphoto Hans Hinz

102 WOMAN IN THE WAVE (ONDINE I), 1889
Oil on canvas, 92 × 72 cm W 336
The Cleveland Museum of Art. Gift of Mr and Mrs William Powell Jones (78.63)

103 WOMAN IN THE WAVES (ONDINE II), 1889
Pastel and watercolour on wove paper, 17.5 × 47.7 cm W 337
Josefowitz collection

104 LA BELLE ANGÈLE (MADAME ANGÈLE SATRE, THE INNKEEPER AT PONT-AVEN), 1889
Oil on canvas, 92 × 73 cm W 315
Musée d'Orsay, Paris (RF 2617) © Photo RMN

105 PORTRAIT OF A WOMAN WITH STILL LIFE BY CÉZANNE, 1890
Oil on canvas, 65.3 × 54.9 cm W 387
The Joseph Winterbotham Collection (1925.753)
© The Art Institute of Chicago. All rights reserved

106 PORTRAIT VASE OF MME SCHUFFENECKER, 1889
Enamelled stoneware with touches of gilding, h. 24.2 cm G 67, B 50
Dallas Museum of Art, The Wendy and Emery Reves Collection

107 SELF-PORTRAIT POT, 1889
Stoneware, glazed and tinted, h. 19.3 cm G 65, B 48
Kunstindustrimuseet, Copenhagen. Photo: Ole Woldbye

108 THE WILLOWS, 1889
Oil on canvas, 92 × 74.5 cm W 357
Nasjonalgalleriet, Oslo. Photo: Jacques Lathion

109 EN BRETAGNE (IN BRITTANY), 1889
Watercolour, metallic gold paint and ink, partially heightened with gum arabic on wove paper laid onto cardboard, 37.9 × 27 cm
The Whitworth Art Gallery, University of Manchester

110 BRETONS AND COWS (PAGE FROM A BRITTANY SKETCHBOOK), c.1889
Black crayon and watercolour on paper
Albertina Museum, Vienna

111 SEATED BRETON GIRL, 1889
Oil on canvas, 72 × 91 cm W 344
Ny Carlsberg Glyptotek, Copenhagen. Photo: NCG/Hans Petersen

112 YELLOW HAYSTACKS/GOLDEN HARVEST, 1889
Oil on canvas, 73 × 92.5 cm W 351
Musée d'Orsay, Paris (RF 1951–6) © Photo RMN

113 LITTLE GIRLS/LANDSCAPE WITH TWO BRETON GIRLS, 1889
Oil on canvas, 73 × 92 cm
Museum of Fine Arts, Boston. Gift of Harry and Mildred Remis
(Inv. 1976.42)

114 SELF-PORTRAIT WITH YELLOW CHRIST, 1889–1890
Oil on canvas, 38 × 46 cm W 324
Private collection. Photo: Lauros-Giraudon

115 YELLOW CHRIST, 1889
Oil on canvas, 92 × 73 cm W 327
Albright-Knox Art Gallery, Buffalo, New York. General Purchase Funds, 1946

116 BRETON CALVARY/GREEN CHRIST, 1889
Oil on canvas, 92 × 73.5 cm W 328
Musées Royaux des Beaux-Arts, Brussels

117 THE AGONY IN THE GARDEN (CHRIST IN THE GARDEN OF OLIVES), 1889
Oil on canvas, 73 × 92 cm W 326
Collection of the Norton Gallery of Art, West Palm Beach, Florida

118 THE CREEK, LE POULDU, 1889–1890
Oil on canvas, dimensions unknown
Private collection, New York

119 BEACH AT LE POULDU, 1889
Oil on canvas, 73 × 92 cm W 362
Private collection/Bridgeman Art Library, London

120 LANDSCAPE FROM BRITTANY (LE POULDU)/FIELDS BY THE SEA, 1889
Oil on canvas, 72 × 91 cm W 356
National Museum, Stockholm

121 LANDSCAPE AT LE POULDU/HARVEST BY THE SEA, 1890
Oil on canvas, 73.5 × 92 cm W 396
The Tate Gallery, London

122 LANDSCAPE AT LE POULDU/THE ISOLATED HOUSE, 1889
Oil on canvas, 60 × 73 cm W 364
Private collection, New York

123 FARMYARD NEAR LE POULDU, 1890
Oil on canvas, 73 × 92 cm W 394
Dallas Museum of Art, The Wendy and Emery Reves Collection

124 THE LOSS OF VIRGINITY, 1890–1891
Oil on canvas, 89.5 × 130.2 cm W 412
The Chrysler Museum, Norfolk, Virginia

125 FIELDS AT LE POULDU/LANDSCAPE AT LE POULDU, 1890
Oil on canvas, 73 × 92.7 cm W 398
Collection of Mr and Mrs Paul Mellon © 1992 National Gallery of Art, Washington

126 HAYSTACKS/THE POTATO FIELD, 1890
Oil on canvas, 74.3 × 93.6 cm W 397
Gift of the W. Averell Harriman Foundation in memory of Marie N. Harriman
© 1992 National Gallery of Art, Washington

127 PORTRAIT OF SUZANNE BAMBRIDGE, 1891
Oil on canvas, 70 × 50 cm W 423
Musées Royaux des Beaux-Arts, Brussels

128 TE FARE HYMENEE (THE HOUSE OF HYMNS), 1892
Oil on canvas, 50 × 90 cm W 477
Private collection/Bridgeman Art Library, London

129 HEAD OF A TAHITIAN WOMAN, 1891
Pencil touched with grey wash, 30.6 × 24.3 cm
The Cleveland Museum of Art, Mr and Mrs Lewis B. Williams Collection (49.439)

130 HEAD OF A TAHITIAN WOMAN, inscribed 'Reconnu de Paul Gauguin.
Émile Bernard. 29', 1891
Pen and black ink, wash and watercolour over pencil on wove paper,
31.8 × 24.2 cm
Mr and Mrs Marshall Field

131 WOMEN OF TAHITI (ON THE BEACH), 1891
Oil on canvas, 69 × 90 cm W 434
Musée d'Orsay, Paris (RF 2765) © *Photo RMN*

132 MOUNTAINS IN TAHITI, c.1891
Oil on canvas, 68 × 92.5 cm W 504
The Minneapolis Institute of Arts, Julius C. Eliel Memorial Fund

133 VAHINE NO TE TIARE (WOMAN WITH A FLOWER), 1891
Oil on canvas, 70 × 46 cm W 420
Ny Carlsberg Glyptotek, Copenhagen. Photo: NCG 1992

134 TA MATETE (WE SHALL NOT GO TO MARKET TODAY), 1892
Oil on canvas, 73 × 91.5 cm W 476
Kunstmuseum Basel. Colorphoto Hans Hinz

135 IDOL WITH A SHELL, 1892
Ironwood and mother of pearl shell and teeth, h. 27 cm G 99
Musée d'Orsay, Paris © *Photo RMN*

136 AHA OE FEII? (ARE YOU JEALOUS?), 1892
Oil on canvas, 66 × 89 cm W 461
Pushkin State Museum of Fine Arts, Moscow (Inv. 3269)

137 PARAU PARAU (CONVERSATION), 1892
Oil on canvas, 76 × 96 cm W 472
Yale University Art Gallery. John Hay Whitney Collection, BA 1926, Hon. MA 1956 Collection

138 TE RAAU RAHI (THE BIG TREE), 1891
Oil on canvas, 73 × 91.5 cm W 439
Gift of Kate L. Brewster (1949.513) © *The Art Institute of Chicago.
All rights reserved*

139 SKETCH OF MANAO TUPAPAU, from *Cahier pour Aline*, 1892–1893
Watercolour
Bibliothèque d'Art et d'Archéologie, Fondation Jacques Doucet, Paris

140 MANAO TUPAPAU (THE SPIRIT OF THE DEAD WATCHES), 1892
Oil on canvas, 73 × 92 cm W 457
Albright-Knox Art Gallery, Buffalo, New York. A. Conger Goodyear Collection (1965)

141 COVER OF *CAHIER POUR ALINE*, 1893
Watercolour and ink, 17 × 21.6 cm
Bibliothèque d'Art et d'Archéologie, Fondation Jacques Doucet, Paris

142 PASTORALES TAHITIENNES, 1893
Oil on canvas, 86 × 113 cm W 470
Hermitage, St Petersburg/Bridgeman Art Library, London

143 SELF-PORTRAIT IN A HAT, 1893–1894
Oil on canvas, 46 × 38 cm W 506
Musée d'Orsay, Paris (RF 1966–7) © *Photo RMN*

144 VASE OF FLOWERS AFTER DELACROIX, frontispiece from *Noa Noa*
(Louvre ms), c.1897
Watercolour, 17 × 12 cm
Musée du Louvre (Orsay), Département des Arts Graphiques, Paris © *Photo RMN*

145 FRAGMENT OF TE ATUA (THE GODS) AND PHOTOGRAPH OF A
TAHITIAN GIRL PASTED ONTO WATERCOLOUR OF HIRO, page 57
from *Noa Noa* (Louvre ms), c.1897
Woodcut (GU 31), photograph and watercolour
Musée du Louvre (Orsay), Département des Arts Graphiques, Paris © *Photo RMN*

146 BLACK PIGS AND HEAD OF A TAHITIAN WOMAN, page 63 from *Noa Noa* (Louvre ms), c.1897
Watercolour and ink
Musée du Louvre (Orsay), Département des Arts Graphiques, Paris © *Photo RMN*

147 PAPE MOE (MYSTERIOUS WATER), 1893–1894
Pen and ink, brush and watercolour on wove paper, 35.4 × 25.6 cm
Gift of Mrs Emily Crane Chadbourne (1922.4797) © *The Art Institute of Chicago.
All rights reserved*

148 MARURU, page 59 from *Noa Noa* (Louvre ms), 1894/1897
Woodcut (GU 23) trimmed and partly retouched with colour
Musée du Louvre (Orsay), Département des Arts Graphiques, Paris © *Photo RMN*

149 FRAGMENTS OF MANAO TUPAPAU (top) AND TE PO (THE
NIGHT), unnumbered page from *Noa Noa* (Louvre ms), 1894/1897
Woodcuts (GU 15 and GU 36), trimmed and partly retouched with colour
Musée du Louvre (Orsay), Départment des Arts Graphiques, Paris © *Photo RMN*

150 SEATED TAHITIAN WOMAN, page 172 from *Noa Noa* (Louvre ms),
c.1896–1897
Watercolour, pen and ink, 19.5 × 17 cm
Musée du Louvre (Orsay), Département des Arts Graphiques, Paris © *Photo RMN*

151 TAHITIAN FIGURES, page 173 from *Noa Noa* (Louvre ms), c.1896–1897
Watercolour on paper
Musée du Louvre (Orsay), Département des Arts Graphiques, Paris © *Photo RMN*

152 PARIS IN THE SNOW, 1894
Oil on canvas, 71.5 × 88 cm W 529
Vincent van Gogh Foundation/Rijksmuseum Vincent van Gogh, Amsterdam

153 BRETON VILLAGE IN THE SNOW, 1894
Oil on canvas, 62 × 87 cm W 525
Musée d'Orsay, Paris (RF 1952–29) © *Photo RMN*

154 AHA OE FEII? (WHAT ARE YOU JEALOUS?), 1894
Watercolour transfer selectively heightened with brush and water-based
colours, brown ink and white chalk on japan paper, 19.5 × 24.2 cm
W 461
Collection of Edward McCormick Blair (RX 16171/2 recto)
© *The Art Institute of Chicago. All rights reserved*

155 TE FARURU (TO MAKE LOVE), 1893–1895
Woodcut printed in colour, 35.6 × 20.5 cm GU 22
Clarence Buckingham Collection (1950.158) © *The Art Institute of Chicago.
All rights reserved*

156 VAHINE NO TE VI (WOMAN WITH A MANGO), 1892
Oil on canvas, 72.7 × 44.5 cm W 449
The Baltimore Museum of Art: The Cone Collection, formed by Dr Claribel Cone and Miss Etta Cone of Baltimore, Maryland (BMA 1950.213)

157 FAATURUMA (MELANCHOLIC), 1891
Oil on canvas, 92 × 73 cm W 424
The Nelson-Atkins Museum of Art, Kansas City, Missouri (Nelson Fund) (38–5)

158 THE BLACK PIGS, 1891
Oil on canvas, 91 × 72 cm W 447
Reproduced by courtesy of the Board of Directors of the Budapest Museum of Fine Arts

159 ROAD IN TAHITI (LANDSCAPE PAPEETE), 1891
Oil on canvas, 115.5 × 88.5 cm W 441
The Toledo Museum of Art, Toledo, Ohio; purchased with funds from the Libbey Endowment, gift of Edward Drummond Libbey

160 TE FAATURUMA (THE BROODING WOMAN), 1891
Oil on canvas, 91.2 × 68.7 cm W 440
Worcester Art Museum, Worcester, Massachusetts (1921.186)

161 PARAU API (NEWS OF THE DAY), 1892
Oil on canvas, 67 × 91 cm W 466
Staatliche Kunstsammlungen, Dresden

162 THE MEAL (WITH THREE TAHITIANS)/BANANAS, 1891
Oil on paper laid down on canvas, 73 × 92 cm W 427
Musée d'Orsay, Paris (RF 1954–27) © Photo RMN

163 TE TIARE FARANI (FLOWERS OF FRANCE), 1891
Oil on canvas, 72 × 92 cm W 426
Pushkin State Museum of Fine Arts, Moscow (Inv. 3370)

164 TAHITIANS AT REST, c.1891
Oil, crayon and charcoal on paper mounted on cardboard, 85.2 × 102 cm W 516
The Tate Gallery, London

165 THE SIESTA, 1891–1892
Oil on canvas, 87 × 116 cm W 515
Philadelphia Museum of Art. From the private collection of Mr and Mrs Walter H. Annenberg

166 IA ORANA MARIA (HAIL MARY), 1891
Oil on canvas, 114 × 88 cm W 428
The Metropolitan Museum of Art, Bequest of Sam A. Lewisohn, 1951 (51.112.2)

167 VAIRAUMATI TEI OA (HER NAME IS VAIRAUMATI), 1892
Oil on canvas, 91 × 68 cm W 450
Pushkin State Museum of Fine Arts, Moscow (Inv. 3266)

168 MAN WITH AN AXE, 1891
Oil on canvas, 92 × 70 cm W 430
Private collection/Bridgeman Art Library, London

169 MATAMOE (LANDSCAPE WITH PEACOCKS), 1892
Oil on canvas, 115 × 80 cm W 484
Pushkin State Museum of Fine Arts, Moscow (Inv. 3369)

170 I RARO TE OVIRI (UNDER THE PANDANUS), 1891
Oil on canvas, 68 × 90 cm W 431
Dallas Museum of Art, Foundation for the Arts Collection, Adèle R. Levy Fund (1963.58FA)

171 PETITES BABIOLES TAHITIENNES (LITTLE TAHITIAN CURIOS), 1892
Pen, brush and ink, heightened in watercolour and pastel over pencil, 44 × 32.5 cm
Private collection

172 TAHITIAN WOMEN BATHING, 1891–1892
Oil on canvas, 110 × 89 cm W 462
The Metropolitan Museum of Art, Robert Lehman Collection, 1975 (1975.1.179)

173 ILLUSTRATION TO LEGEND OF ROUA HATOU, 'The God told him to go with all his family ...' from *Ancien culte mahorie* (*Ancient Maori Cult*), page 36, 1892–1893
Watercolour and pen and ink, 7 × 15 cm
Musée du Louvre (Orsay), Département des Arts Graphiques, Paris © Photo RMN

174 ILLUSTRATION TO BIRTH OF THE STARS, from *Ancien culte mahorie* (*Ancient Maori Cult*), page 40, 1892–1893
Watercolour and pen and ink, 15 × 16 cm
Musée du Louvre (Orsay), Département des Arts Graphiques, Paris © Photo RMN

175 PARAU NA TE VARUA INO (WORDS OF THE DEVIL), 1892
Oil on canvas, 91.7 × 68.5 cm W 458
Gift of the W. Averell Harriman Foundation in memory of Marie N. Harriman © 1992 National Gallery of Art, Washington

176 PARAHI TE MARAE (THERE LIES THE TEMPLE), 1892
Oil on canvas, 68 × 91 cm W 483
Philadelphia Museum of Art. Gift of Mrs Rodolphe Meyer de Schauensee

177 TAHITIAN SKETCHES (STUDIES OF TAHITIANS' HEADS), c.1892
Charcoal and watercolour on japan paper, 24.3 × 31.2 cm
Musée du Louvre (Orsay), Département des Arts Graphiques, Paris © Photo RMN

178 TAHITIAN VILLAGE, 1892
Oil on canvas, 90 × 70 cm W 480
Ny Carlsberg Glyptotek, Copenhagen

179 CROUCHING TAHITIAN WOMAN, STUDY FOR NAFEA FAAIPOIPO, 1892
Pastel and charcoal, partly stumped, squared up on wove paper, 55.3 × 47.8 cm
Gift of Tiffany and Margaret Blake (1944.578 recto) © The Art Institute of Chicago. All rights reserved

180 NAFEA FAAIPOIPO (WHEN ARE YOU GETTING MARRIED?), 1892
Oil on canvas, 105 × 77.5 cm W 454
Rudolf Staechelin Family Foundation, Basel. Colorphoto Hans Hinz

181 HINA AND TE FATOU, 1892
Tamanu wood, h. 32.3 cm G 96
Art Gallery of Ontario, Toronto. Gift of the Volunteer Committee Fund, 1980

182 IDOL WITH A PEARL, c.1892
Tamanu wood, polychrome and gilded, h. 25 cm G 94
Musée d'Orsay, Paris © Photo RMN

183 MATAMUA (TIMES GONE BY), 1892
Oil on canvas, 91 × 69 cm W 467
Thyssen-Bornemisza Collection, Lugano, Switzerland

184 AREAREA (THE RED DOG), 1892
Oil on canvas, 75 × 93 cm W 468
Musée d'Orsay, Paris (RF 1961–6) © Photo RMN

185 E HAERE OE I HIA? (WHERE ARE YOU GOING?), 1892
Oil on canvas, 96 × 69 cm W 478
Staatsgalerie, Stuttgart

186 EA HAERE IA OE! (WOMAN WITH MANGO), 1893
Oil on canvas, 92 × 73 cm W 501
Hermitage, St Petersburg/Bridgeman Art Library, London

187 FATATA TE MITI (NEAR THE SEA), 1892
Oil on canvas, 67.9 × 91.5 cm W 463
Chester Dale Collection © 1992 National Gallery of Art, Washington

188 OTAHI (ALONE), 1893
Oil on canvas, 50 × 73 cm W 502
Private collection

189 MAU TAPORO (THE LEMON PICKER), 1892
Oil on canvas, 89 × 66 cm W 475
Private collection, Switzerland

190 PAPE MOE (MYSTERIOUS WATER), 1893
Oil on canvas, 99 × 75 cm W 498
Private collection

191 CYLINDER DECORATED WITH HINA AND TWO ATTENDANTS,
1892–1893
Tamanu wood, painted and gilded, h. 37 cm G 95
*Hirshhorn Museum and Sculpture Garden, Smithsonian Institution, museum purchase
with funds provided under Smithsonian Institution Collections Acquisitions Program,
1981. Photographer, Lee Stalsworth*

192 MERAHI METUA NO TEHAMANA (ANCESTORS OF TEHAMANA),
1893
Oil on canvas, 76.3 × 54.3 cm W 497
*Gift of Mr and Mrs Charles Deering McCormick (1980.613) © The Art Institute
of Chicago. All rights reserved*

193 AREAREA NO VARUA INO (WORDS OF THE DEVIL), 1894
Watercolour monotype in blues, green, brown, ochre, black, flesh tone and
grey with seal printed in magenta on japan paper, 24.5 × 16.5 cm
Field 1973.8
*Rosenwald Collection (Inv. 1943.3.9078) © 1992 National Gallery of Art,
Washington*

194 AREAREA NO VARUA INO, 1894
Oil on canvas, 60 × 98 cm W 514
Ny Carlsberg Glyptotek, Copenhagen. Photo: NCG/Hans Petersen

195 NOA NOA (FRAGRANCE), 1894
Woodcut printed in colour with stencils, block 35.5 × 20.5 cm
GU 17
Collection, The Museum of Modern Art, New York. Lillie P. Bliss Collection

196 NAVE NAVE FENUA (DELIGHTFUL LAND), 1894
Woodcut printed in colour with stencils on paper, 35.5 × 20 cm GU 29
Bequest of W. G. Russell Allen. Courtesy Museum of Fine Arts, Boston

197 NAVE NAVE MOE (SACRED SPRING), 1894
Oil on canvas, 73 × 98 cm W 512
Hermitage, St Petersburg/Bridgeman Art Library, London

198 MAHANA NO ATUA (THE DAY OF THE GOD), 1894
Oil on canvas, 68.3 × 91.5 cm W 513
*Helen Birch Bartlett Memorial Collection (1926.198) © The Art Institute of
Chicago. All rights reserved*

199 BRETON PEASANT WOMEN, 1894
Oil on canvas, 66 × 92.5 cm W 521
Musée d'Orsay, Paris (RF 1973-17) © Photo RMN

200 UPAUPA SCHNEKLUD, 1894
Oil on canvas, 92.5 × 73.5 cm W 517
*The Baltimore Museum of Art. Given by Hilda K. Blaustein in memory of her
husband Jacob Blaustein (BMA 1979.163)*

201 TE ARII VAHINE (THE KING'S WIFE), 1896
Oil on canvas, 97 × 130 cm W 542
Pushkin Museum, Moscow/Bridgeman Art Library, London

202 NO TE AHA OE RIRI (WHY ARE YOU ANGRY?), 1896
Oil on canvas, 95.3 × 130.5 cm W 550
*Mr and Mrs Martin A. Ryerson Collection (1933.1119) © The Art Institute of
Chicago. All rights reserved*

203 STILL LIFE, TEAPOT AND FRUIT, 1896
Oil on canvas, 48 × 66 cm W 554
*Philadelphia Museum of Art, from the private collection of Mr and Mrs Walter H.
Annenberg*

204 TE TAMARI NO ATUA (THE BIRTH OF CHRIST), 1896
Oil on canvas, 96 × 128 cm W 541
Bayerische Staatsgemäldesammlungen, Neue Pinakothek

205 CHRISTMAS NIGHT, 1896
Oil on canvas, 72 × 83 cm W 519
Josefowitz collection

206 NEVERMORE, inscribed 'O TAHITI', 1897
Oil on canvas, 60 × 116 cm W 558
Courtauld Collection, Courtauld Institute Galleries, University of London

207 TE RERIOA (DAY DREAMING), 1897
Oil on canvas, 95 × 130 cm W 557
Courtauld Collection, Courtauld Institute Galleries, University of London

208 VAIRUMATI, 1897
Oil on canvas, 73 × 94 cm W 559
Musée d'Orsay, Paris (RF 1959-5) © Photo RMN

209 LETTER TO DANIEL DE MONFREID WITH SKETCH OF D'OÙ
VENONS-NOUS?, February 1898
*Musée du Louvre (Orsay), Département des Arts Graphiques, Paris © Photo
RMN*

210 NAVE NAVE MAHANA (DELIGHTFUL DAYS), 1896
Oil on canvas, 94 × 130 cm W 548
Musée des Beaux-Arts de Lyon

211 FAA IHEIHE (TAHITIAN PASTORAL), 1898
Oil on canvas, 54 × 169 cm W 569
The Tate Gallery, London

212 OVIRI, 1891
Glazed stoneware, h. 74 cm G 113, B 57
Musée d'Orsay, Paris © Photo RMN

213 CHANGE OF RESIDENCE, 1899
Woodcut, 16.5 × 30.2 cm GU 66
*Albert H. Wolf Memorial Collection (1939.322) © The Art Institute of Chicago.
All rights reserved*

214 LETTER TO DANIEL DE MONFREID WITH SKETCH OF NEW
STUDIO ON STILTS, November 1901
Vincent van Gogh Foundation/Rijksmuseum Vincent van Gogh, Amsterdam

215 SOYEZ MYSTÉRIEUSES (LOWER LEFT PANEL FROM DOOR
FRAME OF GAUGUIN'S LAST RESIDENCE IN ATUONA), 1902
Sequoia wood, carved and painted, 40 × 153 cm G 132
*Private collection, loaned to Musée Gauguin, Papeari. Musée d'Orsay, Paris
© Photo RMN*

216 RIDERS ON THE BEACH, 1902
Oil on canvas, 66 × 76 cm W 619
Folkwang Museum, Essen

217 SELF-PORTRAIT WITH SPECTACLES, 1903
Oil on canvas, mounted on wood, 41.5 × 24 cm W 634
Kunstmuseum Basel. Colorphoto Hans Hinz

218 RUBBINGS FROM MARQUESAN CARVED ORNAMENT, 1892–1893,
pasted onto page 168 of *Noa Noa* (Louvre ms), *c.*1897
Pencil and watercolour
*Musée du Louvre (Orsay), Département des Arts Graphiques, Paris © Photo
RMN*

219 RUBBING FROM MARQUESAN CARVED ORNAMENT, 1892–1893, pasted onto page 126 of *Noa Noa* (Louvre ms), *c.*1897
Pencil and watercolour
Musée du Louvre (Orsay), Département des Arts Graphiques, Paris © Photo RMN

220 L'APPEL (THE CALL), 1902
Oil on canvas, 130 × 90 cm W 612
The Cleveland Museum of Art, Gift of the Hanna Fund (43.392)

221 D'OÙ VENONS-NOUS? QUE SOMMES-NOUS? OÙ ALLONS-NOUS? (WHERE DO WE COME FROM? WHAT ARE WE? WHERE ARE WE GOING?), 1897
Oil on canvas, 139.1 × 374.6 cm W 561
Tompkins Collection. Courtesy Museum of Fine Arts, Boston

222 PORTRAIT OF A YOUNG WOMAN, VAÏTE (JEANNE) GOUPIL, 1896
Oil on canvas, 75 × 65 cm W 535
The Ordrupgaard Collection, Copenhagen

223 POOR FISHERMAN, 1896
Oil on canvas, 74 × 66 cm W 545
Collection Museu de Arte de São Paulo, São Paulo, Brazil. Photo by Luiz Hossaka

224 THATCHED HUT UNDER PALM TREES, page 181 of *Noa Noa* (Louvre ms), *c.*1896–1897
Watercolour, 30 × 22.5 cm
Musée du Louvre (Orsay), Département des Arts Graphiques, Paris © Photo RMN

225 THE WHITE HORSE, 1898
Oil on canvas, 140 × 91.5 cm W 571
Musée d'Orsay, Paris (RF 2616) © Photo RMN

226 RUPE RUPE (FRUIT GATHERING), 1899
Oil on canvas, 128 × 191 cm W 585
Pushkin State Museum of Fine Arts, Moscow (Inv. 3268)

227 IDYLL IN TAHITI, 1901
Oil on canvas, 74.5 × 94.5 cm W 598
Foundation E. G. Bührle, Zurich. Photo: W. Dräyer, Zurich

228 LANDSCAPE WITH THREE FIGURES, 1901
Oil on canvas, 67.3 × 77.5 cm W 601
The Carnegie Museum of Art, acquired through the generosity of Mrs Alan M. Scaife (63.9)

229 MATERNITY (THREE WOMEN ON THE SEASHORE), 1899
Oil on canvas, 94 × 72 cm W 581
Hermitage, St Petersburg/Bridgeman Art Library, London

230 CONTES BARBARES, 1902
Oil on canvas, 130 × 91.5 cm W 625
Folkwang Museum, Essen

231 FLOWER PIECE, 1896
Oil on canvas, 64 × 74 cm W 553
The National Gallery, London

232 STILL LIFE WITH PARROTS, 1902
Oil on canvas, 62 × 76 cm W 629
Pushkin Museum, Moscow/Bridgeman Art Library, London

233 THE OFFERING, 1902
Oil on canvas, 67 × 72.5 cm W 624
Foundation E. G. Bührle, Zurich. Photo: W. Dräyer, Zurich

234 MOTHER AND DAUGHTER (PORTRAITS OF WOMEN), 1901–1902
Oil on canvas, 73 × 92 cm W 610
Philadelphia Museum of Art. From the private collection of Mr and Mrs Walter H. Annenberg

235 TAHITIAN WOMAN WITH CHILDREN, 1901
Oil on canvas, 97.2 × 74.3 cm W 595
Helen Birch Bartlett Memorial Collection (1927.460) © The Art Institute of Chicago. All rights reserved

236 GIRL WITH A FAN, 1902
Oil on canvas, 91 × 73 cm W 609
Folkwang Museum, Essen

237 FOUR CARVED PANELS FROM DOOR FRAME OF GAUGUIN'S FINAL RESIDENCE IN ATUONA, 1902
Sequoia wood, carved and painted, upper panel inscribed 'Maison du jouir', 39 × 242.5 cm; left-hand panel, 200 × 39.5 cm; right-hand panel, 159 × 40 cm; lower panel, 40 × 205 cm
Musée d'Orsay, Paris © Photo RMN

Guide to the Principal Personalities and Organizations Mentioned

AUBÉ, Jean-Paul (1837–1916/20?)
The sculptor Aubé, portrayed in a pastel of 1882 [plate 35], had met Gauguin in 1877 when the latter moved to an adjacent studio in Vaugirard. Aubé's work included a monument to Dante and small-scale modelled nudes used as ceramic decorations by the Haviland firm.

AURIER, Albert (1865–1892)
Symbolist poet and critic, Aurier ran his own journal, *Le Moderniste illustré*, during 1889 (to which both Gauguin and Bernard (*q.v.*) contributed articles) before joining the *Mercure de France*. In its inaugural issue of January 1890 he published the first serious appraisal of Vincent van Gogh. His article «*Le Symbolisme en peinture: Paul Gauguin*», *Mercure de France*, March 1891, gave a timely boost to Gauguin's publicity campaign (though it angered Bernard whose name had been omitted), as did his more general article «*Les Symbolistes*», *Revue encyclopédique*, April 1892, to which reference is made in Gauguin's letter to Mette of September 1892. Aurier's early death and replacement by Mauclair (*q.v.*) were greatly regretted by Gauguin.

BASTIEN-LEPAGE, Jules (1848–1884)
Academically-trained and runner-up for the Prix de Rome in 1875, Bastien-Lepage achieved enormous success with a sequence of peasant subjects loosely indebted to Courbet and Manet (*q.v.*), painted in a tonal palette with minutely observed detail. He had a considerable posthumous following, notably among the cosmopolitan groups of artists Gauguin met in Copenhagen and Brittany. Like Huysmans (*q.v.*), Gauguin was hostile to what he saw as the falsity of Bastien-Lepage's naturalism.

BERNARD, Émile (1868–1942)
Bernard, a brilliantly talented student who studied at Cormon's studio with Toulouse-Lautrec, Anquetin and Vincent van Gogh between 1885 and 1886, developed the novel *cloisonist* technique with Anquetin between 1887 and 1888. Having met Gauguin in Pont-Aven in 1886 he joined him there in 1888, when the two worked side by side to their mutual benefit. Bernard raised the older artist's awareness of the ideas of the symbolist movement. Although they were closely associated up to 1891, Bernard felt cheated by Gauguin of what he saw as his stylistic primacy, bitterly attacking him in the press. His later art and criticism turned to the Old Masters.

BERNARD, Madeleine (1871–1895)
Younger sister of Émile Bernard, many of whose enthusiasms she shared, Madeleine met Gauguin in Pont-Aven in 1888. Gauguin fell for the 17 year-old, and painted her portrait. The letter he wrote to her in October that year was intercepted by her father who discouraged both Émile and Madeleine from having further contact with Gauguin. Madeleine was briefly engaged to Charles Laval (*q.v.*) but, like him, died young from tuberculosis.

BIBESCO, Prince Emmanuel (1877–1917)
The Princes Bibesco were Rumanian aristocrats living in Paris. Emmanuel, like his younger brother Antoine, was an art lover. He acquired six of Gauguin's paintings in January 1900 and approached the artist with a view to purchasing his entire production. Gauguin regarded Bibesco as a useful patron to play off against Vollard (*q.v.*).

BOUILLOT, Jules-Ernest (active *c.*1877–1889)
A sculptor, Bouillot also owned a number of studios in the Impasse Frémin, Vaugirard, where Gauguin was his tenant and neighbour between 1877 and 1880. It was in Bouillot's studio that Gauguin learned sculptural techniques and completed his early portrait busts in marble.

BRACQUEMOND, Félix (1833–1914)
Etcher and ceramicist with the Haviland firm, Bracquemond was attracted by the sculpted bas-relief, *La toilette*, Gauguin exhibited at the 8th Impressionist exhibition in 1886. It was Bracquemond who provided the crucial introduction to Ernest Chaplet in whose studio Gauguin made his first ceramics.

BRANDÈS, Edvard (1847–1931)
Danish novelist, playwright, finance minister and diplomat, Brandès became the Gauguins' brother-in-law when he married Ingeborg Thaulow (née Gad) in 1887. He was the founder and editor of the newspaper *Politiken* and built up a substantial art collection. Gauguin complained of the underhand way his art collection had been scooped up by Brandès.

CÉZANNE, Paul (1839–1906)
Gauguin met Cézanne through Pissarro (*q.v.*), with whom they both painted in the late 1870s. Gauguin jealously treasured the various paintings by Cézanne he was able to acquire around 1880, learning important lessons in touch, colour and composition from their example. Subsequently the two artists would appear to have lost contact, Cézanne evidently disapproving of the flattened 'Chinese' style cultivated by Gauguin.

CHARLOPIN, Doctor
Little is known of this would-be investor who in 1890, using the profits from a successful invention exhibited at the Universal Exhibition, looked set to finance Gauguin's proposed trip to the tropics by acquiring a consignment of 38 canvases and five ceramic pots to the value of 5000 francs. Bernard acted as intermediary, but after protracted negotiations the deal fell through.

CHAUDET, Georges-Alfred (1870–1899)
A painter of landscape and still-life, Chaudet was a friend of Sérusier (*q.v.*) and other artists based in Brittany. He met Gauguin in 1894 and acted as his dealer for a brief period. However, his shop in Paris, which exhibited works by several Pont-Aven artists, seems to have gone bankrupt in 1898.

DEGAS, Edgar (1834–1917)
Degas was the Impressionist artist whose example and approval meant most to Gauguin throughout his career. Their relations in the 1880s were intermittent, but from Degas's example Gauguin learned of the primacy of drawing and use of memory. Degas supported Gauguin morally and financially from the late 1880s on, acquiring pictures at the latter's auction sales of 1891 and 1895.

DELACROIX, Eugène (1798–1863)
Delacroix was widely hailed, after his death, as the leader of the romantic school in painting. His exotic imagery and colouristic innovations were held in high esteem by Gauguin, who cited the poor reception of Delacroix's work by such a critic as Albert Wolff (*q.v.*) as evidence for the inevitable suffering to be borne by the true artist.

DELIUS, Frederick (1863–1934)
The English composer Delius, resident in France from the mid 1890s on, was the first owner of *Nevermore* [plate 206], Gauguin's major nude painting of 1897. On learning from de Monfreid that Delius had acquired the painting, Gauguin expressed his pleasure that it had been bought not as a speculation but for enjoyment.

DENIS, Maurice (1870–1943)
Denis was a leading member of the group of art students at the Académie Julian who came together as the Nabis in 1888–1889. Taking the message of Gauguin's synthetism as a central principle, Denis defended Gauguin's art in his seminal article, 'Definition of Neo-Traditionism', published in 1890. Acknowledged by Gauguin as an influential activist, Denis was unable to persuade the older artist to join the Nabi group show at the Durand-Ruel gallery in 1899.

DUBOIS-PILLET, Albert (1846–1890)
Dubois-Pillet, who followed a military career before becoming an officer in the Republican Guard, was a part-time, self-taught artist who painted many views of the Seine. He was one of the main organizers of the Salon des Indépendants (*q.v.*) where, in 1884, he met Seurat, Signac and Angrand, subsequently adopting their pointillist manner.

DURAND-RUEL, Paul (1831–1922)
Gauguin had a complex relationship with Durand-Ruel, the main picture dealer for the Impressionists, being himself not only a buyer but also a potential client artist. His criticism, early on, of Durand's methods, reveal Gauguin as something of an entrepreneurial dealer manqué. Yet Gauguin's first ever one-man-show was held at Durand-Ruel's gallery on his return from Tahiti in 1893 and his later references to the dealer show considerable respect.

FAYET, Gustave (1865–1926)
This rich patron and amateur painter from Béziers was a friend of Daniel de Monfreid (*q.v.*). After 1900 he acquired works by both Gauguin and Redon (*q.v.*), amassing a substantial collection of modern art at his home, the Abbaye de Fontfroide. Gauguin refers to his support in a letter of 25 August 1902.

FÉNÉON, Félix (1861–1944)
See entry for *La Revue indépendante*.

FONTAINAS, André (1865–1948)
A man of letters and adherent of symbolism, Fontainas, with whose opinions Gauguin was broadly in tune, replaced Mauclair (*q.v.*) as chief art critic of the *Mercure de France* after 1896. Keen to engage in aesthetic debate and to justify his own practice, Gauguin addressed letters to him as well as the collections of his late writings on art, *Racontars de rapin* and *Avant et après*.

GAUGUIN family
Paul Gauguin (1848–1903) was the second child of Clovis Gauguin (1814–1849) and Aline, née Chazal (1825–1867). His elder sister Marie (1846–?), mentioned in several letters around 1884–1886, married a Colombian trader, Jean Uribe, in 1875. She had little sympathy for her brother's decision to abandon wife, children and financial career for art. On various occasions her husband seems to have offered to find Gauguin work in the colonies. Gauguin's marriage in 1873 to the Danish governess Mette-Sophie Gad (1850–1920), the eldest daughter of a Danish civil servant, produced five children, Emil (1874–19?), Aline (1877–1897), Clovis (1879–1900), Jean (1881–19?) and Paul Rollon, known as Pola (1883–195?). Of these, Gauguin felt closest to his daughter, whose early death from pneumonia was a devastating blow, and to Clovis, whom the artist took with him to Paris in 1885–1886 and of whose premature death from septicaemia he was never to learn.
Gauguin also had several illegitimate children. Juliette Huet (*q.v.*) bore him a daughter, Germaine, in 1891. In Tahiti, Tehamana's (*q.v.*) pregnancy, announced in September 1892, was terminated. Pau'ura (*q.v.*) bore him a daughter in 1896 who died at birth, and a son Émile in 1899. In the Marquesas Vaeoho bore him a daughter in 1902.

GEFFROY, Gustave (1855–1926)
Influential novelist and critic, Geffroy wrote for Clémenceau's newspaper *La Justice* during the 1880s and did much to advance the careers of Monet, Rodin and Cézanne. Although he admired Gauguin's talent he was not a wholehearted advocate of the artist. Gauguin's proposal of Geffroy as a suitable replacement for Roujon (*q.v.*) as Directeur des Beaux-Arts anticipated Geffroy's subsequent appointment to the directorship of the Manufacture des Gobelins.

GOGH, Theo van (1857–1891)
Younger brother of the painter, Theo van Gogh worked as art dealer for the Goupil firm in Paris, assuming charge of their branch gallery at 19 boulevard Montmartre in 1882. Encouraged by Vincent, whose career he supported financially, Theo began to buy work from the Impressionists. The support he gave Gauguin from late 1887 onwards was of crucial importance to the artist. After Vincent's death, Theo too suffered a mental breakdown and died, tragically, in January 1891. His last contact with Gauguin was a telegram falsely promising him the financial backing he needed for his departure for the tropics.

GOGH, Vincent van (1853–1890)
The son of a Dutch Protestant pastor, Vincent van Gogh took an indirect path to become a full-time painter. His Northern evangelical zeal combined with his commitment to pictorial and literary naturalism were tempered by his debts to the colour and symbolic experimentation of avant-garde art in Paris where he stayed in 1886–1888. Gauguin's account of his relations with Vincent is given in *Avant et après*. Their two months together at Arles in late 1888 saw an intense production of pictures but ended in aesthetic disagreement and, for van Gogh, psychological breakdown. From 1889 to his suicide in July 1890 he was intermittently hospitalized in a mental asylum. Despite this, he maintained a close correspondence with Gauguin and each followed the other's artistic development with keen interest.

GOGH-BONGER, Johanna (Jo) van (1862–1925)
Johanna Bonger married Theo van Gogh in 1889 and bore him a son, Vincent, shortly before he died. Jo inherited many hundreds of pictures by her brother-in-law, hence Gauguin's letter to her in 1894. She devoted much of her life to arranging the brothers' letters for publication.

GOUZER, Doctor
Medical officer aboard the *Duguay-Trouin*, Dr Gouzer met Gauguin in 1897 during a stopover in Tahiti and bought one of his pictures.

GUILLAUMIN, Armand (1841–1927)
Guillaumin was a part-time painter who worked with the Impressionists Pissarro and Cézanne during the 1870s. At first closely associated with Gauguin, after 1886 they drifted apart. Guillaumin continued to paint landscape subjects in the Paris region – including many views of the Seine – until 1892, when he settled in the South of France.

HEEGAARD, Madame
Mme Heegaard, to whom Gauguin addressed some early letters, was the mother of Marie Heegaard, the young Danish woman in whose company Mette Gad first came to Paris in 1872.

HUET, Juliette
Juliette Huet, a seamstress, was the model for *The loss of virginity* [plate 124]. She was briefly Gauguin's mistress when he lived in Paris in the winter of 1890–1891 and bore him a daughter, to whom he refers in the letter of 7 November 1891 to Daniel de Monfreid.

HUYSMANS, Joris-Karl (1848–1907)
As a writer, Huysmans belonged to the naturalist school of Émile Zola. As an art critic, his stance veered from that of apologist of modernity in 1883 to defender of symbolism in the later 1880s. His book *L'Art moderne*, 1883, a collection of several years' Salon and exhibition reviews, was one of the first serious attempts to defend the innovations of the Impressionists and contained a glowingly positive review of Gauguin's *Study of a nude*, 1880 [plate 33].

INDÉPENDANTE, *La Revue*
One of the foremost radical avant-garde periodicals in Paris in the 1880s, this journal became firmly associated with the cause of Neo-Impressionism. Although its art critic, Félix Fénéon, was not hostile to Gauguin's work, the artist took umbrage at certain remarks critical of his character and resolved never to have dealings with what he called the 'enemy camp', turning down an invitation to exhibit his paintings at the journal's office in December 1888.

INDÉPENDANTS, *Salon des*
Established as a jury-free biennial exhibition in 1884 (annual after 1886), the *Indépendants*, whose leading lights included Dubois-Pillet (*q.v.*), Schuffenecker (*q.v.*) and Signac (*q.v.*), offered an alternative forum to the official Salon. Although studiously avoided by Gauguin (as shown by his letter to Theo van Gogh of 10 June 1889), it served as the showcase for many avant-garde painters of his generation.

KRÖYER, Peter (1851–1909)
A pupil of Bonnat and regular exhibitor at the Paris Salon in the 1880s, the Danish artist Kröyer was responsible for inviting Gauguin to exhibit with the *Société des amis de l'art* in Copenhagen, a short-lived show that occurred in late April 1885.

LATOUCHE, Madame
The framing and picture shop run by Madame Latouche is referred to in several letters of the early 1880s.

LAVAL, Charles (1861–1894)
Laval, who appears in Gauguin's *Still life with profile of Laval* [plate 43], was a French painter who met Gauguin in Pont-Aven in 1886. In 1887 he accompanied Gauguin to Panama and Martinique, where both fell ill. They exhibited together at the café Volpini in 1889, then seem to have lost touch. Laval was engaged to Madeleine Bernard (*q.v.*) between 1890 and 1892.

LEROLLE, Henry (1848–1929)
The painter Henry Lerolle was wealthy and collected art. Encouraged by his friend Degas, Lerolle bought his first painting by Gauguin in 1889, to the latter's delight. Although this was followed by several further acquisitions, Gauguin failed to persuade Lerolle and his brother-in-law, the composer Ernest Chausson, to invest more heavily in his work.

LOTI, Pierre, pseudonym of Julien Viaud (1850–1923)
Naval officer and pioneer of the exotic colonial novel, Loti's poetic autobiographical bestseller *Le Mariage de Loti* or *Rarahu* (1880), set in Tahiti, was familiar to Gauguin before his departure in 1891. Its subjective descriptions and mood of melancholy pessimism have parallels not only in *Noa Noa* but also in Gauguin's Tahitian paintings, although Gauguin played them down.

MALLARMÉ, Stéphane (1842–1898)
The most distinguished poet of his generation, Mallarmé's regular Tuesday salons
were important meeting places for the symbolists. Gauguin valued Mallarmé's
support very highly. Prior to his departure for Tahiti he paid homage to the poet
in the form of a portrait etching; his painting *Nevermore* [plate 206] was inspired
by Mallarmé's translation of Edgar Allan Poe's poem.

MANET, Édouard (1832–1883)
Manet, the rallying point of independent anti-academic artists since the 1860s,
enjoyed renewed attention following his death in 1883 thanks to a major
retrospective exhibition. Although his memory was revered by Gauguin, a
painting and pastel by Manet were among the first items he parted with when he
ran into financial difficulties. Gauguin kept a reproduction of Manet's *Olympia* in
his studio and in 1891, soon after *Olympia* (having been shown at the Universal
Exhibition) had been accepted into the State collection, Gauguin painted his copy
[plate 87].

'MARSOUIN le'
Gauguin's friendship with the man invariably referred to in early letters as 'le
Marsouin' (the familiar name for a colonial infantry officer), probably dated from
his days in the merchant marine.

MAUCLAIR, Camille (1872–1945)
Successor to Aurier (*q.v.*) as art critic of the *Mercure de France*, where he published
his monthly '*Choses d'art*' between 1894 and 1896, Mauclair was a symbolist writer
and art critic who sought intellectual qualities in the artist. Gauguin's fierce
antagonism, expressed in his letter to Vallette (*q.v.*) of July 1896, was fuelled by
Mauclair's undisguised distaste for Gauguin's art.

MEYER DE HAAN, Jacob (1852–1895)
A Jewish painter from a wealthy Amsterdam family, de Haan was encouraged by
the van Gogh brothers to join Gauguin in Brittany in 1889. He adopted
Gauguin's synthetist manner and they jointly decorated the dining room of the
inn of Marie Henry at Le Pouldu. De Haan was prevented from making the
voyage to the tropics with Gauguin by family opposition and ill health.

MOLARD, William (1862–1936)
Whilst in Paris between 1893 and 1895, Gauguin struck up a friendship with
Molard, his wife Ida and stepdaughter Judith, who were his neighbours in the rue
Vercingétorix. Molard was a talented amateur musician, in whose unconventional
circle Gauguin met several Scandinavian painters and writers, including the
playwright August Strindberg (*q.v.*).

MONFREID, Georges-Daniel de (1856–1929)
Gauguin met Daniel de Monfreid in Paris through Schuffenecker and he was
included in the exhibition at the café Volpini in 1889. Financially secure but only
moderately talented, after 1891 de Monfreid took upon himself the rôle of
Gauguin's chief correspondent, agent and factotum. A keen yachtsman, de
Monfreid was a native of the Roussillon like his close friend the sculptor Aristide
Maillol.

MONTICELLI, Adolphe-Joseph Thomas (1824–1886)
A Provençal painter, much admired by Vincent van Gogh, Monticelli's works are
characterized by thick textural paint.

MORICE, Charles (1861–1919)
French poet and critic, whose study of the symbolist movement, *La Littérature de
tout à l'heure*, 1889, brought him to prominence, Morice met Gauguin in 1890 and
organized the benefit performance for Gauguin and Verlaine at the Théâtre de
Vaudeville in May 1891. Despite failing to forward the promised funds, Morice
was engaged by Gauguin to write an introduction to his one-man-show at
Durand-Ruel's gallery in 1893 and to collaborate on *Noa Noa* with a prose
commentary and some poems. The collaboration's much-delayed publication in
1901 displeased Gauguin, who felt Morice had overdone his contribution.

NITTIS, Giuseppe de (1846–1886)
Italian painter of modern life subjects, de Nittis settled in Paris in 1872. Friend of
Degas (*q.v.*) and Manet (*q.v.*), he exhibited at the first Impressionist show in
1874, thereafter achieving considerable success with fashionable urban subjects in
daring compositions.

PAU'URA (1881–?)
The second of Gauguin's Tahitian 'wives', Pau'ura cohabited with the painter
from 1896 to 1901 and bore him two children, the first a girl who died soon after
birth in December 1896, the second a boy, Émile, in 1899. She refused to
accompany Gauguin to the Marquesas.

PISSARRO, Camille (1830–1903)
As he admitted in *Racontars de rapin*, Gauguin owed a great deal to the
encouragement and teaching of Pissarro, his earliest mentor in the Impressionist
group with whom he practised *plein air* landscape painting between 1879 and
1884. They corresponded regularly at that time. Pissarro was critical of Gauguin's
decision to abandon his family in 1885 and found Gauguin's increasing tendency
towards exoticism and symbolism pretentious and anti-democratic.

PUVIS DE CHAVANNES, Pierre (1824–1898)
This painter of grand-scale mural decorations for public buildings was widely
admired by the symbolist generation. As he recalled in *Racontars de rapin*, Gauguin
attended the banquet held in Puvis's honour in January 1895 where he objected
to the speech of the Academician and man of letters Ferdinand Brunetière.
Gauguin's later paintings, particularly those such as *Where do we come from?*
[plate 221] in which figures appear in frieze-like arrangements and primitive
Arcadian settings, frequently prompted comparison with Puvis.

RAFFAËLLI, Jean-François (1850–1924)
Like Gauguin, Raffaëlli was on the margins of the Impressionist group. Invited by
Degas (*q.v.*) to join their exhibitions in 1880 and 1881, his inclusion met
considerable opposition. He held a one-man-show in 1884 and coined the label
'*caractérisme*' to describe his style, which combined loosely Impressionist handling
and naturalist detail. Although Raffaëlli had a wide appeal, some critics, including
Gauguin and Pissarro (*q.v.*), despised his opportunism.

REDON, Odilon (1840–1916)
As an artist Redon developed an idiosyncratic style and fantasy subject matter
which had considerable appeal to the symbolist generation. First championed by
Huysmans (*q.v.*) in 1884, Gauguin too had great respect for his art, as his letters
of 1890 show. Mme Redon, a native of the Île Bourbon, was able to supply
Gauguin with information about life in Madagascar.

ROUJON, Henri (1853–1914)
In 1892 it was to Roujon, newly appointed Directeur des Beaux-Arts, that
Gauguin addressed his bid for repatriation from Tahiti. On Gauguin's return to
Paris, Roujon reneged on the State's commitment to purchase one or two of his
Tahitian paintings, for which the artist never forgave him. A successful
administrator and friend of Mallarmé, he was responsible for the State's
negotiations over the Caillebotte bequest.

SCHUFFENECKER, Émile, referred to by Gauguin as 'Schuff' (1851–1934)
A French painter who, like Gauguin, took up art after a career on the Stock
Exchange, Schuffenecker was a founder member of the *Salon des Indépendants* (*q.v.*).
Despite offering Gauguin much financial and moral support and hospitality
during his stays in Paris, his bourgeois outlook was treated with contempt by
Gauguin (manifest in his painting of *The Schuffenecker family* [plate 71]).
Nevertheless the malicious rumour, apparently started by Bernard, of Gauguin's
having seduced Mme Schuffenecker seems to be unsubstantiated. Schuffenecker
stayed on friendly terms with Mette Gauguin, attempting to act as go-between
for the couple.

SEGUIN, Armand (1869–1903)
Painter and printmaker, Seguin trained at the École des Arts Décoratifs before
joining the Nabis in 1889. From 1891 on he regularly visited Pont-Aven where he
befriended the Irish painter Roderic O'Conor. Both admired Gauguin's work
before meeting the artist himself during his last stay in France. Gauguin hoped
they would accompany him to the South Seas and wrote an appreciation of
Seguin's work for his one-man-show in 1895. Alcoholism and poverty led to a sad
decline in Seguin's career in the late 1890s.

SÉRUSIER, Paul (1864–1927)
A convert to Gauguin's synthetist art in late 1888, Sérusier was responsible for transmitting Gauguin's teachings to his fellow students at the Académie Julian (who became the Nabis) and for developing his *ad hoc* ideas into a coherent theory. Of all the members of the Nabi group which included Denis, Bonnard and Vuillard, Sérusier remained most closely in touch with Pont-Aven ideas and with Gauguin, returning to work in central Brittany after Gauguin's departure for Tahiti.

SIGNAC, Paul (1863–1935)
Signac's painting career began at about the same date as Gauguin's. A founder member of the *Indépendants*, like Seurat he exhibited works painted in the pointillist manner at the 8th Impressionist exhibition of 1886. Signac offered Gauguin the use of his studio that summer but Seurat officiously refused him entry, hence the angry letter Gauguin wrote to Signac. Thereafter Gauguin took a firm stand of opposition to the Neo-Impressionists and their 'little dot'.

STRINDBERG, August (1849–1912)
The celebrated Swedish author and playwright, whose plays were much performed in Paris in the symbolist climate of the 1890s, was also a painter. In 1895 Gauguin asked him to write a preface for the catalogue of his sale at the Hôtel Drouot. Although Strindberg replied apologizing for his inability to perform the task, Gauguin published his letter as it stood.

TANGUY, Julien 'Père' (1825–1894)
'Père' Tanguy was a colour merchant beloved by artists for his willingness to accept works of art in payment for materials. His small shop at 14 rue Clauzel, Montmartre, the only place to study Cézanne's work in the 1880s, was frequented not only by Gauguin who bought several Cézannes from him, but also by Pissarro, van Gogh and Bernard.

TEHAMANA (1878–?)
Gauguin's shortlived 'marriage' to the Tahitian girl Tehamana, aged 13 when he met her, is described in *Noa Noa*. She lived with him until 1893 and was the model for many important paintings of the first Tahitian voyage, including *Manao tupapau* [plate 140]. When Gauguin returned to Tahiti in 1895, Tehamana had remarried.

VALLETTE, Alfred (1858–1935)
Editor of the *Mercure de France* and husband of the actress Rachilde, Vallette was the recipient of several letters from Gauguin in Tahiti.

VEENE, Théophile van der (1843–1885)
The Dutchman referred to in Gauguin's letter of 1890 to Willumsen (*q.v.*) had delivered a lecture on Tahiti published in the *Bulletin de la Société des Études coloniales et maritimes*, Paris, 1884.

VINGT, Les
This Belgian group of 20 artists held annual exhibitions in Brussels between 1884 and 1893. The group's secretary, Octave Maus, made it his business to invite the key foreign artists of the day to show work. Gauguin exhibited with *Les Vingt* in 1889 and 1891 and with *La Libre Esthétique*, successor to the earlier group, in 1894 and 1896.

VOLLARD, Ambroise (1868–1939)
Vollard's arrival on the Paris art scene coincided with Gauguin's final departure for Tahiti. An ambitious dealer, Vollard played a significant rôle in the encouragement of the graphic arts and offered the first one-man-show to Cézanne in 1895. Encouraged by younger painters such as de Monfreid, he began to exhibit Gauguin's work in 1896. In November–December 1898 he showed *Where do we come from?* [plate 221] and some related works at his gallery. Gauguin remained highly suspicious of the dealer in all their business affairs.

WILLUMSEN, Jens Ferdinand (1863–1958)
Willumsen, an accomplished painter and carver when he joined Gauguin's circle of admirers in Pont-Aven in the summer of 1890, was the only Danish artist Gauguin seems to have respected. Following Willumsen's visit to Holland, Gauguin wrote him a long didactic letter on the subject of Dutch art. Further contacts appear to have been spasmodic. Willumsen is considered one of Denmark's most important painters of the turn of the century.

WOLFF, Albert (1835–1891)
Journalist and influential art critic of *Le Figaro* in the 1870s and 1880s, Wolff was despised by Gauguin for remaining sceptical of Manet's (*q.v.*) and of Delacroix's (*q.v.*) talents and a harsh critic of the Impressionists while being one of the strongest supporters of Bastien-Lepage (*q.v.*).

Index

Academy, French 28
Alexandre, Arsène 260
Annah [the Javanese] 165, 194
Arles 7, 82, 93, 97, 100, 102, 120, 121, 122, 194
Aubé, Jean-Paul 40
Aurier, Albert 8, 82, 115, 122, 175, 184, 249
Australia 164, 166
avant-garde 82

Barbizon school 10
Bastien-Lepage, Jules 23, 27
Batignolles 173
Baudry, Paul 104
Beethoven, Ludwig von 170, 262
Belgium 193
Bernard, Émile 8, 9, 82, 89, 90, 94, 100, 102, 104, 110, 115, 173, 174, 248, 250, 274
Bernard, Madeleine 82
Bertin [employer] 39
Bevan, Robert 165
Bibesco, Prince Emmanuel 269
Bible 120, 266
Bing [gallery] 260
Bjørnson, Bjørnstjerne [writer] 84
Bodelsen, Merete 8
Bonnard, Pierre 275
Bonnat, Léon 260
Bouillot, Jules 10, 31, 35, 36
Boussod & Valadon 11, see also Goupil
Bracquemond, Félix 10, 40, 260
Brandès, Edvard 193
Brittany 7, 9, 11, 35, 40, 82, 83, 84, 106, 111, 122, 165, 184, 267, 270, 273, 274, see also Pont-Aven
Bruges 193
Brunetière, Ferdinand 275
Brussels 96, 98, 100, 247
Buffalo Bill Cody 103

Café Volpini Exhibition, 1889 82, 102, 103, 104, 264
Café Voltaire 124
Cassatt, Mary 38
Centennial Exhibition 104, 106, see also Universal Exhibition
Cézanne, Paul 10, 16, 23, 25, 28, 38, 85, 111, 121, 193, 275
Champ-de-Mars Exhibition 168
Chaplet, Ernest 260
Charlopin, Dr 116
Chaudet, Georges-Alfred 251, 254, 257, 260, 267
Chausson, Ernest 123
Cimabue, Giovanni 262, 277
Colon 46
Concarneau 165, 194
Copenhagen 7, 8, 9, 14, 26, 27, 30, 39, 41, 46, 100, 113, 114, 124, 164, see also Denmark
Coquelin cadet, Ernest 260
Corot, Jean-Baptiste-Camille 19, 106, 111
Courbet, Gustave 19

Daniel, M. G. see Monfreid, Daniel de
Daubigny, Charles François 97
Daudet, Alphonse 120
Daumier, Honoré 94, 97, 106
Degas, Edgar 9, 15, 16–24 passim, 38, 86, 94–5, 97, 100, 111, 121, 249, 260, 263, 267, 268, 271
Delacroix, Eugène 262, 275, 276
Delaroche, Achille 8, 260, 266
Delius, Frederick 237
Denis, Maurice 7, 197, 264, 267
Denmark 26, 35, 36, 38, 83, 84, 100, 117, 187, 249, 267, see also Copenhagen
Denmark Exhibition, 1893 178, 179, 180, 185, 186

Dieppe 11, 36
Dillies & Co. 11
Dolent, Jean 248, 249, 260
Dubois-Pillet, Albert 96
Duguay-Trouin 259
Durand-Ruel 10, 16–25 passim, 31, 260, 263
Durand-Ruel Exhibition, November 1893 165, 185, 187, 257
Dutch masters 117

Echo de Paris 104
École des Beaux-Arts 17, 18, 183, 256, 266, 276, 277
Emigration Society 116
Evénement, l' 15

Faone 191
Fatu-iva 270, see also Marquesas Islands
Fayet, Gustave 273
Fénéon, Félix 85
Figaro, le 84
Fontainas, André 9, 244, 262, 263, 266
France, Anatole 260
Franck, Auguste César 275

Gad family 10, 36
Gallimard, Paul 260
Gauguin, Aline [mother of Gauguin] 12, 255
Gauguin, Aline [daughter of Gauguin] 39, 83, 100, 181, 244, 255
Gauguin, Clovis [son of Gauguin] 11, 36–43 passim, 100
Gauguin, Clovis [father of Gauguin] 12
Gauguin, Emil 14, 31, 83, 100
Gauguin, Mette 7–14 passim, 20, 30, 31, 112, 114, 125, 165, 184, 246–7, 249, 255, 256, 278
Gauguin, Paul [entries are for paintings etc. referred to in the letters or text]
[Paintings]
Aha oe feii? (Are you jealous?) 176, 178
The Alyscamps, Arles 96
Breton boys wrestling 82, 102
Breton Calvary/Green Christ 111
Breton girls dancing, Pont-Aven 96, 102
Café at Arles 96
Caricature self-portrait 106
Christ in the Garden of Olives 108
D'Où venons-nous? Que sommes-nous? Où allons-nous? (Where do we come from? What are we? Where are we going?) 244, 258, 262, 268, 270–1, 273
Farmhouse in Arles 102
The first flowers (Brittany) 95, 102
Flower piece 253
Grape harvest at Arles (Human anguish) 95, 96, 99
I raro te oviri (Under the pandanus) 179
Ia orana Maria (Hail Mary) 171, 268
In the heat of the day (In the hay) 96
Man with an axe 188
Manao tupapau (The spirit of the dead watches) 164, 178, 180
Mango pickers, Martinique 102
Meyer de Haan 106
Nave nave mahana (Delightful days) 253, 261
Nevermore 244, 253, 273
No te aha oe riri? (Why are you angry?) 253
Parahi te marae (There lies the temple) 179
Parua Parua (Conversation) 178
Pastorales tahitiennes 183
Portrait of Vincent van Gogh painting sunflowers 99
Seaweed gatherers 106–7
Self-portrait 253
Self-portrait, les Misérables, for Vincent van Gogh 92
Still life, teapot and fruit 253

Still life with three puppies 82
Study of a nude, Suzanne sewing 10, 23, 171
Ta faaturuma (The brooding woman) 179
Te arii vahine (The king's wife) 246
Te fare Maorie 179
Te raau rahi (The big tree) 179
Te rerioa (Day dreaming) 254
Vahine no te tiare (Woman with a flower) 172, 177, 179
Vairaumati 164
Vision after the sermon (Jacob wrestling with the angel) 82, 91
Winter (Young Breton adjusting his clog) 102
[Sculpture]
Oviri 269
Soyez amoureuses et vous serez heureuses (Be in love and you will be happy) 82, 109, 273
[Writings]
Avant et après 9, 10, 82, 120–2, 244
Cahier pour Aline 164, 181–2
Noa Noa 165, 244, 247, 257–9, 270, 273
Notes synthétiques 7, 11
Racontars de rapin 7, 244, 274–7
Gauguin, Paul [son of Gauguin] 31, 100
Gauguin children 39, 83, 86, 112, 125, 177, 278–9
Geffroy, Gustave 260, 266
Gil Blas 24
Gogh, Theo van 11, 82, 85, 93–9 passim, 102, 121, 123, 177, 252, 267, see also Goupil
Gogh, Vincent van 9, 82, 94–9 passim, 102, 104, 111, 115, 116, 118–22, 123, 184, 194, 274
La berceuse 194
Sower 99
Sunflower paintings 99
Goncourt, Edmond de 120
Goupil [dealer] 113, 121, 123, 168, 172, 177, 267, see also Gogh, Theo van
Gourmont, Rémy de 249
Guêpes, les 244
Guillaumin, Armand 10, 18–19, 22, 26, 29, 31, 41, 102, 104, 115

Hals, Frans 117
Handel, George Frederick 118
Hiva-Oa see La Dominique
Holland 117, 121
Huet, Juliette 169
Huysmans, Joris-Karl 10, 23, 106

Impressionism/Impressionists 10, 11, 18, 22, 23, 24, 29, 31, 38, 40, 82, 89–94 passim, 98, 104, 275, 277
Indépendants' exhibition 29, 104, 115
Ingres, Jean-Dominique 97, 117, 121, 276, 277
Itia 191

Jourdain, Franz 26

Kanakas 105, 180, 184

La Dominique (Hiva-Oa) 175, 245
La Fontaine, Jean de 263
La Rochefoucauld, Comte [Antoine] de 173, 248, 260
La Vire, Governor 166
Lacascade, Governor 187
Latouche, Mme 15, 23
Laval, Charles 11, 44, 90, 91, 94, 103
Le Pouldu 111
Lerolle, Henry 104, 123, 248
Lima 12
London 36, 184
Loti, Pierre 82, 164, 275
Le Mariage de Loti – Rarahu 82, 164

Louvre 117, 118, 262

Madagascar 43, 82, 115, 122
Mallarmé, Stéphane 9, 82, 125, 186, 249, 260
Manet, Édouard 23, 24, 30, 38, 40, 106
 Olympia 106
Maoris 173, 180, 191, 192, 197, 279, 281
Marquesans 279, 280–1
Marquesas Islands 165, 175, 184, 244, 245, 270, *see also*
 La Dominique
Marseilles 185
'Marsouin' 26
Martinique 7, 11, 44–5, 46, 95
Marx, Roger 260
Mataiea district 188
Mauclair, Camille 249
Maufra, Maxime 9
Melbourne 166
Memling, Hans 193
Mercure de France 9, 120, 244, 249, 260, 262, 266, 274
Meyer de Haan, Jacob 106, 108, 110, 111, 116
Michelangelo 245
Midi 28, 88, 91, 93, 106, 121, 245, 273
Millet, Jean-François 19, 106, 112
Mirbeau, Octave 82, 104, 260
Moderniste, le 82
Moerenhout, J. A. 164
Molard, William 165
Moltke, Countess of 31
Monet, Claude 15, 17, 25, 34, 85, 104, 267
Monfreid, Daniel de 9, 165, 173, 177, 178, 185, 244,
 259, 267, 274
Monticelli, Adolphe-Joseph 97, 121
Montparnasse studio 263
Montpellier 99
Moorea 187
Morice, Charles 82, 165, 168, 171, 172, 244, 259, 273
Moscoso, Pio de Tristan 12
Mucha, Alphonse 165
Munch, Edvard 165

Napoleon I 275
National, le 12
Neo-Impressionists 98
New Caledonia 164
Nittis, Giuseppe de 27

Norway 26, 84
Nouméa 166

O'Conor, Roderic 165
Octon, Vigné d' 260
Orléans 12, 185

Panama 7, 11, 42, 44, 115
Panorama 18
Papeete 164, 188, 244, 245, 252
Paris 8, 10, 11, 16, 18, 25, 26, 31–6 *passim*, 40, 41, 42,
 82, 98–101 *passim*, 106, 109, 111, 113, 124, 165, 168,
 169, 173, 183, 185, 186, 195, 244, 249, 257, 267, 281
Parthenon 257
Peru 12
Pissarro, Camille 7–10 *passim*, 24, 31, 41, 97, 103, 104,
 170, 274, 275
Pissarro, Julie 8, 21, 23, 24
Plume, la 197, 260
Poe, Edgar Allan 253
Polynesia 8, 9
Pomaré V, King of Tahiti 164, 167, 187–8
Pont-Aven 9, 11, 41, 46, 82, 83, 84, 90, 91, 94, 120,
 165, 194, *see also* Brittany
Pontoise 21, 25
Portier, Alphonse [dealer] 24, 44, 172, 248, 255, 260
Poussin, Nicolas 275
Proudhon, Pierre Joseph 12
Proust, Antonin 260
Provence 82, 86, 106, *see also* Arles
Puvis de Chavannes, Pierre 94, 258, 260, 263, 268, 275

Raffaëlli, Jean-François 18, 19, 23, 29
Raphael 29, 97
Redon, Odilon 9, 122, 123, 260
Rembrandt 34, 117, 118, 262, 275
Renoir, Auguste 16, 19, 34, 260, 275
Revue blanche, la 260
Revue encyclopédique, la 260
Revue indépendante, la 85, 94, 98, 104, 115, 197
Rodin, Auguste 260
Rouart, Henri 248, 260, 261, 267
Rouen 32
Roujon, Henri 266
Rousseau, Henri 97
Rubens, Peter Paul 34, 193

St Briac 89
Salon 17, 277
Salon of 1876 10
Schuffenecker, Émile 9, 36, 41, 42, 46, 47, 82, 98–104
 passim, 111, 171, 173, 185, 248, 250, 252, 256, 260,
 273
Schuffenecker family 101
Seguin, Armand 9, 165, 195, 197, 247, 252
Sérusier, Paul 9, 123, 164, 168, 172, 177, 248, 275
Seurat, Georges 11, 41, 82, 94, 103
Sèvres [porcelain factory] 105
Signac, Paul 41, 94, 96
Sisley, Alfred 15, 17
Sourire, le 244
Stock Exchange 25, 36, 37, 85
Strindberg, August 8, 165, 196, 197
Sweden 84, 267
Sydney 166
Symbolism/Symbolists 8, 82, 175

Tabogas 42
Tahiti 7, 8, 82, 115–23 *passim*, 164–74 *passim*, 184–93
 passim, 245, 251, 257, 259, 269, 273, 280
Tahiti exhibition *see* Durand-Ruel Exhibition
Tanguy, Julien 23, 25
Tehamana 164, 193
Thomereau [employer] 10
Tonkin 82, 113
Tristan, Flora [Gauguin's grandmother] 12
Turanians 197

Universal Exhibition 1889 82, 104, 105–6, 115, 268

Veene, Théophile van der 118
Velásquez, Diego 117
Vingtistes 96, 98
Virgil 28, 275
Vollard, Ambroise 244, 255, 260, 262, 266, 267, 268,
 269, 271, 279

Wagner, Richard 123
Willumsen, Jens-Frederik 9, 117, 118

Zola, Émile 39

Sources and Bibliography

Unless otherwise credited, all translations are by Andrew Wilson and Belinda Thomson.

Every effort has been made to secure permission to reproduce extracts from Gauguin's letters and writings; however, where we have been unable to trace a particular copyright-holder, we have nonetheless accredited the source as fully as possible.

KEY TO ABBREVIATIONS

N.B. Numerals after abbreviations refer to the numbering system used in that particular publication.

BAA Bibliothèque d'Art et d'Archéologie (Fondation Jacques Doucet), Paris

BODELSEN 1957 Merete Bodelsen, 'An unpublished letter by Theo van Gogh', *Burlington Magazine*, 99, no. 651, June 1957, pp. 199–202.

BODELSEN 1970 Merete Bodelsen, 'Gauguin the Collector', *Burlington Magazine*, 112, no. 810, Sept. 1970, pp. 590–615.

COOPER Douglas Cooper (ed.), *Paul Gauguin: 45 lettres à Vincent, Théo et Jo van Gogh*, Collection Rijksmuseum Vincent van Gogh, Vincent van Gogh Foundation, Amsterdam, 1983

DROUOT Hotel Drouot, Salle no. 6, *Archives de Camille Pissarro*, Catalogue de vente, vendredi 21 novembre 1975, Paris

FIELD Richard Field, *Paul Gauguin: The Paintings of the First Trip to Tahiti*, Harvard University, Cambridge MA, 1963 (New York and London, 1977)

GAUGUIN CATALOGUE, 1988–9 Galeries nationales du Grand Palais, Paris, *Gauguin* exhibition catalogue 1989 (formerly in Washington and Chicago, 1988)

GETTY CENTER From the Resource Collections of the Getty Center for the History of Art and the Humanities

GUÉRIN D. Guérin (ed.), *Paul Gauguin: The Writings of a Savage*, Viking Penguin translation copyright 1978, trans. E. Levieux; Paragon House, 1990; original French edn Editions Gallimard copyright 1974. Used by permission of Viking Penguin, a division of Penguin Books USA Inc. (Page numbers refer to Paragon House edition.)

JOLY-SEGALEN A. Joly-Segalen (ed.), *Lettres de Paul Gauguin à Georges Daniel de Monfreid*, Paris, 1950

MALINGUE M. Malingue (ed.), *Lettres de Gauguin à sa femme et à ses amis*, Paris, 1946

REWALD, *IMPRESSIONISM* John Rewald, *The History of Impressionism*, New York, 1946

REWALD, *POST-IMPRESSIONISM* John Rewald, *Post-Impressionism: From van Gogh to Gauguin*, 1958, rev. edn London, 1978

REWALD, *STUDIES* John Rewald, *Studies in Post-Impressionism*, Thames & Hudson, London, 1986, trans. Gerstle Mack

RIJKSMUSEUM VVG Rijksmuseum Vincent van Gogh, Amsterdam

SOURCES

From *Avant et après* (Before and After)
Extract from Guérin, pp. 231–9

To Madame Heegaard, 9 February 1873
Malingue I were misdated Sept.–Oct. 1873; BAA MS211

To Madame Heegaard, 25 April 1874
Malingue II; BAA MS211

To Madame Heegaard, 8 July 1874
Malingue III; BAA MS211

To Madame Heegaard, 12 September 1874
Malingue IV; BAA MS211

To Camille Pissarro, 3 April 1879
Drouot 31

To Camille Pissarro, 26 July 1879
Drouot 30

To Camille Pissarro [summer 1881]
Drouot 35; dated Rewald, *Impressionism*, p. 458

To Camille Pissarro [summer 1881]
Drouot 42; Durand-Ruel Archives

To Camille Pissarro, 11 November 1881
Drouot 33; Getty Center

To Camille Pissarro, 14 December 1881
Drouot 34; Durand-Ruel Archives

To Camille Pissarro, 18 January 1882
Drouot 37

To Camille Pissarro [March 1882]
Drouot 41

To Camille Pissarro [1882?]
Drouot 43

To Camille Pissarro [late 1882]
Drouot 46; dated J. Bailly-Herzberg, *Correspondance de Camille Pissarro* I, 1865–1885, Presses Universitaires de France, Paris, 1980, p. 171

To Camille Pissarro, 8 December 1882
Ashmolean Museum, Oxford, Pissarro archive

To Camille Pissarro [early 1883]
Drouot 55; Durand-Ruel Archives

To Camille Pissarro [mid-May 1883]
Drouot 50

To Camille Pissarro [summer 1883]
Drouot 52; Bodelsen 1970, p. 606, where dated

To Camille Pissarro [1883]
Drouot 53

To Camille Pissarro, 11 October 1883
Drouot 56

To Camille Pissarro [January 1884]
Drouot 58

To Camille Pissarro [spring 1884]
Drouot 63; dated Rewald, *Impressionism*, p. 519

To Camille Pissarro [July 1884]
Drouot 62; dated Bodelsen 1970, p. 594; Durand-Ruel Archives

To Camille Pissarro [October 1884]
Drouot 67; J. Bailly-Herzberg, *op. cit.*, I, pp. 15–16

To Camille Pissarro [November 1884]
dated Bodelsen 1970, p. 597
Ashmolean Museum, Oxford, Pissarro archive

To Camille Pissarro [late 1884]
Drouot 59

To Dillies & Co., Roubaix [late December 1884]
Malingue VII

To Camille Pissarro [early 1885]
Drouot 69

To Émile Schuffenecker, 14 January 1885
Malingue XI

To Camille Pissarro, 30 January 1885
Drouot 68 where misdated 30 February 1885; dated Rewald, *Impressionism*, p. 519

To Émile Schuffenecker, 17 March 1885
Getty Center

To Émile Schuffenecker, 24 May 1885
Malingue XXII; Durand-Ruel Archives

To Camille Pissarro [spring 1885]
Drouot 70; dated Rewald, *Impressionism*, p. 519

Notes synthétiques, 1884–1885
Raymond Cogniat and John Rewald, *Paul Gauguin: A Sketchbook*, Paris and New York, 1962; facsimile edn of sketchbook dated *c*.1884–1888, Arnold Hammer Collection. Extract from Guérin, pp. 10–11

To Paul Durand-Ruel, 22 June 1885
Durand-Ruel Archives

To Mette, 19 August 1885
Malingue XXIV; BAA MS211

To Mette, 19 September 1885
Malingue XXV; BAA MS211

To Camille Pissarro, 2 October 1885
Drouot 72

To Mette, 13 October 1885
Malingue XXVII; BAA MS211

To Mette, 2 November 1885
Malingue XXIX; BAA MS211

To Mette [late November 1885]
Malingue XXX; BAA MS211
[not checked against original]

To Mette, 29 December 1885
Malingue XXXII; BAA MS211

To Mette [April 1886]
Malingue XXXV; BAA MS211

To Mette, 24 May 1886
Malingue XXXVI; BAA MS211

To Mette [May 1886]
Malingue XXXVII; BAA MS211

To Mette [late May 1886]
Malingue XXXVIII; BAA MS211

To Mette [early July 1886]
Malingue XXXIX; BAA MS211

To Paul Signac [June–July 1886]
H. Dorra and J. Rewald, *Seurat, L'Œuvre peint, biographie et catalogue critique*, Les Beaux-Arts, Paris, 1959, p. L

To Mette, July 1886
Malingue XLII; BAA MS211

To Mette, 15 August 1886
H. Rostrup, 'Gauguin et le Danemark', *Gazette des Beaux-Arts*, 1958, p. 73; Royal Library, Copenhagen

To Mette, 26 December 1886
Malingue XLV; BAA MS211

To Félix Bracquemond [January 1887]
Malingue XLVI

To Mette [early April 1887]
Malingue XLVIII; BAA MS211

To Émile Schuffenecker [late April 1887]
Malingue LI

To Mette, 20 June 1887
Malingue LIII; BAA MS211

To Émile Schuffenecker, 14 July 1887
A. Alexandre, *Paul Gauguin*, 1930, pp. 58–60

To Mette [August 1887]
Malingue LV; BAA MS211

To Émile Schuffenecker [September 1887]
Malingue LVII

To Mette, 24 November 1887
Malingue LVIII; BAA MS211

To Mette, 6 December 1887
Malingue LIX; BAA MS211

To Mette, February 1888
Malingue LXI; BAA MS211

To Émile Schuffenecker [February 1888]
Malingue appendix, p. 321

To Vincent van Gogh [late February 1888]
Cooper 28; Rijksmuseum VVG

To Vincent van Gogh [c.19 March 1888]
Cooper 29; Rijksmuseum VVG

To Émile Schuffenecker, 26 March 1888
Malingue LXIII

To Émile Schuffenecker [June 1888]
Malingue LXV; Durand-Ruel Archives

To Theo van Gogh [c.15 June 1888]
Cooper 3; Rijksmuseum VVG

To Mette [c.15] June 1888
Malingue LXIV; BAA MS211

To Émile Schuffenecker [c.8 July 1888]
Malingue LXVI; Rijksmuseum VVG

To Theo van Gogh [mid-July 1888]
Cooper 5; Rijksmuseum VVG

To Vincent van Gogh [c.25 July 1888]
Cooper 30; Rijksmuseum VVG

To Émile Schuffenecker, 14 August 1888
Malingue LXVII and appendix, p. 321

To Émile Schuffenecker [September 1888]
Malingue appendix, p. 322

To Vincent van Gogh [c.10 September 1888]
Cooper 31; Rijksmuseum VVG

To Vincent van Gogh [c.22 September 1888]
Cooper 32; Rijksmuseum VVG

To Vincent van Gogh [c.25 September 1888]
Cooper 33; Rijksmuseum VVG

To Émile Schuffenecker, 16 October 1888
Malingue LXXIII

To Madeleine Bernard [October 1888]
Malingue LXIX

To Émile Bernard [early November 1888]
Malingue LXXV

To Émile Bernard [mid-November 1888]
Malingue LXVIII where misdated Pont-Aven, October 1888

To Theo van Gogh [c.16 November 1888]
Cooper 8; Rijksmuseum VVG

To Theo van Gogh [c.4 December 1888]
Cooper 9; Rijksmuseum VVG

To Émile Schuffenecker [early December 1888]
Malingue LXXIV where misdated 13 November; dated Bodelsen 1957, p. 201

To Émile Bernard [December 1888]
Malingue LXXVIII

To Theo van Gogh [c.8 December 1888]
Cooper 10; Rijksmuseum VVG

To *La Revue indépendante*
Cooper 10; Rijksmuseum VVG

To Mette [mid-December 1888]
Malingue LXXVI where misdated November 1888; dated Bodelsen 1957, p. 201; BAA MS211

To Theo van Gogh [c.12 December 1888]
Cooper 11; Rijksmuseum VVG

To Theo van Gogh [c.20 December 1888]
Cooper 12; Rijksmuseum VVG

To Vincent van Gogh [c.9 January 1889]
Cooper 34; Rijksmuseum VVG

To Mette [January 1889]
Malingue CXIV where misdated December 1890; BAA MS211

To Vincent van Gogh [c.20 January 1889]
Cooper 35; Rijksmuseum VVG

To Émile Schuffenecker [April 1889]
Malingue LXXVII where misdated December 1888

To Émile Bernard [end May 1889]
Malingue LXXXI where misdated March 1889

To Theo van Gogh [c.10 June 1889]
Cooper 13; Rijksmuseum VVG

To Theo van Gogh [c.1 July 1889]
Cooper 14; Rijksmuseum VVG

From *Notes on art at the Universal Exhibition*
Guérin, pp. 28–32

To Theo van Gogh [c.15 August 1889]
Cooper 15; Rijksmuseum VVG

To Vincent van Gogh [c.20 October 1889]
Cooper 36; Rijksmuseum VVG

To Vincent van Gogh [c.8 November 1889]
Cooper 37; Rijksmuseum VVG

To Theo van Gogh, 20 or 21 November 1889
Cooper 22; Rijksmuseum VVG

To Émile Bernard [November 1889]
Malingue XCII

To Mette [December 1889]
Malingue LXXXII where misdated June 1889; BAA MS211

To Theo van Gogh [c.16 December 1889]
Cooper 23; Rijksmuseum VVG

To Émile Schuffenecker [January 1890]
Malingue appendix, pp. 322–3

To Vincent van Gogh [c.1 April 1890]
Cooper 40; Rijksmuseum VVG

To Émile Bernard [June 1890]
Malingue CV; Getty Center

To Émile Bernard [late July 1890]
Malingue CIX

To Émile Bernard [August 1890]
Malingue CX

To J. F. Willumsen [late summer 1890]
Extracts published in Guérin, pp. 44–6; J. F Willumsens Museum, Frederikssund

To Theo van Gogh [c.2 August 1890]
Cooper 26; Rijksmuseum VVG

To Émile Bernard [August 1890]
Malingue CXI; Guérin, p. 42

From *Avant et après*, 'On Vincent van Gogh'
Extract from Guérin, pp. 250–4

To Odilon Redon [September 1890]
R. Bacou (ed.), *Lettres à Odilon Redon*, Librairie José Corti, Paris, 1960, pp. 193–4; Guérin, pp. 42–3

To Émile Bernard [October 1890]
Malingue CXIII

To Odilon Redon [October 1890]
R. Bacou, *op. cit.*, pp. 194–5

To Mette [19 February 1891]
Malingue CXX; BAA MS211

To J. F. Willumsen [mid-March 1891]
Unpublished document; J. F. Willumsens Museum, Frederikssund

To Mette [24 March 1891]
Malingue CXXIII; BAA MS211

To Mette [4 May 1891]
Malingue CXXIV; BAA MS211

To Mette [late June 1891]
Malingue CXXVI where dated July 1891; redated Field, p. 359; BAA MS211

To Paul Sérusier [November 1891]
Paul Sérusier, *ABC de la peinture, suivi d'une correspondance inédité*, Floury, Paris, 1950, pp. 52–5; extract from Guérin, p. 54

To Daniel de Monfreid, 7 November 1891
Joly-Segalen II; Rijksmuseum VVG

To Mette [c.March 1892]
Malingue CXXVII; BAA MS211

To Daniel de Monfreid, 11 March 1892
Joly-Segalen III

To Daniel de Monfreid [March 1892]
Joly-Segalen IV where dated May 1892; redated *Gauguin* catalogue 1988–9, p. 212; Rijksmuseum VVG

To Paul Sérusier, 25 March 1892
Paul Sérusier, *op. cit.*, pp. 58–60

To Mette [late April – early May 1892]
Malingue CXXX where dated July 1892; redated Field, p. 361; BAA MS211

To Henri Roujon, 12 June 1892
Gauguin catalogue, 1988–9, p. 213; Archives nationales, F21 2286, dossier Gauguin

To Daniel de Monfreid [September 1892]
Joly-Segalen XII where misdated 31 March 1893; redated Rewald, *Post-Impressionism*, p. 537, n. 39

To Mette [September 1892]
Malingue CXXVIII where misdated May 1892; redated Field, p. 364; BAA MS211

To Daniel de Monfreid [October–November 1892]
Joly-Segalen VI; Malingue CXXXII where dated August 1892; redated Field, p. 364; BAA MS211

To Mette [5 November 1892]
Malingue CXXXIII; BAA MS211

To Daniel de Monfreid, 8 December 1892
Joly-Segalen VIII

To Mette, 8 December 1892
Malingue CXXXIV; extract from Guérin, p. 63; BAA MS211

Cahier pour Aline (Notebook for Aline), 1892–1893
Facsimile published as, "*A ma fille Aline ce cahier est dédié . . . 1893*", Société des Amis de la BAA, et les Éditions William Blake & Co., 1989; extracts from Guérin, pp. 66–9; BAA MS227

To Daniel de Monfreid, late December 1892
Joly-Segalen IX; Rijksmuseum VVG

To Mette [February 1893]
Malingue CXXXV where dated April 1893; redated Field, p. 366; BAA MS211

To Daniel de Monfreid, 11 February 1893
Joly-Segalen X

To Daniel de Monfreid [March 1893]
Joly-Segalen XIII where dated April–May?; redated Field, p. 367; Getty Center

To Mette [3 August 1893]
Malingue CXXXVII; BAA MS211

To Daniel de Monfreid, 4 September 1893
Joly-Segalen XV; Rijksmuseum VVG

To Mette [October 1893]
Malingue CXLIII; BAA MS211

To J. F. Willumsen [October 1893]
M. Bodelsen, *Gauguin and van Gogh in Copenhagen in 1893*, Ordrupgaard, 1984, p. 27; J. F. Willumsens Museum, Frederikssund

To Stéphane Mallarmé, 3 November 1893
Malingue CXLIV

To Mette [November 1893]
Malingue CXLVII where dated December 1893; BAA MS211

To Mette, December 1893
Malingue CXLV; BAA MS211

From *Noa Noa*
Draft manuscript, 1893; published in facsimile as *Paul Gauguin: Noa Noa, Voyage to Tahiti*, (ed. J. Loize), Bruno Cassirer, Oxford, 1961, trans. Jonathan Griffin; Getty Center

To Mette [5 February 1894]
Malingue CXLVIII; BAA MS211

To Daniel de Monfreid [February 1894]
Joly-Segalen XVII where misdated September? 1893

To Jo van Gogh-Bonger, 29 March 1894
Cooper 43; Rijksmuseum VVG

To William Molard [May 1894]
Malingue CL

To William Molard [late August 1894]
Malingue CLII where dated September 1894

To Durand-Ruel, 16 January 1895
Unpublished, Durand-Ruel Archives

To August Strindberg [5 February 1895]
Malingue CLIV; Guérin, pp. 104–5

To Maurice Denis [early March 1895]
Malingue CLVII

To William Molard [September 1895]
Malingue CLX where dated July 1895

To Daniel de Monfreid, November 1895
Joly-Segalen XX; extract from Guérin, p. 116

To Daniel de Monfreid, April 1896
Joly-Segalen XXII; Collection Annick and Pierre Bérès, Paris

To Émile Schuffenecker, 10 April 1896
See Sale catalogue, Hôtel Drouot, 3–4 décembre 1958 (cat.115), of former collection Alfred Dupont

To Charles Morice [May 1896]
Malingue CLXII

To Daniel de Monfreid, June 1896
Joly-Segalen XXII; possession E. W. Kornfeld, Bern

To Émile Schuffenecker [June? 1896]
See Sale catalogue, Hôtel Drouot, 3–4 décembre 1958 (cat.116), of former collection Alfred Dupont

To Daniel de Monfreid, 13 July 1896
Joly-Segalen XXIII; Guérin, p. 118

To Alfred Vallette, July 1896
Malingue appendix, p. 324; Guérin, pp. 118–19

To Daniel de Monfreid, August 1896
Joly-Segalen XXIV; Guérin, p. 118

To Daniel de Monfreid, November 1896
Joly-Segalen XXVI; Rijksmuseum VVG; extract from Guérin, p. 120

To Armand Seguin, 15 January 1897
See Sale catalogue, Hôtel Drouot, 5 June 1962, salle 6, (cat. no. 18) collection Edmond Sagot; Bengt Danielsson, *Gauguin in the South Seas*, George Allen & Unwin (an imprint of HarperCollins Publishers Limited), London, 1965, trans. Reginald Spink, pp. 190–1

To Charles Morice [c.15] January 1897
Malingue CLXIII

To Daniel de Monfreid, 14 February 1897
Joly-Segalen XXIX; Rijksmuseum VVG; extract from Guérin, p. 124

To Daniel de Monfreid, 12 March 1897
Joly-Segalen XXX; Rijksmuseum VVG

To Daniel de Monfreid, April 1897
Joly-Segalen XXXI; possession E. W. Kornfeld, Bern

To Daniel de Monfreid, 14 July 1897
Joly-Segalen XXXIV; Rijksmuseum VVG

To Mette [August? 1897]

Malingue CLXV where dated June 1897; BAA MS211

To Daniel de Monfreid, October 1897
Joly-Segalen XXXVII; extract from Guérin, p. 125

To Charles Morice, November 1897
Malingue CLXVI

Diverses choses (Miscellaneous Things), 1896–1898
Extract from Guérin, pp. 127, 136–7; Notes added to the illustrated manuscript of *Noa Noa*, Musée du Louvre, Département des Arts Graphiques (fonds du Musée d'Orsay)

To Daniel de Monfreid, February 1898
Joly-Segalen XL; Musée du Louvre, Département des Arts Graphiques (fonds du Musée d'Orsay); extract from Guérin, p. 159

To Daniel de Monfreid, March 1898
Joly-Segalen XLI; extract from Guérin, p. 180

To William Molard [March 1898]
Malingue CLXVII

To Dr Gouzer, 15 March 1898
Malingue CLXVIII

To Daniel de Monfreid, July 1898
Joly-Segalen XLV; Rijksmuseum VVG

To Daniel de Monfreid, 15 August 1898
Joly-Segalen XLVI; Rijksmuseum VVG; Guérin, p. 181

To Daniel de Monfreid, October 1898
Joly-Segalen XLVII

To André Fontainas, March 1899
Malingue CLXX; Rewald, *Studies*, pp. 182–4

To Daniel de Monfreid, May 1899
Joly-Segalen LIV; extract from Guérin, pp. 185–6

To Maurice Denis [June 1899]
Malingue CLXXI

To André Fontainas, August 1899
Malingue CLXXII; Rewald, *Studies*, pp. 184–6

To Daniel de Monfreid, September 1899
Joly-Segalen LVIII; Rijksmuseum VVG

To Ambroise Vollard, January 1900
Malingue CLXXIII where mistakenly given to Bibesco; Rewald, *Studies*, pp. 189–92

To Daniel de Monfreid, January 1900
Joly-Segalen LX; Rijksmuseum VVG

To Daniel de Monfreid, 27 January 1900
Joly-Segalen LXI

To Daniel de Monfreid, April 1900
Joly-Segalen LXIII

To Daniel de Monfreid, October 1900
Joly-Segalen LXVIII; Rijksmuseum VVG

To Daniel de Monfreid, November 1900
Joly-Segalen LXIX; possession E.W. Kornfeld, Bern

To Daniel de Monfreid, June 1901
Joly-Segalen LXXIV; Rijksmuseum VVG; Guérin, p. 210

To Charles Morice, July 1901
Malingue CLXXIV; Museum of Fine Arts, Boston

To Daniel de Monfreid, August 1901
Joly-Segalen LXXVII; Rijksmuseum VVG

To Daniel de Monfreid, November 1901
Joly-Segalen LXXVIII; Rijksmuseum VVG

To Daniel de Monfreid, May 1902
Joly-Segalen LXXXI; Guérin, pp. 212–13

To Daniel de Monfreid, 25 August 1902
Joly-Segalen LXXXII

To André Fontainas, September 1902
Malingue CLXXVI; Rewald, *Studies*, pp. 205–7

Racontars de rapin (Recollections of a Dauber), 1902

Extracts from Guérin, pp. 215–27; Josefowitz Collection

To Daniel de Monfreid, October 1902
Joly-Segalen LXXXIII; Rijksmuseum VVG

To André Fontainas, February 1903
Malingue CLXXVII; Rewald, *Studies*, pp. 209–10

From *Avant et après* (Before and After)
Extracts from Guérin, pp. 280–2; private collection

To Charles Morice, April 1903
Malingue CLXXXI; Guérin, p. 294

FURTHER READING

(For catalogues of Gauguin's work, see LIST OF
PLATES, p. 303)

LETTERS AND COLLECTED WRITINGS

Malingue, Maurice (ed.), *Lettres de Gauguin à sa femme et
à ses amis*, Bernard Grasset, Paris, 1946; *Paul Gauguin:
Letters to his Wife and Friends*, Saturn, London, 1948,
trans. H. Stenning

Joly-Segalen, A. (ed.), *Lettres de Gauguin à Georges Daniel
de Monfreid*, (1st edn. Crès, Paris, 1918; 2nd edn.
Librairie Plon, Paris, 1930), Editions G. Falaize, Paris,
1950

Guérin, Daniel (ed.), *Paul Gauguin: Oviri, écrits d'un
sauvage*, Gallimard, Paris, 1974
— *Paul Gauguin: The Writings of a Savage*, Viking
Penguin 1978 – Paragon House 1990, trans. Eleanor
Levieux (this anthology contains extracts from various
of Gauguin's writings including *Notes synthétiques*, *Notes
sur l'art à l'Exposition universelle*, *Cahier pour Aline*, *Noa
Noa*, *Diverses choses*, *Racontars de rapin*, *Avant et après*)

Cooper, Douglas (ed.), *Paul Gauguin, 45 lettres à Vincent,
Théo et Jo van Gogh*, Collection Rijksmuseum Vincent
van Gogh, Amsterdam, Gravenhage & Lausanne, 1983

Merlhès, Victor (ed.), *Correspondance de Paul Gauguin,
documents, témoignages*, Vol.1, 1873–1888, Fondation
Singer-Polignac, Paris, 1984

Wadley, Nicholas (ed.), *Noa Noa, Gauguin's Tahiti*,
Phaidon, Oxford, 1985 (contains useful bibliography of
editions of *Noa Noa*)

MONOGRAPHIC STUDIES

Gauguin sa vie, son oeuvre, Réunion de textes, d'études,
de documents, special number of *La Gazette des Beaux-
Arts*, jan. – avril 1956
Huyghe, René *et al.*, *Gauguin*, Collection Génies et
Réalités, Hachette, Paris, 1960
Perruchot, Henri, *La vie de Paul Gauguin*, Hachette,
Paris, 1961; *Gauguin*, Perpetua, London, 1963, trans.
Humphrey Hare
Danielsson, Bengt, *Gauguin in the South Seas*, George
Allen & Unwin, London, 1965, trans. Reginald Spink
Cachin, Françoise, *Gauguin*, Livre de Poche, Paris, 1968;
augmented edn. Flammarion, Paris, 1989
Pickvance, Ronald, *The Drawings of Gauguin*, London,
1970
Bowness, Alan, *Gauguin*, Phaidon, London, 1971
Field, Richard, *Paul Gauguin: The Paintings of the First
Voyage to Tahiti*, Garland, London & New York, 1977
Thomson, Belinda, *Gauguin*, (World of Art), Thames &
Hudson, London, 1987
Prather, Marla and Stuckey, Charles (ed.), *Gauguin: a
Retrospective*, New York, 1987

GENERAL

Rewald, John, *Post-Impressionism: From Van Gogh to
Gauguin*, Secker & Warburg, 1958, rev. edn. London,
1978
Roskill, Mark, *Van Gogh, Gauguin and the Impressionist
Circle*, Thames & Hudson, London, 1970
Thomson, Belinda, *The Post-Impressionists*, Phaidon,
Oxford, 1983, 2nd edn. pbk, 1990
Pollock, Griselda, *Avant-Garde Gambits, 1888–1893:
Gender and the Colour of Art History*, Thames & Hudson,
London, 1992

EXHIBITION CATALOGUES

Orangerie des Tuileries, *Gauguin*, Exposition du
Centenaire, (with contributions by Jean Leymarie &
René Huyghe), Éditions des musées nationaux, Paris,
1949
Gauguin and the Pont-Aven School, Tate Gallery, London,
1966
Field, Richard, *Paul Gauguin Monotypes*, Philadelphia
Museum of Art, Philadelphia, 1973
Bodelsen, Merete, *Gauguin and Van Gogh in Copenhagen in
1893*, Ordrupgaard, 1984
The Art of Paul Gauguin, exhibition catalogue, with
contributions by R. Brettell, F. Cachin, C. Frèches-
Thory & C. Stuckey, National Gallery of Art,
Washington, & Art Institute, Chicago, 1988
Galeries nationales du Grand Palais, Paris, *Gauguin*,
(with contributions by R. Brettell, F. Cachin, C.
Frèches-Thory & C. Stuckey), Éditions de la Réunion
des musées nationaux, Paris, 1988–1989